SPECTACULAR HOMES

of Philadelphia

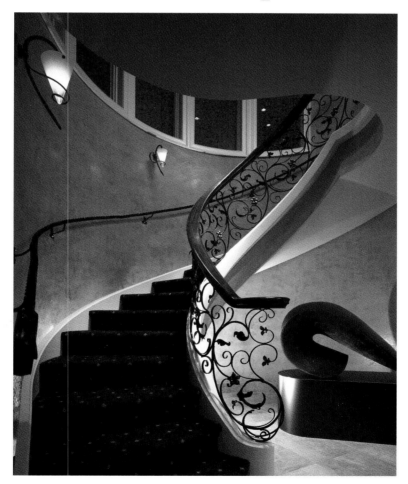

AN EXCLUSIVE SHOWCASE OF PHILADELPHIA'S FINEST DESIGNERS

Published by

PANACHE
PARTNERS LLC

13747 Montfort Drive, Suite 100
Dallas, Texas 75240
972-661-9884
972-661-2743
www.panache.com

Publishers: Brian G. Carabet and John A. Shand

Printed in Malaysia

Distributed by Gibbs Smith, Publisher
800-748-5439

PUBLISHER'S DATA

Spectacular Homes of Philadelphia

Library of Congress Control Number: 2005909010

ISBN Number: 978-1-933415-24-6

First Printing 2006

10 9 8 7 6 5 4 3 2 1

728
SPE

Previous Page: Joseph A. Berkowitz, Joseph A Berkowitz Interiors, Inc.
See page 125 Photo by Barry Halkin

This Page: Cecil Baker, Cecil Baker & Associates
See page 11 Photo by Barry Halkin

2

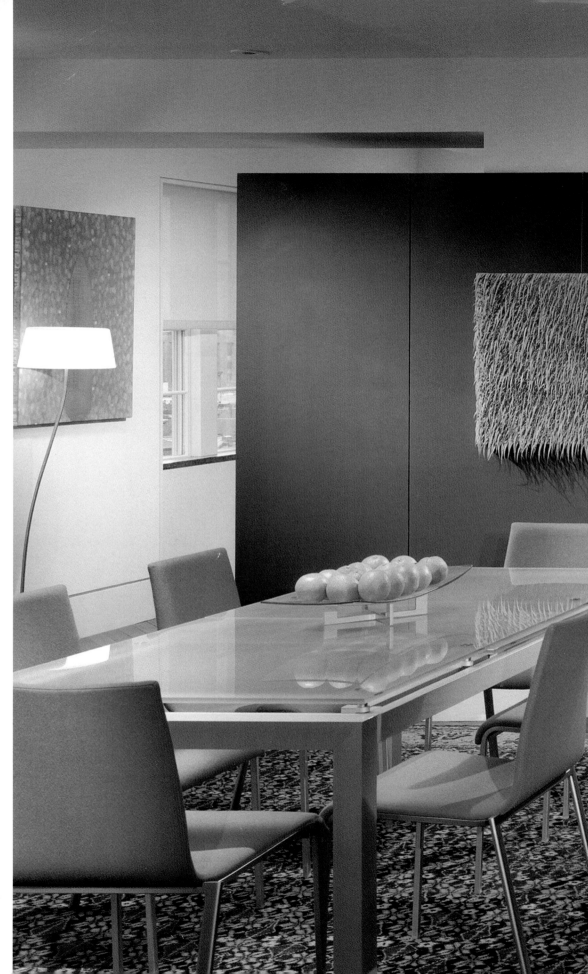

SPECTACULAR HOMES
of Philadelphia

AN EXCLUSIVE SHOWCASE OF PHILADELPHIA'S FINEST DESIGNERS

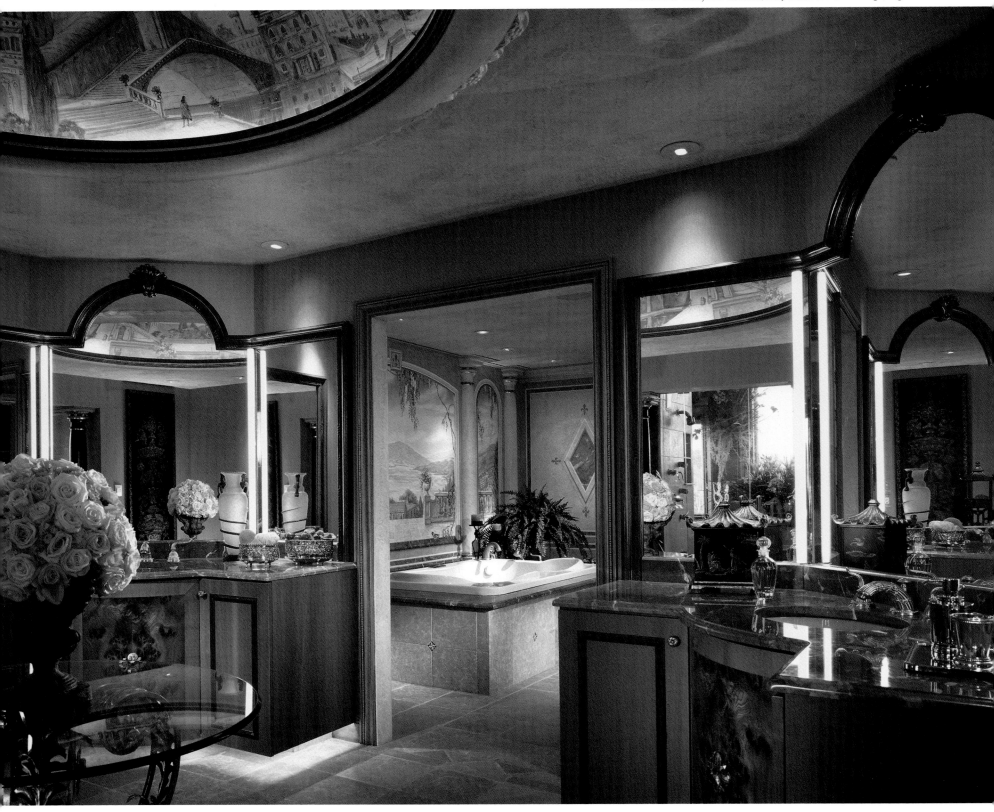

INTRODUCTION

I am pleased to present to you *Spectacular Homes of Philadelphia,* a collection of the most beautiful homes created by the most esteemed designers in the area.

While putting this book together, I had the fortune of touring homes touched by a designer's deft hand, meeting these talented artists, and hearing about their many transformations. It is their ability to see what could be in a room that is truly fascinating for the untrained eye to witness.

I was introduced to design early and embraced it. My mother loved not only organizing charity open houses, but also going on house tours with friends. My father's love of color, style and nature is why I am now drawn to spaces that are clean, calm and natural. As a native of Philadelphia, I had the fortune of being surrounded by magnificent country homes, horse farms, stately manors on the Main Line, and a city filled with brownstones, high-rises and an ever changing skyline. Philadelphia is not only rich in history but also architecture and design as you will see in the pages to come.

In this book, you will meet and get to know some of the most influential designers of our time. You will experience spaces that vary from the traditional to modern and everything in-between. You will see how designers use color, light, fabric, furniture and art to make a home come alive.

The goal is to showcase that which we love about our homes. Maybe it's a rustic farm table we gather around with friends, a contemporary kitchen where the food is the texture, the afternoon light from the glass wall or the beauty of the exposed brick with your favorite painting, all of these elements have been carefully thought out by a designer. You will see and feel how a keen eye can enhance and transform a space. The vision unfolds to become the place we call home.

Warmest regards,

Kathryn Newell
Senior Associate Publisher

Kathryn Newell, Senior Associate Publisher

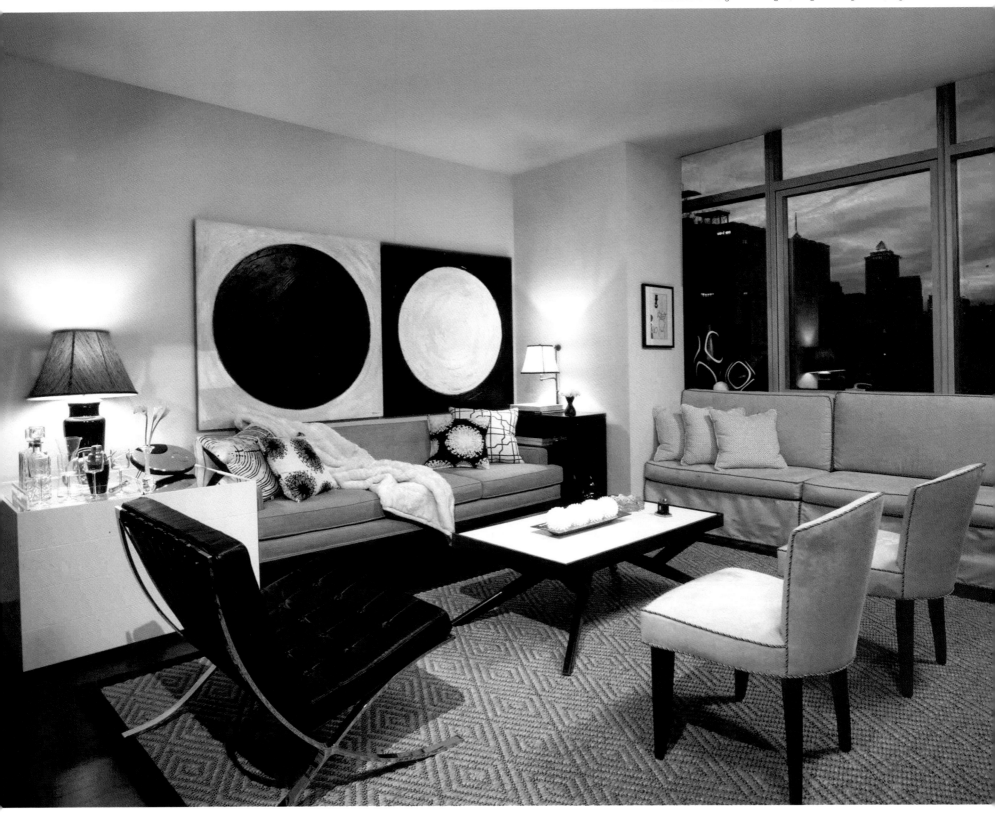

TABLE OF CONTENTS

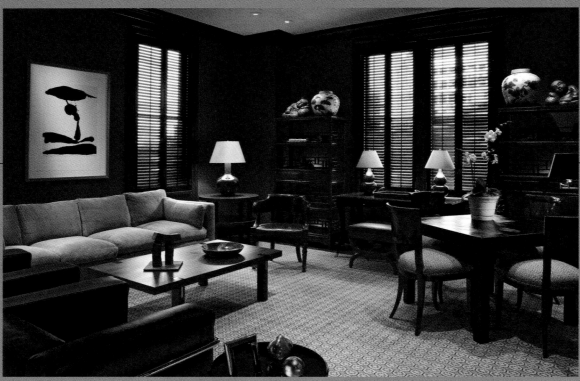

DESIGNER: Carl Steele, Carl Steele & Associates., Page 111

CENTER CITY PHILADELPHIA

AN EXCLUSIVE SHOWCASE OF PHILADELPHIA'S FINEST DESIGNERS

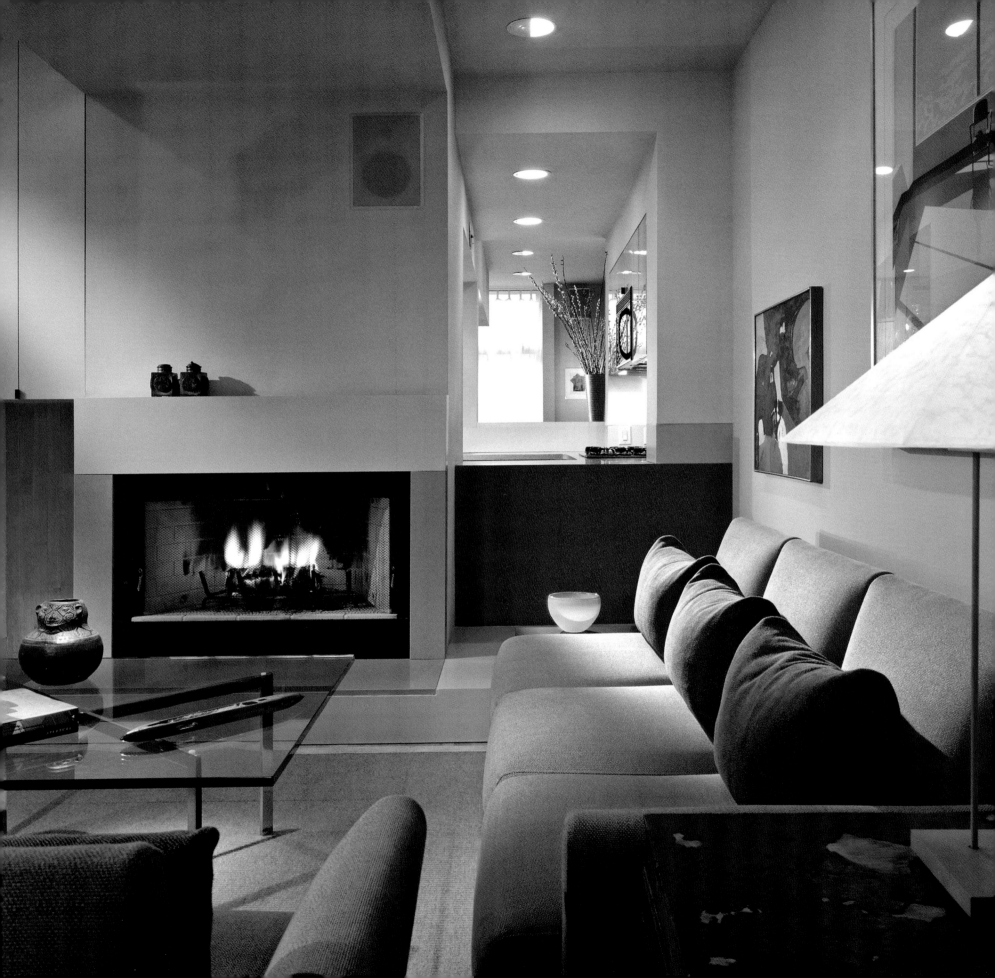

ABOVE
View of stairway in urban town home.

LEFT
Open progression from living room to kitchen to dining room with subtle volume variations.

Not many designers tell you good design is choosing what to leave out, rather than what to put in. Cecil Baker will. An icon in Philadelphia for his quiet, clean contemporary designs, he opened his own firm 20 years ago, and continues to make headlines for his work such as the elegant and serene flats he was commissioned to design for the adaptive reuse of the historic Lanesborough and Lippincott buildings in Center City, Philadelphia.

Baker's work has received more than 40 national and regional design awards and has been featured in *Architectural Record, Progressive Architecture* and *GA Homes*.

Each room in a Cecil Baker & Associates design feels complete and yet, in what he calls the choreography of passage, some asymmetrical moment will draw the viewer to experience the next room—a purposeful restlessness. He seeks to create quiet theater: spaces that slip from sanctuary to mystery, that remain in the mind like chapters in a book.

Compression and expansion, the introduction of diffused natural light, materials that blur distinctions between floor, wall, or ceiling planes, and subtle shifts in color—these are the hallmarks of a Cecil Baker home.

ABOVE LEFT
Kitchen with Corten eating counter floats in former industrial space.

ABOVE RIGHT
Kitchen/breakfast area with uncomplicated but crisply detailed walls and cabinetry.

FACING PAGE
Simple sculptural moments define an otherwise open living environment.

Every project begins with a conversation between the owner and the architect: the shared exploration. His clients wish to be different. He therefore partners with them to create a new environment that is original for them, a home that makes them proud, that stretches them to new possibilities.

Born to British parents in Argentina, Cecil was sent to the United States to study engineering. He wanted to be an artist, but architecture, initially a compromise, grew into a passion. He sees his buildings as sculpture and painting on a large scale.

When he is not working, the tall, elegant father of three spends time with his wife, a psychologist, exploring the backroads of his native land: places shaped by culture and myth, weather and time, by the hands of the mason and carpenter, and, sometimes, by the whimsy of an architect. Place, he senses, in turn shapes us.

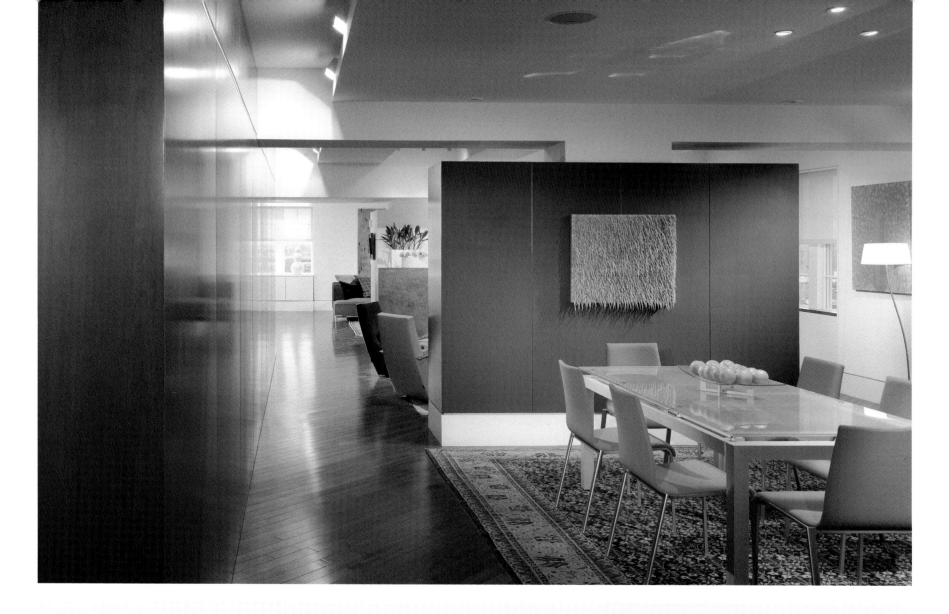

More About Cecil

WHAT DO YOU LIKE MOST ABOUT BEING AN ARCHITECT?

I get to play every day.

WHAT ONE ELEMENT OF STYLE OR PHILOSOPHY HAVE YOU STUCK WITH FOR YEARS THAT STILL WORKS FOR YOU TODAY?

The romantic possibilities ripening in an austere environment.

WHAT IS A SINGLE THING YOU WOULD DO TO BRING A DULL HOUSE TO LIFE?

I believe that a good design has to do with making choices out of what to leave out, rather than what to put in.

IF YOU COULD ELIMINATE ONE DESIGN/ARCHITECTURAL/BUILDING TECHNIQUE OR STYLE FROM THE WORLD, WHAT WOULD IT BE?

Post Modernism—facile reinterpretation of styles developed under other cultural paradigms.

WHAT IS THE HIGHEST COMPLIMENT YOU'VE RECEIVED PROFESSIONALLY?

That I have consistently held to my design vision.

Cecil Baker & Associates
Cecil Baker
1107 Walnut Street
Philadelphia, PA 19107
215.928.0202
FAX 215.928.1517
www.cbaarch.com

DAVID BANKES

ABOVE
Lofty ceilings provide the perfect stage for David's wall designs, based loosely on a Mondrian painting. A shock of red pulls the whole room together.

LEFT
Sunlight and soft neutrals dominate this room. David anchored it with a magnificent sky-blue antique rug. The combination created an airy backdrop for the clients' beautiful antiques and artwork.

David Bankes emerged from a creative family. Being surrounded by artists and furniture makers was an early inspiration for David to think "outside the box." Sketches of glass walls and flat roof lines were conceptualized in his mind and came to fruition on paper.

David has practiced interior design for 15 years and designs furniture as a passion. In 2001 he won an ADEX (Award for Design Excellence) for a console he envisioned. In 2002 he displayed his contemporary Rouleau desk of solid bird's-eye maple and plate glass at the ICFF (International Contemporary Furniture Fair) in New York City. The wife/author of a famous novelist duo spotted the desk and eventually purchased it for their home in Osprey, Florida.

David's design expertise ranges from traditional to minimalist with a focus on contemporary and modern installations. He creates spaces that have unique characteristics no matter where your eye leads you.

The best part of designing, David confesses, is the ability to live vicariously through his clients. He enjoys seeing the expression of delight on their faces as they enter their finished home for the first time. One of his New York clients told him they sit down in their living room every night and say to each other, "Who lives here?"

David Bank Interiors
David Bankes
124 Market Street, 2nd Floor
Philadelphia, PA 19106
215.627.7189
FAX 215.627.0817
www.davidbankesinteriors.com

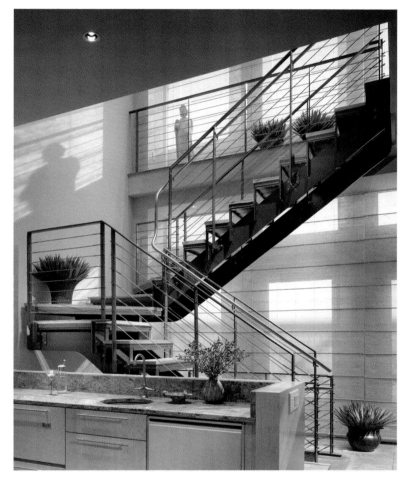

O n an Eames lounge chair, at the entry of the studio, sits Floss Barber curled up. Nearby is Dorothy Marie, her Boston bulldog. Today Floss is particularly relaxed as she is off to spend some downtime at her residence in the Arizona desert.

It is obvious that Floss' years on the yoga mat have made her simultaneously flexible and relaxed. These wonderful nimble qualities are the same characteristics that she has been bringing to projects for years. Well known for her expertise in aesthetics, she is particularly focused on creating and enhancing "breathing space" in the interiors she designs.

Floss Barber was raised on a farm in the open green landscape of New Jersey. This experience of seeing the seasonal impact on the environment, and the need for order and process, gave Floss a deep understanding for the holistic aspect of interior design—balance, light, order, form, freshness, not static. With no portfolio or finishing school pedigree, she was accepted to Drexel University in Philadelphia and voted "Most Creative" in her class. While at Drexel she received the Mary Epstein Award for Design Direction. Mary Epstein was the department chair at Drexel in the '70s and '80s and became a key mentor for Floss' for many years.

Hanging in the office is an oversized photograph of Mary Epstein, commemorating her influence on Barber's development as an interior designer in Philadelphia. Curiously, when Mary Epstein sat for the photo,

it was with the key stipulation that "it would be funny." Thus, in the image, one sees a dignified senior, perched and poised on the edge of a chair in the most ladylike fashion, but appearing as though she will hit the floor at any moment! It is this tension between humor and serenity that creates a special dynamic of life and grace in the work, and atmosphere, of Floss Barber, Inc.

In 1986, Floss opened her own studio, which grew to become a successful and widely recognized full-service interior design firm. The firm specializes in high-end hospitality and corporate design, yet finds a place for distinctive residential projects for private clients. Never formulaic, Floss' strength is in unique planning. Besides accommodating the things that are needed to inhabit space, she thrives on creating room for breath, light and open movement. She derives pleasure in playing with the boundary between the fresh and the everlasting.

Floss captures timelessness in that moment she calls "the collapsing of time." Collapsing of time in space is where old and new come together, merging in such a way that blurs the distinction between past and present. For example, a 1929 Corbusier chair in a modern space creates a timeless classic interior, an experience in which one does not know which is the classic or which is the modern. It is this moment that collapses time.

TOP LEFT
Media space and artwork collection.

BOTTOM LEFT
Spacious bedroom and entrance to dressing area.

FACING PAGE LEFT
Bathroom.

FACING PAGE RIGHT
Bedroom detail of Ingo Maurer lamp against natural light and skyline.

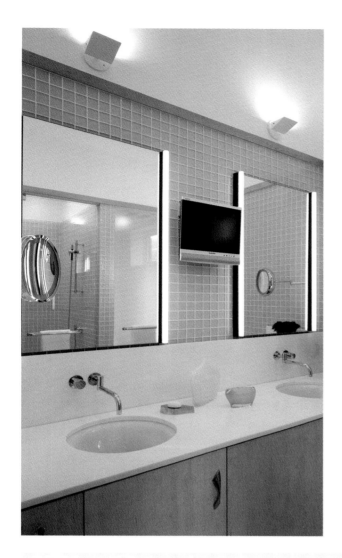

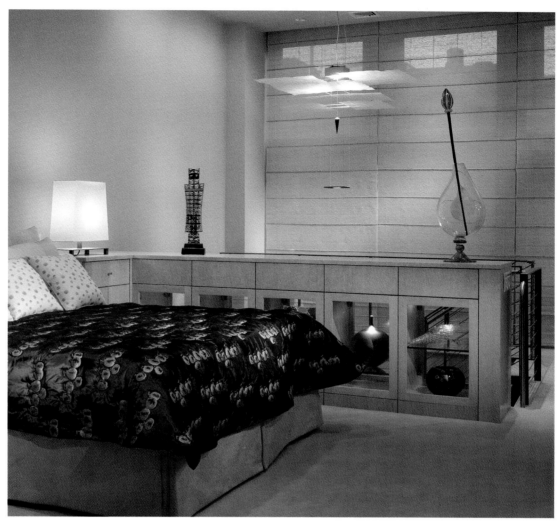

More About Floss

WHAT IS THE BEST PART OF BEING A DESIGNER?

The front end part; quickly deducing what a client wants, and needs, and then finding a way to give it to them. Also, dealing with beautiful things every day—dealing with the designers, the contractors, bank presidents. Those parts that are ever changing remain curious to me; where nothing is ever the same.

WHAT IS THE HIGHEST COMPLIMENT YOU HAVE BEEN PAID PROFESSIONALLY?

For one client, I did their corporate offices and then we designed their home. They told me that I "had an ability to listen and uniquely capture the spirit and soul of the client and translate the clients' dream."

WHO HAS BEEN THE BIGGEST INFLUENCE ON YOUR CAREER?

Mary Epstein from Drexel. She would mix modern and antiques. She would put antiques in a modern space. I also respect Andre Putnam and early Phillipe Stark—especially when he designed the Royalton.

WHAT BRINGS A DULL HOUSE TO LIFE?

Light. Cleaning it up and sorting out the clutter.

Floss Barber, Inc.
Floss Barber
1420 Locust St., Suite 310
Philadelphia, PA 19102
215.557.0700
www.flossbarber.com

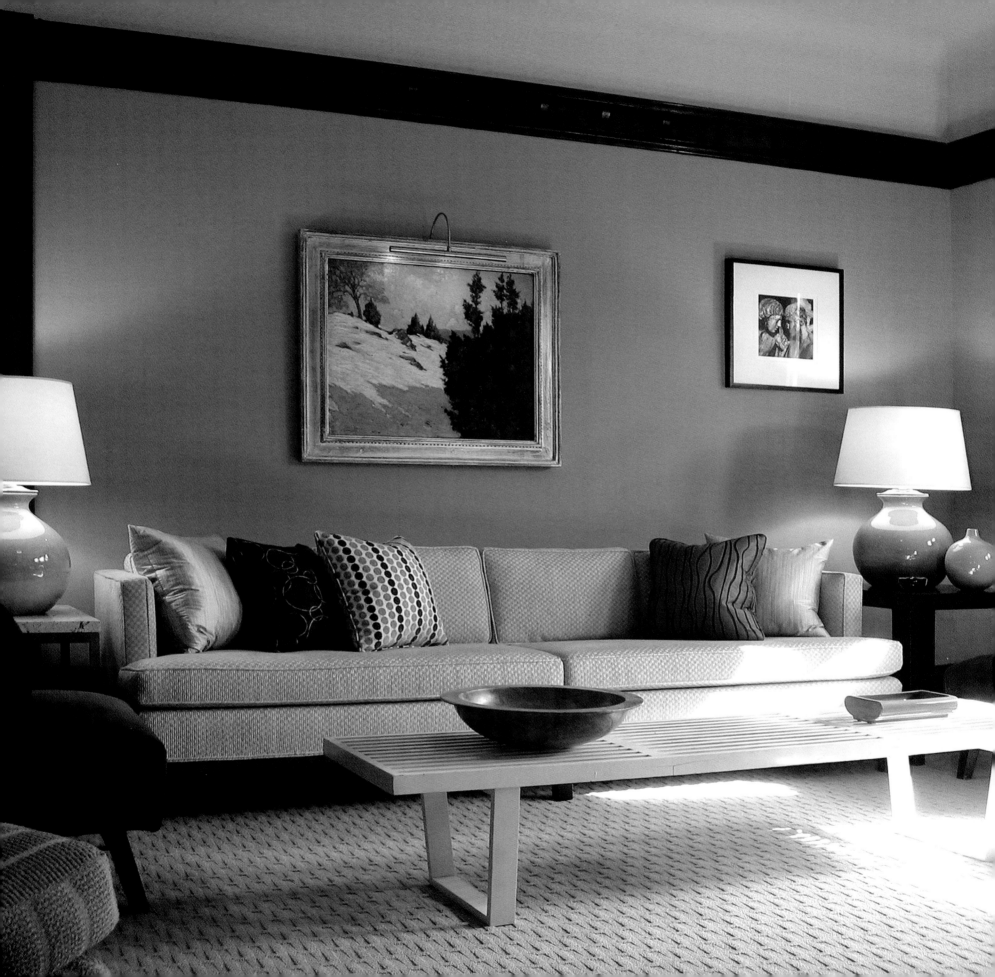

GREG BERZINSKY

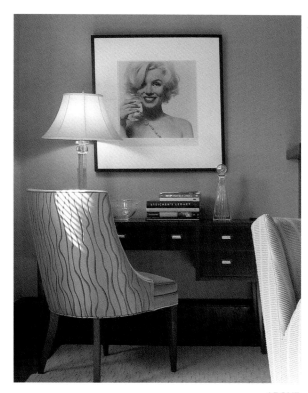

ABOVE
A Bert Stern photograph of Marilyn Monroe watches over a walnut writing table. Desk chair is upholstered in a grey blue silk from Bert Stern.

LEFT
A painting by Gustave Cimiotti hangs above a group of custom furniture by the architect for this town house living room. Sofa fabric by Rodolph. The white lacquered Nelson platform bench sits in contrast to the living room's dark walnut woodwork and slate blue walls.

G reg Berzinsky was fascinated by TV sets as a child and would draw them with great precision and accuracy. Today, his architectural renderings, works of art in and of themselves, are in demand by large firms that commission them for publication in newspapers such as *The Philadelphia Inquirer* and *The New York Times*.

A graduate of the Pennsylvania State University with a bachelor of architecture, Berzinsky opened his own firm 16 years ago, with four on staff after working for larger architectural firms. Specializing in renovations, additions and interior design, he keeps his hand in hospitality design by consulting for DAS Architects working on Bliss, a hot Broad Street eatery, and the redo of the Philadelphia institution, Le Bec Fin. His latest collaboration, with Banik Cumby Inc., was the revamping of the prestigious, historic Union League, which involved designing millwork and period plaster details, and face-lifting other aspects of the Heritage Room, the Cigar Room, and the Old Café.

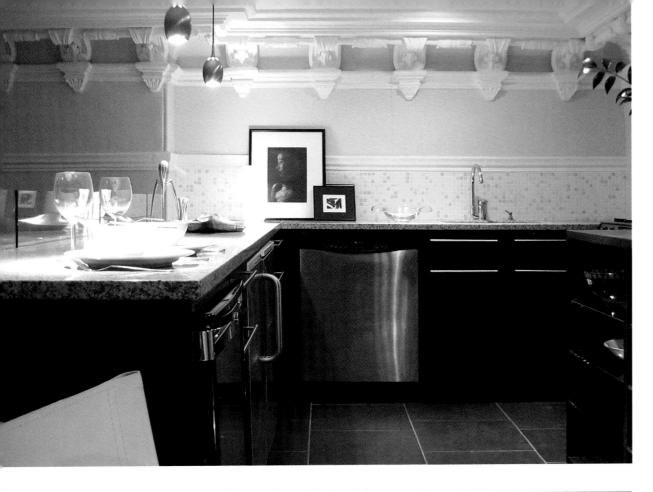

But Greg's love, along with interior designer Mary Ryan Berzinsky, is a space that can combine modern with traditional. Custom kitchens with one-of-a-kind cabinetry are also a forte. For one Center City brownstone, he made a low, modern kitchen to set off the elaborate period moldings of the existing space. Berzinsky often rebuilds furniture that clients have—making a traditional piece more streamlined or changing its height so it is in better scale with the room's proportions.

Many times they are called upon to gut a Center City townhouse and to add a floor to what is there, or to change a carriage house into a guest house or office. They have built homes from scratch in the South and transformed older Main Line manses into ones that function better for young families who want to cook, entertain and spend time in a room that is more modern in concept—the family room. He likes the challenge of working with existing spaces, especially older homes, sometimes doing contemporary additions or ones that look like they have always been there.

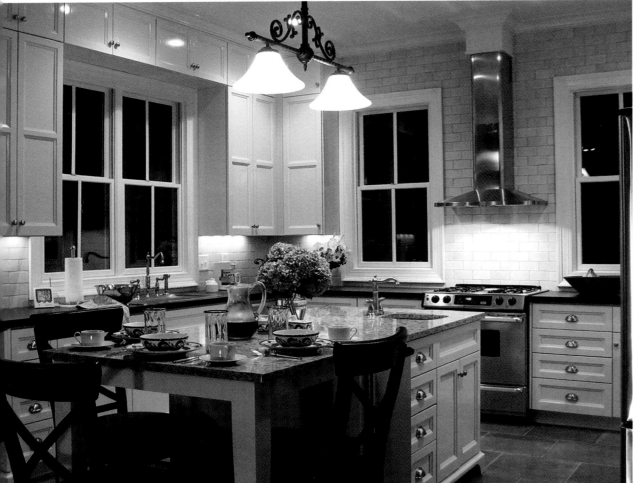

TOP LEFT
The base cabinet only scheme for this mezzanine kitchen sets off the restored ornate plaster crown. Low under-counter refrigeration and storage direct attention up to the architectural features and down into the living spaces below.

BOTTOM LEFT
Abundant and simple cabinets in this elegantly symmetrical kitchen provide ample storage. The massive granite-top island serves multiple functions, providing storage, an extra sink, plenty of counter space and places to sit.

More About
Greg

WHAT PERSONAL INDULGENCE DO YOU SPEND THE MOST MONEY ON?

Collecting art, especially by Philadelphia artists. I like Chris LaFuente, John Redmond, Jesse Gardener, Mark Bullen, and Alex Kanevsky.

WHAT IS THE BEST PART OF BEING AN ARCHITECT AND DESIGNER?

Every project is new and different. I like the initial conceptual phase when you are presenting the initial scheme to a client, seeing the excitement in their eyes, as well as going into the field to see the job progressing.

WHAT IS THE HIGHEST COMPLIMENT YOU HAVE RECEIVED PROFESSIONALLY?

"I didn't know I wanted this, but it is exactly what I want. You read my mind."

WHAT ONE ELEMENT OF STYLE OR PHILOSOPHY HAVE YOU STUCK WITH FOR YEARS THAT STILL WORKS FOR YOU TODAY?

We can rebuild it. We don't assume that everything "has to go."

IF YOU COULD ELIMINATE ONE ARCHITECTURAL TECHNIQUE OR STYLE FROM THE WORLD, WHAT WOULD IT BE?

Spec housing.

WHAT IS THE SINGLE THING YOU WOULD DO TO BRING A DULL HOUSE TO LIFE?

Throw a party with interesting people.

Berzinsky Architects
Greg Berzinsky, AIA
923 South 46th Street
Philadelphia, PA 19143-3701
215.387.6636
www.berzinsky.com

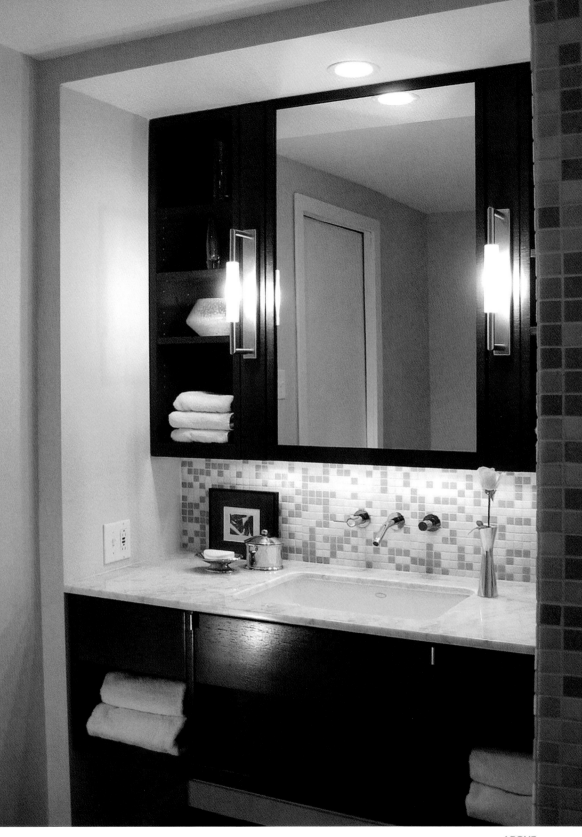

ABOVE
A custom hanging vanity of wenge with matching mirror and storage accentuates the bathroom alcove of this Center City residence. Glass mosaic tiles by Bisazza.

THOM CROSBY

CROSBY ASSOCIATES INTERIOR DESIGN

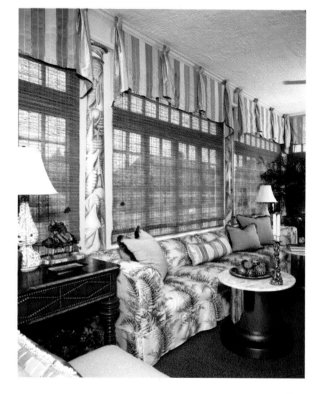

Thom Crosby is known for his innovative thinking about interiors, his sharp wit and his beautiful manners. He was once told he was the true definition of a gentleman, but he gives his mother credit for that. After 30 years in the design business in Philadelphia, the young-looking designer still loves what he does, and gets excited at the beginning of each new project. Still, you're only as good as the people who are your supports. Otherwise, you are just another person with great taste.

The elegantly dressed designer is humble about what he does and frank with clients about his preferences. Everyone loves him for his honesty. He doesn't tell you what to like, but he'll direct. And he'll never say yes when he means no. In his Queen Village home filled with art from the Sande Webster Gallery, he sits at his glass dining table and talks about projects that have taken him from Philadelphia to Florida, with Manhattan and Weshampton, New York and Vail tossed in the mix. Once a Thom Crosby devotee, you are sure to stay with him. About half of his clientele has been with him anywhere from 5 to 25 years, and many clients now have their children going to him. The trend for the last seven years is to design The Homestead, a grand retreat where parents, children and grandchildren can all come together.

While the modest designer will confess to a strong sense of style, he never does trendy. You can look at a room he's done 10 years ago and it still looks right. He likes his rooms to look quietly monied. Starting

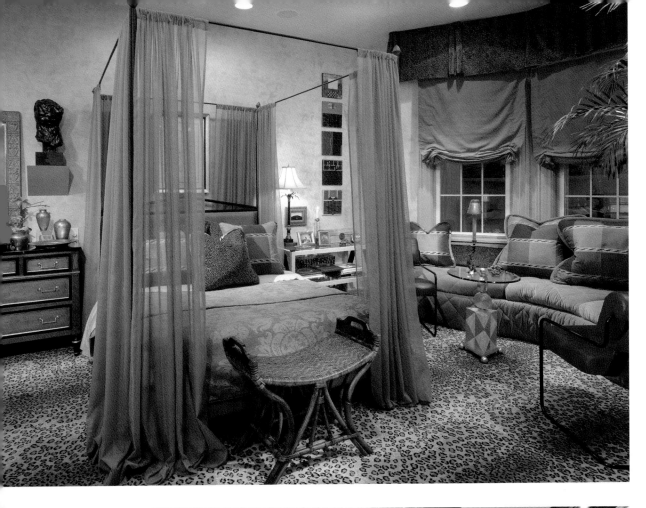

with the room's architectural feeling—whether it is with floors or a great coffered ceiling—he will fill them with color or texture on the walls, clean-lined comfortable upholstery, and depending on the clients taste, English, French or Oriental antiques mixed in with modern pieces. He loves designing custom furniture like the built-ins he made for a living room that changes into a home theater at the click of a button. The equipment is concealed in cabinets he created.

Born and raised in Connecticut, Thom had taken business classes to go into a family business but knew this was not his forte. He moved to Philadelphia and studied at Philadelphia College of Art. One oil pastel hangs in a corner of his home as testament to his aspirations to be a fine artist. Many Philadelphians are thankful he chose another path. Crosby has done 12 Vassar showhouses in Philadelphia and for the past 10 years has done the RNS showhouse near Atlantics City, New Jersey. He has won the RNS Grand Space Award four times.

But the highest compliment he received came from clients whose home was flooded and needed their rooms re-done by Thom. He asked them what they wanted to do this time and they replied: "Can you put it back the way it was?"

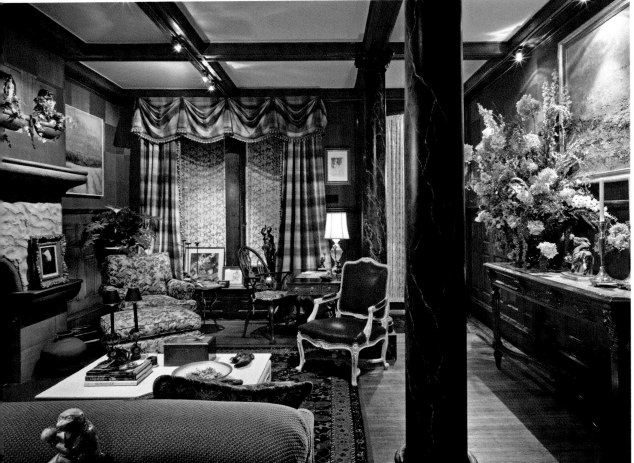

TOP LEFT
Master bedroom by the ocean filled with art and color. The crescent window seat was designed to soften the angles of the space.

BOTTOM LEFT
In a Center City townhouse columns were installed to create a feeling of a foyer, and set a perimeter for the sitting area.

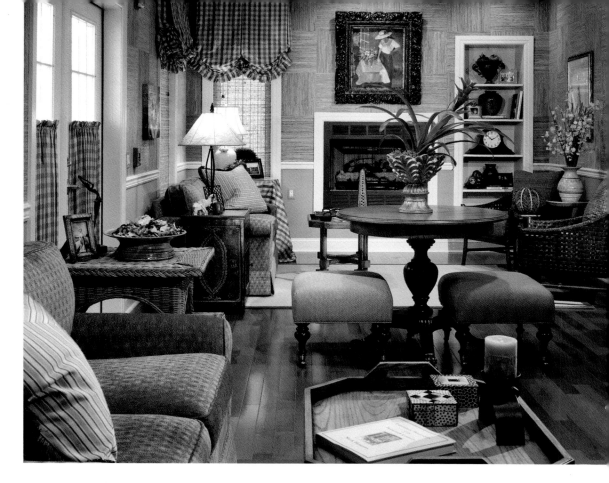

More About
Thom

WHAT IS THE BEST PART ABOUT BEING
A DESIGNER?

The people I have met—some are really lovely. And, the
exposure to wonderful architects.

WHAT IS THE HIGHEST COMPLIMENT
YOU'VE RECEIVED PROFESSIONALLY?

After 15 years, a client had a flood and after looking at
things to redo in the home, they asked if it could be put
back the way it was!

WHAT IS THE MOST UNIQUE/IMPRESSIVE/
BEAUTIFUL HOME YOU'VE SEEN IN
PHILADELPHIA? WHY?

A house in the Hamptons—a modern design of
Japanese style house on an inland waterway—the
landscaping was a work of art.

WHAT THINGS WOULD YOU DO TO BRING
A DULL HOUSE TO LIFE?

Texture, lighting, color and fabrics..

WHAT ONE ELEMENT OR PHILOSOPHY
HAVE YOU STUCK WITH FOR YEARS THAT
STILL WORKS FOR YOU TODAY?

Never work with what is au courant. I'm very careful that
things won't be dated.

Crosby Associates Interior Design
Thom Crosby
717 S. 11th Street
Philadelphia, PA 19147
215.928.8823

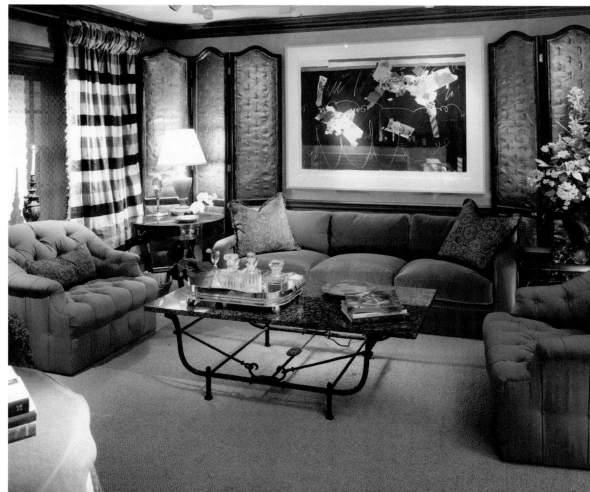

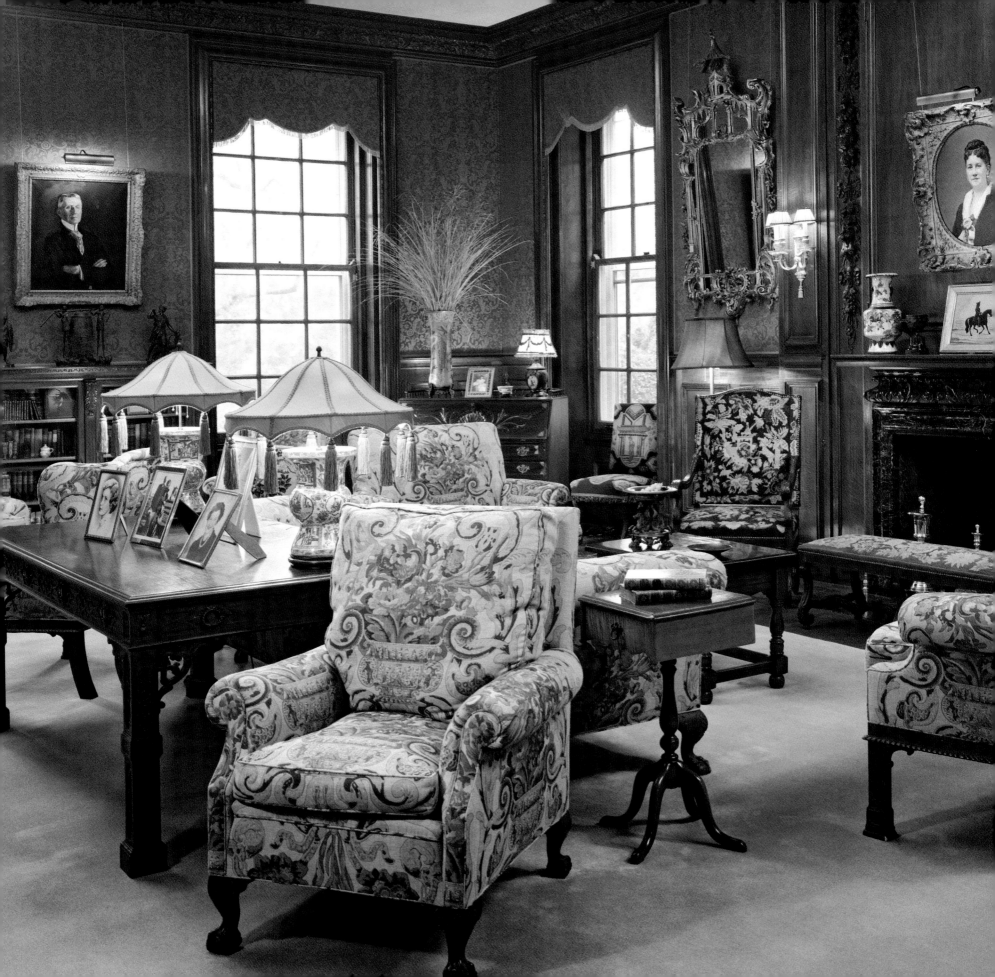

BARBARA EBERLEIN

EBERLEIN DESIGN CONSULTANTS LTD.

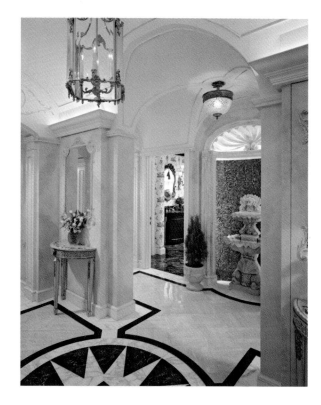

Let's see how rich each day can be. It is the motto of Barbara Eberlein. On one autumn day, case in point, she darts from a client meeting to the Philadelphia Museum of Art for a symposium on the future of period rooms, then to a dance performance at the avant-garde Fringe Festival of the Arts, then back to the museum—all before dinner.

After 26 successful years in the design business, Barbara has not slackened the pace at all. One of Philadelphia's most treasured creative minds, she has won 30 design awards including ASID's Designer of the Year Award, yet she is still the consummate pupil taking every opportunity to broaden her knowledge base at places like Sotheby's, The Bard Graduate Center, and The Institute of Classical Architecture.

Maybe that is why Barbara wants to capture every opportunity too when designing a home. She doesn't like seeing a room that is ambivalent or timid. In fact, she contends, creativity has nothing to do with budget and everything to do with confidence and

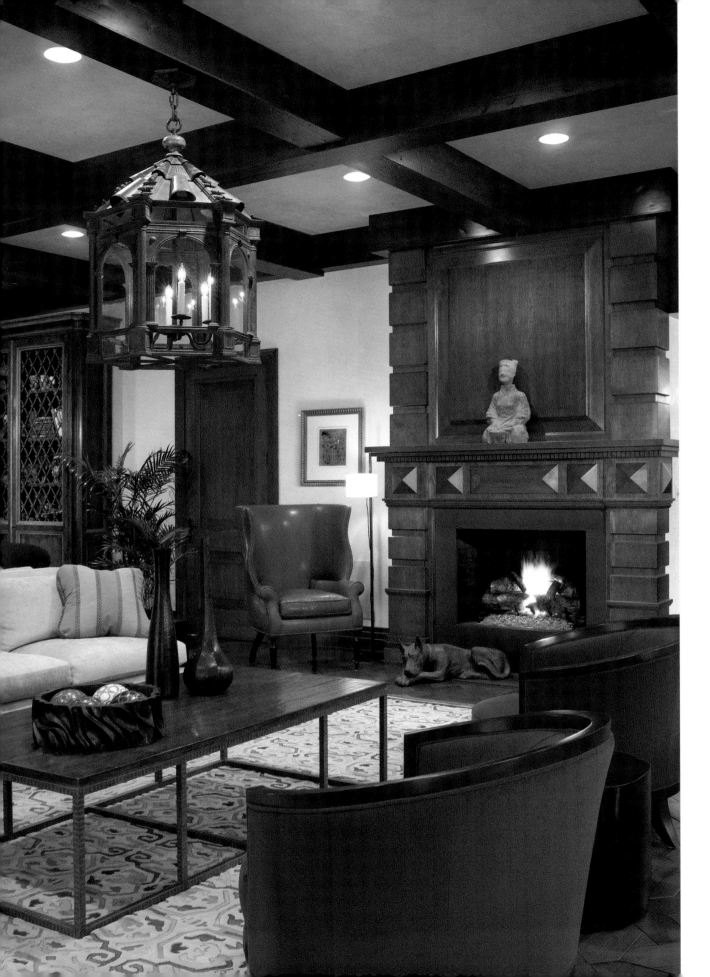

LEFT
Contemporary elegance is given scale and importance with bold materials, strong details and a warm color palette. The double-sided sofa welcomes multiple seating groups.

FACING PAGE TOP
The ballroom of this architectural masterpiece celebrates Gilded Age aesthetics with its Aubusson rug and needlepoint sofas presided over by an impressive Georgian fireplace.

FACING PAGE BOTTOM
Warmth and comfort are the hallmarks of this robustly masculine den with aniline dyed maple walls, suede and crewel fabrics and Chinese porcelains and bronzes.

expressiveness. If you develop people's confidence in their own ideas, taste will flourish.

Her approach to design is as unusual as her training. Although she studied classics, religion and archeology as a student at the University of Chicago, she always knew one day she would practice design. As a child she would design and make her own clothes, then explore local home furnishing stores, her head filled with visions of how she would live and look in these rooms. When she moved from Chicago to Philadelphia, she devoured classes in architectural history, construction and design before opening her own firm 20 years ago.

Foresight and interpretation are what make her approach to design so different. There is no signature look to her work, but rather an introspective process. She asks clients to look inward to discover what pleases them—something that is truly their own vision that may never have appeared on the pages of a magazine. She encourages them to slow down and imagine themselves in their ideal space, enjoying the life they want to live. After she identifies her clients' desires, the evolving design resolves both aesthetic and technical challenges. Throughout the process, there is a special focus on advancing clients' knowledge and love of the fine arts and collecting.

Barbara, with a staff of eight designers, has the luxury of taking on only comprehensive projects from contemporary landmarks of today's most innovative architects to significant historic structures created in the 18th, 19th and early 20th centuries.

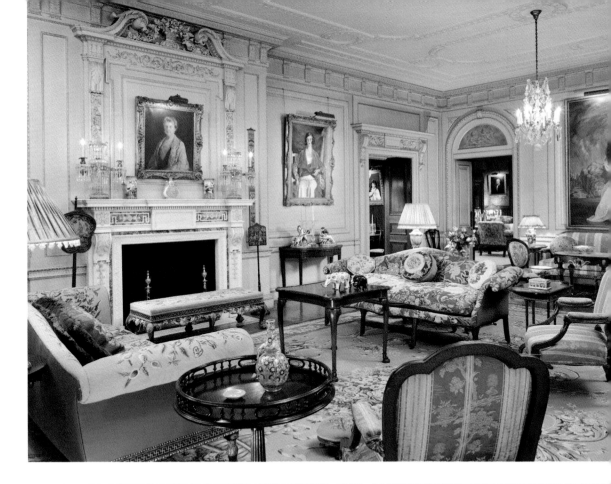

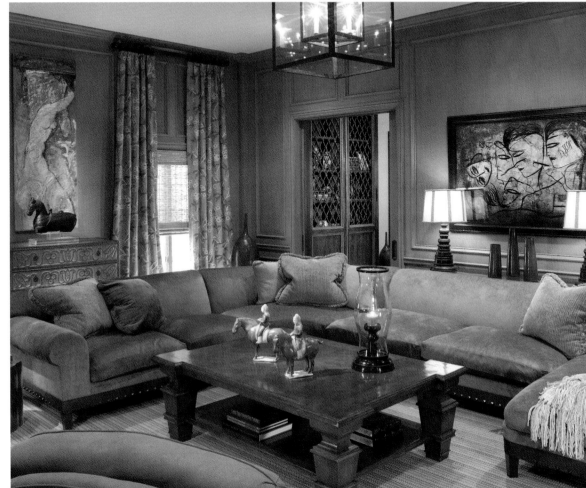

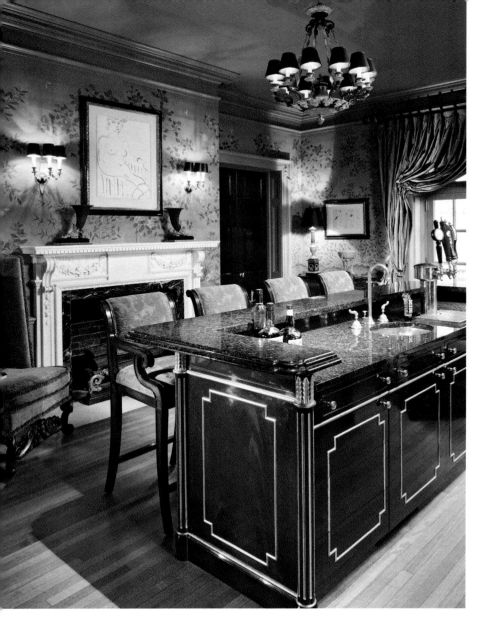

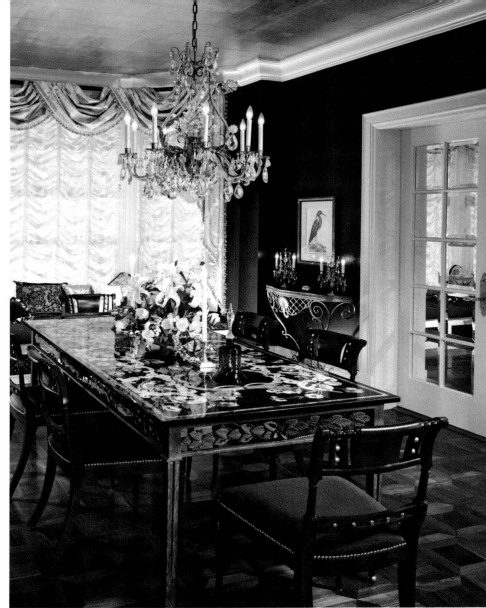

Her most treasured project is the distinguished historic estate, Ardrossan. In 1995, the late Robert Montgomery Scott invited Barbara to undertake the complete restoration of this 40,000-square-foot masterpiece set on 600 pastoral acres on the Main Line. Barbara considers the collaboration with Mr. Scott the ultimate privilege, counting him as a major career influence. She admired the icon, the former president of the Philadelphia Museum of Art, for his aesthetically discerning eye, his commitment to the arts and his generosity of spirit. Here is a case where this designer's inspiration was channeled directly from her learned client.

Her work at Ardrossan has been widely published, as have many of her other homes across the country, in countless books and magazines. She is still intrigued by what writers focus on and how they, like she, express complex concepts verbally. She actively encourages her clients to read about design, draw from their travels and absorb everything they can visually. Educated clients learn to trust their aesthetic sense, which in turn leads to better collaboration and more astute interpretation.

Editorial praise aside, Barbara's fondest accolades come from clients who say there is no place like home. One couple who travels extensively and stays in the world's finest hotels told her that their favorite moment of every trip is when they return home, open the front door, and realize how lucky they are. And that makes Barbara honored to do what she does.

More About Barbara

YOU CAN TELL I LIVE IN PHILADELPHIA BECAUSE:

I walk really fast. I love Philadelphia because the city is alive with culture.

WHAT PERSONAL INDULGENCE DO YOU SPEND MONEY ON?

Shoes. Shoes. Shoes. And some I collect to not actually wear, but to mark their place on the color spectrum produced by the ones I do wear.

WHAT COLOR BEST DESCRIBES YOU AND WHY?

My personal favorite color is a fluid mix of aqua and turquoise. I am an Aquarius after all.

WHAT IS YOUR FAVORITE PERIOD OF FURNITURE?

So many! There's 17th century Italy, 18th century France, 19th century England, and 20th century America. And 21st century—who can tell?

Eberlein Design Consultants Ltd.
Barbara Eberlein, ASID
1616 Walnut Street, Suite 1500
Philadelphia, PA 19103
215.790.0300
www.eberlein.com

ABOVE
Serenity reigns supreme in this master bedroom oasis, subtly blending taupe and turquoise in Fortuny fabrics, linen carpet and 19th century Chinese wallpaper.

FAR LEFT
Glamour abounds in this library bar with painted silk walls, welcoming modern art and millwork inspired by English Regency cabinetry, all aglow with bronze lighting.

LEFT
Sapphire blue walls sparkle beneath a shimmering silver teapaper ceiling in this unique dining room. The Florentine scagliola top renders the table itself a piece of art.

JAMES G. FULTON JR. & ERIC RYMSHAW

FURY DESIGN, INC.

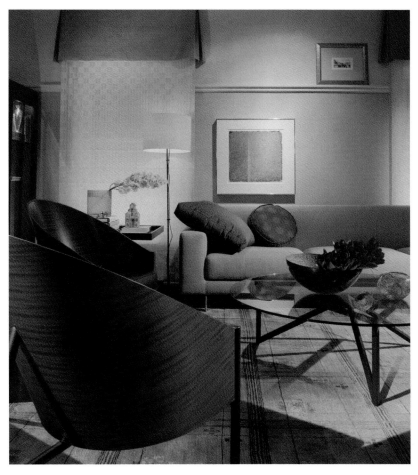

Living room of Villanova residence uses a hip eclectic mix of contemporary furniture and neutral textures.

Philadelphia townhouse featuring mid-century classic and works on paper by local artists.

Every room that has been touched by the hand of Jim Fulton and Eric Rymshaw oozes calm, exudes good design and boasts great original art as its centerpiece. Jim, a reserved Philadelphia College of Art trained interior designer with a background in home fashions retailing, and Eric, an outgoing Drexel-schooled architect, are the yin and yang team called FURY Design. For the past seven years, forward-thinking Philadelphians have called upon them to create thoroughly modern spaces.

With 25 years of design experience between them, they opened FURY Design Inc. in 1998 and are now a firm of five. They have tackled 25 residences—from a 250 square-foot room in Center City to a 17,000-square-foot Main Line estate. Their work has also taken them from the Eastern shores of Maryland to Colorado. Their services range from conceptual space planning, construction administration, custom furniture design, and art procurement down to the final details of purchasing sheets, towels, tableware and kitchen equipment. Every job is a collaborative effort with the client.

Based in Northern Liberties, the FURY approach is anything but antiquated—there is always a modernist approach throughout their houses. Never dictators of style, they favor architectural solutions to decorative ones. Rather than add layers, they'll

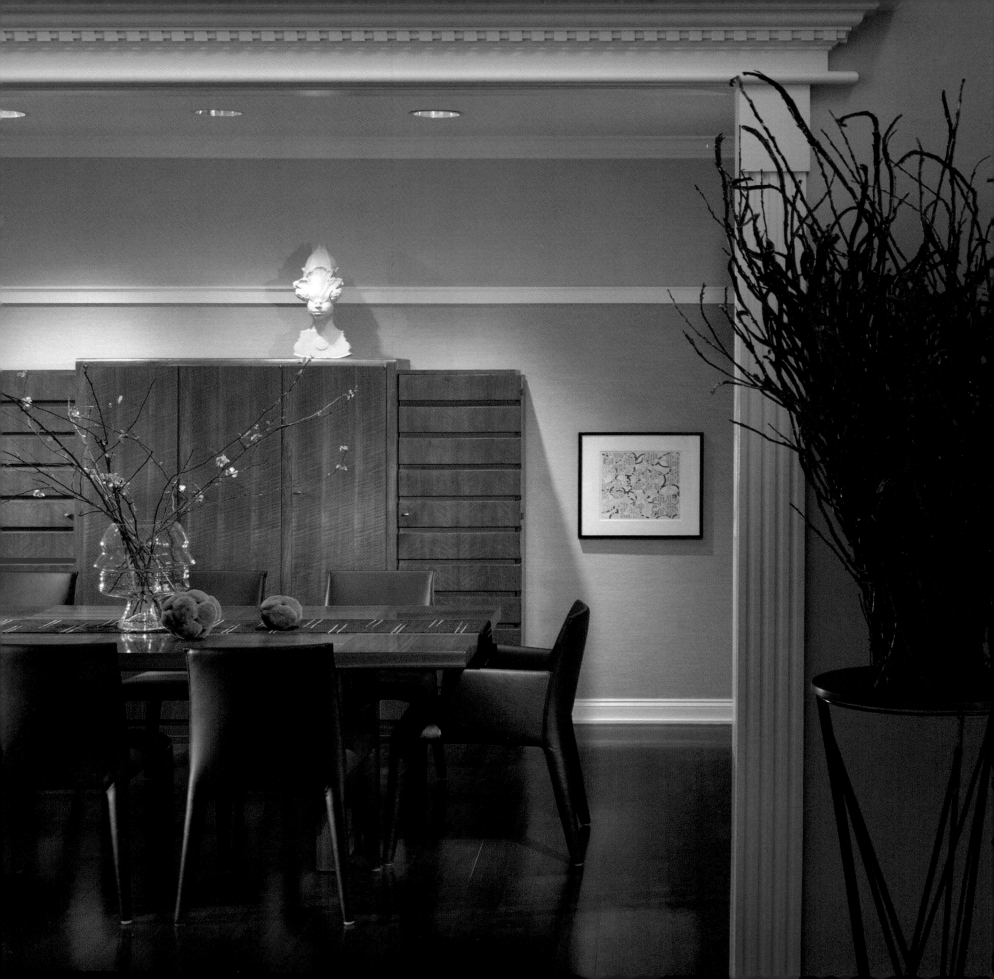

take away to reveal the essence of the room, letting the furniture, lighting, art and architectural details do all the talking.

Starting with clear layout and design, the duo help clients de-clutter and are known for organizing collections. Though not afraid of color, they believe the best start is with a good neutral base. The calm stage that is set is perfect for art from galleries like Wexler, Snyderman, Marion Locks, and Sande Webster and range from established works by modern masters, to local hot talent, black and white photography, sculpture, and crafts. They enjoy working with established collectors, but can also create collections for the novice.

Rymshaw and Fulton are known for combining styles and eras of furniture with the added twist of contemporary upholsteries. Their own living room mixes current contemporary black leather furniture with mid-century classics. They believe that even modern design should be warm and approachable.

They tell all of their clients, no matter what the creative quandary, the design process should be enjoyable. Fulton adds: design decisions are very elegant problems.

LEFT
Berwyn dining room featuring 1930s vintage French furniture and Italian leather dining chair.

RIGHT
Center City penthouse master suite creates a place for relaxing as well as sleeping.

More About James & Eric

WHAT PERSONAL INDULGENCE DOES FURY SPEND THE MOST MONEY ON?

Seasonal fresh flowers every week.

WHAT BOOK ARE YOU READING RIGHT NOW?

Jim is reading *Devil in the White City* by Eric Larson. Eric is reading *Palladian Days* by Sally Gable.

WHAT ONE ELEMENT OF STYLE OR PHILOSOPHY HAVE YOU STUCK WITH FOR YEARS THAT STILL WORKS FOR YOU TODAY?

Twentieth century Modernism, for its simplicity, flow and continuity.

WHAT IS THE BEST PART OF BEING AN INTERIOR DESIGNER?

The people we meet from all walks of life, and the magic we create for them.

IF YOU COULD ELIMINATE ONE DESIGN ARCHITECTURAL/BUILDING TECHNIQUE OR STYLE FROM THE WORLD, WHAT WOULD IT BE?

We wouldn't eliminate any. Every style and technique has its good elements in the hands of the right designer.

FURY Design, Inc.
James G. Fulton Jr.
Eric Rymshaw, AIA, IIDA
908-B North Third Street
Philadelphia, PA 19123
215.627.7680
FAX 215.627.7682
www.furydesigninc.com

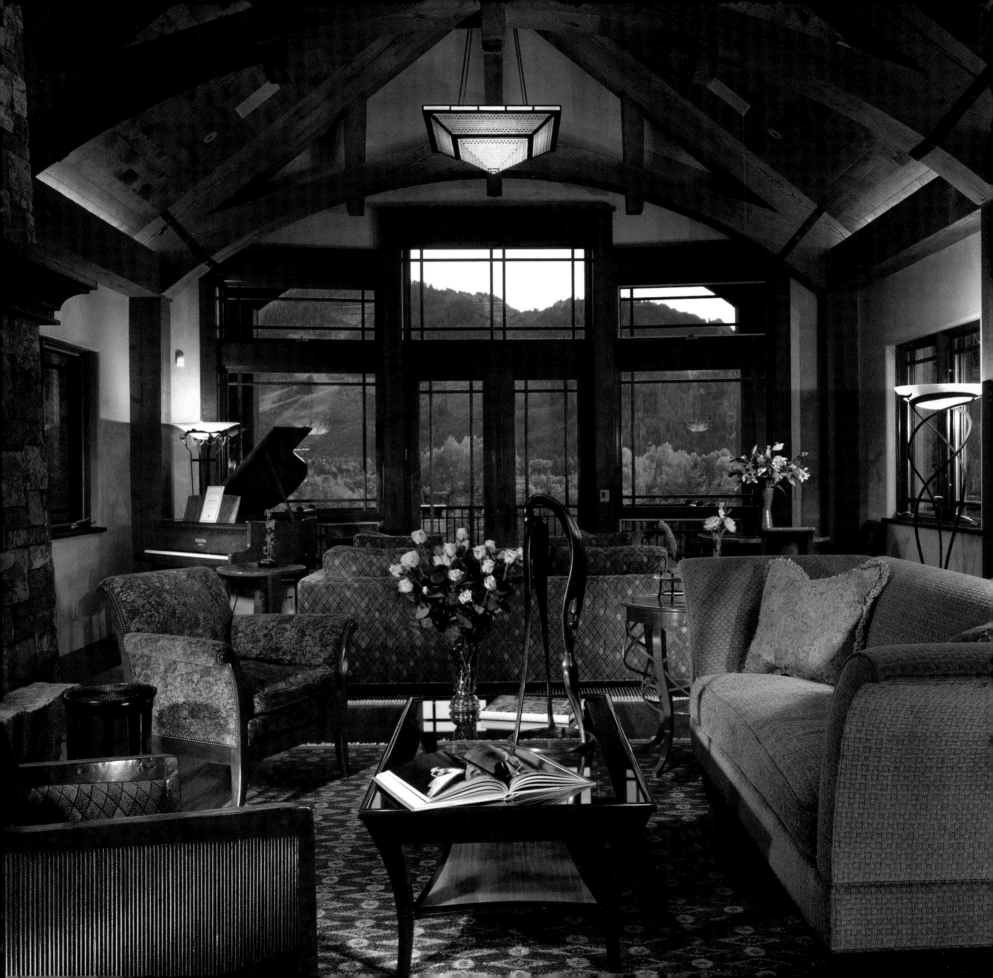

PATRICIA GORMAN

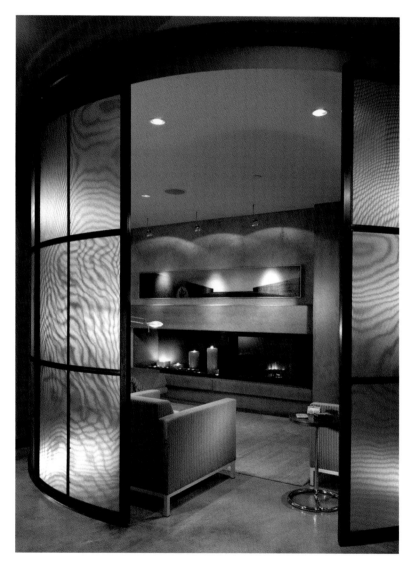

ABOVE
This master sitting area is separated from the sleeping area by means of curved Imago screens on tracks.

LEFT
Dramatic Arts & Crafts styling with rich Brazilian cherry beams and flooring and iron accents.

S pend an hour with Patricia Gorman and you realize that her energy and spark are just why she can tackle the projects others call impossible. Interior design has been a lifelong dream and a passion, so when a favorite client classified her as an overachiever for her tireless work in getting every detail right, she knew the shoe fit.

Patricia attended the Pratt Institute in New York, married, had three children, and opened a catering business while at home. She finished her architecture degree at the University of the Arts in Philadelphia, and in 1984 started her own business, based in Manayunk, where her canine mascot Bella holds court.

Her team of seven employees works with great precision on projects across the United States, many in "playground" areas like New York and Aspen. She loves designing second homes because of a client's sense of levity about them. She always challenges herself and sets high standards for herself and her staff, finding solutions to problems others find impossible. She believes in developing close working relationships with her clients so that they are personally involved in the results. Her environments are warm, timeless, and inviting with lots of personal touches.

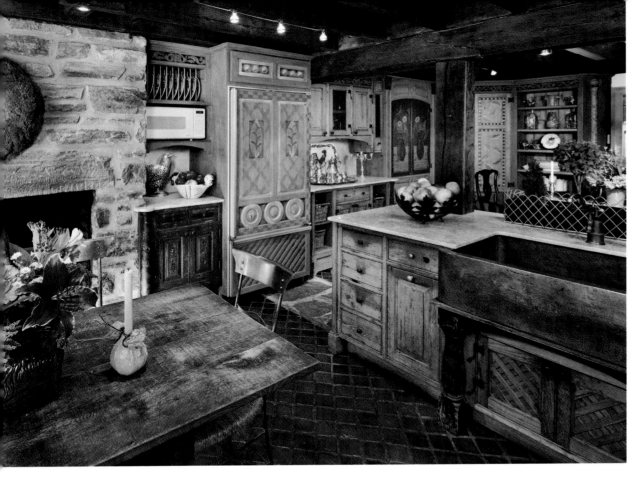

Patricia does not have a signature look; rather, her parameters are always a client's lifestyle and taste. She does favor a more traditional, comfortable approach with a fluid blending of European antiques and reproductions of ageless fabrics. Her spaces are architecturally interesting, many with dramatic paneled or beamed ceilings, and feature a mix of textures—sleek stone, rustic brick, exotic woods, or warm chenille—designed with a keen sense of color. She loves aged finishes and patinas that stand the test of time.

Patricia has a gift for visualizing things in 3-D, understanding the architectural elements of a space so she knows how a space can be manipulated. In all projects, she likes the elements of surprise and intrigue.

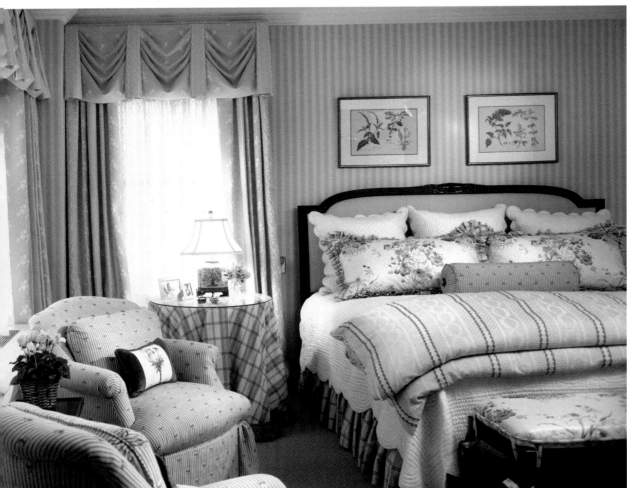

TOP LEFT
Custom-designed cabinetry of antique wormy Chestnut, with each cabinet designed for a vintage look added over time. Custom-hammered copper sink made in Mexico.

BOTTOM LEFT
A master bedroom showcasing a Lewis Mittman French bed with upholstered headboard and other traditional style furnishings, fabrics and finishes.

TOP RIGHT
1780 Pennsylvania tenant house transformed with French antiques & Cowtown & Tout silk drapery fabric and Asmara needlepoint rug.

BOTTOM RIGHT
A Nierman Weeks chandelier in the foyer illuminates the entrance to the living room.

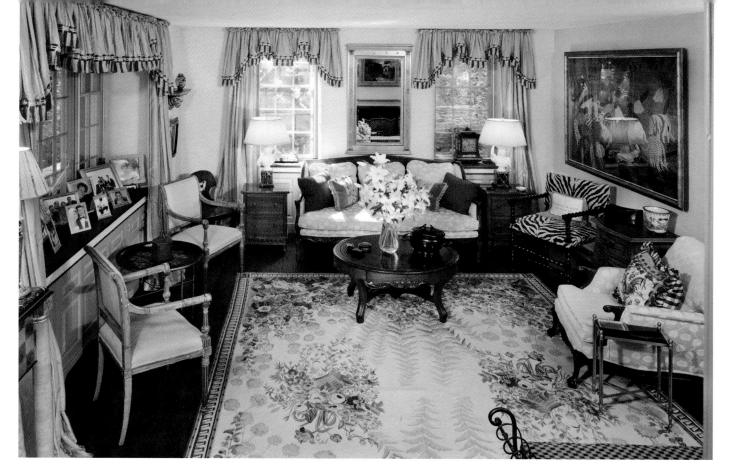

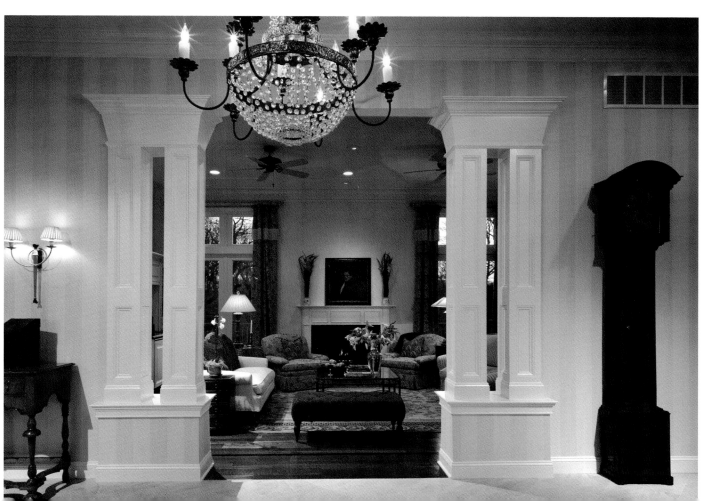

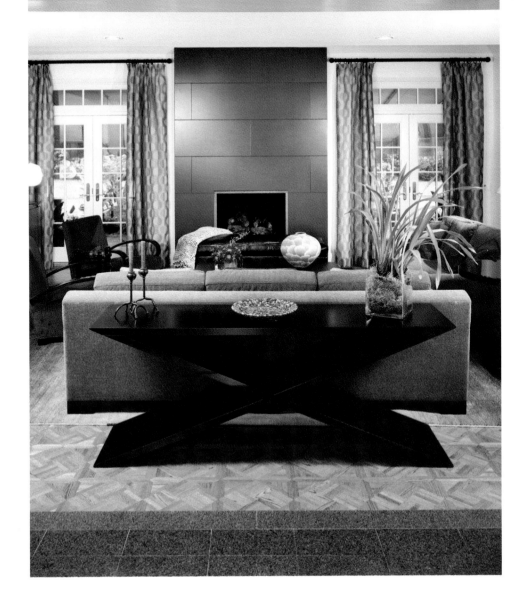

ABOVE LEFT
An industrial loft setting to showcase the client's artwork.

ABOVE RIGHT
A Holly Hunt sofa and chairs and a custom zinc paneled fireplace are key elements in this family room where the client likes to display his ever changing artwork.

She enjoys the thrill of the hunt—combing antique shops to find the perfect piece for each room.

A board member of the ASID, she is one of the founding directors of the Interior Design Legislation Coalition, a group established to make Interior Design a licensed profession in Pennsylvania.

When she is not working, she can be found entertaining for the masses or in the kitchen cooking for her children and grandchildren. She wouldn't know how to cook for just two. After all, life is a feast for this designer, and one to be enjoyed.

More About Patricia

WHAT PERSONAL INDULGENCE DO YOU SPEND THE MOST MONEY ON?

Anything unique. I love antiquing, travel adventures, cooking and entertaining. And a fun pair of leopard shoes!

WHAT IS THE BEST PART OF BEING AN INTERIOR DESIGNER?

The conceptualization phase. The other part I like is the hunt—finding the right pieces from the infinite amount of products available on the market today, and using them in the right spaces. For example, I designed a custom oval moveable screen in a Colorado home that provided privacy to the master suite.

WHAT COLOR BEST DESCRIBES YOU AND WHY?

Chartreuse, because of its vibrancy.

WHO OR WHAT HAS BEEN THE BIGGEST INFLUENCE ON YOUR CAREER?

The art history I learned in school, which continues its timeless influences on today's designs. I was influenced by the fluid lines of the classical French movements, as well as the clean and innovative designs of Alvar Aalto, Mies van der Rohe, Frank Lloyd Wright, Louis Khan, and Louis Sullivan.

Patricia Gorman Associates, Inc.
Patricia Gorman, Allied Member ASID
4319 Main Street
Philadelphia, PA 19127
215.482.1820
www.patriciagorman.com

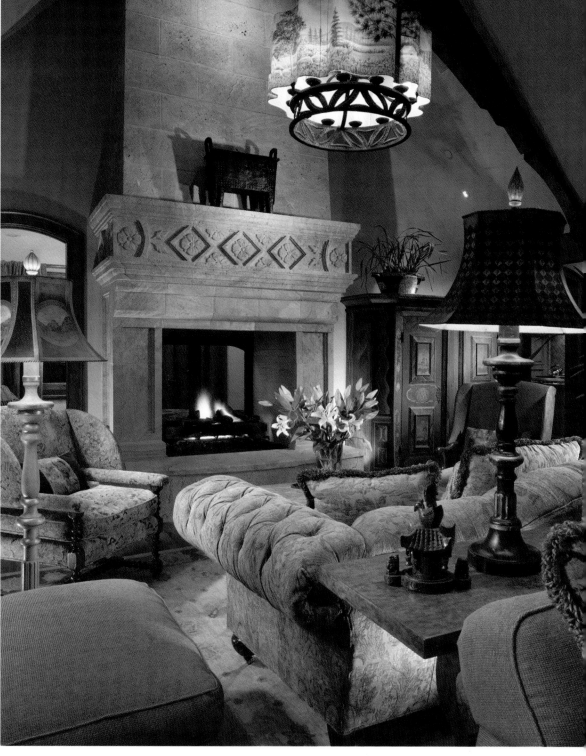

ABOVE
The focus points in this living room are without doubt an oversized custom limestone fireplace mantel and a custom iron chandelier with a parchment shade.

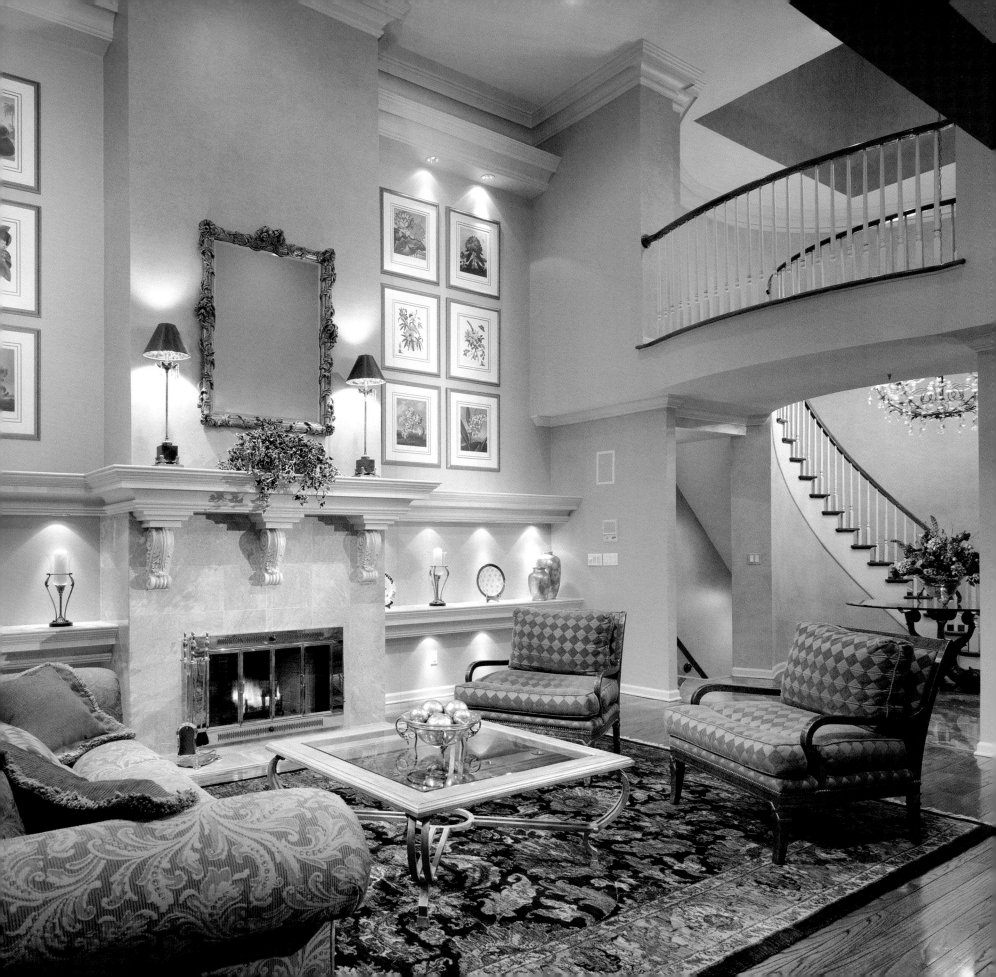

CARYL HAYNES-COGAN

HAYNES ASSOCIATES

Caryl Haynes has never done a totally white interior. Maybe it is her deep California roots that have her so drawn to color, especially gold for its warm, outgoing properties. You can say the same about this sunny designer who has had a diverse life. A descendant of the legendary Kit Carson, she too is an adventurer—flying airplanes, scuba diving and taking up underwater photography—before ever laying hands on a floor plan. Earning a Bachelor of Fine Arts in interior design from Moore College of Art and Design, Caryl worked for designer Barbara Eberlein for five years before starting her own firm 15 years ago.

Caryl doesn't focus her work on one particular style, always leaving herself open to the tastes of her clients, ready to blend antiques with new purchases and her custom designed furnishings. She wants her work to be beautiful, yet livable—so kids can jump and play and dogs can lie down where they may.

A recipient of an ASID Award for Excellence, Caryl nonetheless feels her greatest professional tributes come from the scores of former clients who show their appreciation for her work by maintaining a seemingly permanent professional and personal relationship with her. She takes pride in the fact that so many clients repeatedly call upon her to work on new and bigger projects. One such client called her back seven times for various homes around the country. And, after completing two homes for another satisfied client, he sent her to London twice to renovate the offices of his European division.

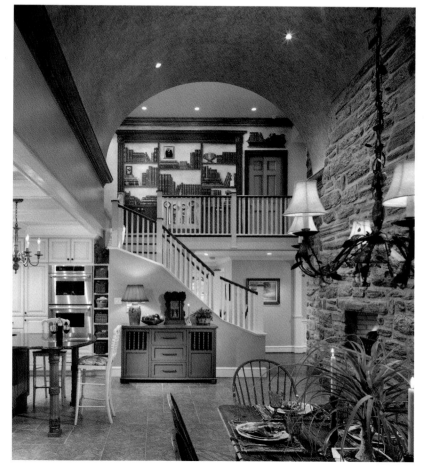

ABOVE
The stone wall of the original house's exterior becomes a focal point of the new addition. Trompe l'oeil bookcases at the top of the stairs add additional interest from below.

LEFT
This dramatic view, with its antique botanical collection, can be seen from the bridge at the top of the sweeping foyer staircase as well as a balcony off the master bedroom.

45

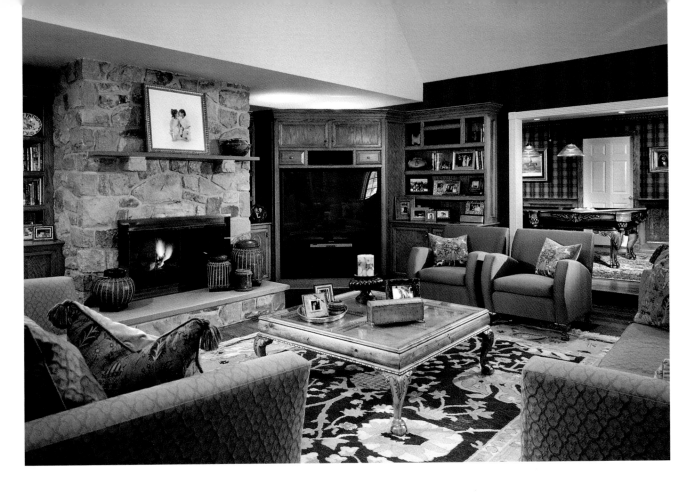

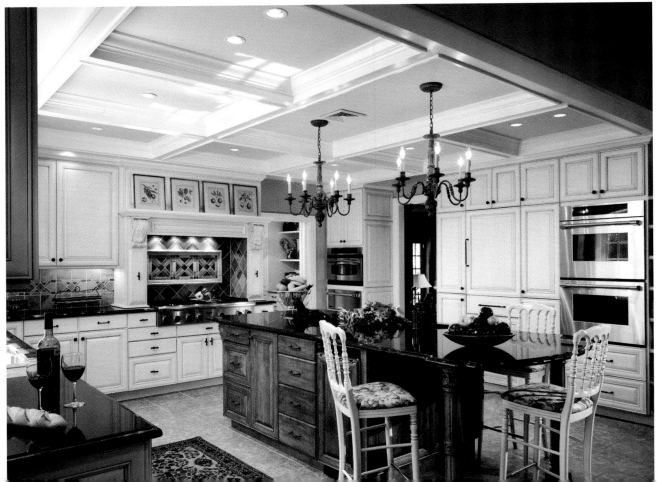

TOP LEFT
This multi-functional family room connects to the adjacent game room, and looks out onto the pool, tennis courts and garden.

BOTTOM LEFT
This element kitchen provides professional amenities for a family that loves to cook. No detail was overlooked, from the custom cabinets to the coffered ceiling.

TOP RIGHT
The buffet, breakfront, and hall bar, designed by Caryl, provide storage for the owners' extensive china and silver collection. The panels behind the bar slide open to provide service for a bartender.

BOTTOM RIGHT
The woodwork of the ceiling and wall paneling was designed to create an intimate, warm library and work space.

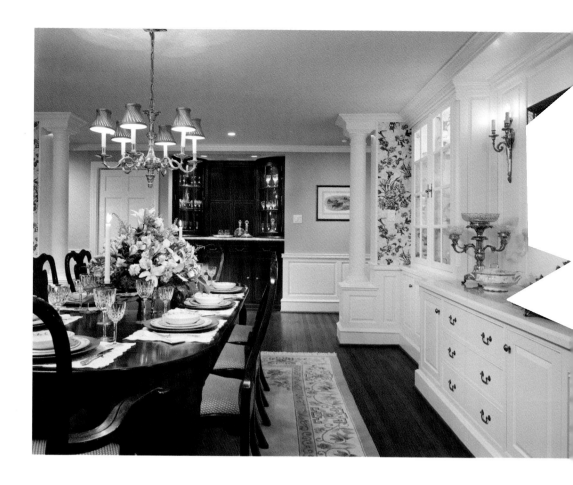

More About Caryl

WHAT DO YOU LIKE MOST ABOUT BEING AN
INTERIOR DESIGNER?

Seeing my concepts and ideas become reality, and enhancing my
clients' lives.

WHAT IS THE HIGHEST COMPLIMENT YOU'VE
RECEIVED PROFESSIONALLY?

Being told that my ideas enhance the value of their property.

WHAT ONE ELEMENT OF STYLE OR PHILOSOPHY
HAVE YOU STUCK WITH FOR YEARS THAT STILL
WORKS FOR YOU TODAY?

I love using an eclectic mix of styles; incorporating the client's
existing possessions with new or antique pieces. The result reflects
the client's taste—in a unique way.

WHAT IS A SINGLE THING YOU WOULD DO TO BRING
A DULL HOUSE TO LIFE?

Add the right color.

WHO HAS HAD THE BIGGEST INFLUENCE ON
YOUR CAREER?

Frank Lloyd Wright; because his designs always complemented
their surroundings.

Haynes Associates
Caryl Haynes-Cogan, ASID
2132 St. James Place
Philadelphia, PA 19103
215.972.1778

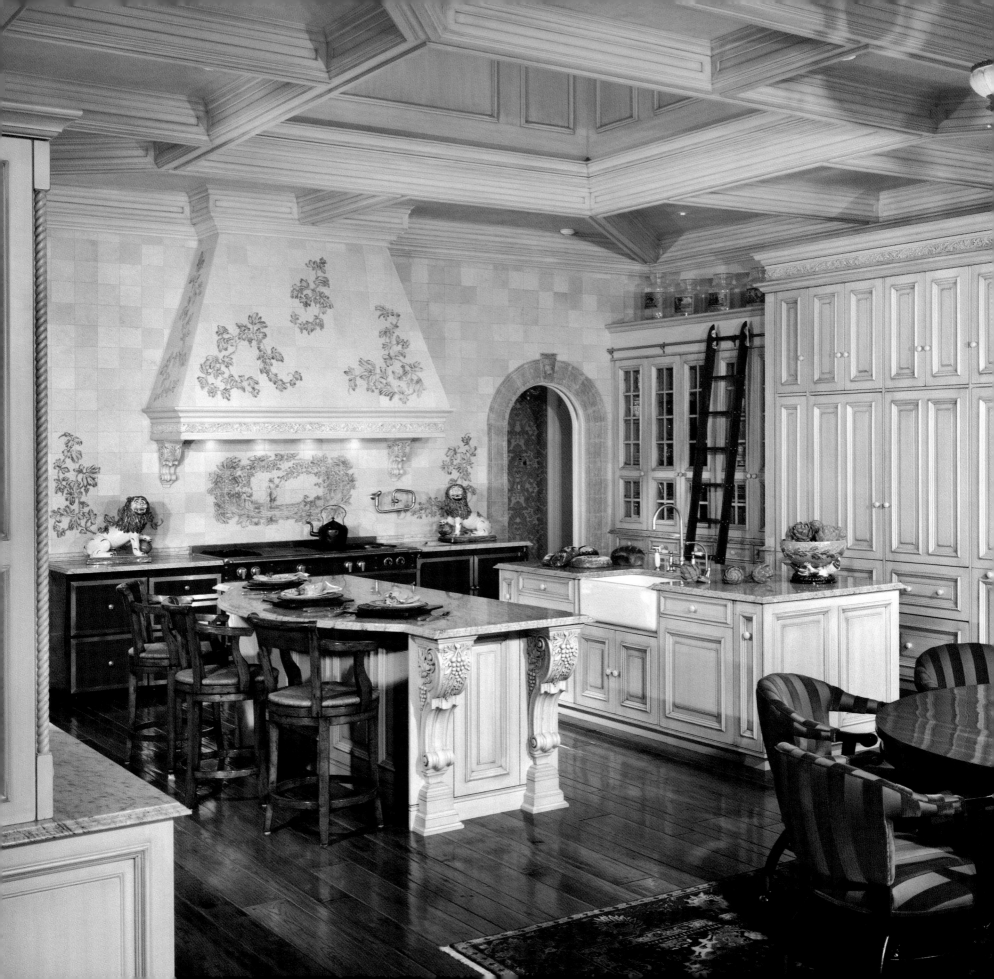

JOANNE HUDSON

JOANNE HUDSON ASSOCIATES

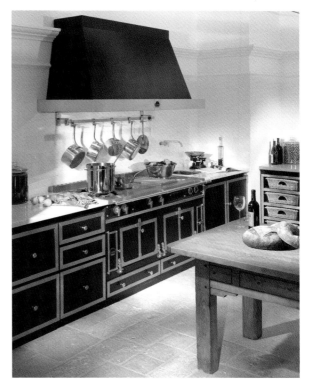

ABOVE
Traditional French country space with a classic "Matte Black"
La Cornue range and cabinets, antique pine table, and random
limestone floor.

LEFT
Main kitchen in an elegant estate home featuring "Bordeaux"
La Cornue range and cabinets.

With a degree in interior design from the University of Manitoba Faculty of Architecture, Joanne Hudson is recognized as a pioneer in the industry. A combination of her own needs for a renovated kitchen and the lack of specialists in the area proved to be a catalyst for her to start her own business and open Design Spaces in Toronto.

After five years of overwhelming success, she moved the business to Philadelphia and grew it into a multi-faceted, four-showroom interior and lifestyle enterprise in the Marketplace Design Center. To date, Joanne Hudson Associates consists of kitchen, tile and stone, bath and closets, and a flourishing online store (joannehudson.com) selling unique dinnerware, serving pieces and utensils that bring the casual chic of Joanne Hudson designs to the table.

Joanne Hudson is synonymous with high-end, one-of-a-kind kitchens ranging from modernist to traditional. Her work is so admired that famous restaurateurs and chefs have sought her out to create their own personal kitchens.

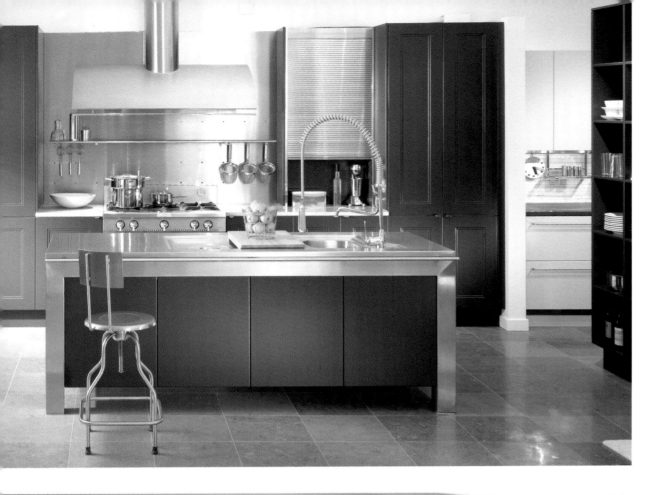

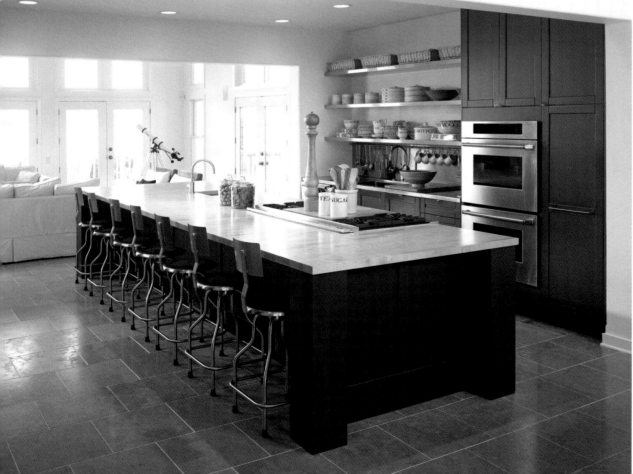

Dressed in a chic modern black tunic and pants accompanied by trendy specs, Joanne looks more like a fashion industry veteran than an interior design maven. She is warm and inviting and ruminates on a career that continues to evolve and expand. Recently, she celebrated her 25th year in business and was awarded Philadelphia's ASID Designer of Distinction for her contributions to the industry. Always at the forefront of trends, she renovated her showroom to reflect the growing popularity of what she calls recreational cooking, and to illustrate the distinction between her five different divisions. The new configuration now includes a La Cornue cooking area where stoves, whose sticker price can rival that of a new car, can be fired up for a test drive. Joanne is excited with the success of the brand, especially with male customers. It is the new sports car of the kitchen.

Joanne approaches each project as a design, lifestyle and architecture challenge, one that not only has to do with geometry, but also visual artistry. She produces stacks of beautiful renderings that have helped her visualize rooms. They are art unto themselves. She loves to draw and paint for relaxation and wants to return to the potter's wheel when life slows down. Each one of her businesses was born out of a love for materials. Tile and stone followed kitchen,

TOP LEFT
Contemporary kitchen space combining polished stainless steel and "Matte Blue/Black" lacquer cabinets.

BOTTOM LEFT
Joanne's own beach kitchen featuring a combination of stainless steel, anthracite stained maple and natural maple.

with bath and closets thereafter. It seemed like a natural progression to create an online business. In addition to her staff of 17, she retains artisans and specialized craftsmen to develop intricate designs for anywhere in or outside the home, including pools. Her showrooms are a feast for the eyes, with glass tiles, handcrafted artisan tiles, modern polished stainless steel soaking tubs, beautiful copper and porcelain sinks that many times look like works of art. Who says form can't be functional?

She contends the trend in kitchens is a cleaner look, and although she creates wonderful corbels and carvings for certain clients, her own style has always had a more contemporary bent. In her vacation home in Canada, she crafted a clean, modern kitchen and gave it a test drive for Thanksgiving, serving 18 for dinner. Thankfully, her love for kitchens goes hand-in-hand with her love for cooking.

ABOVE
A sophisticated urban environment featuring the use of beautiful old pine floors and the classic French La Cornue, this time in stainless steel and brass.

More About Joanne

WHAT ONE PHILOSOPHY HAVE YOU STUCK WITH FOR YEARS THAT STILL WORKS FOR YOU TODAY?

An honest approach to design. Not getting caught in a fashion disaster—it is still nice to go into a kitchen I did 20 years ago and it still looks right. Kitchens are personal and clients don't want to live in someone else's kitchen.

WHO HAS HAD THE BIGGEST INFLUENCE ON YOUR CAREER?

Andre Putnam. I love what she loves—things that are clean and pure. She was at a reunion dinner at my alma mater. I sat next to her and we talked about how she got into design in her 40s. I loved her work for the Royalton and the Paramount. Also an architecture professor of mine told me that 'every single line counts'—and he was right.

WHAT IS THE MOST DIFFICULT DESIGN YOU HAVE USED IN ONE OF YOUR PROJECTS?

The most challenging element in a kitchen is the hood of a stove. There are so many mechanical components to it. The most important element in any room are floors and windows. Both have to look great or the house falls short.

WHAT IS THE HIGHEST COMPLIMENT YOU HAVE RECEIVED PROFESSIONALLY?

I designed five kitchens in five years for one family.

Joanne Hudson Associates
Joanne Hudson
The Marketplace Design Center
2400 Market Street
Philadelphia, PA 19103
215.568.5501
www.joannehudson.com

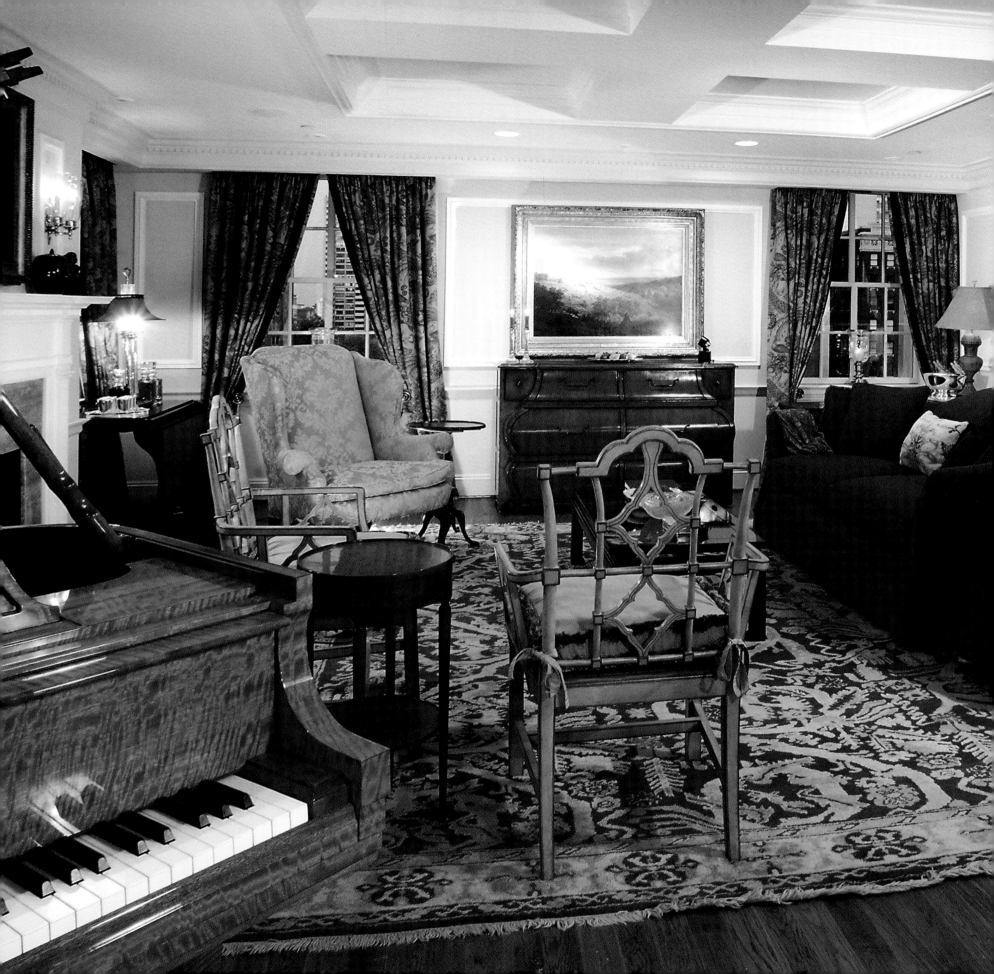

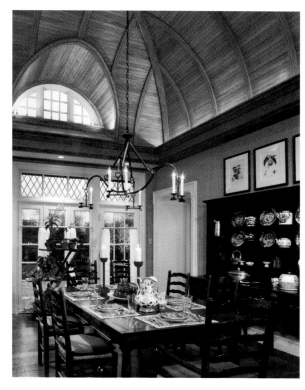

ABOVE
This breakfast room is part of a new addition to a Main Line Tudor home originally built in 1899. The warm tones of the vaulted pine ceiling were inspired by the banquet halls of English country houses and rooms from America's Gilded Age. The light-filled space is the focus of family gatherings and is the symbolic heart of the home.
Architecture: Kass & Associates;
Interior Design: Amy Miller Interior Design

LEFT
A living room at The Lanesborough evokes the spatial flow and elegant scale of classic New York apartments in this full-floor residence as part of the transformation of a 1920s high-rise office building in downtown Philadelphia into a luxury condominium.
Architecture: Kass & Associates;
Interior Design: Rotella Associates, Inc.

Recently, a well-known politician visited a home architect Spence Kass designed and began his fund-raiser speech: "Everyone should live in a home like this." The very humble and unassuming Spence is unfazed by such accolades. Forthcoming about the work he and his team of nine provided to the expansion of a 1965 French eclectic home, he more than doubled the house's square footage to fulfill the owner's desire to entertain formally, and added numerous flourishes: an octagonal conservatory—for cocktails and dessert—with a copper dome, a ballroom that seats 120 with decorative plaster vaulted ceiling, and curving staircases with hand-forged wrought iron railings.

You could say Kass & Associates has helped revitalize an appreciation of fine craft in the Philadelphia area. In college, Spence remembers professors telling him this type of architecture could not be done. It was too elaborate by modern standards, artisans' work would prove too expensive, and, even if you could afford it, this type of craftsmanship was extinct. Spence's ongoing work demonstrates that this kind of design not only exists—it thrives.

A graduate of Cornell University and the Rhode Island School of Design, Spence studied with noted architect and teacher Robert Stern, won a Rome Prize Fellowship to study at the American Academy in Rome, and apprenticed with architect Charles Moore. In the 1980s he worked on finely crafted interiors of numerous corporate headquarters, including Aramark, Bell Atlantic, and Provident Mutual.

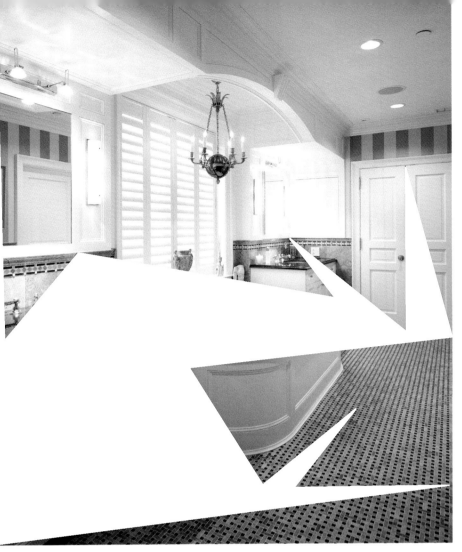

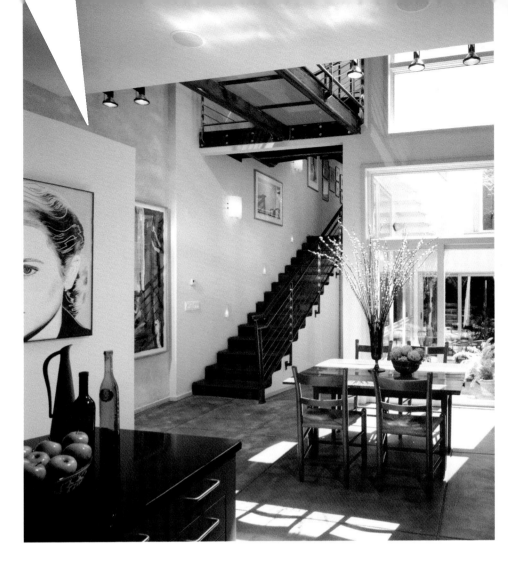

ABOVE LEFT
Double vanities flank the curved wood panels of the marble-topped tub surround in this state-of-the-art master bathroom. The room gains warmth from the soft tones of the basket weave of marble tile with underfloor radiant heat provided for comfort.
Architecture: Kass & Associates;
Interior Design: Creg Oosterhart

ABOVE RIGHT
The dramatic transformation of a traditional townhouse near Rittenhouse Square displays a loft-like modern interior highlighted by a glass bridge and four-story steel stair with Brazilian cherry treads. A newly inserted glazed courtyard allows light to penetrate the first floor open kitchen and dining area set upon a leather-toned stained concrete floor.
Architecture & Interior Design: Kass & Associates

When he started his own residential firm in 1990, he discovered that numerous Main Line homes and estates had been neglected and looked for opportunities to save them from further decay. Not content to merely restore old houses, Spence specializes in creating new additions that enhance the existing homes to fit modern living. Known for his level of detail and his melding of interiors and exteriors, this architect creates high-quality new homes, additions, renovations of country homes and estates, as well as urban townhouses and apartments. Many have been published in *Architectural Digest, House Beautiful, Custom Home, Philadelphia Magazine* and *Philadelphia Style*.

All of his projects are collaborative with clients and often a team of consulting landscape and interior designers as well as numerous local artisans. Many of the region's best decorators have enlisted Spence to design grand rooms as a backdrop for their project's furnishings, antiques, and art collections. Sometimes the most unusual ideas from clients turn out to foster fresh design solutions. Spence welcomes these challenges and the chance to reinterpret tradition in a new way. The firm is able to design across a wide variety of styles, both traditional and contemporary. Inspired by travel and the richness of architectural history, the firm has been known to take members of its staff to

Italy to expand their appreciation of architecture and design.

As part of the renaissance of residential living in downtown Philadelphia, the firm recently completed the architectural design of The Lanesborough, a luxury condominium created from a former university club and high-rise office building. Spence designed the new bronze street canopy and lobby sequence, as well as a 3,500-square-foot model apartment featured in *Philadelphia Magazine*'s Design Home 2003. Spence has been commissioned to create five additional single floor apartments in the building. The firm continues to design apartments in some of Philadelphia's most prestigious buildings on Rittenhouse Square and Society Hill, as well as custom homes around the region in a variety of contexts and styles.

ABOVE
Painted wood cabinetry with inset recessed paneled doors are composed into a multi-purpose island with honed granite countertops to anchor the kitchen in this handsome addition to a country home outside of Philidelphia. The large windows flanking the hearth-like stove open to expansive garden views.
Architecture: Kass & Associates;
Interior Design: Amy Miller Interior Design

More About Spence

WHAT IS THE BEST PART OF BEING AN ARCHITECT AND DESIGNER?
The thrill of giving a sketch to an artisan and watching the transformation of the drawing from concept to reality.

WHAT IS THE HIGHEST COMPLIMENT YOU HAVE BEEN PAID PROFESSIONALLY?
1. Referring to our extensive stone work on a large addition to a 1899 Main Line home., a mason once told me that he had been waiting his whole life to do something like this.
2. A realtor recommended someone interested in building their own home to visit one of our projects for ideas. Upon seeing the interior, she called her husband and said "I'm home!" and subsequently purchased the home for herself and family.

WHAT IS THE SINGLE THING YOU WOULD DO TO BRING A DULL HOUSE TO LIFE?
Create character by adding a sense of order, scale and proportion—no matter what the style is.

WHAT IS THE MOST DIFFICULT AND EXPENSIVE DESIGN TECHNIQUE YOU HAVE USED IN ONE OF YOUR PROJECTS?
An all glass mosaic tile pool we designed in conjunction with Landscape Architect Charles E. Hess Jr. We had to tent the pool to keep the tile installation at a certain temperature and protect it during the construction process. The tile alone cost hundreds of thousands of dollars.

Kass & Associates
Spence Kass, RA
2201 Pennsylvania Avenue
Philadelphia, PA 19130
215.665.9140
www.kassarchitects.com

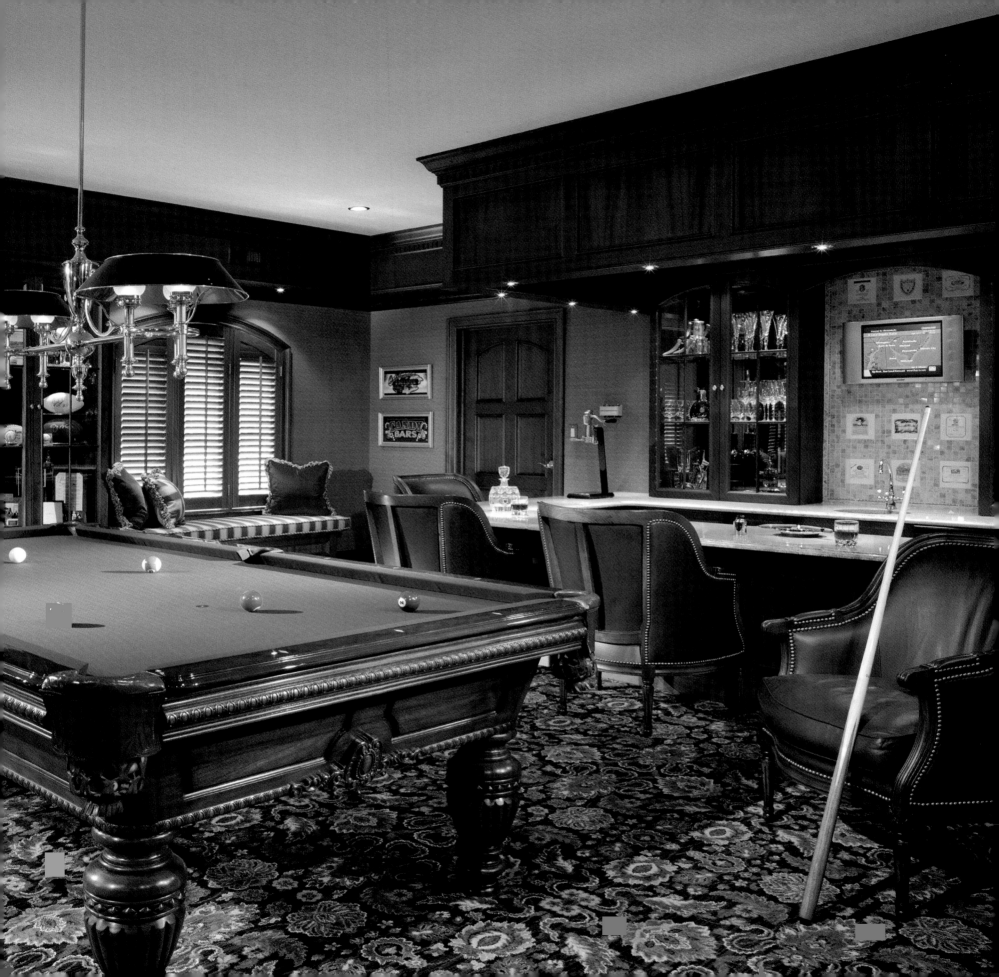

JOHN KELLY

JOHN KELLY INTERIOR DESIGN, INC.

John Kelly started winning awards for his designs while he was still studying at The Art Institute of Philadelphia. Since then he has won several from the Philadelphia chapter of ASID and a Design Excellence Award from *Window Fashion* magazine. His work has been seen on the pages of 11 magazines—from *HG* and *Traditional Home* to *The Philadelphia Inquirer* and boating magazines for his impressive yacht interiors, which is a direct result of his consulting for yacht manufacturers on their interior design and styling.

John's low-key demeanor is what his client's admirer about him. His design credo is somewhat low-key too: Make it clean, comfortable and functional. A 3-D thinker, he believes his space planning prowess sets him apart. Regardless of the project, his look is never stamped; rather he culls ideas from spending up-front time with clients, a part of the process he enjoys. What do they expect the outcome to be? What pieces do they have that are special to them? These are things that make the client feel comfortable. Kelly will then work on giving them the style they want; he's done classic traditional, modern, contemporary or a mix to fit the client's vision. The most successful jobs come from a good team, he contends, including the client, the architect, the contractor and the craftspeople.

This designer's style comes out in different ways: using all types of lighting—from task to overhead to decorative, to furniture placement; angling furniture to create interest and make better use of the space for seating; choosing the right accessories—he likes to

cluster sculpture, pictures or greenery in a built-in. He also likes to find a focal point in a room and to always have a "wow" factor. It can be the sum total of the room, a window treatment, a fabric or accessory. You will never catch him buying furniture just to fill a room. He favors custom built-ins and upholstery.

When taking on new projects, John always likes a challenge. In addition to his high-end residential projects, he has designed everything from a recording studio, sets for television, car dealerships, beauty salons, recreational vehicles, to the corporate offices of a national franchiser. His latest conquest is a private country club in southern New Jersey with a separate guest house with eight bedrooms, where he created the Old World look with beautiful paneling and exquisite detailing. He also loves show houses, not only for the charity aspect, but for the opportunity to be his own client.

His greatest joy and indulgence is his 48-foot 1966 Chris Craft motor yacht that he gutted and restored and decorated in the classic style. It is his getaway and his passion, and maybe

TOP LEFT
Yards of fabric on the ceiling and walls created that outdoor cabana feel in this Atlantic City sunroom.

BOTTOM LEFT
A mix of classic, traditional and contemporary elements complement one another for that eclectic living room.

FAR RIGHT
A beautiful entrance foyer sets the tone for the rest of the home by saying welcome.

More About John

WHAT PERSONAL INDULGENCE DO YOU SPEND THE MOST MONEY ON?

My boat.

WHAT BOOK ARE YOU READING RIGHT NOW?

What Color is Your Skipcover by Denny Daikeler.

WHAT DO YOU LIKE MOST ABOUT BEING AN INTERIOR DESIGNER?

I can create a lifestyle and comfortable spaces for people to live, work, and play.

WHAT ONE ELEMENT OF STYLE OR PHILOSOPHY HAVE YOU STUCK WITH FOR YEARS THAT STILL WORKS FOR YOU TODAY?

Timeless design is everlasting.

IF YOU COULD ELIMINATE ONE DESIGN/ ARCHITECTURAL/BUILDING TECHNIQUE OR STYLE FROM THE WORLD, WHAT WOULD IT BE?

Imitation Everything.

John Kelly Interior Design, Inc.
John Kelly, ASID
208 S. Third Street
Philadelphia, PA 19106
215.922.4822
www.johnkellyinteriordesign.com

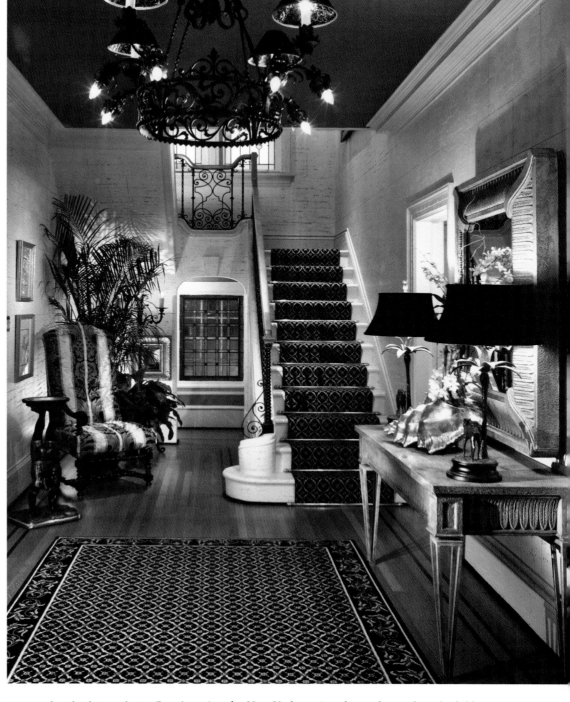

even an inspiration at times. Case in point: the New York carriage house he made to look like a sailboat interior with teak and holly floors, mahogany built-ins, bed, nightstand and walls. Another transformation of his was a three car garage transformed into an exciting billiard room, complete with a sunken bar, corner fireplace, windows seats, and mahogany paneling throughout with two TV's to watch the game while shooting pool.

One of John's other inspirations was designer Angelo Donghia, founder of the Donghia empire. Donghia's interiors had a certain style-appropriate, innovative, statement making, but never trendy. You'll never find a retro or trendy Kelly interior either, because 20 years from now, he wants his spaces to still look like they were just done.

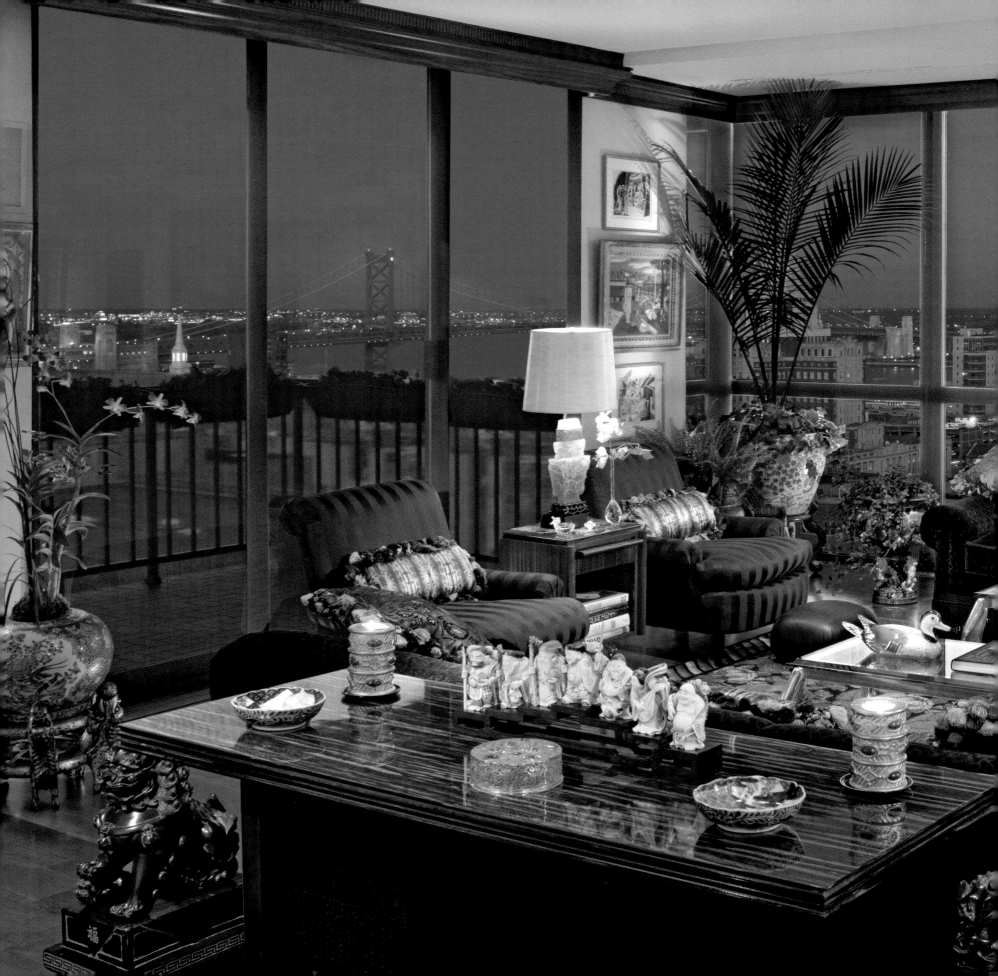

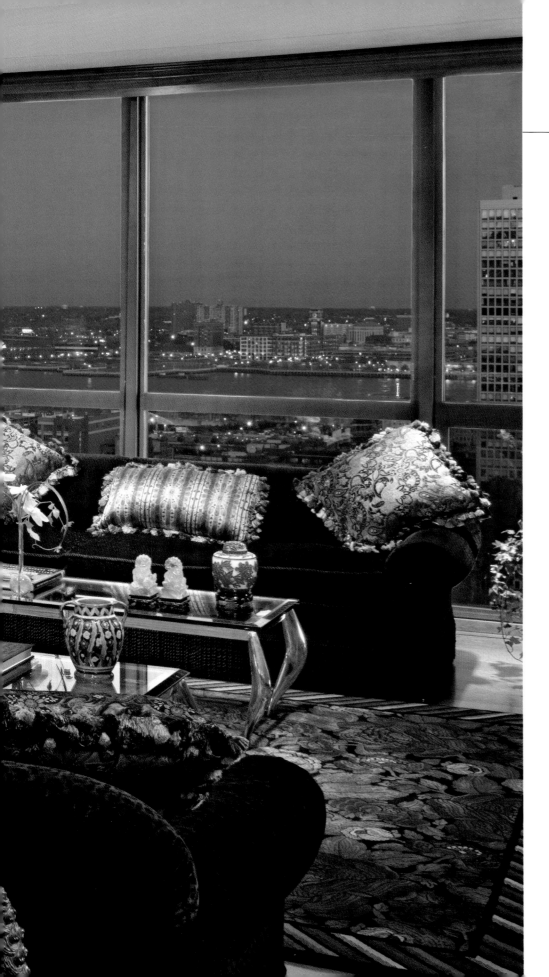

BETH ANN
KESSLER

BETH ANN KESSLER DESIGNS

A rt and life are inseparable for Beth Ann Kessler. All the qualities
that give art its value are those that are found in everyday life.
Beth Ann's interior designs are works of art. They have unity that
achieves order, and variety that achieves interest.

Beth Ann's hobby as a child was painting and she wanted to be
a fine artist. While still in high school, she took a summer course
in architectural design at Cornell University. There, she picked up
a T-square and was hooked on architecture. She earned a B.S. in
Architecture from the University of Michigan and continued to hone
her artistic eye by studying for 19 years at The Barnes Foundation in
Merion, Pennsylvania. Today, in addition to being a designer, Beth Ann
is an avid collector of art.

Beth Ann's passion for the aesthetic is seen in her work, a visual
feast of art in rooms that have been space-planned with the utmost
precision and detail. Appealing at first glance, they then provide

LEFT
This open and richly colored living room was designed to complement the
spectacular views of historic Philadelphia and the Delaware River. Paintings by Harry
Sefarbi and Angelo Pinto.

sensuous stimulation to the intellect. Her rooms are scaled for comfortable living amidst distinctive furnishings. The use of details, both subtle and obvious, is her signature—custom crown mouldings as intricate as gilded picture frames disappear into ceiling drops; hand-carved cabinets have left- and right-side mirror images; door veneers book-match in starburst patterns; rare stones pair with exotic woods; custom tables open and fit together for entertaining.

She uses space, color, light, line, and texture as her means of expression. Her design, or overall intention, controls the selection of her materials. To accessorize, Beth Ann finds unusual pieces in her travels and at auctions.

LEFT
Designed as a second den, this living space features custom-made pieces including a shagreen coffee table mixed with period furniture. Caryatid drawing by Modigliani.

RIGHT
Black and gold portoro marble wet bar counter top provides a stunning contrast to the four-piece book-match crotch primavera panels set in mahogany door frames. Paintings by Angelo Pinto and lithograph by Paul Cézanne.

She's hired on jobs as the space planner, architectural designer, interior designer, and general contractor. She knows that results of her creative work can be only as good as the quality of the materials and the competency of her subcontractors.

Since 1981, after working for the architectural firm Evantash Associates that specialized in shopping mall design, Beth Ann has operated her own firm. She began her career as a commercial interior architectural designer renovating commercial spaces, notably the Frank Lloyd Wright synagogue, Beth Sholom Congregation. Other spaces include retail stores such as Célene Ltd., numerous offices, a country club, a surgical center, an art gallery, and a condominium building, as well as residential spaces.

Although Beth Ann has all the talents required of a good designer, her hallmark is her functional space planning. Just as every painting is a record of a painter's experience, every interior that Beth Ann Kessler designs is a response to her clients' needs and an artistic experience.

TOP LEFT
Limestone guest bathroom includes shower, jetted tub, and steam. Curly maple curved front vanity has silver leaf scalloped details. Cabinet work by Rossi Brothers of Philadelphia.

BOTTOM LEFT
Dining space created using Art Deco period lighting and furniture, including a dining table by period designer Dominique.

FACING PAGE
Entrance foyer viewed from the living space features a niche cabinet with ebonized hand-carved floral panels. The art work includes Fernand Léger and Jules Pascin drawings below two Angelo Pinto reverse glass paintings. A Red Grooms 3-D lithograph sits on an ebony table.

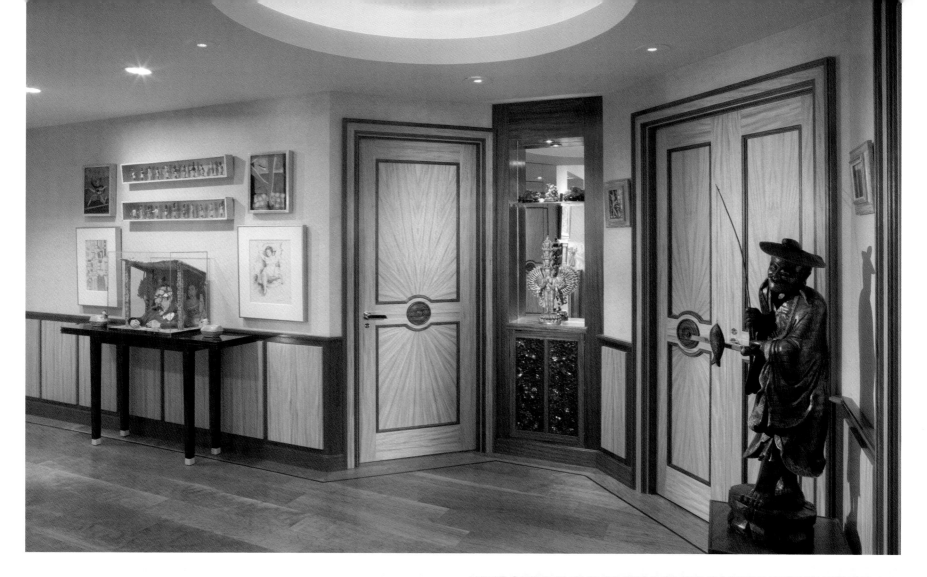

More About Beth Ann

WHAT HAVE BEEN THE BIGGEST INFLUENCES ON YOUR CAREER?

The University of Michigan's College of Architecture and Urban Planning for teaching me how to think.

The Barnes Foundation for teaching me how to see.

Macrobiotics for enabling me to live, create, and feel my best through a nourishing diet.

My parents and grandparents for encouraging me to develop my talents.

WHAT IS THE MOST UNUSUAL, EXPENSIVE OR DIFFICULT DESIGN OR TECHNIQUE YOU HAVE USED IN ONE OF YOUR PROJECTS?

Choosing my materials carefully to build a healthy home. Many chemically treated building products can cause poor indoor air quality, creating health problems to the residents. I know which materials to use to build a healthy indoor environment and cure a sick one.

WHAT ONE ELEMENT OF STYLE OR PHILOSOPHY HAVE YOU STUCK WITH FOR YEARS THAT STILL WORKS FOR YOU TODAY?

I listen to my clients' goals and give them designs that are timeless rather than trendy.

WHAT IS THE BEST PART OF BEING A DESIGNER?

The high I get when I've expressed myself creatively and originally to produce a space that works.

WHAT IS THE SINGLE THING YOU WOULD DO TO BRING A DULL HOUSE TO LIFE?

Fill it with children.

Beth Ann Kessler Designs
Beth Ann Kessler
233 South Sixth Street, #2307
Philadelphia, PA 19106
215.922.4849

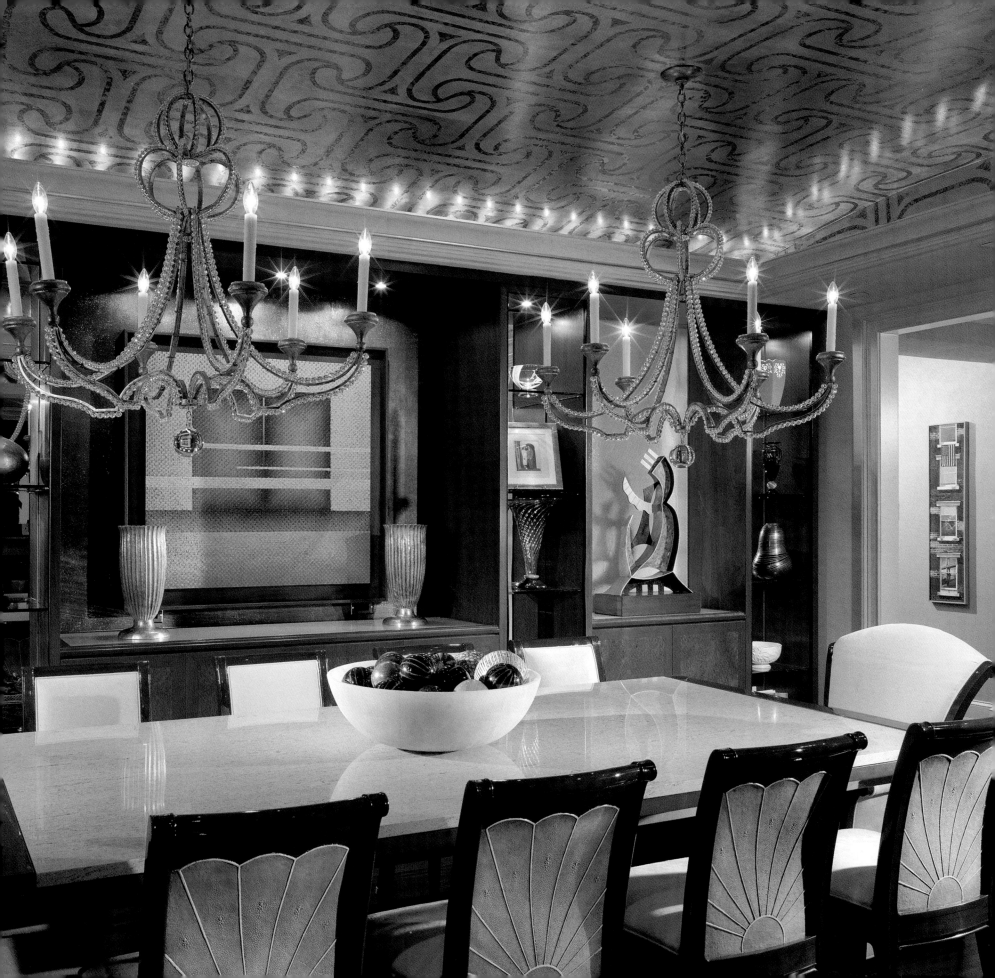

MARY ANN KLESCHICK

MARY ANN KLESCHICK INTERIOR DESIGN

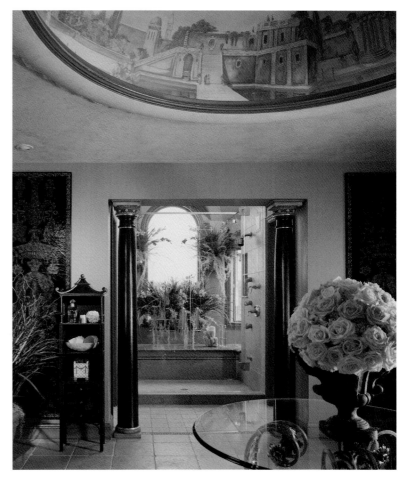

Detailed tromp l'oeil of Italian Village painted on lit domed ceiling glows with Venetian Splendor in this elegant master bath. Crystal clear Starchier Ultra Glass shower is flanked by rich gold accented wood columns.

Glamorous penthouse dining room features twin Neirman Weeks crystal chandeliers hung from hand-painted ceiling of variegated gold leaf applied over sterling silver by High Luck of Pine Street Studios. Color-changing LED lights behind textured glass panels provide the perfect backdrop for Charles Searles sculptures in cabinetry.

To meet strangers, come into their life and become a force in it by guiding them, is the best part of her profession, confesses Mary Ann Kleschick. This is one designer who is extremely engaging; you'd be hard-pressed to find someone who is not drawn in by her warmth, her comic timing and her discerning eye when it comes to matters of the home.

Accessible, yet self-assured, she listens and interprets, capturing the client's dreams through the tangible objects of the home—art, furniture, fabrics and trim, and even state-of-the-art electronics.

A Philadelphia native who studied at Drexel University, Kleschick spent a summer in Italy where she learned to appreciate their attention to detail in art and architecture, something that influences her interiors today. After working for other design firms in the area, she opened her own business 11 years ago.

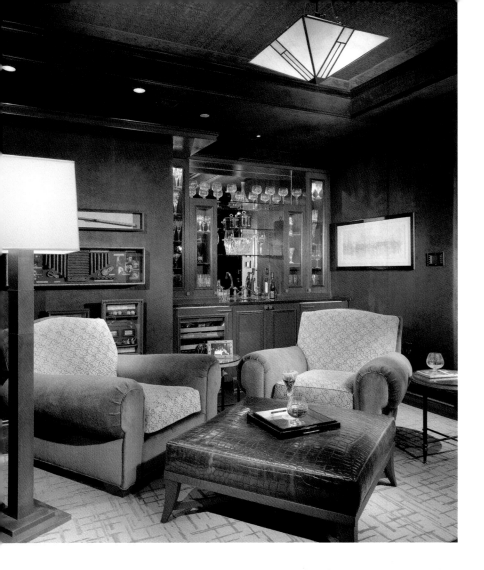

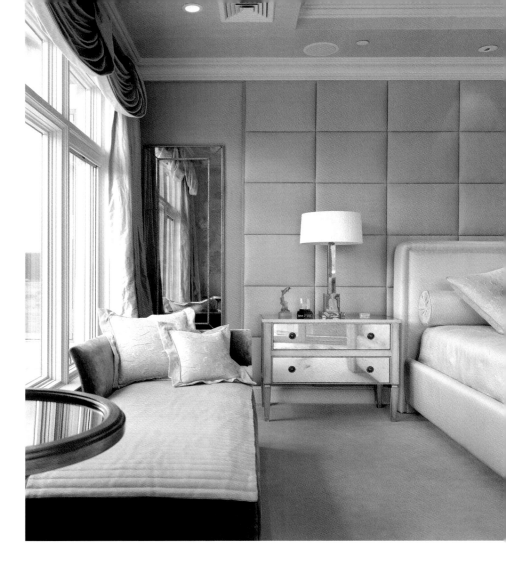

For 25 years she has called upon the same team of craftspeople, artisans and professionals, crediting them for executing her ideas with precision.

In 2002, Mary Ann received the Award for Excellence from the Philadelphia chapter of ASID, and the following year the Designer of Distinction Award. Her work has been published in *Philadelphia Home and Garden Design*, *Philadelphia Style*, *The Philadelphia Inquirer*, *Design NJ*, and *Kitchen and Bath Business*.

Her most recent editorial, an 11-page spread in *Philadelphia Magazine*'s Home and Garden featured a Bucks County condo created over three years for an empty-nester couple who downsized on the Delaware River in the most glamorous way.

The result was an eclectic mix of old Hollywood furniture, a myriad of artisan touches and original artwork curated by the designer. On this job and others, she's earned a reputation for taking the varied ideas of the client and pulling them together to unveil a unified, functional interior that reflects the client's taste.

Mary Ann shares her Center City home with her two year-old daughter Lily Q. Their latest project will be designing a home in Maine they found last summer while vacationing. The Colonial Greek style revival home looks like something out of a Rockwell painting. She spotted it in the morning and put a deposit on it in the afternoon. It spoke to her, she recalls. This is one designer who knows what she likes.

ABOVE LEFT
Smooth upholstered ultra suede walls next to the thick textured woven leather ceiling set the stage for deep relaxation in this gentlemen's study. The lit mahogany bar shimmers with crystal decanters and tumblers.

ABOVE RIGHT
This master bedroom features soft blocked upholstered walls of dupioni silk. The plush quilted bed contrasts with the slick mirrored nightstand to create Hollywood luxe.

FACING PAGE
Sophisticated yet youthful bedroom would comfort a guest of any age. Innovative use of drapery conceals an offset window behind the bed.

More About Mary Ann

WHAT IS THE HIGHEST COMPLIMENT YOU HAVE BEEN PAID?

I ran into a client eight years after we created her home together. She had been sick and during her illness she felt the living room I designed was her true sanctuary. She called me her angel.

WHAT IS ONE DESIGN PHILOSOPHY YOU HAVE STUCK WITH FOR YEARS THAT STILL WORKS TODAY?

Every client deserves good functioning design that supports their lifestyle and enhances their daily living. It is my job to create this by listening to their needs and using my honed design skills to make beautiful interiors.

IF YOU COULD ELIMINATE ONE STYLE, WHAT WOULD IT BE?

American country or Early American. It is not pretty or comfortable.

Mary Ann Kleschick Interior Design
Mary Ann Kleschick, ASID
2031 Locust Street
Philadelphia, PA 19103
215.640.8820

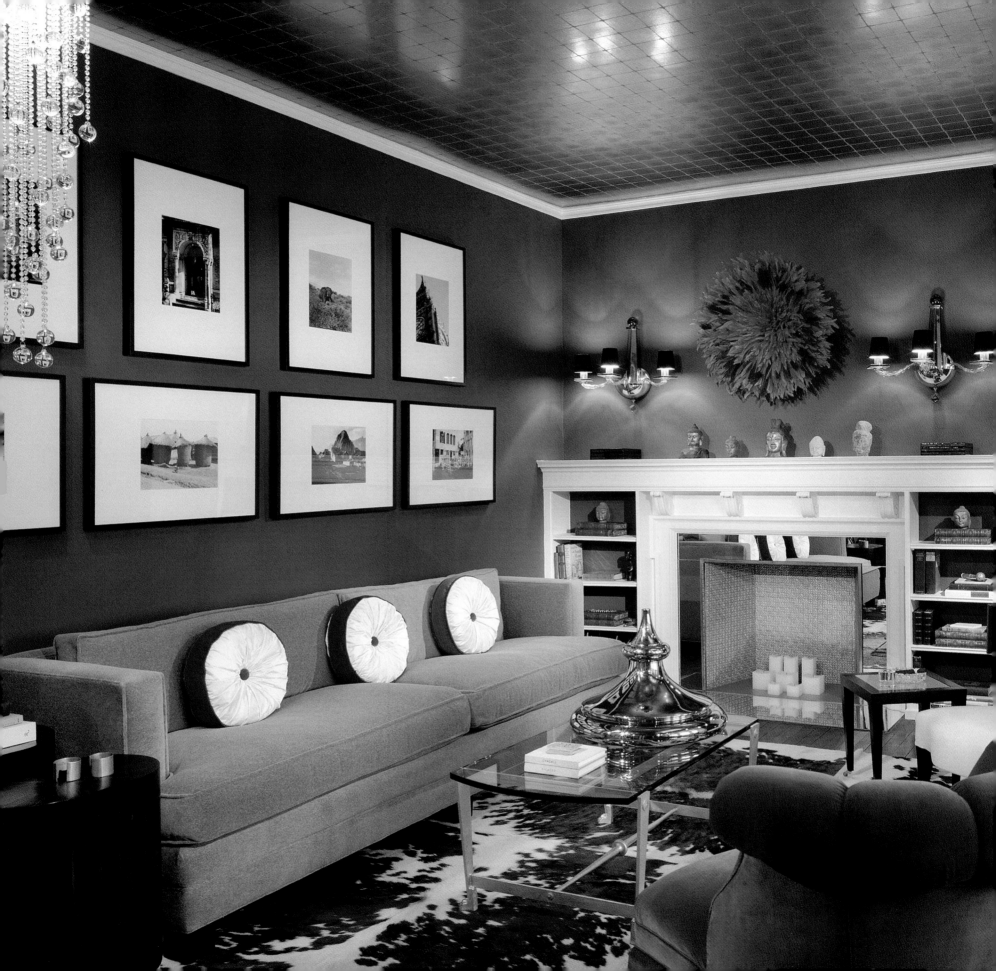

Ashli Mizell recalls her Southern upbringing as tranquil and completely authentic. With days spent drawing, creating and tweaking her mother's bookshelves, it was there she discovered her future. At age seven, on the pages of a magazine, she spotted the Manhattan skyline and knew she wanted the city life someday. After earning a degree in art history, she set off for South America, working with archeologists dealing with antique textiles and furnishings across the continent. Then it was on to Europe, where her appetite for classical architecture and global design was whet. However far flung her travels, Manhattan kept calling. Ashli answered by spending the next decade working in the city's luxury interior business, from downtown's art and antique galleries to uptown's premiere fabric and furniture design houses. Finally, with a solid range of aesthetic influences, practical expertise and a desire to take on projects of all sizes, she looked to another great city for inspiration.

In 2002, Ashli Mizell Design was established in Philadelphia. With a focus on high-end residential design, she began to build her brand of "approachable luxury," creating sophisticated spaces as individual as her clients. She favors crisp lines, handsome detailing, fine materials and functionality, and believes that while glamorous details punctuate the story that a home tells about its inhabitants, it is the necessities and pleasures of the clients' everyday life that are paramount. Two "must haves" in any space: great lighting and comfortable proportions. From the seamless integration of modern technology to the finest in

ABOVE
19th century Tansu chest, Donghia Sofa in Silk Velvet, Wedgewood bowl, Electric Chair by Andy Warhol

LEFT
Replete with lavish fabrics, crystal, fur and platinum, this luxe lounge combines the glamour of Old Hollywood with clean, modern sophistication.

ABOVE
Designed as an addition to an existing home, the vaulted ceiling and skylight provide a lofty, luminous space for cooking and casual entertaining.

detailed accessories, this young designer enjoys the playful mix between modern and period furnishings; emphasizing that the most beautiful modern pieces are always based on an understanding of classical design. When it comes to inspiration, she cites classic Hollywood films from Auntie Mame to James Bond as infinitely rich, but is the first say that rooms only look as good as they feel. She quotes Billy Baldwin by saying that "comfort is the ultimate luxury" and believes that the revival of luxury is in full swing.

In Ashli's view, the home is the ultimate retreat and should serve all purposes for its owners, from self expression through decoration to functionality in the design of kitchens and baths. In kitchens, spaces are tailored to the needs of the individual chef, while baths are designed to be the retreat within the retreat. She selects luxe,

natural materials like slate, limestone and glass, and saturates the room with them. In the end, she softens hard edges with plush textures and personal touches such as black and white photography and hand-embellished accessories.

Continually inspired by her own travels, she looks to Africa and India for color cues, fashion for fabric and texture, and New York City for the best of everything. All the while Ashli maintains that individual expression is what design is all about. It makes sense that her dream project would be a safari lodge in Africa or a private ranch in the desert Southwest—done luxuriously and with a twist, of course.

Ashli's work has been featured in *Traditional Home, Philadelphia Magazine, Out* magazine, *Main Line Today, The Philadelphia Inquirer, Home & Garden*, and HG-TV's Smart Design.

LEFT
This Japanese inspired bath integrates rich, natural materials into distilled, functional space. Brazilian slate, Spanish glass tile, cantilevered limestone vanity, Dornbracht fixtures, textured walls and Waterworks accessories.

RIGHT
Inspired by the vibrant palette of India, unrestrained color envelopes this space filled with period antiques and modern furnishings from around the globe.

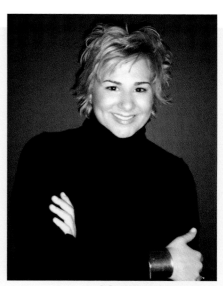

More About Ashli

WHAT IS THE BEST PART OF BEING AN INTERIOR DESIGNER?

Being given the opportunity to influence the spaces where clients spend their most important moments.

WHAT ONE ELEMENT OF STYLE OR PHILOSOPHY HAVE YOU STUCK WITH FOR YEARS THAT STILL WORKS FOR YOU TODAY?

That true style is about individual expression and cannot be bought.

WHY DO YOU LIKE DOING BUSINESS IN YOUR LOCALE?

Philadelphia's rich architectural history and Old World charm provide the perfect backdrop for a sophisticated and contemporary lifestyle.

Ashli Mizell Design
Ashli Mizell
313 S.17th Street
Philadelphia, PA 19103
215.546.7606
www.ashlimizell.com

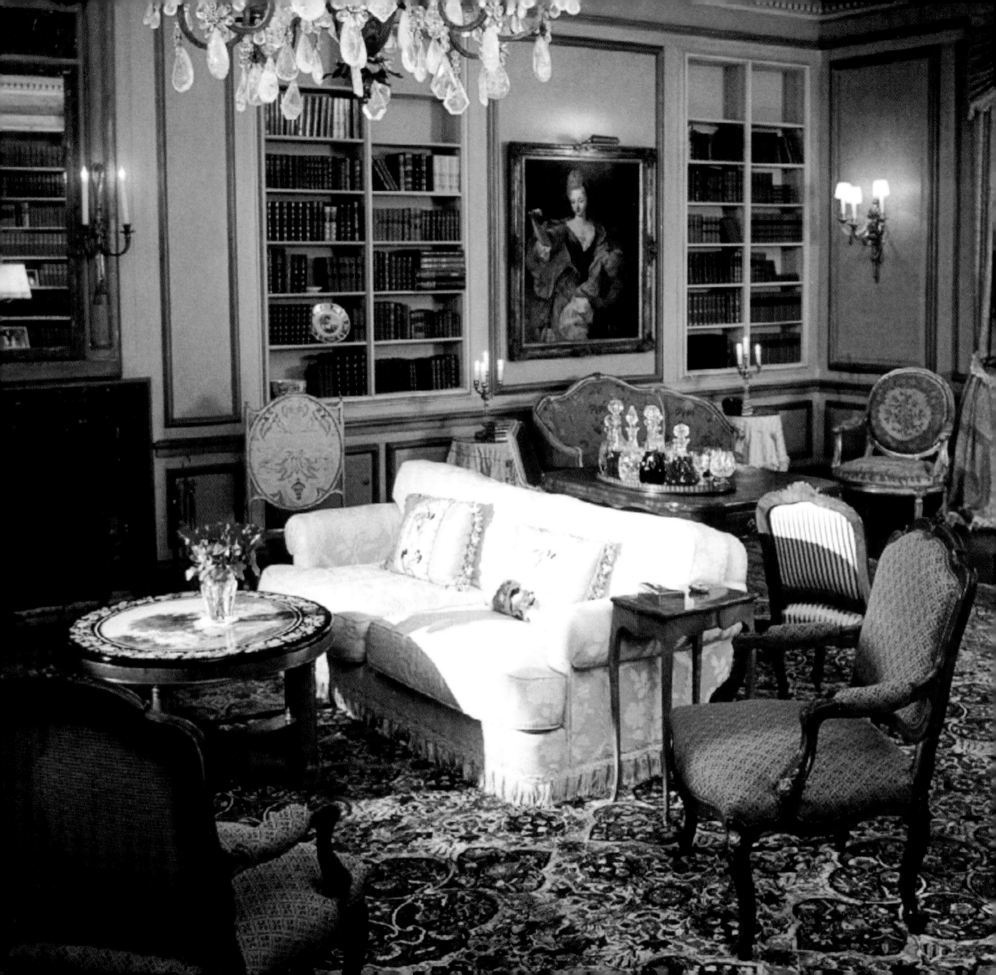

LOUIS N.

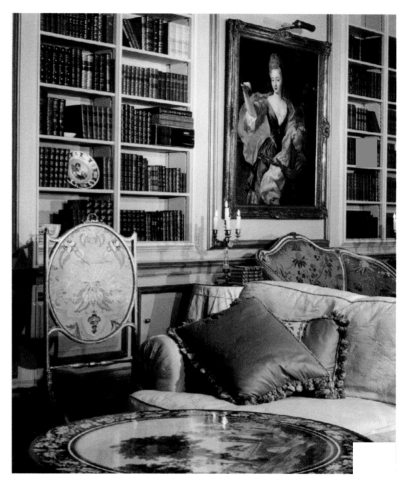

Louis Navarrete's family has a history that dates back to the 1500s in Cuba. He was born there but moved to the United States at five, studied ballet, and spent time all over the world touring. He remembers his time working in Monte Carlo most, performing and then attending parties in lush homes decorated by Mongiordano. He thought most people lived in such style.

When he suffered a career-ending injury, Louis looked to another passion. He won a scholarship to Parson's School of Design. After a stint with Bunny Williams during his senior year, the dean of the department, Ann Borsch of Parish-Hadley, recommended him for a job on a 16,000-square-foot home in West Chester County, New York. He worked on many a highbrow project for years in New York before relocating to Philadelphia in 2004.

His showroom, Louis Navarrete, for interior designers and architects in the Marketplace Design Center, is a low-key, yet glamorous loft filled with objects picked with the help of international scouts he has known for two decades. Artisans will also make reproductions like the Pollard oak table he sat

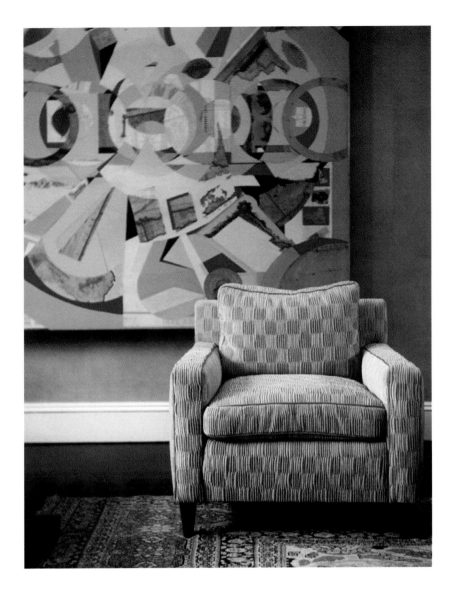

next to for this interview. Louis still takes on residential projects that are interesting. One on Pine Street in Center City is a five-floor townhouse that will be streamlined, modernized and filled with antiques. The client is involved in the ballet here.

Kind yet opinionated, soft-spoken yet open, and elegant but so comfortable to be around, Louis compares good design to the artlessness of dancing. It should look natural, like it just happened. If there are two things he has learned over the years, it's not to do anything for effect, and there is no such thing as bad taste, just things used improperly.

There is only one rule he does have—don't make it too contrived; always make it comfortable regardless of style. He favors pre-Industrial Revolution furniture, but his modern thinking is that no matter how grand, it's meant to be used. Otherwise it loses its purpose.

ABOVE LEFT
Detail of a modern living room with goatskin walls.

ABOVE RIGHT
Detail of a modern living room with a small calder and table by Frank Lloyd Wright.

RIGHT
View of a sitting area in a dinning room.

More About Louis

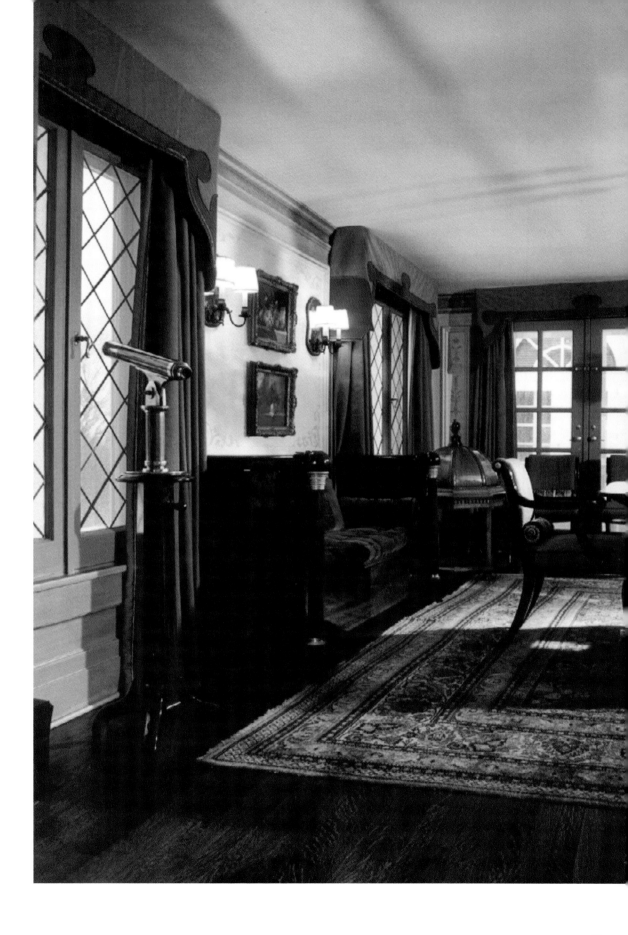

WHAT DO YOU LIKE MOST ABOUT BEING AN INTERIOR DESIGNER?

In my showroom I get to live with these objects for a while and see them go to a good home.

WHAT ONE ELEMENT OF STYLE OR PHILOSOPHY HAVE YOU STUCK WITH FOR YEARS THAT STILL WORKS FOR YOU TODAY?

Less is more. When in doubt, do without.

WHAT IS A SINGLE THING YOU WOULD DO TO BRING A DULL HOUSE TO LIFE?

Use color.

IF YOU COULD ELIMINATE ONE DESIGN/ ARCHITECTURAL/BUILDING TECHNIQUE OR STYLE FROM THE WORLD, WHAT WOULD IT BE?

Ugly. And, it's not subjective. If your eye is untrained or uneducated, you may use things the wrong way.

WHAT IS THE HIGHEST COMPLIMENT YOU'VE RECEIVED PROFESSIONALLY?

I was honest.

WHO HAS BEEN THE BIGGEST INFLUENCE ON YOUR CAREER?

Parish-Hadley.

WHAT IS THE MOST EXPENSIVE DESIGN YOU HAVE USED IN A PROJECT?

A garage for 200 cars, loosely based on the Batcave.

Louis N.
Louis Navarrete
2400 Market Street #403
Philadelphia, PA 19103
215.564.1890

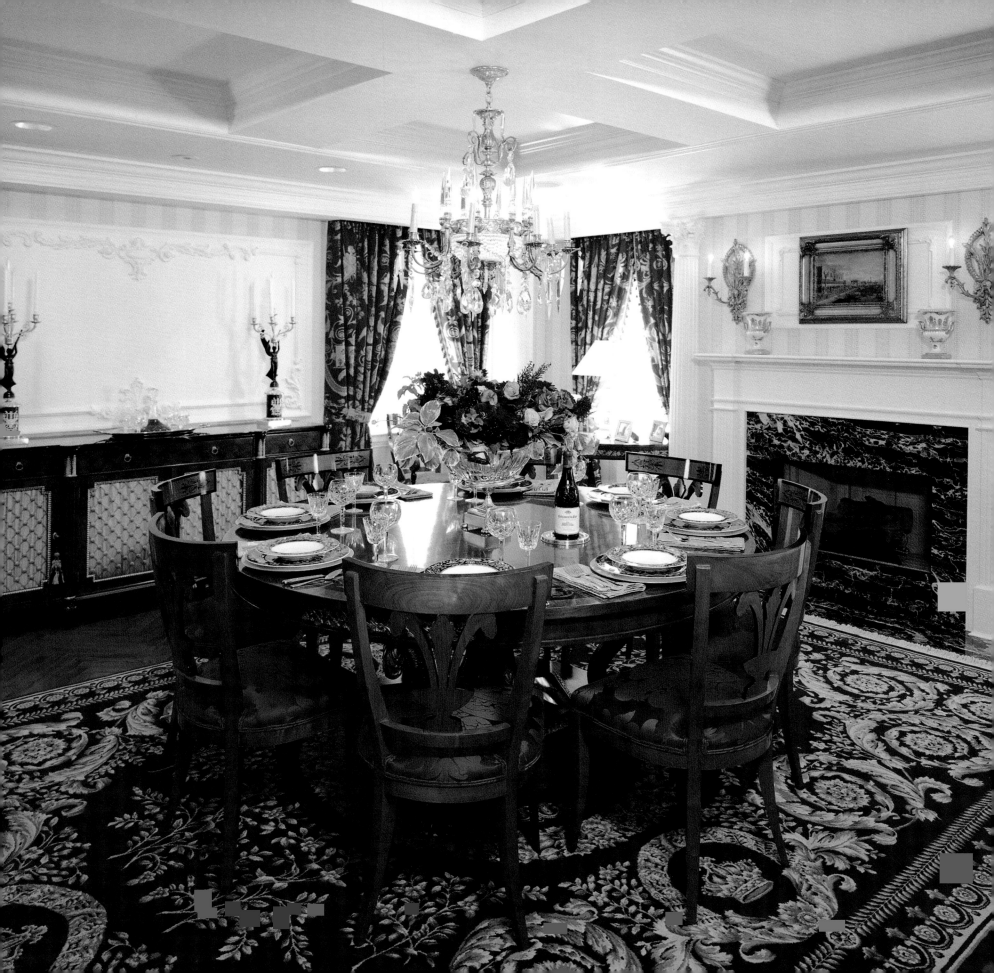

CREG RICHARD DESIGN

The neoclassical rotunda is the heart of this 3,800-square-foot home allowing access to the master bedroom suite, living/dining rooms and a state-of-the-art kitchen.

LEFT
In keeping with a neoclassical feeling, the fireplace was adorned with a pair of gold leaf sconces. Both the dining table, and sideboard are from Giemme, accented by a Burgundy Savonerrie.

Some say that interior designers love entertaining because they love designing the set. It makes sense then that Creg Oosterhart spent time as an innkeeper, buying an abandoned circa 1929 inn in Pittsford, Vermont, restoring it and making it The Iron Master's Inn he operated for four years.

Not long after, he was given the opportunity to work in Philadelphia at the Polo Store, home collection. Soon customers were asking him to do their homes and he could not resist. He has done nothing but since. Charming and talented, with a comfortable, easy gift of gab, he inspires his clients' dreams, and they inspire him.

One project had him taking a classic Delancey Place brownstone and juicing it up, highlighting a client's enviable art collection. Of the pair who lived there, one wanted traditional and the other cutting edge. He had faux leather wallcovering and primary color dining room chair seats to pick up the colors in the contemporary art nearby. Although the transitional format is where Creg is most at home, he likes classic if it is done to the nines. His ability to shift gears according to his clients' wishes and needs has given him the opportunity to work with a variety of design contemporaries like architect Spence Kass. These opportunities and associations are like an added education and he passes his knowledge on to his broad-based clientele.

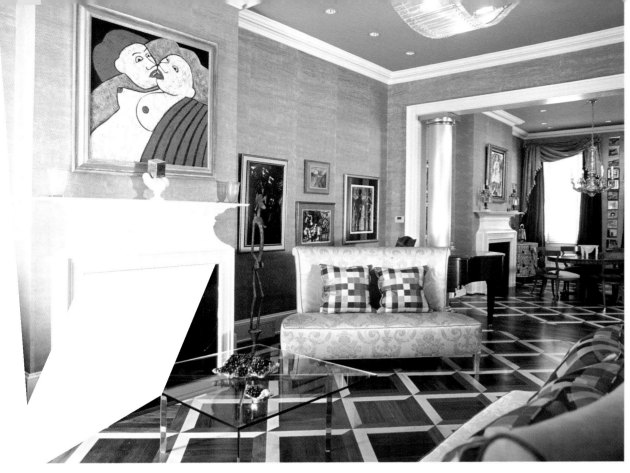

When you examine his accomplishments, their diversity is clear. He created the Meisner-esque lobby of The Carlyle Apartments to be a nod to the Moors. This is where he resides and keeps an office. His current roster includes Chef Jayson Grossberg's new chic gourmet restaurant Alphabet Soup located in Audubon, New Jersey, a design that is fresh, contemporary and whimsical. Every Creg Richard Design patron has the good fortune of getting a very personalized, finished product with the gift for color and texture he delivers every time.

Along with his right-hand designer Michelle Borden, this team takes every challenge and transforms it into a visual victory. But his credo is also that the designer doesn't live here. Hence, his spaces are a reflection of those who do. That is the goal.

Creg's work has been published in *Philadelphia Magazine*, *The Philadelphia Inquirer* and *Philadelphia Style*.

TOP LEFT
Dynamic flooring set in a diamond pattern of American Black Walnut, Maple and Brazilian Cherry are host to the silk armless sofas and Venini light fixture.

BOTTOM LEFT
The library warms you with hand-crafted faux leather wallcovering, a traditional paisley tufted ottoman, a corduroy upholstered sofa, and a pair of Eames lounge chairs and ottomans.

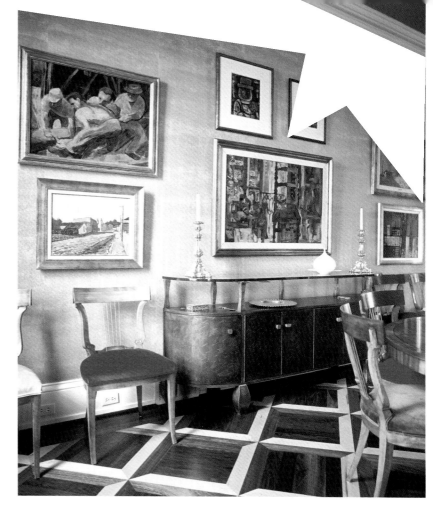

More About Creg

WHAT DO YOU LIKE MOST ABOUT BEING AN INTERIOR DESIGNER?

The freedom to express my creativity.

WHAT ONE ELEMENT OF STYLE OR PHILOSOPHY HAVE YOU STUCK WITH FOR YEARS THAT STILL WORKS FOR YOU TODAY?

I believe clients do know what they want. It's my job to interpret and bring to life those wants.

WHAT IS A SINGLE THING YOU WOULD DO TO BRING A DULL HOUSE TO LIFE?

Lamps!

IF YOU COULD ELIMINATE ONE DESIGN/ARCHITECTURAL/BUILDING TECHNIQUE OR STYLE FROM THE WORLD, WHAT WOULD IT BE?

The current trend of poorly made knock down furniture.

WHAT IS THE HIGHEST COMPLIMENT YOU'VE RECEIVED PROFESSIONALLY?

I can't wait to start my next project with you.

Creg Richard Design
Creg Oosterhart
2031 Locust Street, #1603
Philadelphia, PA 19103
215.557.0480

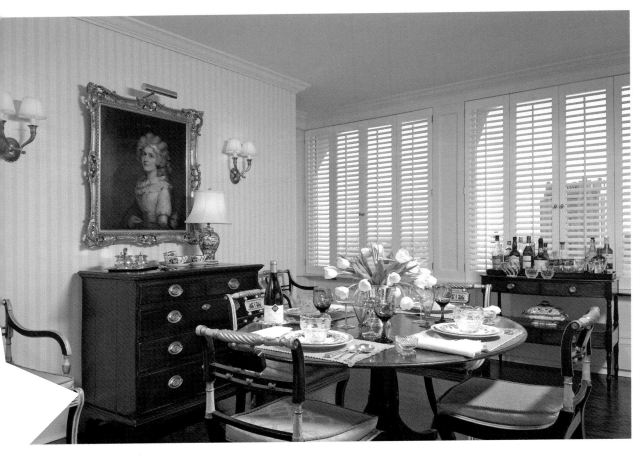

His clients love him for his personality and his ability to be both professional as well as flexible.

Joe loves to cook, read about it and entertain, a passion that involves setting the stage for the dinner party, something he's also adept at. As one of his interior design client's puts it about his approach to things:

"What you get when working with Joe is the ability to laugh and enjoy the experience while learning and growing from his expertise and his ability to listen and create the vision you brought to him."

Another client so pointedly said, "What he says makes sense, and what he does looks good."

TOP LEFT
The dining area for the living room showing antique furniture paired with lots of white and bare floors, contrasting the formality of the painted and gilded early Regency chairs.

BOTTOM LEFT
Maximum seating in a small area has been achieved in this living room, creating a conversation grouping using a sofa, backless settee, chairs, and a bench accommodating nine people.

FACING PAGE LEFT
My favorite kitchen is one that has good quality materials and appliances, is not fussy, and looks very functional.

FACING PAGE RIGHT
A cozy corner in my Rittenhouse Square apartment, doubling as a dining area and library. Notice the Mountain Grass carpeting. It is a favorite of mine.

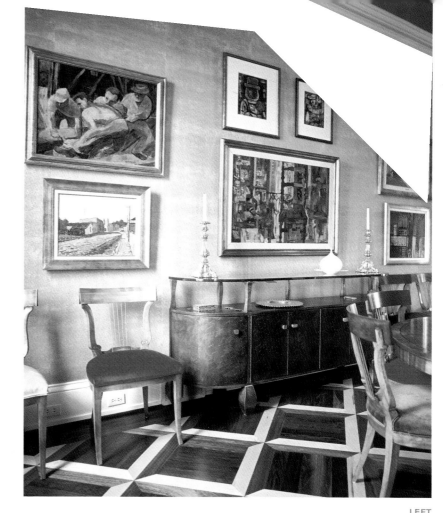

More About Creg

WHAT DO YOU LIKE MOST ABOUT BEING AN INTERIOR DESIGNER?

The freedom to express my creativity.

WHAT ONE ELEMENT OF STYLE OR PHILOSOPHY HAVE YOU STUCK WITH FOR YEARS THAT STILL WORKS FOR YOU TODAY?

I believe clients do know what they want. It's my job to interpret and bring to life those wants.

WHAT IS A SINGLE THING YOU WOULD DO TO BRING A DULL HOUSE TO LIFE?

Lamps!

IF YOU COULD ELIMINATE ONE DESIGN/ARCHITECTURAL/BUILDING TECHNIQUE OR STYLE FROM THE WORLD, WHAT WOULD IT BE?

The current trend of poorly made knock down furniture.

WHAT IS THE HIGHEST COMPLIMENT YOU'VE RECEIVED PROFESSIONALLY?

I can't wait to start my next project with you.

Creg Richard Design
Creg Oosterhart
2031 Locust Street, #1603
Philadelphia, PA 19103
215.557.0480

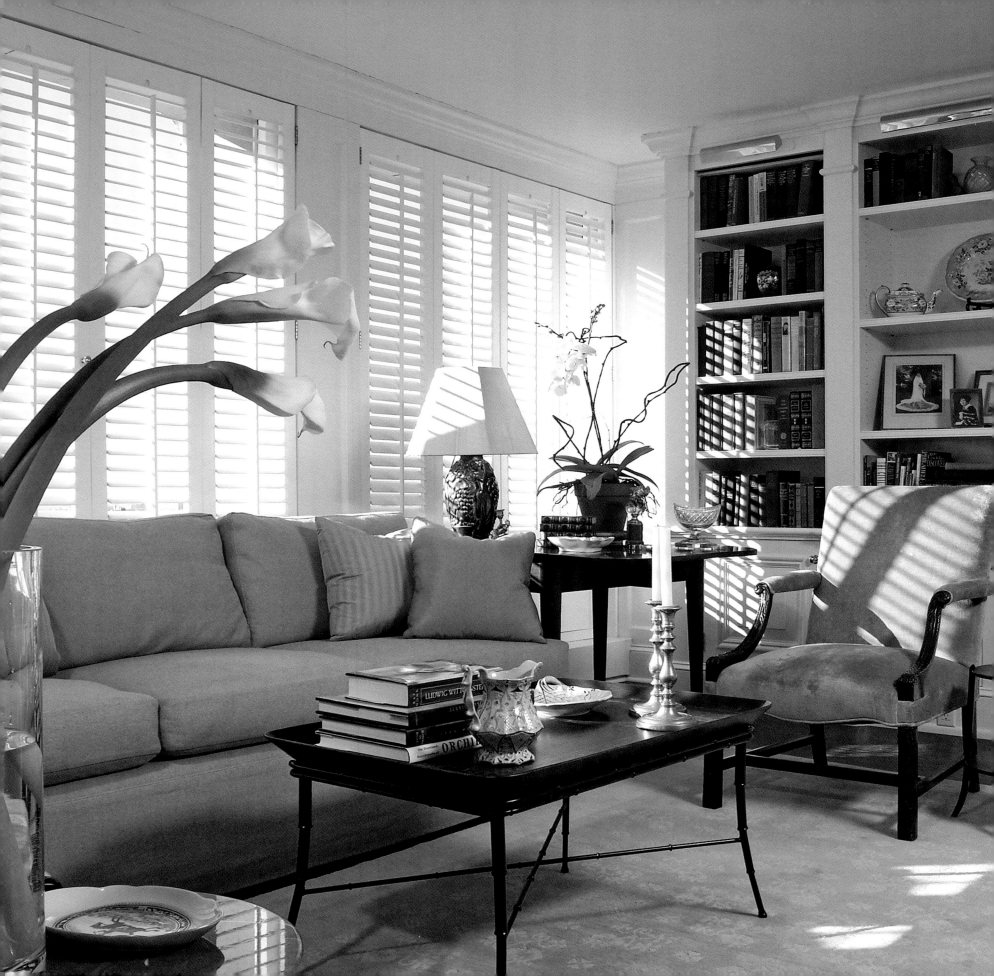

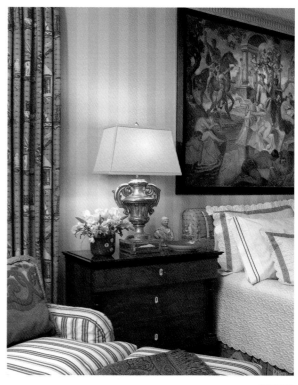

A tight shot showing a mixture of patterns and objects accomplishing the desired neoclassical look.

The room is traditional but still has the look of contemporary. This was achieved by using a bright white base with simple solid textured fabrics on the upholstered pieces.
Custom bookcases by Gersh Woodworking.
Interior renovations and kitchen by Hansell Construction, Inc.
Window treatments by Stuart London.
Wallpapering by Tim Hampshire.

This witty, affable designer has strong roots in design that date back to his childhood working in his father's furniture store in Philadelphia. His knowledge and love for furniture is still seen today. His tastes are eclectic. He likes everything from Louis XV, XVI, Empire, Charles X, Art Deco, to Asian. He also likes clean and contemporary, but never trendy. He is not one to overdo a design and is attuned to his client's needs and individual tastes, giving them something that they want and that is livable and appropriate for the space.

Joe's education started at The William Penn Charter School, and he went on to graduate from Villanova University with a degree in business administration. With a passion for interior design, he attended Philadelphia College of Art, transferring to The Parson's School of Design in New York, and graduating in 1982. He was a staff designer at Bloomingdale's, and then worked for a firm specializing in yacht interiors before starting his own business in 1986. He is the sole designer, and only takes on as many jobs as he can handle with the utmost of personal service.

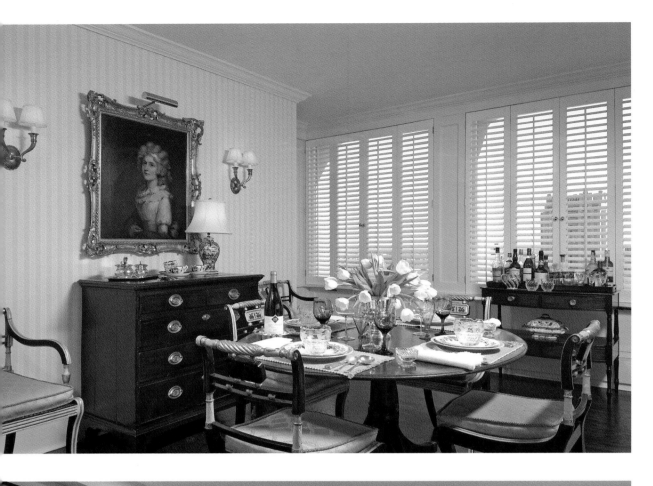

His clients love him for his personality and his ability to be both professional as well as flexible.

Joe loves to cook, read about it and entertain, a passion that involves setting the stage for the dinner party, something he's also adept at. As one of his interior design client's puts it about his approach to things:

"What you get when working with Joe is the ability to laugh and enjoy the experience while learning and growing from his expertise and his ability to listen and create the vision you brought to him."

Another client so pointedly said, "What he says makes sense, and what he does looks good."

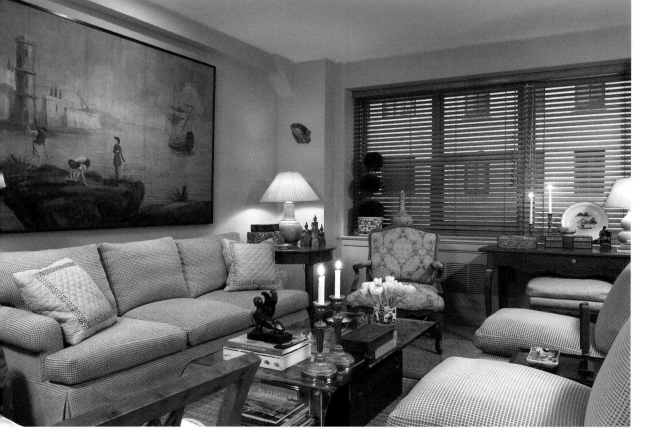

TOP LEFT
The dining area for the living room showing antique furniture paired with lots of white and bare floors, contrasting the formality of the painted and gilded early Regency chairs.

BOTTOM LEFT
Maximum seating in a small area has been achieved in this living room, creating a conversation grouping using a sofa, backless settee, chairs, and a bench accommodating nine people.

FACING PAGE LEFT
My favorite kitchen is one that has good quality materials and appliances, is not fussy, and looks very functional.

FACING PAGE RIGHT
A cozy corner in my Rittenhouse Square apartment, doubling as a dining area and library. Notice the Mountain Grass carpeting. It is a favorite of mine.

More About Joe

WHAT COLOR BEST DESCRIBES YOU AND WHY?

Coral because it is a cheerful, uplifting color and it goes with neutrals, greens, blues and yellows.

WHAT BOOK ARE YOU READING RIGHT NOW?

Italian Cuisine. A Cultural History by Alberto Capetti. I enjoy cooking and eating. Italy's cuisine is rich in history of the ingredients, dishes, techniques and social customs.

WHAT IS THE BEST PART OF BEING AN INTERIOR DESIGNER?

Meeting new people and seeing how I can help them. It is often the most successful people who are at a loss when it comes to decorating their house.

WHAT IS THE HIGHEST COMPLIMENT YOU HAVE BEEN PAID PROFESSIONALLY?

A client once told me that I was making the world more beautiful room by room, house by house. (I have a long way to go).

WHO HAS BEEN THE BIGGEST INFLUENCE ON YOUR CAREER?

Billy Baldwin. I admire his style and philosophy. He felt rooms should be contemporary with a mix of antique and the modern styles and periods. He also believed you should never under scale; the meagerness of under scale never has any guts or style.

Joseph Picardo Interior Design Inc.
Joseph Picardo
220 West Rittenhouse Square
Philadelphia, PA 19103
215.735.0882

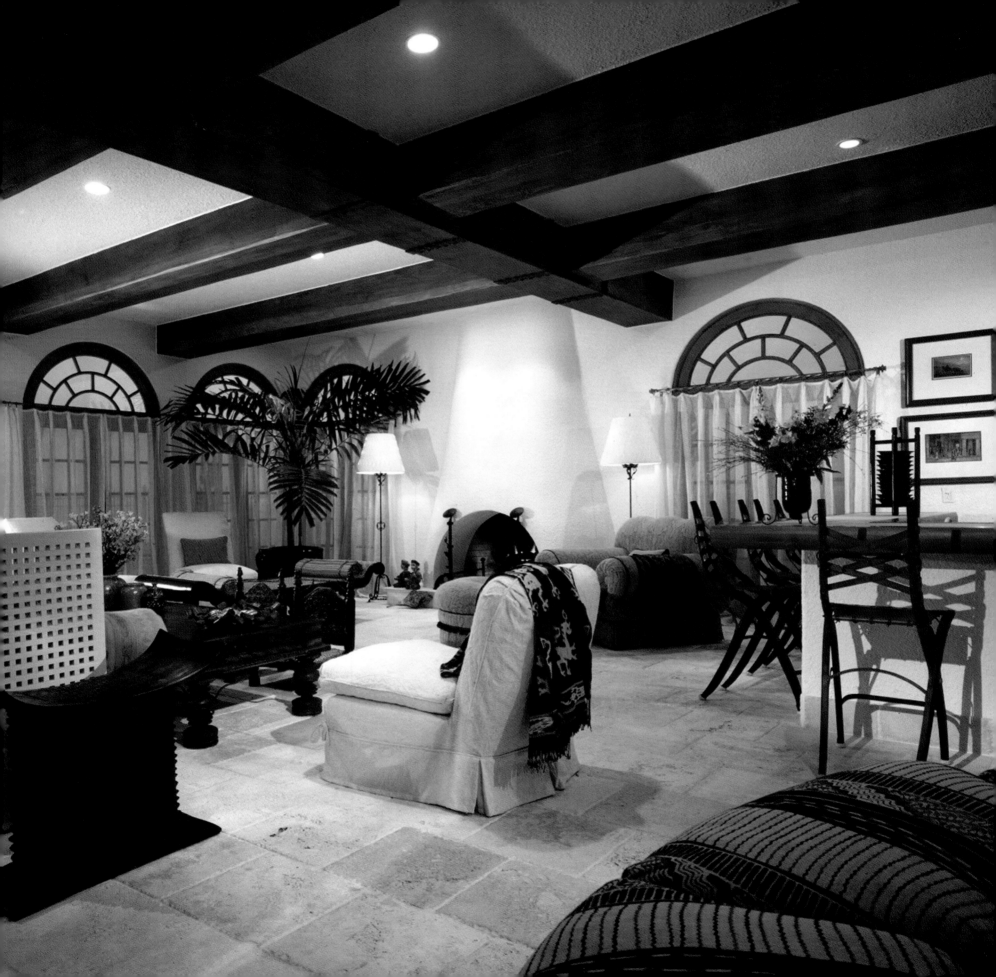

MARGUERITE V. RODGERS

MARGUERITE RODGERS LTD.

Meg Rodgers is a Philadelphia treasure—a nationally acclaimed designer whose surpassing attention to composition and detail brings residences, restaurants, offices, and boutiques to unforgettable life. Her visionary approach to Striped Bass, Lacroix at The Rittenhouse, Fork, and Susanna Foo helped reinvigorate the restaurant business in Philadelphia. Her residential work has been praised for its symmetry, elegance, and calm. With recent projects ranging from the furnishing of three colleges at Yale University to the renovation of the Park Hyatt at the Bellevue, Meg and her staff of 16 bring a refreshing depth of imagination to the opportunities with which they are entrusted.

The youngest of five children, Meg left her childhood home in coastal Maine to study fashion design at Moore College of Art and Design. Textile design soon replaced fashion as a focus, and a six-week internship with modern sculptor Clark Fitzgerald further broadened her range, introducing her to what would become a lifelong passion for the design and detailing of wood.

Between 1978 and 1980, Meg worked for a woodworker on a number of boutique projects while simultaneously studying interior design at the night school of Philadelphia College of Art. By 1981 she had formed her own woodworking company, and when a former client invited her to help select and then renovate a home, she took the challenge on—not just designing the interior and supervising the construction, but personally attending to the millwork, the kitchen, and the furnishings. That job led to many others including, in short order, a key opportunity to design a model apartment in The Rittenhouse Hotel.

Once based in whatever space she was designing at the time, Meg now works, with her staff, in a former warehouse building in north Philadelphia—a space that burgeons with storyboards and material samples, with sketches, journals, and books. Rescued animals from the neighborhood can often be found in the studio as well, as Meg takes her commitment to her community as seriously as she takes her dedication to design.

TOP LEFT
Meg artfully combines Asian antiques with contemporary art and crafts to create a city living room that is infused with warmth.

BOTTOM LEFT
This small living room in a city condominium combines a neutral palette with clean and contemporary lines to create an illusion of a larger space that is perfect for entertaining.

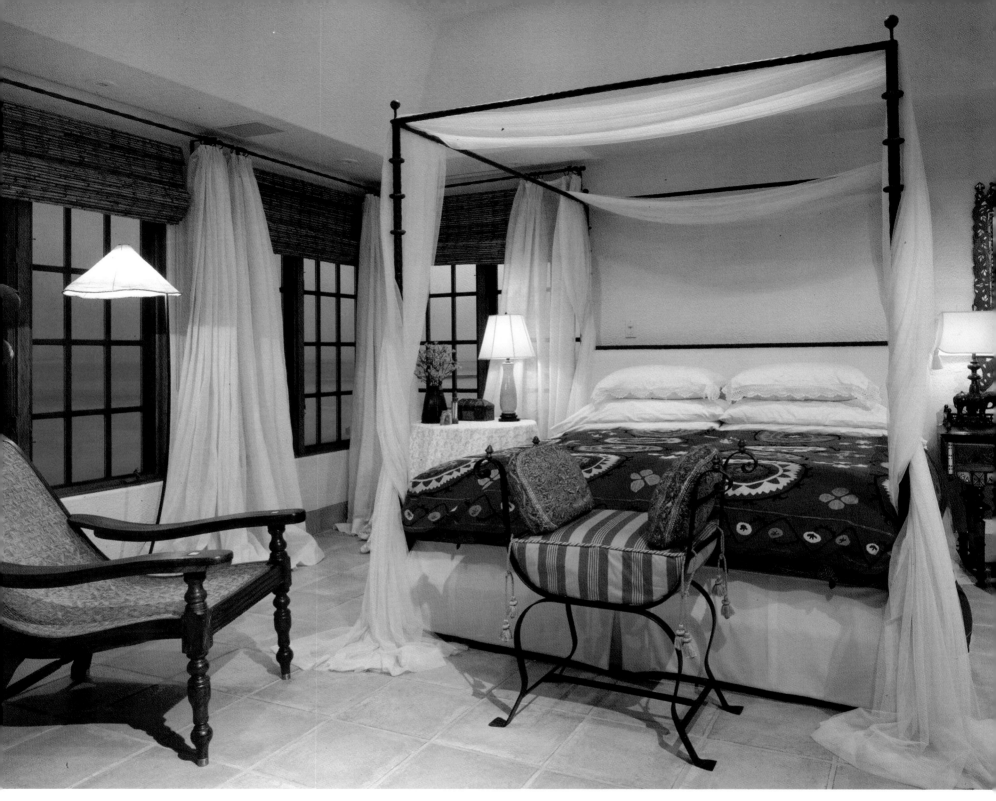

Meg has infused this seaside master suite with a casual elegance that creates a romantic getaway for her clients.

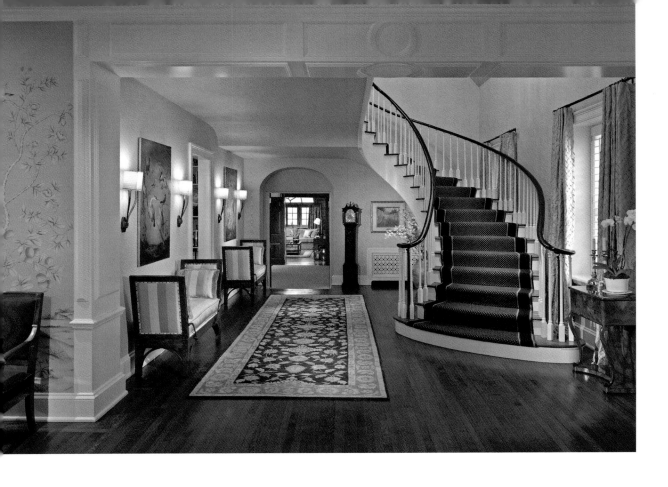

With her work published in countless magazines—*Interior Design, Architectural Record, The New York Times, Esquire, Gourmet,* and *Philadelphia Magazine* among them—Meg continues to bring a freshness of perspective to every new project, a detail suggested by a film, a mood provoked by a foreign place, or a color discovered in the garden. When not traveling for business, Meg, her husband, and two children, Harrison, age 7, and Veronica, age 3, escape to their rustic cabin in Maine on Meg parents' property, where she experiments with new possibilities in a private workshop.

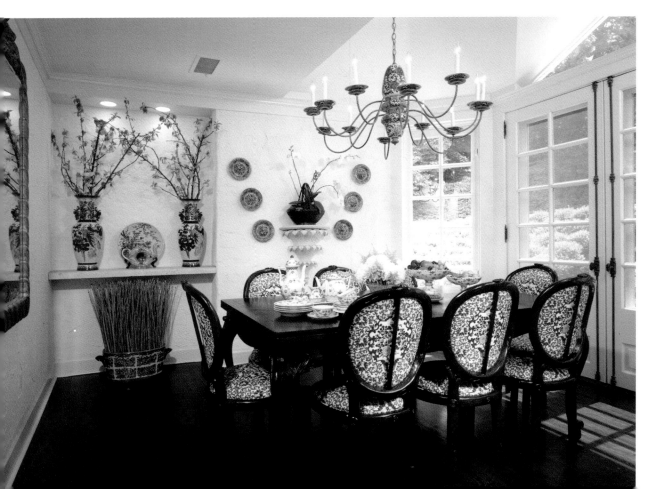

TOP LEFT
The design enhances existing architectural elements and, through the use of artistic details, the foyer becomes a prelude to the elegance of the home, as well as a visual connection to the adjoining rooms.

BOTTOM LEFT
This fresh suburban breakfast room overlooks the landscape and is filled with natural morning light. Meg chose a color palette that echoes the clients collection of blue and white accessories, creating a refreshing room that greets them each morning.

FACING PAGE
In this formal living room, Meg creates a sense of serenity through the use of symmetry and balance. The combination of Asian antiques, contemporary artwork and custom lighting result in a room that is both elegant and warm. Handmade eglomise screens depict the home's landscape as well as the client's beloved pets.

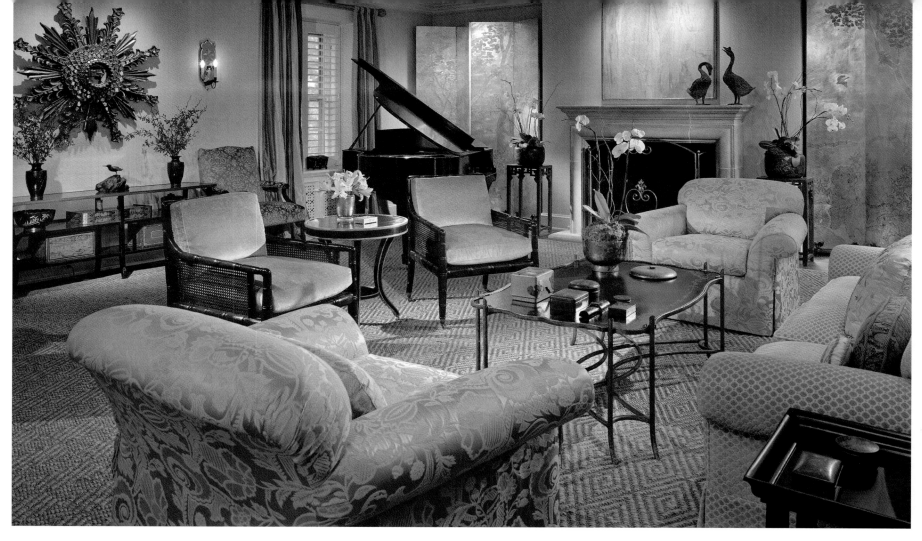

More About Marguerite

WHAT IS THE BEST PART OF BEING A DESIGNER?

The relationships we have with clients, artisans, and vendors. The ability to produce anything we have a vision to make. Your artisans get excited. Each job is a new team, a new experience. I never get bored. I learn different trades; your world is really unlimited.

WHAT IS THE HIGHEST COMPLIMENT YOU HAVE RECEIVED PROFESSIONALLY?

When I overhear someone talking about a project and they understand the intent or the emotion, it is rewarding.

Marguerite Rodgers Ltd.
Marguerite V. Rodgers
2131 N. American Street
Philadelphia, PA 19122
215.634.7888
www.mrodgersltd.com

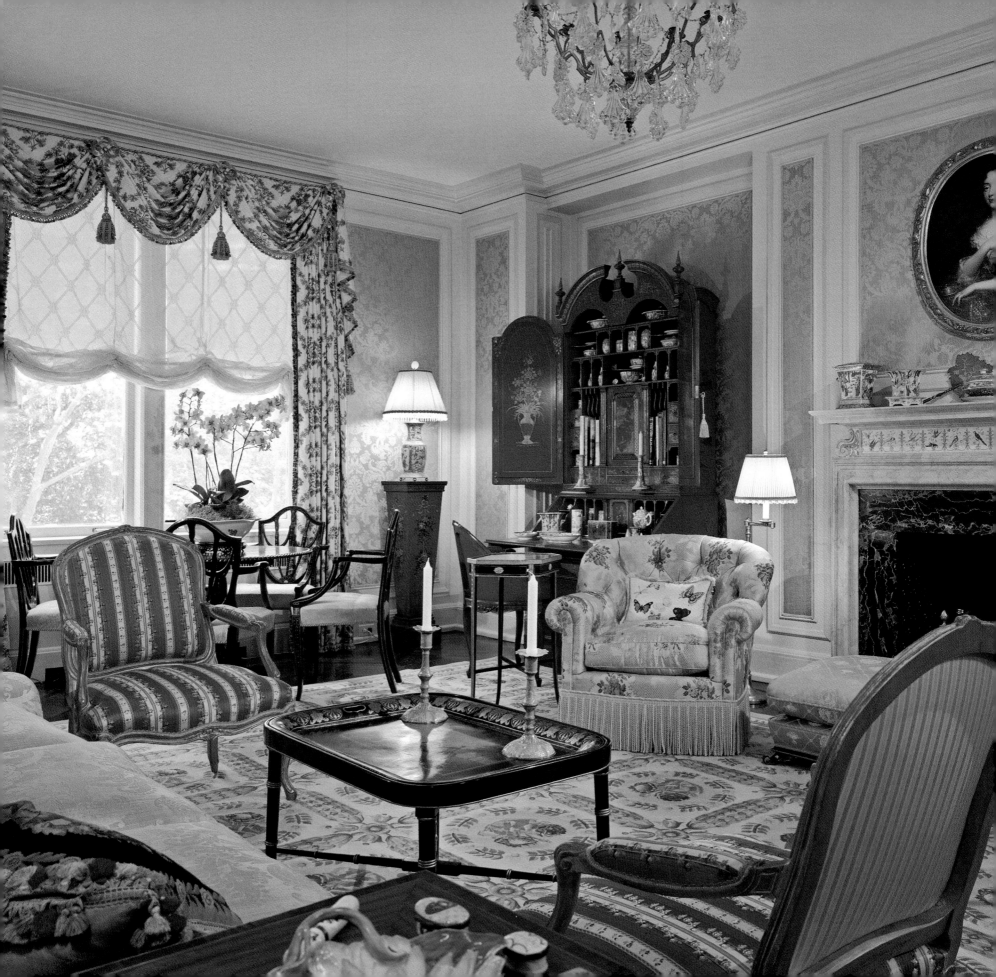

JOHN ROLLAND

ABOVE
Red antique English bureau secretary-London collection of
Chinese export-Mandarin porcelain Bilston boxes, tortoise boxes.

LEFT
Gold silk Damask upholstered on walls, Scalamandre french
fauteuils-Kentshire Galleries-silk Brocade chairs-old world weavers.

After 25 years in the design business, John Rolland still loves taking a blank room and turning it into something beautiful. At home in the Barclay, John, is nonchalant about his two-bedroom spread that includes an elegant library and office, two living rooms (one can be transformed into a dining room in a pinch) and an all-white kitchen with custom hand-painted tiles. He is the epitome of the turned-out designer, head-to-toe custom clothes, a closet stacked with orange and brown Hermes boxes and another that holds his Louis Vuitton luggage. The master bedroom with an elaborate blue and white canopy bed looks positively prince-like.

A graduate of Drexel University, John worked for other designers before opening his own firm 16 years ago. He is the man who seemlessly puts together elegant, timeless interiors that have an Anglo bent. Inspired by such classics as Colefax & Fowler, Parrish Hadley and Mark Hampton, this designer sides with sunny yellows, deep terra-cottas and rich blues for his rooms. John's spread, with charming views of Rittenhouse Square from behind the tassle-trim silk draperies, is a homage to good taste. There is the fireplace with custom plaster painted birds decorating it, antique porcelain lamps, and small boxes that dot each side table. Each antique has a provenance that can be

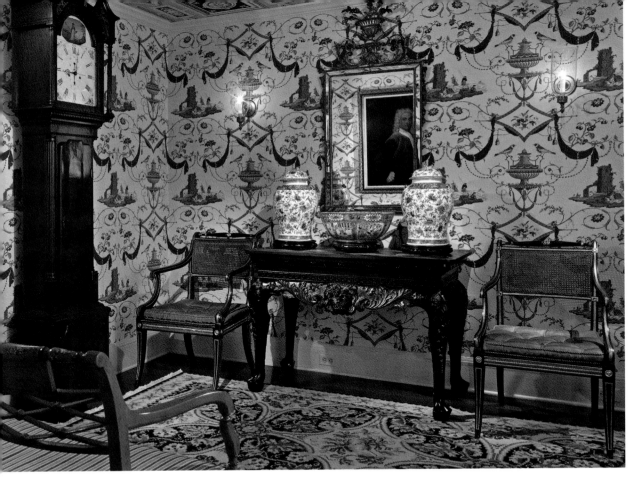

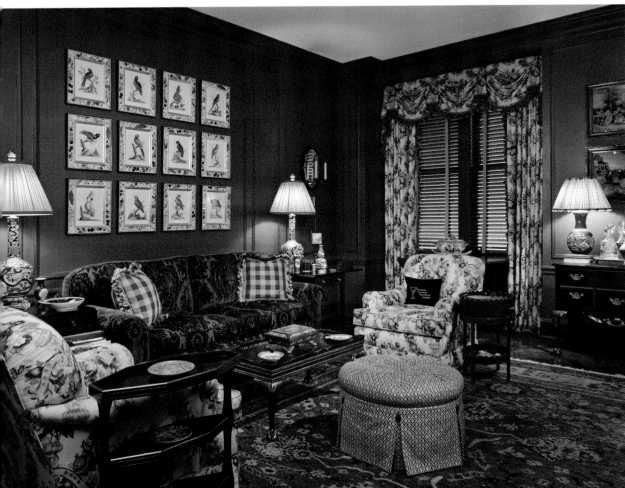

produced detailing its past. There are giant oils, end tables, secretaries and bookcases dating back to 1700s England. He collects Canton and Chinese export porcelain and Bilston/Battersea boxes, as well as tortoise ones.

At the centerpiece of his living room is an impressive red secretary, painted in the chinoiserie style, in perfect condition even though it dates to the 18th century.

Pieces like this were well taken care of—dust covers placed on them by the servants when the house was not being used—he tells. Rolland's clientele is not so different from the English where his antiques originated. He is trying to reach one young client now, at her Long Island weekend home, to arrange a shoot of her Philadelphia home.

Much of John's business is repeat and all high-end. He is now redoing homes of clients, helping them downsize into new, just-as-luxe digs, or taking on their children, many with their own young children, as clients.

John's formula for a room is simple and sophisticated. He starts with a great anchor—a fabulous, eye-catching rug for a living room, dining room or bedroom—he adds plump down custom sofas and chairs, and sprinkles in antiques or good reproductions (he instructs the young couples to opt for the latter if the former is out of their budget) and leaves the draperies to last. Just don't skip them, he advises, since a room is not finished until they are up. John's signature is opulent window coverings replete with the fanciest of trims.

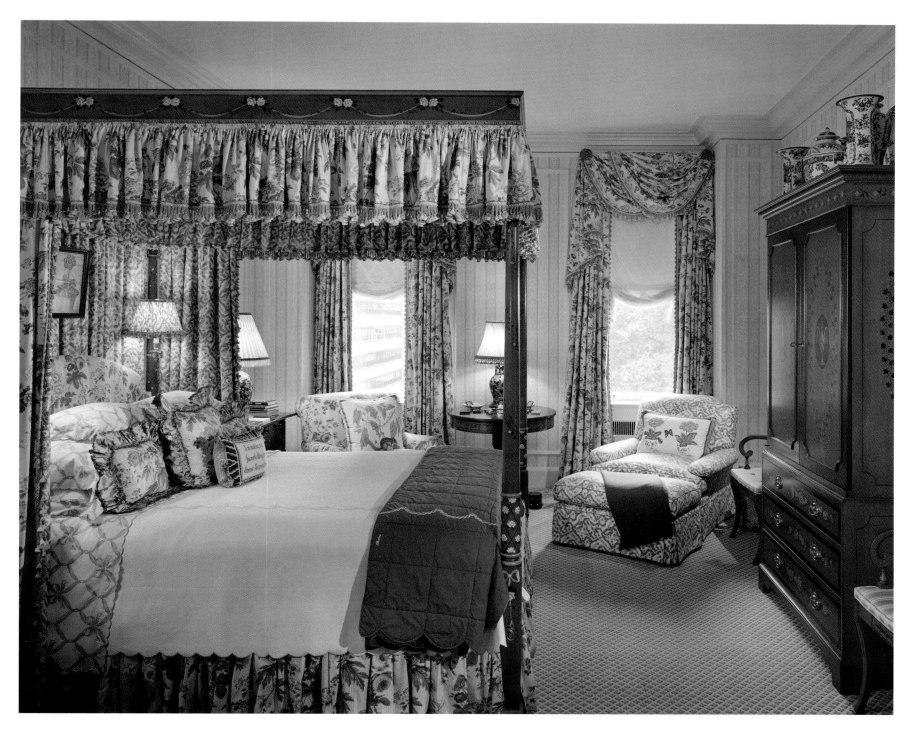

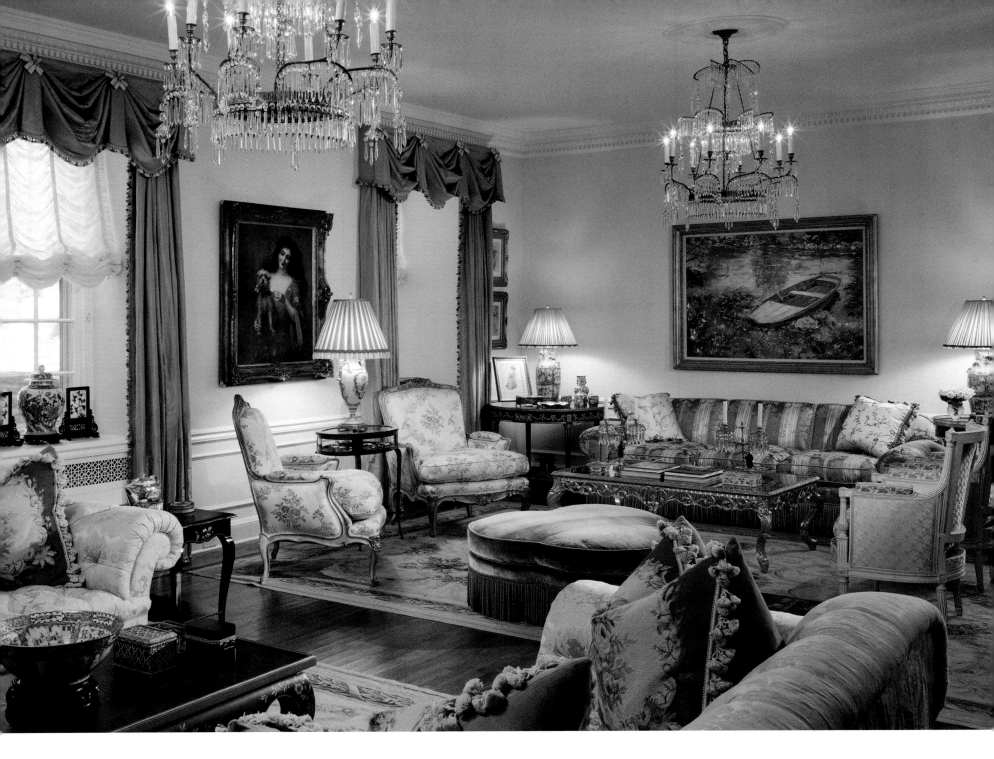

While magazines may be touting something more modern, his young following is not biting. They've have seen their parents through that phase and want a more classic look. John obliges and loves to get them started on collecting once the design job is complete. He buys them an antique piece of Staffordshire or a box and instructs to keep adding to it when they are traveling. Another signature of the designer is his use of lamps and lamp shades. He loves antique lamps with opulent silk shades with lovely fringes. He is always hunting for porcelain vases he

can turn into one. He tops off these luminaries with rock crystal, or jade antique finials. John says he can do a whole home with a client and have a hard time selling them on such accessories, since the ones he chooses can be as pricey as the upholstery. Last year a fully loaded interior of John's was featured in a book about the fabric house Scalamadre entitled, *Scalamandre: Luxurious Home Interiors* by Brian Coleman (Gibbs Smith, October 2004). Another home of his design will appear in the soon-to-be released book, *Opulent Window Coverings*.

More About John

WHO HAS HAD THE BIGGEST INFLUENCE ON YOUR CAREER?

My brother Dennis Rolland—a New York designer—has the best taste of anyone I know.

WHAT ONE ELEMENT OF STYLE OR PHILOSOPHY HAVE YOU STUCK WITH FOR YEARS THAT STILL WORK FOR YOU TODAY?

Classic style traditional upholstery, rugs, antiques, and beautiful antique accessories.

WHAT COLOR BEST DESCRIBES YOU?

I Love yellow, it's happy and cheerful makes me happy.

WHAT IS A SINGLE THING YOU WOULD DO TO BRING A DULL HOUSE TO LIFE?

Fabulous draperies, and accessories.

John Rolland Interiors
John Rolland
The Barclay on Rittenhouse Square
273 S. 18th Street
Philadelphia, PA 19103
215.546.3223
FAX 215.546.7337

FACING PAGE
Living room of Mr. & Mrs. Richard Cooper, Russian chandeliers-Nesle, French antiques-Paris, fabrics Scalamandre, Brunshwig afils.

TOP RIGHT
Dining Room-English crystal chandelier-Nesle antique table, chairs, sideboard-Agostino antiques, porcelain collection-Leticia Lundeen-Palm Beach

BOTTOM RIGHT
Master Bedroom-fabulous Stark Summer Flower carpet, silk wall U7H-Brunschwig, fil & silk taffeata draperies-Bye Julia Gray bed, all antique furniture from Paris & London, Miller Parisian Draperies.

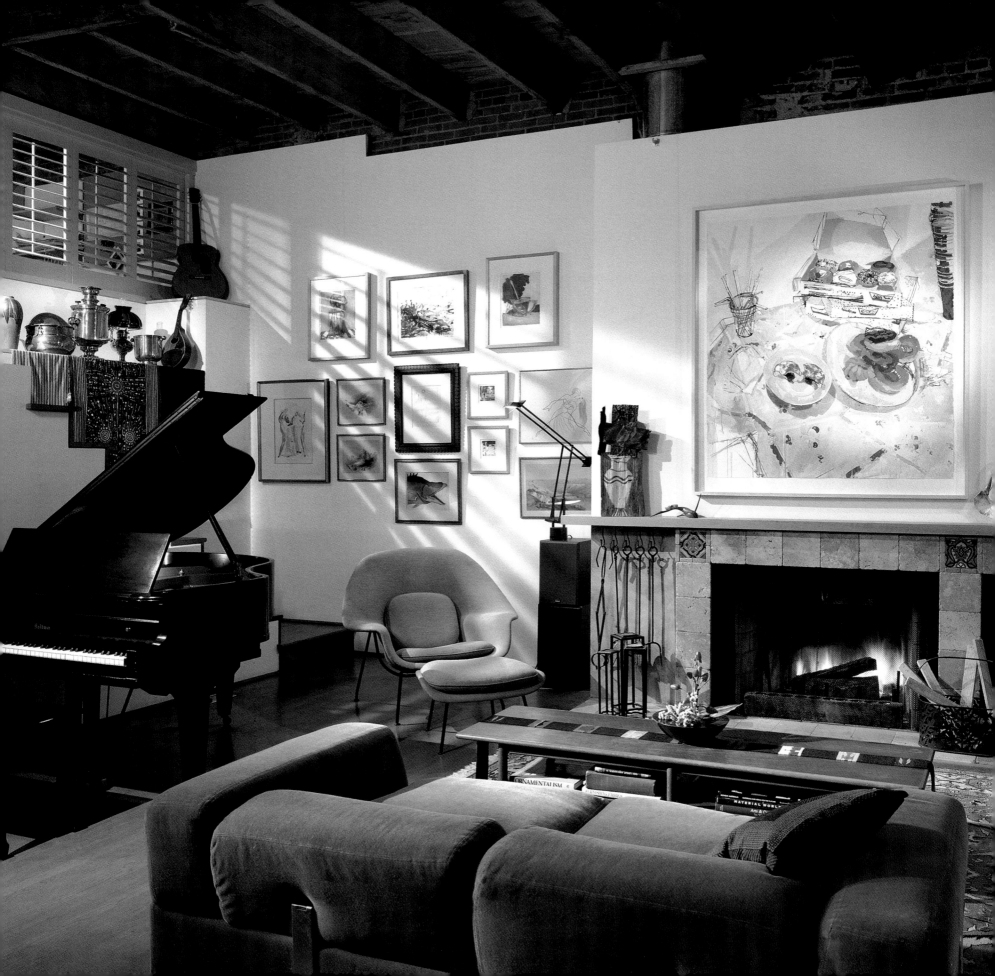

BARBARA RUTH

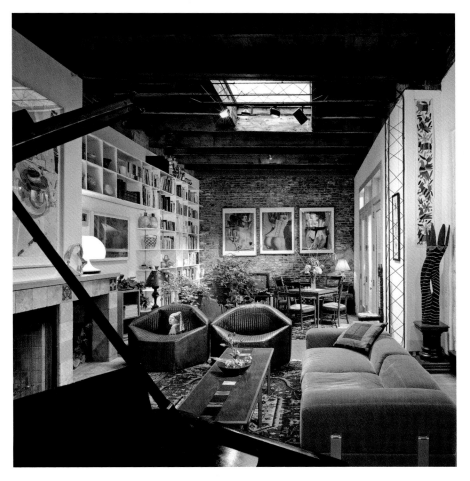

Barbara Ruth earned a degree in fine and applied arts and, after a European tour, settled in New York City to design sportswear and eventually textiles. After gaining experience, she took the opportunity to live, love and design textiles in Paris for a year before returning to her hometown of Philadelphia. Without opportunities in fabric design, she worked as a draftsman in a Center City A&E firm. The architects asked her to create an interiors department to develop interior building materials and details, space planning and lighting for their projects. She also was awarded additional contracts for the selection and installation of loose furnishings, much of it custom.

After 11 years of working closely with architects, she started her own firm. Over the years her work won several city, county and state awards and was featured in several journals and publications. However, the most challenging project was the design of her urban house, which has resulted in dramatic amounts of light, comfort and vitality.

She now has filled her lovely spaces with global crafts, flea market items, 20th century furniture and her artist friends' paintings. She recently counted up her biggest collectible—chairs—59 of them. Barbara has a vast array of interests that include jazz, pottery, chess and watercolor. Modernizing her home is high on her to-do list, using more granite, glass and steel and, of course, not losing site of her favorite background color (camel), and her favorite background texture (books).

In addition to 40 Philadelphia residences, her work includes 11 area universities, several restaurants, institutions, corporate headquarters, graphics programs and museum exhibits. She has taught and lectured throughout the area and in Bangkok, Thailand.

ABOVE
Art pieces in view are by Joan Becker, Linda Brenner, Ed Bronstein, Tom Judd, Emily Brown, Diane Burko and Debbie Boardman. Scattered pieces and artifacts of traditional and modern crafts from many countries are often moved around to form new groupings.

LEFT
The sofa and lip chairs are 20th century Italian, and with Saarinan's womb chair, surround a working fireplace of tumbled marble and Arts & Crafts tile. The Krispy Kremes over the fireplace is by Joan Becker.

Barbara Ruth Interior Planning
Barbara Ruth
626 South 21st Street
Philadelphia, PA 19146
215.732.8855

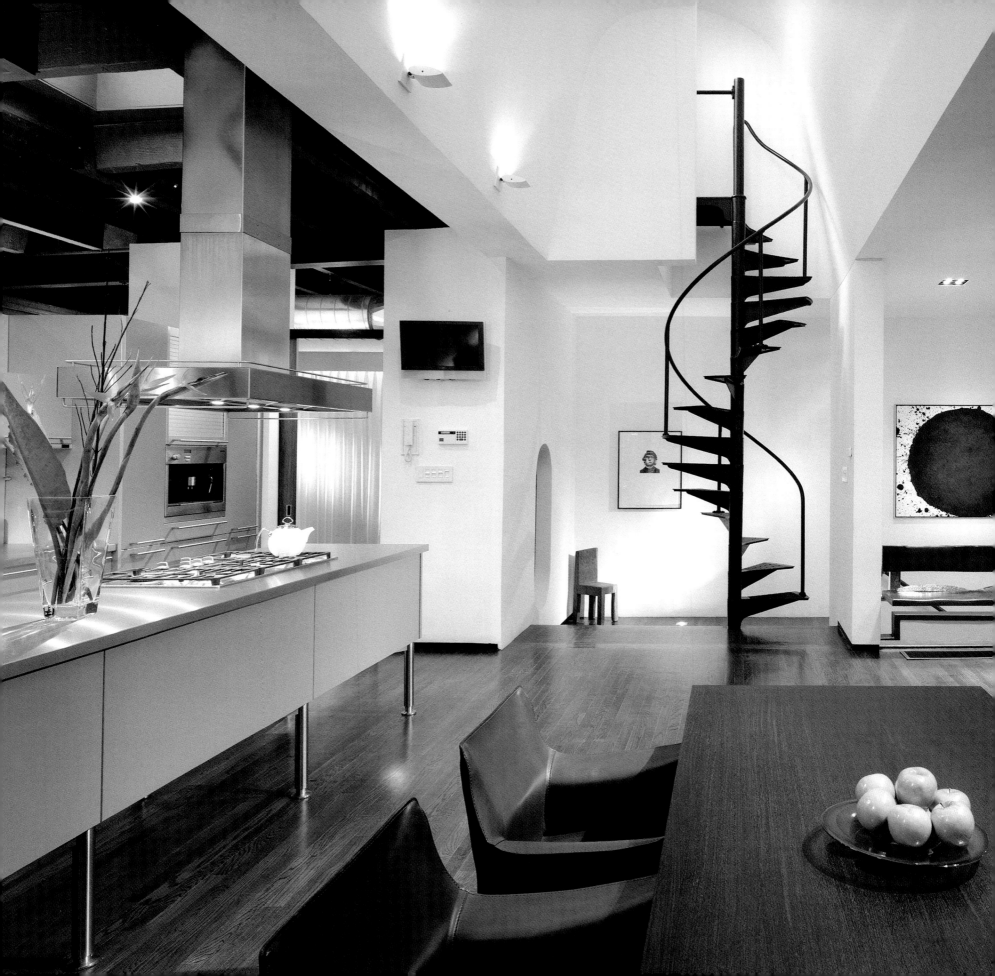

NEIL SANDVOLD
& ANDREW BLANDA

SANDVOLD BLANDA ARCHITECTURE + INTERIORS

Design partners Neil Sandvold and Andrew Blanda met while pursuing their master's degrees in architecture at the University of Pennsylvania. Working together for more than 20 years, their goal is to create architecture known for its originality, strength and lasting beauty. Although their designs are contemporary, they would rather not call themselves modernists. The firm's signature is high-quality work, custom details, and timeless design. Sandvold and Blanda have expanded their practice to include restaurants, condominiums, and a wide range of commercial projects.

As both architects and interior designers, Neil and Andrew see spaces in a comprehensive manner. For most residential clients, any project represents a transition in their lives that must be fully explored. The pair carefully interview their clients to understand their goals and desires and then produce designs to reflect their clients' tastes and needs. When complete, they reveal living spaces that are polished, original and unexpected.

This complete renovation of a 19th century carriage house created an urban loft crafted from a rich palette of materials. Rough wood beams and exposed steel contrast with the white walls and vivid artwork. The living room/dining room is bathed in light from a two-story clerestory. A sculptural spiral stair leads to a private roof deck. Hidden behind the kitchen is the lavish bedroom with custom shower, soaking tub and gallery of closets. At street level, the den has the original slate floor of the carriage house. A white box conceals a private meditation room as well as his and her bathrooms detailed in green slate. Behind the wall of Italian glass block is the garage. The home is vibrant, uncluttered and perfectly functional.

ABOVE
A comfortable, oversized sofa faces a custom credenza that features an entertainment center. The green slate steps lead to the garage behind a glass block wall. A meditation room, office and his/her bathrooms are screened by a white glass panel.

LEFT
Clean lines and a skylit cathedral ceiling create a dramatic great room. To the right of the open kitchen and dining table is an intimate arrangement of custom furniture embraced by a cozy fireplace. The sculptural stair leads to a private rooftop terrace.

Sandvold Blanda Architecture + Interiors
Neil Sandvold
Andrew Blanda
The Architects Building
117 S. 17th Street, #1500
Philadelphia, PA 19103
215.636.0099
www.sandvoldblanda.com

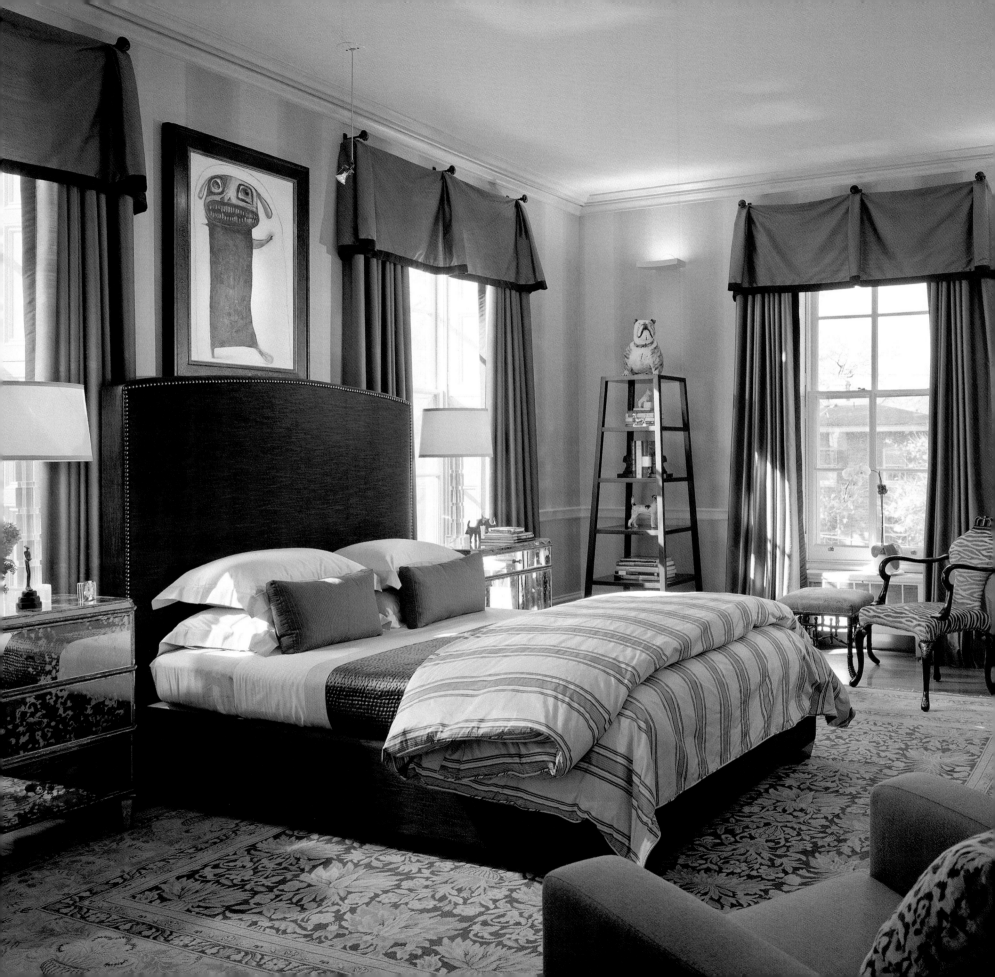

MICHAEL SHANNON

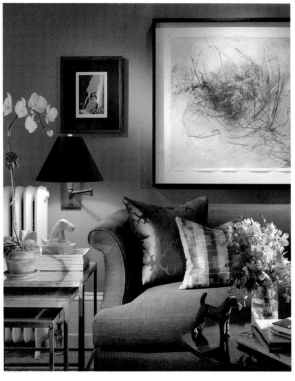

The balance of neutral tones and a positive/negative color scheme strongly accentuate the adjacent sitting room for the same PSPCA benefit.

This master bedroom is a play between whimsy and sophistication. Canine art and accessories are lightheartedly used in this show house room benefitting the PSPCA.

Michael Shannon is a study in contrast: Hip enough to perceive the inherent coolness of the sleekest modern lines and discerning enough to appreciate the intricate work of craftspeople who conjure the rustic sophistication of generations of artists. Michael's style draws on and improves upon the best each design period has to offer. Whether contemporary or traditional, his designs are always classic.

For the better part of a decade, Michael Shannon Designs has been helping clientele from the Philadelphia area and beyond transcend the confines of uninspired space. His designs are emotionally evocative, striking a stunning balance between comfort and class, but always, his client's needs are his creative compass.

For all the thought and passion that guides this designer's work, he's not without humor. In fact, his effervescent personality has become a hallmark of his easy rapport with clientele. To tap into Michael's refreshing levity, one need only visit his Center City office, where the most enthusiastic—if not the furriest—of doormen greets each guest:

Shannon's endearing Jack Russell terrier, Jackson. But bringing Jackson to the office every day is not merely a nod to Michael's softer side; it's a testament to the firm's philosophy: All members of the team are valued—clients, craftspeople, design staff and beloved mascots alike.

Trained at the Art Institute of Pittsburgh, Michael was a consultant for furniture manufacturers Herman Miller and Haworth before starting a residential design division for Hellyer Schneider in Philadelphia. The experience was the impetus to start his own firm in 1997. Now a company of six, Michael Shannon Designs services clientele nationally, but the majority of the firm's clients hail from Philadelphia and surrounding areas.

To walk into Michael Shannon Designs is to become a client and friend for life. Once Michael has cast his spell on his clients' spaces, they seem to find themselves inexplicably drawn back, trusting that he alone has the unparalleled ability to actualize the perfect space for them—a space deeply satisfying to both the eye and the heart.

TOP LEFT
The clean qualities of an Asian interior subtly influence the design direction of this master bedroom. The Pascin painting hung above the red lacquered case piece is juxtaposed by the sculptural qualities of an Ingo Maurer lamp.

BOTTOM LEFT
The plan of this bathroom blurs typical boundaries of function. An intimate sitting area, an extension of the master suite, is accompanied by Duravit sinks with crafted mahogany bases.

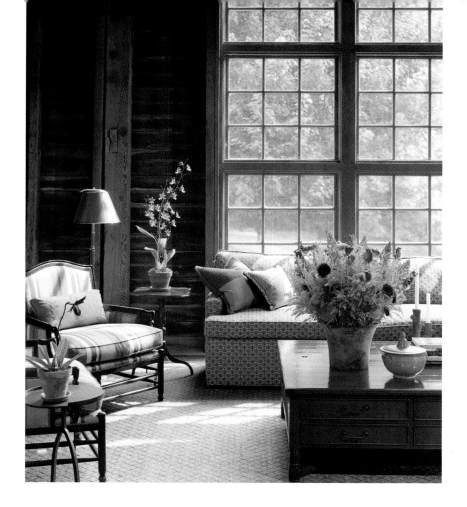

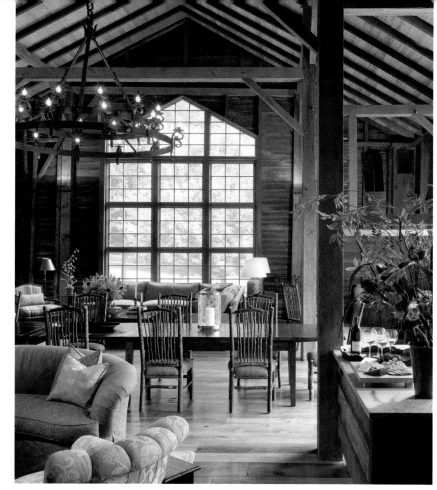

More About Michael

WHAT ONE ELEMENT OF STYLE OR PHILOSOPHY HAVE YOU STUCK WITH FOR YEARS THAT STILL WORKS FOR YOU TODAY?

Creating beautiful spaces for people to live their lives.

WHO OR WHAT HAS BEEN THE BIGGEST INFLUENCE ON YOUR CAREER?

Working at Herman Miller as part of the sales force selling their deeply rooted Design Culture. After all, our stock-in-trade in the business of design, is selling our creative ideas.

WHAT IS THE MOST BEAUTIFUL HOME YOU HAVE SEEN IN PHILADELPHIA AND WHY?

The barn renovation we did in Gladwyne. The true success of this project was the result of a well formed team and the undying trust of the client.

WHAT IS THE SINGLE THING YOU WOULD DO TO BRING A DULL HOUSE TO LIFE?

Color. The cohesiveness of a home's color palette is extremely important. All fabrics and finishes should look like they belong to the same house.

Michael Shannon Designs
Michael Shannon
1315 Walnut Street
Philadelphia, PA 19107
215.717.1094
www.michaelshannondesigns.com

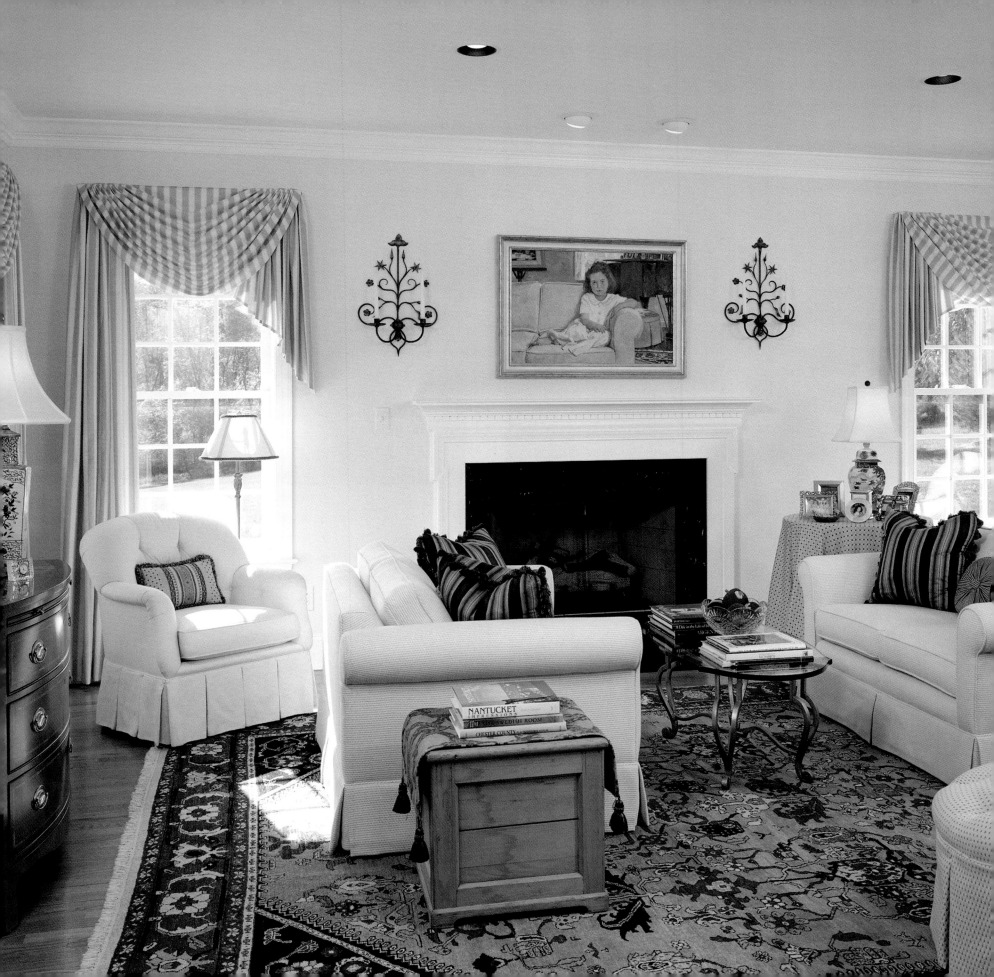

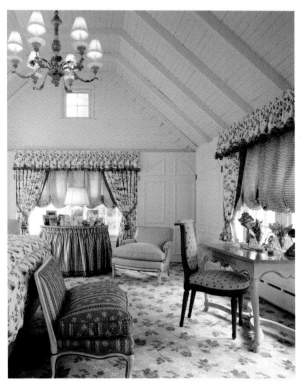

ABOVE
High, vaulted ceiling, gilded chandelier and French silk taffeta add grandeur to this master bedroom.

LEFT
Afternoon sun drenches this living room, where neutral upholstery is highlighted with jewel-tones in the accessories and fine oriental carpet.

For over 21 years, Sam Simkins has been bringing both residential and commercial interiors to light! With a client base that stretches from Boston to the Virgin Islands, Sam maintains offices in both Philadelphia and Palm Beach so he can be close to the project at hand. Through his specialization in lighting design, Sam started Prism Tech Design in 1984 and brings his understanding of interior space and light to each of his commercial projects. He transitioned into the field of residential interiors in 1990 and opened Estate Interiors LLC, one of Philadelphia's first design/build firms. The Simkins signature is his acute attention to detail and his daily hands-on involvement, which is carried out by the firm's credence in the design/build process. It may be another way of saying control, but this designer does not leave his designs to the misinterpretation of others. Through the design/build approach, Sam's team of Old-World craftsmen and artisans execute every phase of the project; from initial inspiration through final installation. Seeing his designs through to completion gives Sam the greatest satisfaction. While always listening to his client's personal tastes and desires, his style is fresh and uncluttered, yet never minimal. He believes that form-follows-function and brings his architectural acumen, expert craftsmanship and design experience in order to achieve his client's objectives. You'd be hard-pressed

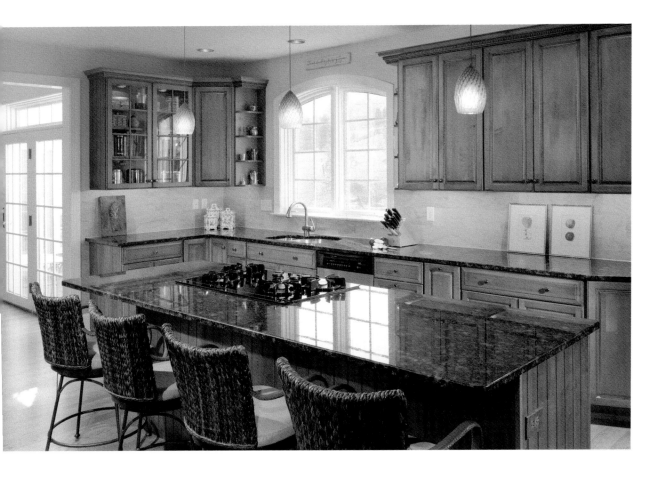

to find anything in one of his interiors that just doesn't make sense. Everything should have a purpose, and too much of one thing is just plain redundant. Sam uses his prowess in lighting design to illuminate everything from clients' specific art collections and treasures to adding highlights and drama to his overall interiors.

His personal influences stem from his passion for travel and experiencing different cultures, along with his study of architecture and photography. By attending international design and furniture shows, he immerses himself with the latest design trends and technologies and challenges himself in order to bring a fresh, new look to his designs. Sam provides the highest level of interior design excellence and professionalism throughout his work and prides himself on his ability to adapt to his different clients' tastes and styles. Through the design/build approach, Sam directly controls the detailed design process so that his client's design experience is completed correctly the first time, in a timely fashion, and on budget.

TOP LEFT
The large granite island is a great gathering spot in this country kitchen with glazed maple cabinetry, hardwood floors and French limestone back splash.

BOTTOM LEFT
This sleek kitchen features professional stainless steel appliances and granite counter tops.

More About Sam

WHAT IS THE HIGHEST COMPLIMENT YOU EVER RECEIVED?

Hearing that I have exceeded my clients' expectations.

WHAT ONE ELEMENT OF STYLE OR PHILOSOPHY HAVE YOU STUCK WITH FOR YEARS THAT STILL WORK FOR YOU TODAY?

The design/build approach to interior spaces.

IF YOU COULD ELIMINATE ONE DESIGN FROM THE WORLD, WHAT WOULD IT BE?

Faux. You will never see anything unnatural in my spaces.

WHAT IS THE SINGLE THING YOU WOULD DO TO BRING A DULL HOUSE TO LIFE?

Because of my background in lighting design, it is key to properly illuminate the space.

WHAT COLOR BEST DESCRIBES YOU AND WHY?

Lapis blue because it is a crisp, clean color that is cool, yet professional and still cutting edge.

Estate Interiors LLC
Sam Simkins
1214 Locust Street
Philadelphia, PA 19107
215.985.4586
www.EstateInteriorsLLC.com

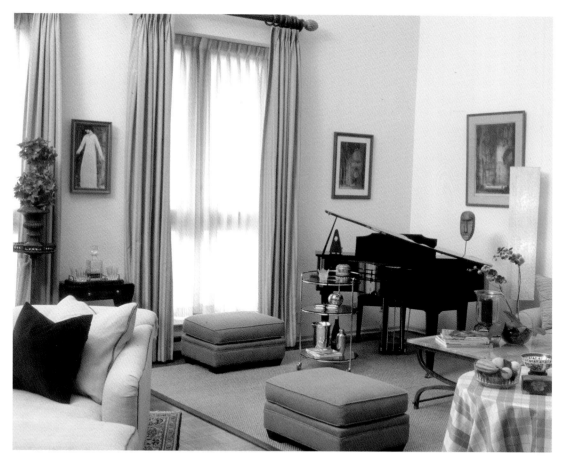

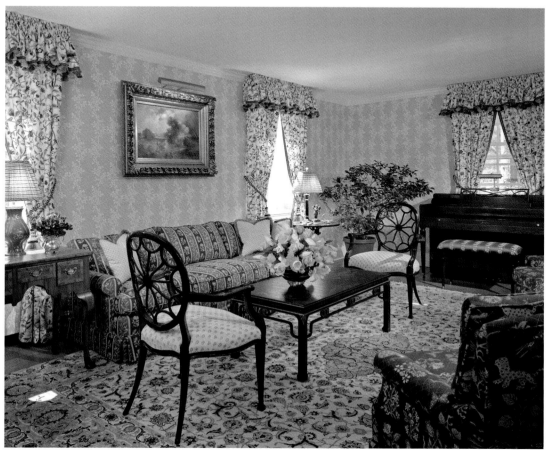

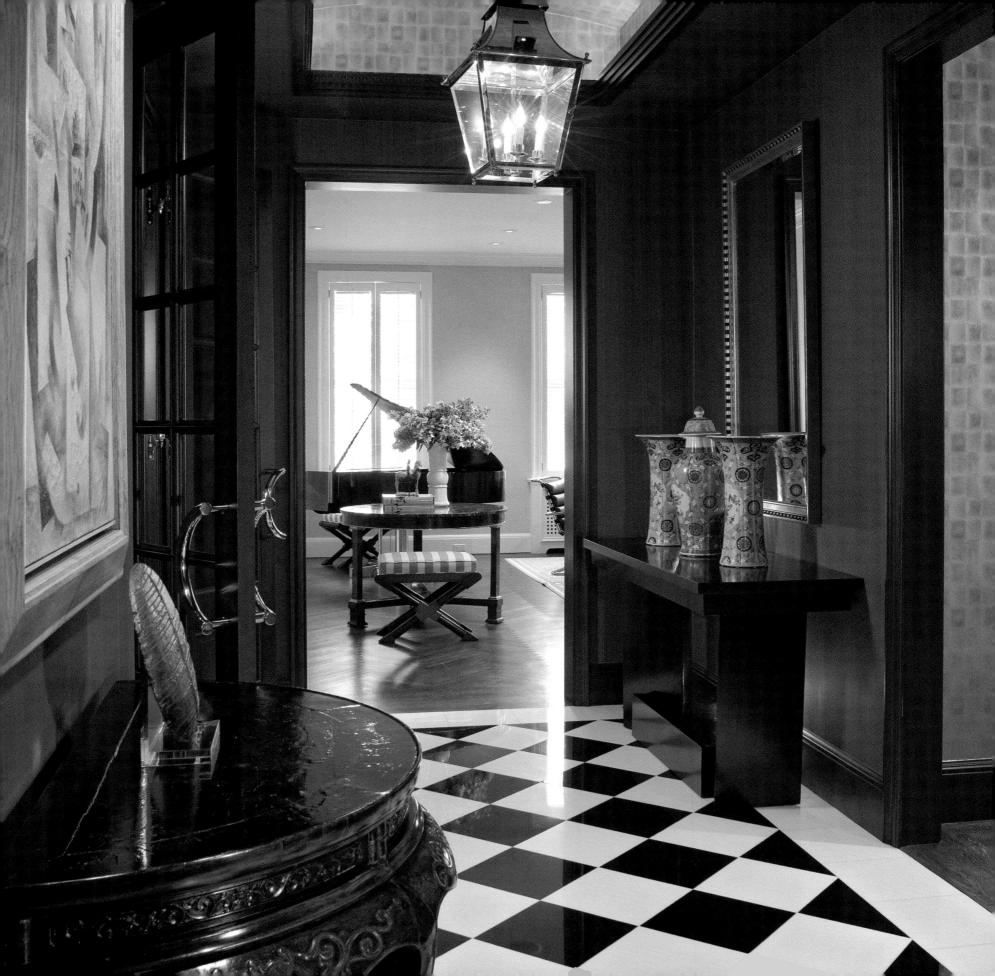

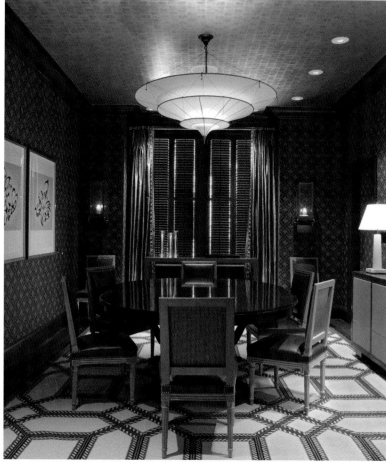

Dining room consisting of fabric covered walls, Fortuny light fixture, silver leaf ceiling. Mixture of contemporary, Art Deco and Louis XVI chairs with handmade needlepoint rug. Residence of Mr. and Mrs. Howard Needleman.

Gallery of sophisticated Rittenhouse Square dwelling with combination of contemporary and antique Chinese furnishings. Classic black and white marble floor. Residence of Mr. and Mrs. Howard Needleman.

A s a young student at the University of the Arts, Carl Steele would finish his projects early, using the extra time to wander through The Philadelphia Museum of Art. Decades later, no matter where Carl is, he still loves to roam museums and galleries, taking in some exhibits several times to continue to train his eye. He calls the time he has spent in museums his greatest career influence.

Carl's Pine Street office is a mixture of sleek, yet classic furniture, and modern art with quiet monochromatic pagoda print wallpaper as the go-between. It is comfortable enough not to be studied, yet still very sophisticated.

Ask any designer in Philadelphia whom they admire, and Carl's name is most mentioned. Dressed in a crisp striped shirt with horn glasses, he is as elegant as he is inviting. He asks for a minute to call a client and go over project progress with his assistant Mary, one of three full-time employees of the firm. When he is done and he starts to talk about his career, he stresses the importance of talent, but underscores professionalism. Jonathon Bassman, his principal associate, is an important asset and has been so for 15 years, and Mary Dupre completes the team.

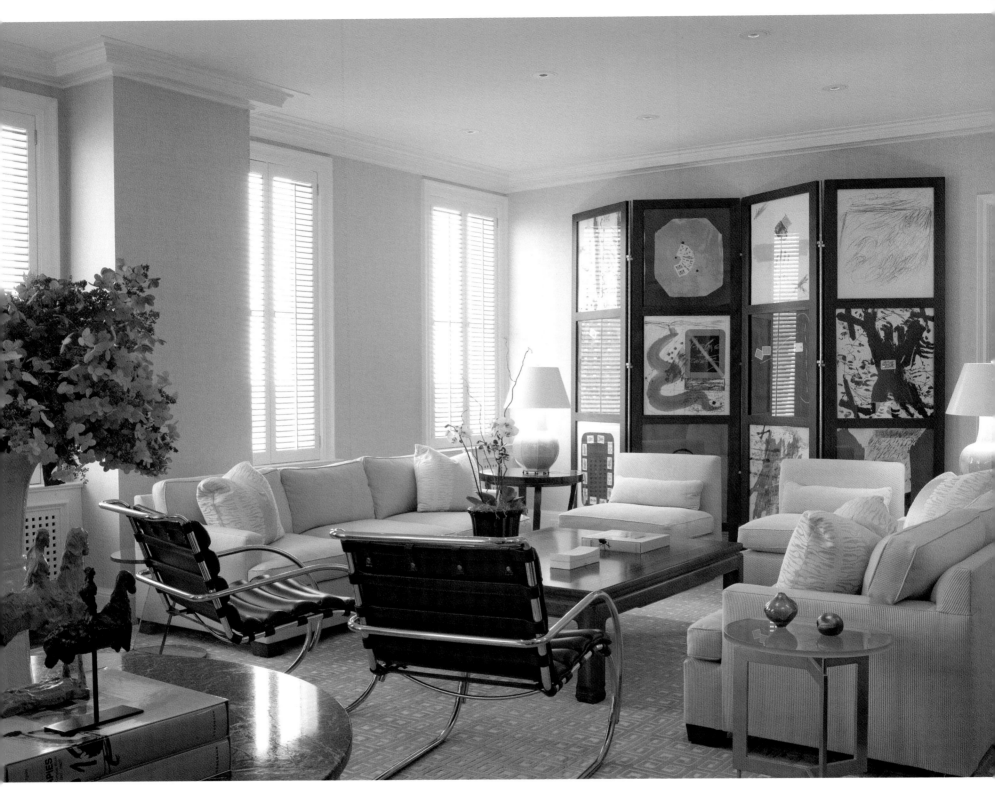

ABOVE
Large, spacious light filled living with Anton Tapies original colored collage prints mounted on a screen to create focal point. Furnishings include classic Mies van der Rohe chairs, mostly contemporary furniture with several pieces of Art Deco and French antiques.
Residence of Mr. and Mrs. Howard Needleman.

RIGHT
Library with coral fabric covered walls, contemporary Chinese needlepoint rug, Le Corbusier leather chairs and leather covered card table. Motherwell print above sofa.
Residence of Mr. and Mrs. Howard Needleman.

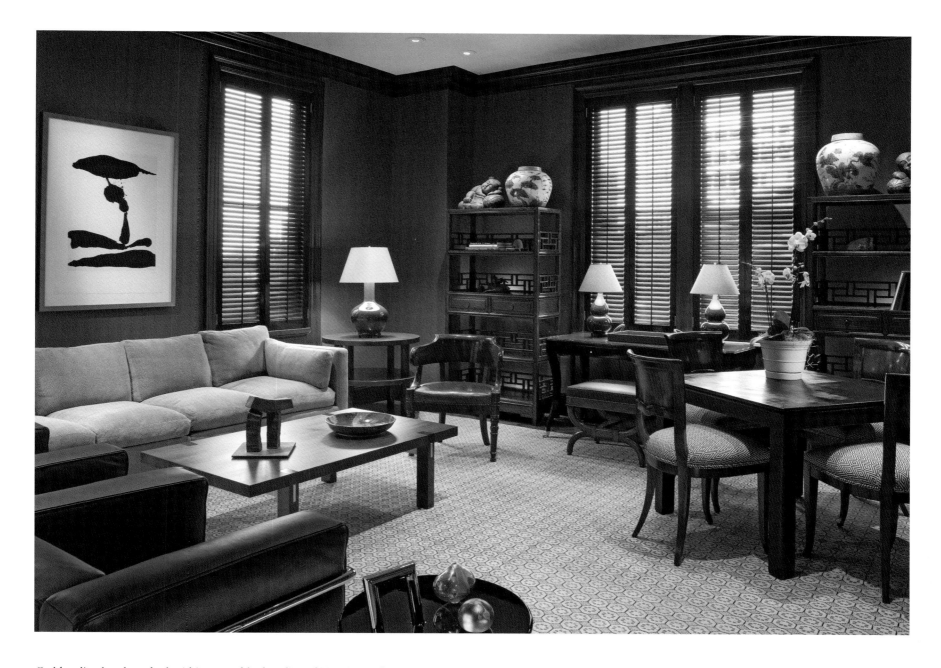

Carl has lived and worked within a two-block radius of Pine Street for many years and keeps an apartment in New York, which he visits monthly to take in art exhibitions and openings and to shop for clients. His work has won him national acclaim on the pages of *The New York Times, House Beautiful, House & Garden, Town & Country*'s Top Designer's issue, *Beautiful Interiors* and locally for *Philadelphia Magazine*. Paging through his portfolio, you see how his career has evolved. When he first opened his business, almost all of his work was contemporary. He shows off one impressive home featuring a high-ceiling room with Mies van der Rohe furniture and wonderful modern art on the walls. It looks like a spread from a magazine today. In the last 15 years, Steele has done more traditional interiors because of the demand for them, but now he is seeing the pendulum swing back to contemporary. Some of his clients are the third generation with him. Ironically, if the parents had a contemporary home, the offspring opts for traditional.

His ideal client is one that is secure—who knows about quality furnishings and is sophisticated about art. His out-of-town projects have taken him from Manhattan

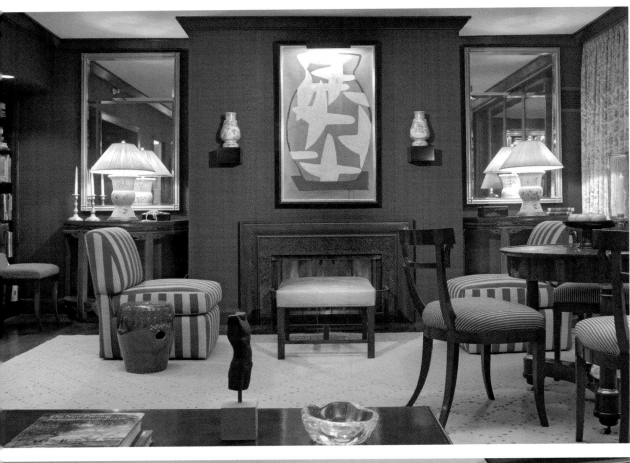

to Maine and Florida to East Hampton, and to Europe, while he has worked on many an apartment on Rittenhouse Square, and homes in the Philadelphia suburbs. Carl first meets with clients, does detailed floor plans and color schemes, then inventories what they have and takes them to New York to begin shopping. He keeps a large inventory of art or goes to galleries here and in Manhattan to help with a collection. Carl believes if there is nothing on the walls that is appealing, a room falls flat.

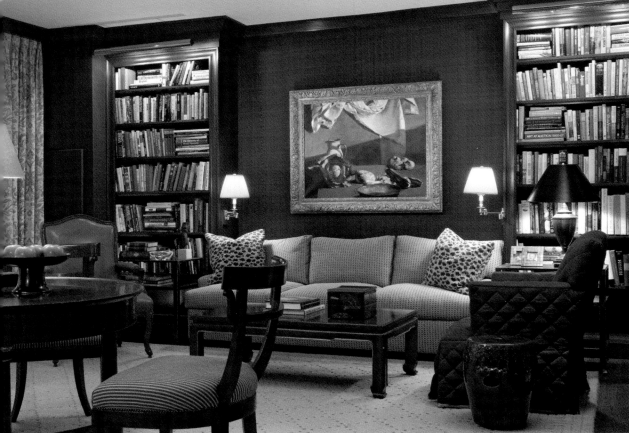

TOP LEFT
Center City Rittenhouse Square area condominium high above Rittenhouse Square. This is a guest apartment connected to a much larger apartment. Eighteenth century Chinese demilune tables, William Willis painting over the fireplace is a tribute to Georges Barque. Fine porcelain vases, mainly contemporary furniture with a few French and continental antiques.

BOTTOM LEFT
Same room as above with Walter Stumpfig painting over sofa.

FACING PAGE LEFT
Large Rittenhouse Square apartment, one of few remaining with original ballroom as part of the original apartment. Fabric covered walls with some 18th and 19th century English, French and Chinese antiques.

FACING PAGE RIGHT
Eighteenth century Viennese angels, chairs hand-painted with nude figures in very large sunroom.

FACING PAGE SMALL PHOTO
Classic contemporary living room using all Mies van der Rohe furniture with painting by Elaine Kurtz. Well executed contemporary design by Joel Levinson, architect for this project.

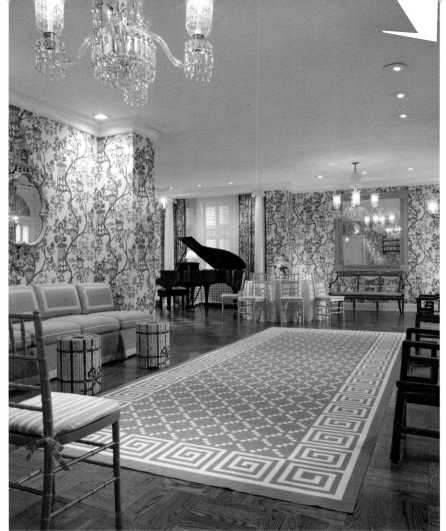

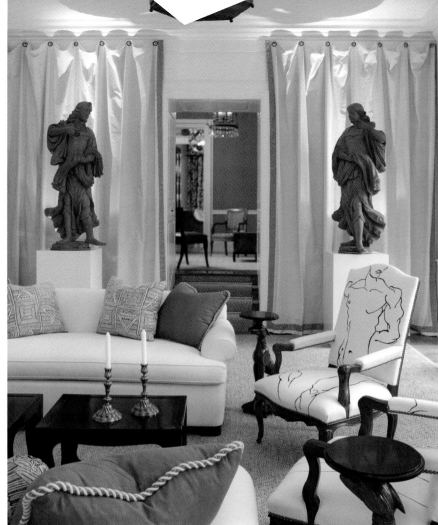

More About Carl

HOW LONG HAVE YOU BEEN AN INTERIOR DESIGNER?

Forty years.

ANY SCHOOLING, ACCREDITATIONS OR ASSOCIATION MEMBERSHIPS YOU WANT MENTIONED?

University of the Arts, Philadelphia, Pennsylvania. ASID

WHAT SEPARATES YOU FROM THE COMPETITION?

Years of experience.

DESCRIBE YOUR STYLE OR DESIGN PREFERENCE.

Suitable for a particular job or client. Ranges from very contemporary to very traditional.

Carl Steele & Associates
Carl Steele, ASID
1601 Pine Street
Philadelphia, PA 19103
215.546.5530
FAX 215.546.1571
www.carlsteele.com

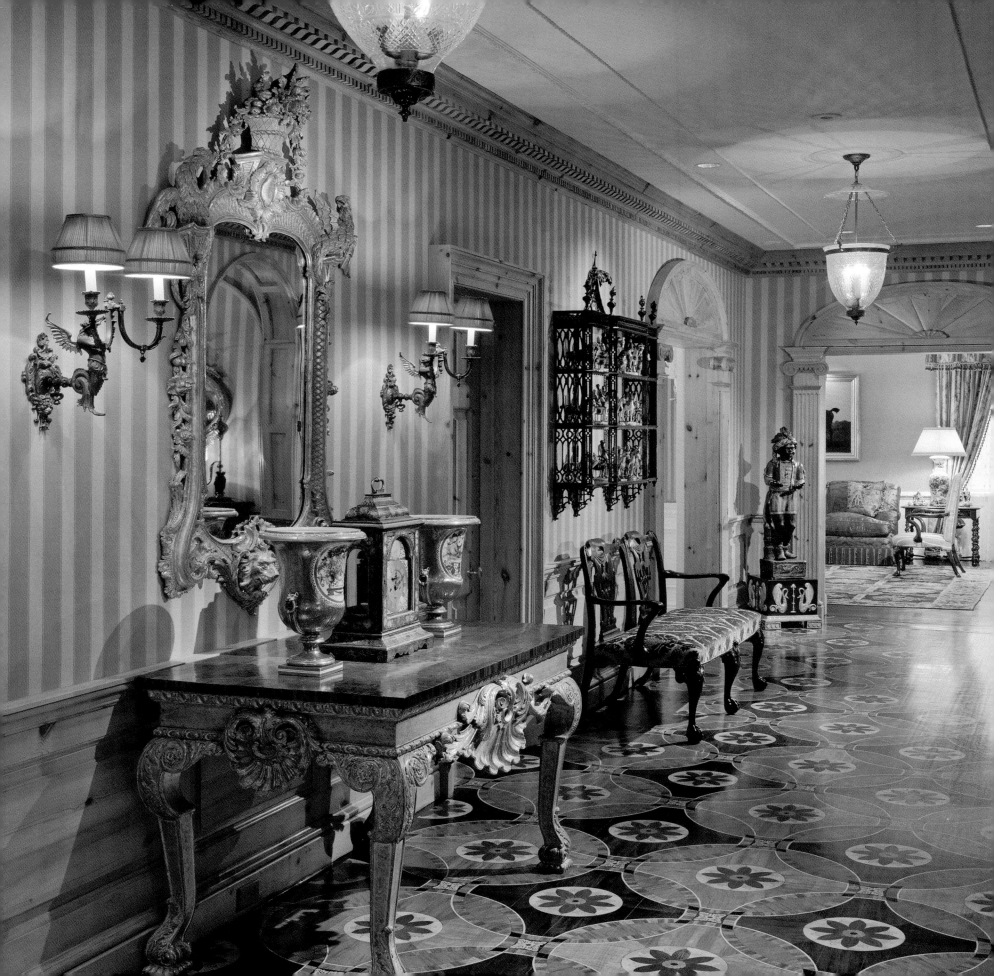

BENNETT & JUDIE WEINSTOCK

Bennett Weinstock has just returned to Center City from his weekend home in Longport, New Jersey offering guests his favorite indulgence: cinnamon buns. Even in his most casual moments, Bennett is the picture of elegance—pale orange cashmere sweater, cream linen slacks, handmade loafers and signature horn glasses. Bennett's beloved Longport Victorian, The Quilted Cottage, is one of three grand homes he maintains with his wife of 41 years, and business partner for 26 of them, Judie. She is a collector of antique quilts, won an award for one of her own designs, and so the pair aptly ran with the whimsical theme for their beach house, even painting floors to mimic quilt patterns. The house makes you smile, Bennett explains simply.

But the couple's primary residence on Rittenhouse Square is a more noble domain, a testament to their love for all things English country. It is their portfolio of sorts. After 22 years in a brownstone on Delancey Street, they moved to the infamous Barclay three years ago when the hotel went condo, snapping up three apartments and making them into one manor house in the sky. To make it so, they brought in antique English pine for one room, which took four men two weeks to craft the built-ins which house their Staffordshire tea ware, had the walls upholstered in the finest fabrics and fashioned ceilings

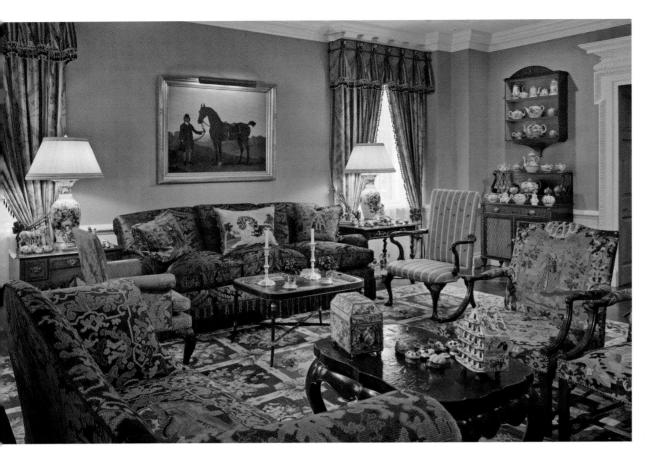

out of French tooled leather. Where there was no wood on the elevator, he had a painter make it appear to match the antique. There is special museum lighting for certain paintings, an all-silver sink they have polished daily and a dressing room that rivals the late fashion designer Bill Blass' with shoes and suits lined up like The Met's Costume Institute's library. The entrance foyer off the elevator is done in bold green and yellow awning stripe, better to show off the impressive oils of hunting dogs that line the walls. Oils of the equines are in the library. The main foyer floor is faux bois to mimic Catherine the Great's inlaid floor in her bedroom of L'Hermitage. Each detail and piece has a story that Bennett is glad to share. A tour of this spread is a history lesson in and of itself.

Bennett's high style calling came by way of a career in law. His father wanted a lawyer or doctor in the family and after 13 years of practicing he had an epiphany at 40. Friends always appreciated Bennett and Judie's taste so they helped friends decorate as a hobby.

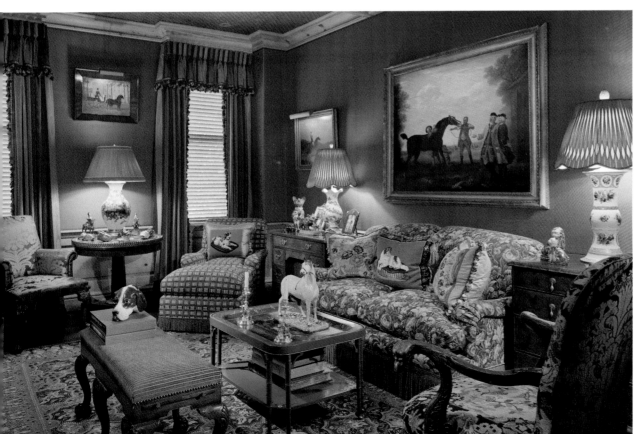

TOP LEFT
Living room: Our romance and passion with color abounds in this living room grounded on 18th century English needlework rug, English sporting art and tea ware.

BOTTOM LEFT
Library: 18th century pine panelling, tooled and embossed leather ceiling, English sporting art and English pottery.

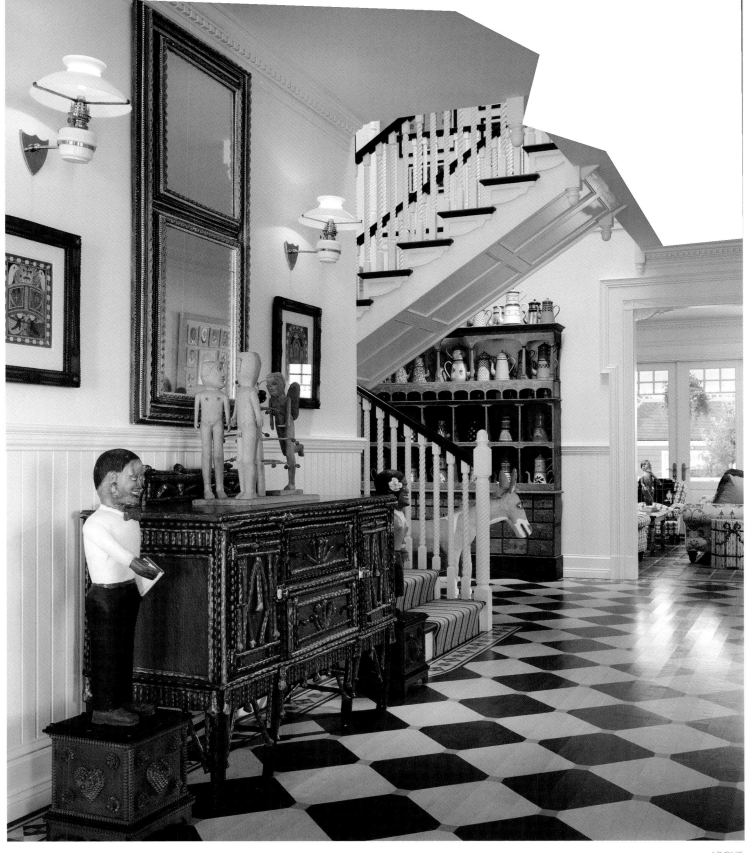

English Gallery to "Quilted Cottage" at the Jersey's Shore painted floors and quilt pattern collection of folk art and 20th Century Outsider art.

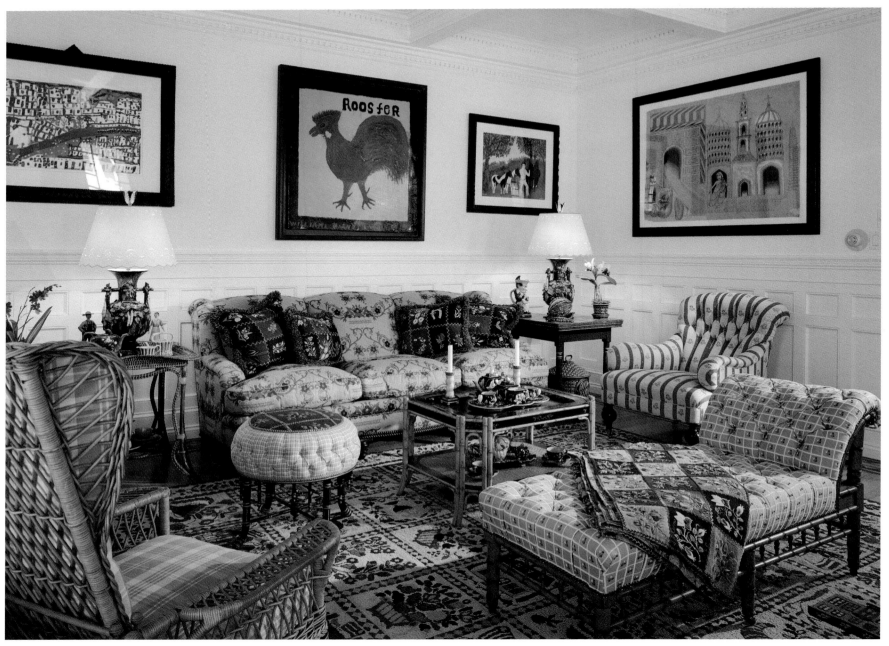

It was Judie who urged her husband to make the change to something he never calls work. His stylish mother instilled in him a fashion sense and a joie de vivre friends always admired. He recalls, with a laugh, the black convertible his mother bought for his 16th birthday. She instructed him to drive only when wearing a color coordinated jacket and tie.

Bennett's other career influence has been Judie and vice versa. Known for their profuse use of color and pattern, they mix it up with the zeal of iron chefs. Send them into the same showroom or store at different times,

and they will come out with the same selections. When a client is unsure that a cacophony of swatches and paint chips will work, Bennett issues a calming declarative: Trust me, it will. And they do, and it does. For their homes, the Weinstocks have won praise with their editorials in *The New York Times, House Beautiful,* and *Architectural Digest*'s special issue on 100 top designers.

Their design edict has always been to create a background for a client and personalize it by collecting. Both of their parents did and this duo

has an affinity for 18th century needlework and Staffordshire pottery.

Bennett insists you can never walk into a room he and Judie have done and date it; yet, clients and their children will call up to do additional homes or update ones they have already decorated for them. Their current roster includes several houses out on Philadelphia's Main Line, two in the Hamptons, one in Palm Beach and three in Manhattan, a place where he and Judie visit every week, where they have their third home. New York is where they shop for antiques and resource for their clients, most of whom are friends.

Not long ago, one customer-turned-friend told him in a toast at a dinner party that Bennett not only decorated his home, but his life.

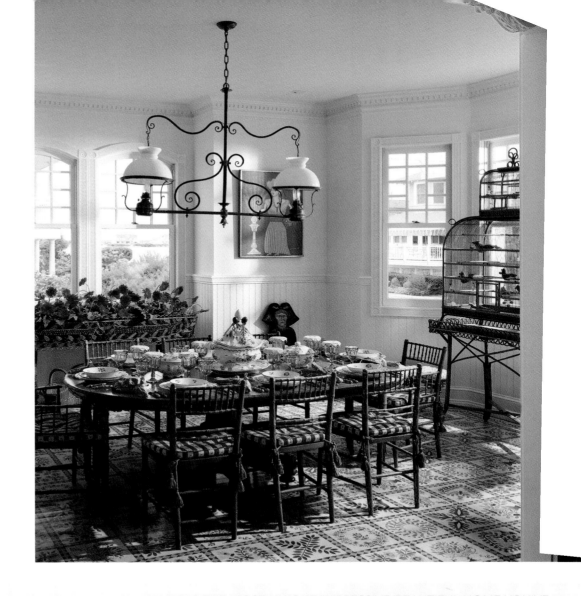

RIGHT
Dining room at the beach house. Painted album quilt on floor 19th century faux bamboo table and chairs and Outsider Art. Table set with 19th century Faince China.

More About Bennett & Judie

WHAT IS THE BEST PART OF BEING AN INTERIOR DESIGNER?

Making wonderful friends and finding homes for the pieces we love.

WHAT ONE ELEMENT OF STYLE OR PHILOSOPHY HAVE YOU STUCK WITH FOR YEARS THAT STILL WORKS FOR YOU TODAY?

Never compromise and do something you will not be proud of.

WHAT IS A SINGLE THING YOU WOULD DO TO BRING A DULL HOUSE TO LIFE?

Strategically place fresh flowers, shelves of books and arrange collectables.

WHAT IS THE MOST UNIQUE/IMPRESSIVE/BEAUTIFUL HOME YOU'VE BEEN INVOLVED WITH? WHY?

Our own home because we made no compromises.

WHAT IS THE HIGHEST COMPLIMENT YOU'VE RECEIVED PROFESSIONALLY?

You decorated my home—but more importantly you decorated my life.

WHO HAS HAD THE BIGGEST INFLUENCE ON YOUR CAREER?

My wife, who always encouraged me to follow my dream.

Bennett & Judie Weinstock Interiors
Bennett Weinstock
Judie Weinstock
The Barclay
237 S. 18th Street
Philadelphia, PA 19103
215.735.2026

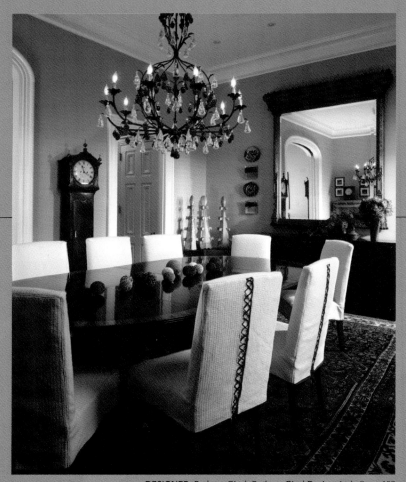

DESIGNER: Barbara Gisel, Barbara Gisel Design, Ltd., Page 139

GREATER PHILADELPHIA

AN EXCLUSIVE SHOWCASE OF PHILADELPHIA'S FINEST DESIGNERS

JOSEPH A. BERKOWITZ

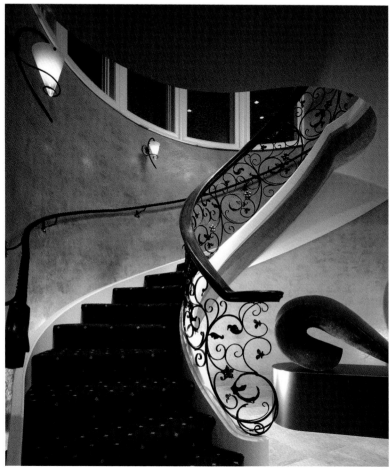

ABOVE
This custom staircase flows away from the wall, allowing carefully hidden lighting to flood the venetian plaster.

LEFT
This Turkish entry parlor sets the tone for a unique beach home with custom banquettes and mosaic glass back chair.

J oe Berkowitz knows the business of Interior Design—it's about personality and he's got that in spades. He loves the people he meets, that each project is a chance to do something new and traveling to new locations to design homes. This designer has an amazing sense of cool even though he juggles 50 jobs at one time, logging in more hours during a week than most surgeons, but enjoying every minute. In 27 years, he has always worked for himself, and he relies on his staff to keep each project running with precision.

The challenge is not in keeping all of the balls in the air, but never repeating yourself, he'll tell you. A tireless researcher, he will always give each client something new. No two will get the same fabrics or furniture.

Joe's own style is eclectic, but he is skilled in doing Country French to high-end contemporary and everything in between. He's done retro Hollywood to Tuscan, but he'll never give you trendy. He wants the home he designs for you to be timeless. Skilled at reading clients quickly, he can figure out in a flash whether they are conservative or if they will push the envelope a little. The affable designer gives them what they want—never what he wants—but always encourages clients to be bold,

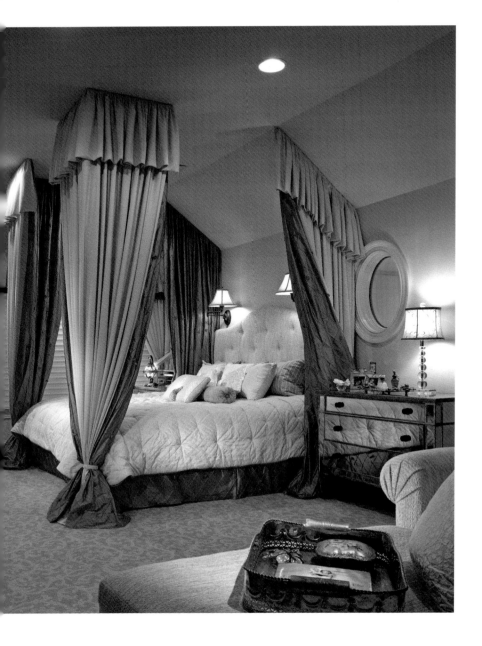

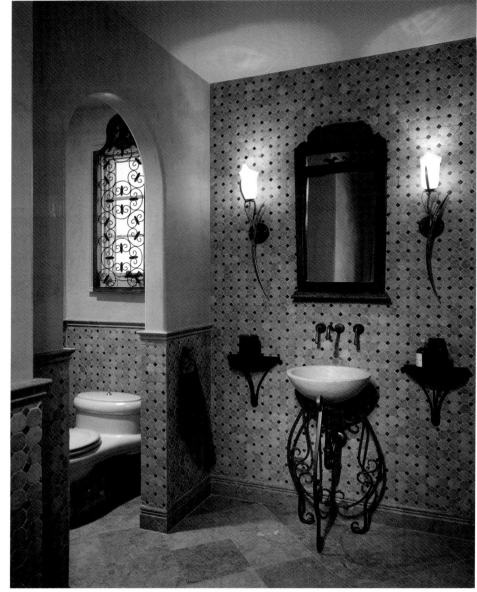

take risks and do something different. He'll put antique Tibetan columns in a dining room, and favors an interesting artifact over a console table versus the predictable painting.

Current projects include a Mediterranean home in West Palm Beach, a Penthouse Apartment in Boca Raton, a two-story apartment in Manhattan, as well as a Federal style home in Brooklyn.

Joe studied architecture a Temple University, and went on to study Interior Design at Philadelphia College of Art.

His work has been published in *Philadelphia Magazine, Philadelphia Style,* as Kips Bay, as well as *Aspen* and *Boca* magazine.

ABOVE LEFT
A dramatic solution to an awkward ceiling. This accomplished designer was able to create the perfect setting for clients who love to read in bed.

ABOVE RIGHT
Mediterranean influenced powder room. The designer added details such as arched wall, floor to ceiling tile, plaster walls, Iron panel over window, marble chair rail and baseboard.

FACING PAGE TOP
"Don't be afraid of color or scale" says Berkowitz, who clearly is not. "We had to frame this 8" x 13" painting in the room."

FACING PAGE BOTTOM
Authentic English library with custom coffered ceiling, upholstered walls and fine antique leather ottoman.

More About Joseph

WHO HAS BEEN THE BIGGEST INFLUENCE ON YOUR CAREER?

I have always been very self motivated, although my mother is a professional painter, sculptor, potter and plays the violin, and my father was an incredible businessman.

IF YOU COULD ELIMINATE ONE STYLE OR DESIGN TECHNIQUE FROM THE WORLD, WHAT WOULD IT BE?

Anything done poorly or unexciting.

WHAT IS THE BEST PART ABOUT BEING AN INTERIOR DESIGNER?

I get to travel. I enjoy meeting people and I get to start over every time. I don't mind the hours. I meet contractors early in the morning and clients throughout the day into the evening.

WHAT IS A PERSONAL INDULGENCE THAT YOU SPEND MONEY ON?

Clothing and cars and my children.

WHAT COLOR DESCRIBES YOU AND WHY?

I couldn't pick one that describes me. I change a lot.

WHAT HAS BEEN THE MOST EXPENSIVE OR UNUSUAL TECHNIQUE YOU HAVE USED IN A HOME?

A Mediterranean inspired house with nine rooms of tile. The client spent more money on tile than most clients do on their entire home. The result was spectacular.

Joseph A. Berkowitz Interiors, Inc.
Joseph A. Berkowitz, ASID Allied Member
1620 Gerson Drive
Penn Valley, PA 19072
610.949.0487
FAX 610.949.9078
www.jabinteriors.com

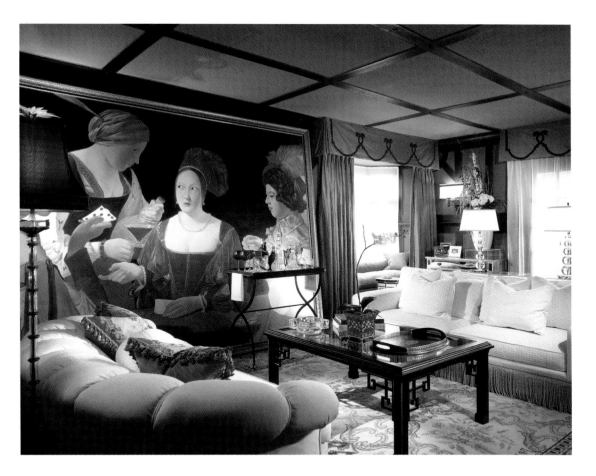

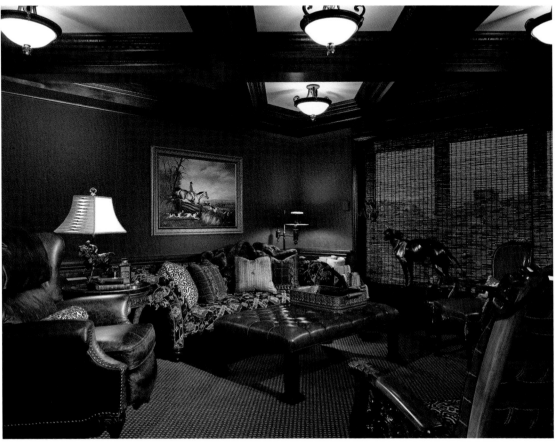

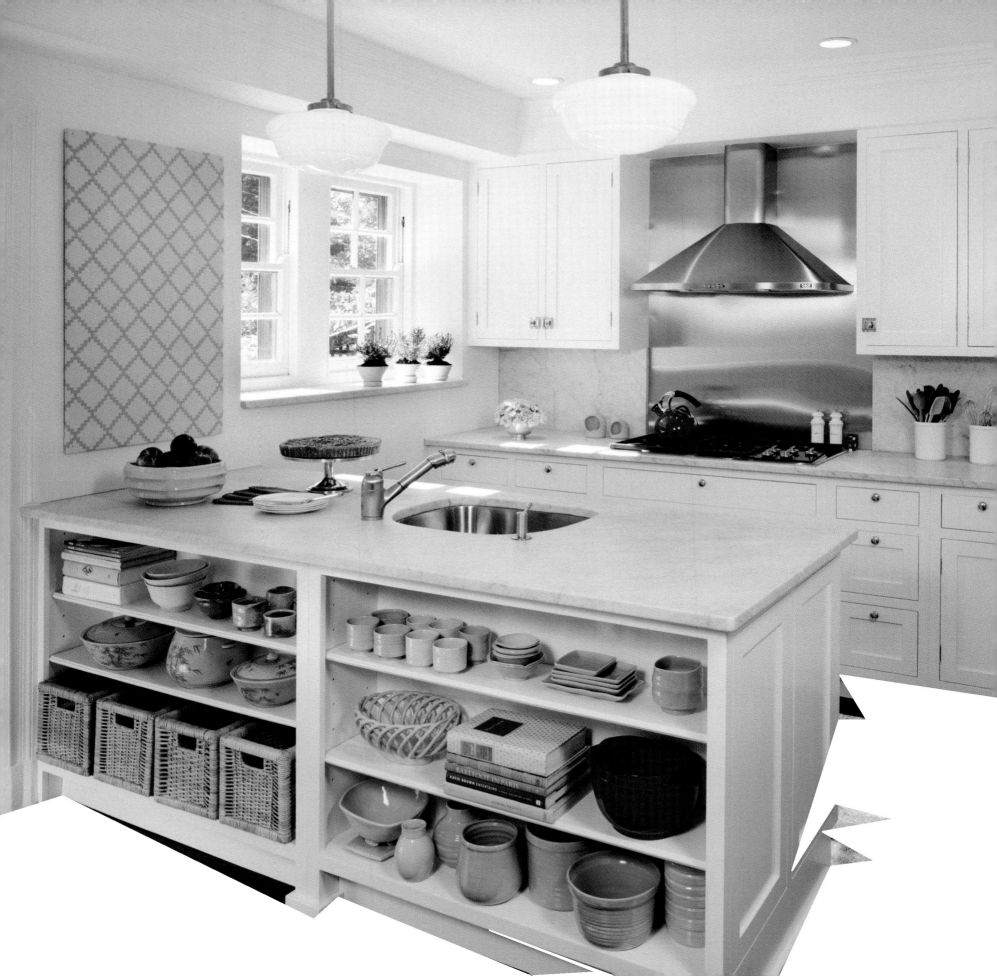

MONA ROSS BERMAN
& KATE CLEVELAND

MONA ROSS BERMAN INTERIORS & KATE CLEVELAND ARCHITECT

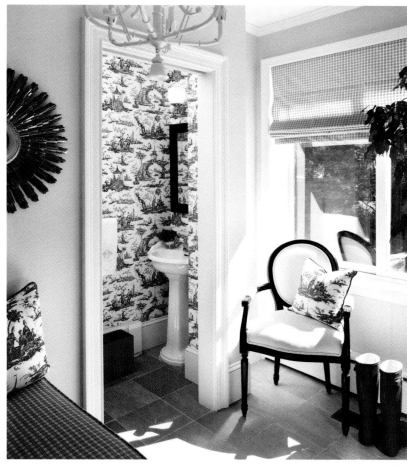

Mona Ross Berman had an epiphany in her DC law office when she fixated on an office redo with the stipend she'd get from making partner. A graduate of Brown University and Georgetown Law, Mona dropped law, apprenticed at Caldwell-Beebe Interiors, and in 2004, opened her own firm with clients that included TV personalities, politicos, and Georgetown socialites. She moved to her husband's native Philadelphia in 2005 and took on a museum district renovation and a Rittenhouse Square re-do right away. The local press quickly lauded her fresh preppy chic style in her first designer showhouse, a Kenneth Noland-inspired "lady office" at the DogHaus in Chestnut Hill last year. Mona is most proud of creating rooms that are timeless, livable, beautiful and personal.

Kate Cleveland didn't enter architecture school until her late 20s, but was quickly noticed by her professor Cecil Baker. He asked her to come to fill in for a few weeks at his firm. She stayed five years, receiving her design foundation and training.

While her institutional work won awards at Cecil Baker & Associates and Susan Maxman and Partners, in 1992 Kate opened her own firm, specializing in residential design. A patient listener, she climbs into clients' heads to see how they live and translates their needs into an aesthetic that doesn't mimic, but looks like it belongs. Clients span from the Philadelphia area to London, England. A longtime resident of historic Chestnut Hill, she often makes smaller, period kitchens in the area's older homes more spacious, light filled and functional. And, like her mentor, Baker, she teaches architecture part-time at Temple University.

Mona Ross Berman Interiors
112 W. Springfield Ave.
Philadelphia, PA 19118
215.680.7200
www.monarossberman.com

Kate Cleveland Architect
8011 Crefeld Street
Philadelphia, PA 19118
215.242.1702

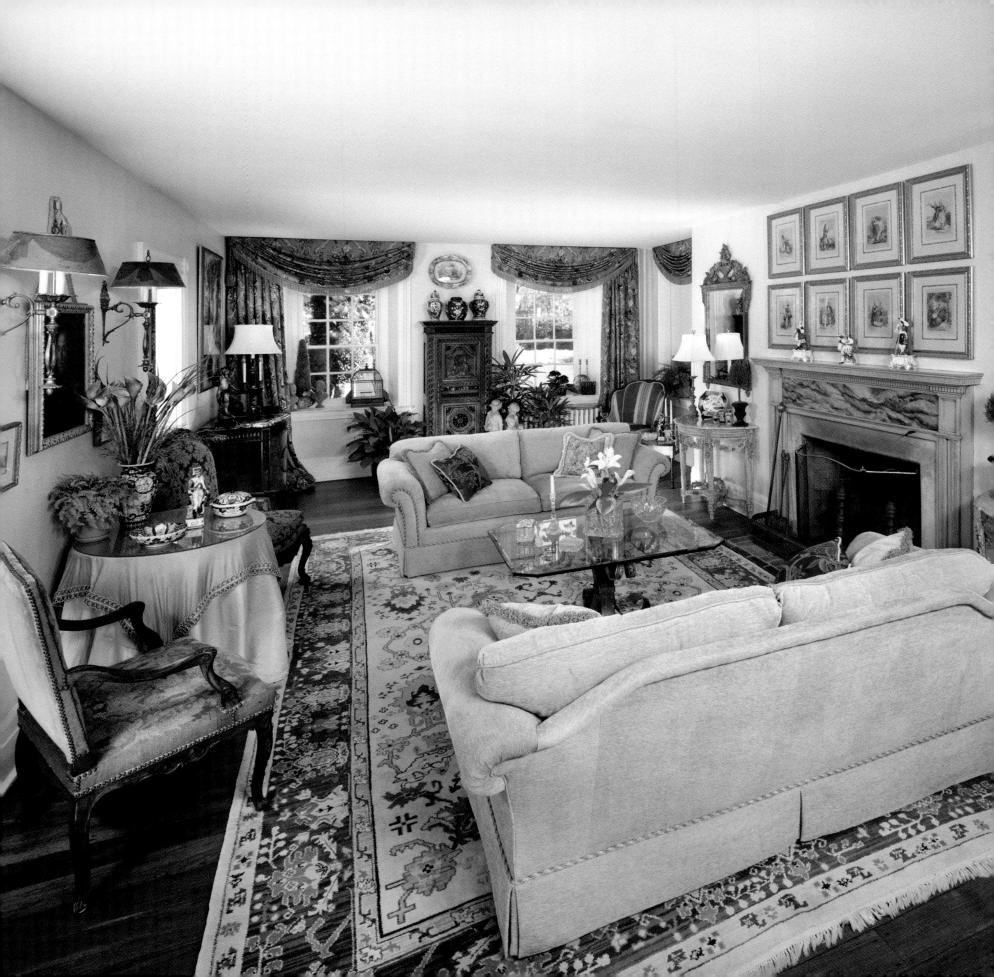

DEBORAH CRAFT

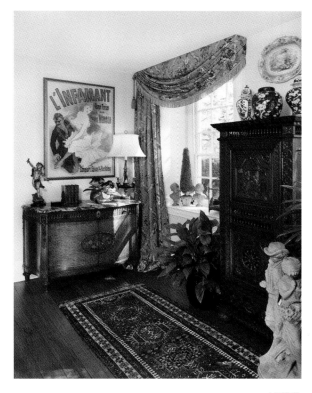

The client has an affinity for French antiques. A formal chest is dressed down with an antique poster and garden pieces.

LEFT
This 18th century farmhouse has gorgeous views, and faces a stream in Chester County, Pennsylvania. The goal was to combine French antiques with family comfort and warmth.

For years, Deborah Craft's phone number was unpublished, but the phones still rang. When she hit her 30-year mark in business recently, she only realized it when vendors sent congratulatory letters. Deborah is not coy or absent-minded. She has thrown herself so much into the business that she has never counted the years.

Deborah grew up in a creative home. Her mother was the original do-it-yourselfer, cutting legs down on an old Victorian table and painting it for use as a coffee table. Craft studied fine art and design at Moore College of Art and Design and continued her studies at the Pennsylvania Academy of Fine Arts. After college, she painted murals before embarking into commercial design, opening her own firm. Her focus is on residential. She prefers it for the human contact. She is the sole designer and her daughter, Pamela, is her business manager.

A member of IFDA and IIDA, Deborah's signature style is classical with a twist. She is able to get into the client's head and find out who they are

before she designs a home. A current project is a home for a well-loved Philadelphia sports figure. Another home in Phoenixville, Pennsylvania, which sits on the Pickering Creek, is a mix of periods and antiques that is both elegant and comfortable.

A vast amount of her business is the creation of vacation homes. Deborah likes to live vicariously through these clients, who take her outside of her mainstay of the Main Line and into more playful lands—Park City, Utah, California, Cape Cod, the Jersey Shore and the Pennsylvania Poconos. Right now she is helping rebuild two hurricane-stricken homes in Florida. Her approach to the vacation home is much lighter and freer, she explains.

Deborah talks about picking up the paint brush again someday when she is finished designing, but then she hasn't tired at all of the canvas called the home.

TOP LEFT
A simple dramatic look was called for to incorporate pieces collected by the clients while living in Asia.

BOTTOM LEFT
Although a second home in Florida, an air of permanency was desired. Above the fireplace is a custom-designed tile mural. The coffee table is from an old hotel in Paris.

TOP RIGHT
This formal room adjoins a music area. Dramatic color was combined with Asian family pieces to create an eclectic look. The architect is John Milner.

BOTTOM RIGHT
This dining room was designed to take advantage of beautiful views. A balcony was added and a handwoven treillage gives a year-round garden atmosphere.

More About Deborah

WHAT IS THE HIGHEST COMPLIMENT YOU HAVE RECEIVED?

People say I have no one signature style. I did two houses on John's Island in Vero Beach, Florida, and they are totally different.

WHAT ONE ELEMENT OF STYLE OR PHILOSOPHY HAVE YOU STUCK WITH FOR YEARS THAT STILL WORKS FOR YOU TODAY?

Classical with an eclectic touch, but not too trendy. Most of my clients can afford nice things but do not get rid of anything on a regular basis because they like to invest in fine pieces.

WHAT PERSONAL INDULGENCE DO YOU SPEND THE MOST MONEY ON?

Travel. I just got back from Russia. I love Italy. I loved Ireland, which is just sparkling and booming right now. Travel has added depth to my creativity.

WHAT IS THE BEST PART OF BEING AN INTERIOR DESIGNER?

I have really enjoyed working with my clients and seeing how creative change can positively affect their lives. My business is word of mouth. I have nice clients, and nice people have nice friends. It has been personally very fulfilling.

WHY DO YOU LIKE DOING BUSINESS IN PHILADELPHIA?

I love the city and its architecture. We have fabulous sources and artisans and great access to quality products and vendors. The Philadelphia area also has a cosmopolitan and sophisticated clientele.

Deborah Craft Interiors
Deborah Craft
474 Nob Hill Lane
Devon, PA 19333
610.687.5681

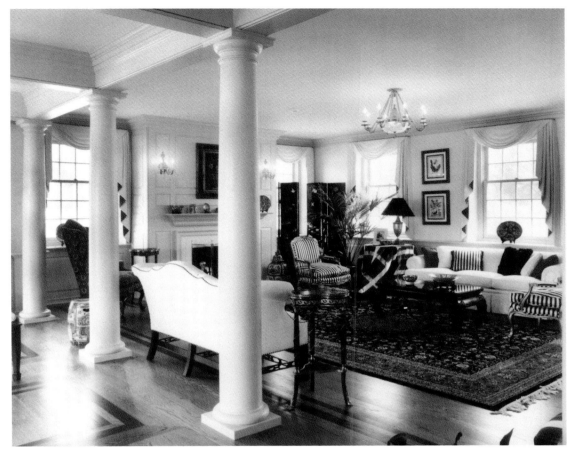

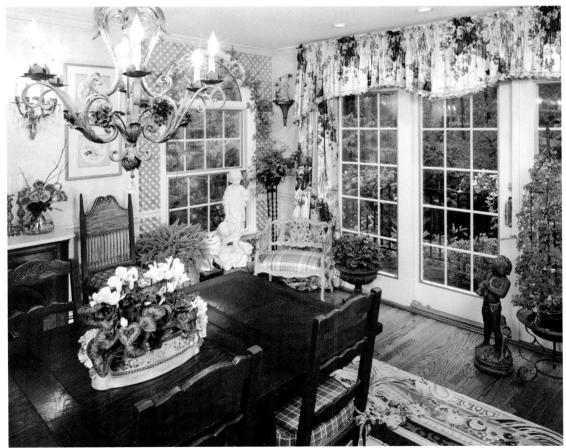

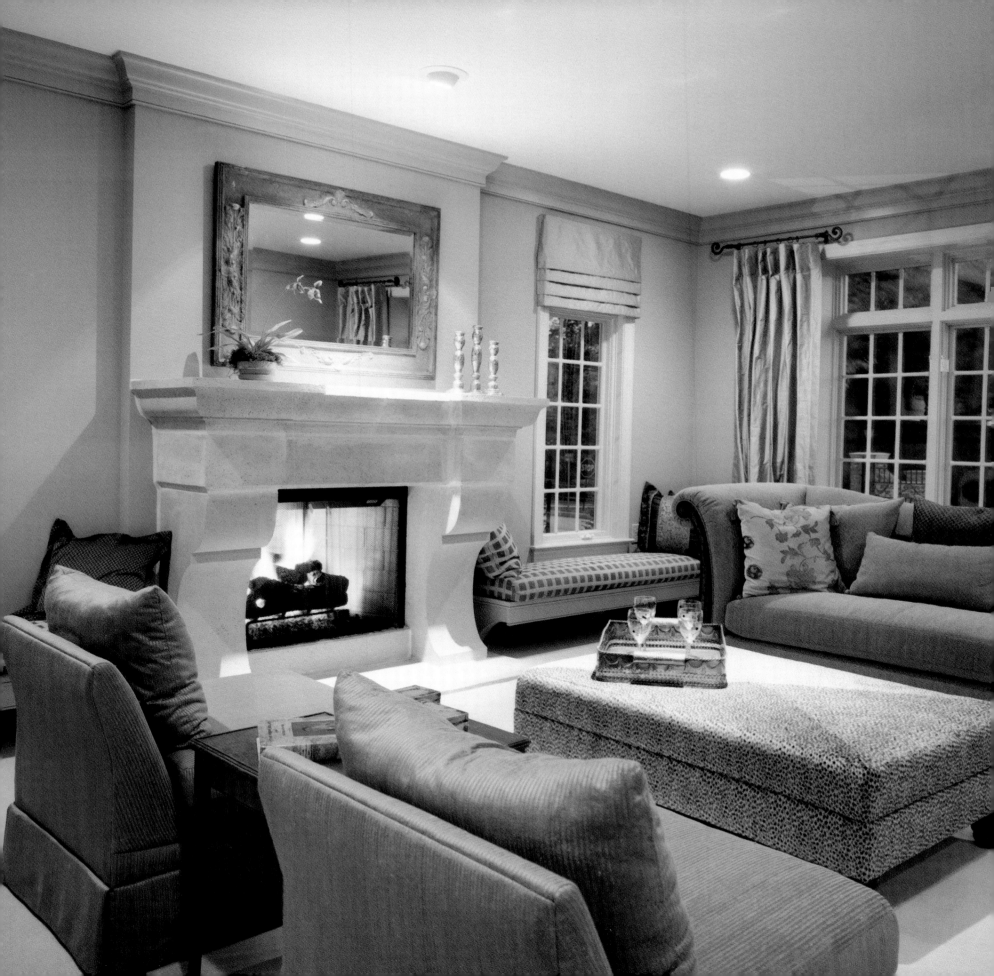

PATRICIA CRANE ASSOCIATES

Born in London, Patricia Crane moved with her family to New York when she was a teen. One of her first jobs was with the legendary furniture design house, Knoll International, which proved to be a pivotal step in her career path.

Today, Patricia caters to clients by giving each an exclusive, rather than signature look. But then, Patricia, herself, is one-of-a-kind. When Patricia moved to Philadelphia, she raised her children, was a mentor to students and did portfolio critiques at many area design schools. During this time, Patricia cultivated a design business that included cultural types, sports figures and collectors. She likes giving them an uncluttered, classic contemporary look mixed with idiosyncratic objects. Sometimes she will even build around a client's own collections.

Fifteen years ago, Patricia traded in a Main Line residence and built a house in the Museum district with the collaboration of architect, Ed Bronstein. Complying with architectural dictates in the area, the outside of her house is of Federalist style, which belies the open and airy feeling inside. The interior blends traditional and contemporary seamlessly, featuring hardwood floors and tile. While showcasing a virtual gallery of *objets d'art* from places far and near—contemporary craft collections,

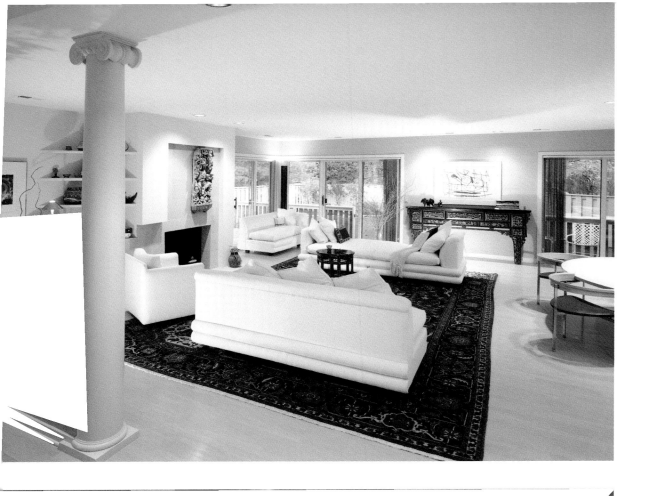

magnificent oils from San Miguel, Mexico, paintings from Spain, hand-woven wall hangings, quirky teapots and an array of hand-built pottery Patricia herself has created over the years. She even has a kiln in the basement.

Patricia's house serves as a portfolio of sorts for clients who are uncertain about their own tastes. When presented with the original and artistic mix, they invariably choose her as their designer.

Patricia's projects have earned her coverage in various publications: *HG, House Beautiful, The Washington Post, The Philadelphia Inquirer, Design NJ,* and *The Main Line Times*. She is also featured in *Interior Vision* by Chris Madden. She has appeared on "AM Live," and she has received the Pyramid Award for Bentley Homes Laurier sample house in Bryn Mawr.

TOP LEFT
An architectural column creates a foyer without walls, while eclectic pieces, such as an antique Chinese altar table, bring charm to a spacious, open floor plan.

BOTTOM LEFT
A fourth floor loft is enlivened with Art Deco accents, primary colors and an entertainment tower with a swiveling television that divides living and sleeping areas.

RIGHT
Patricia's city house showcases her original, artistic sensibility and serves as a portfolio for prospective clients.

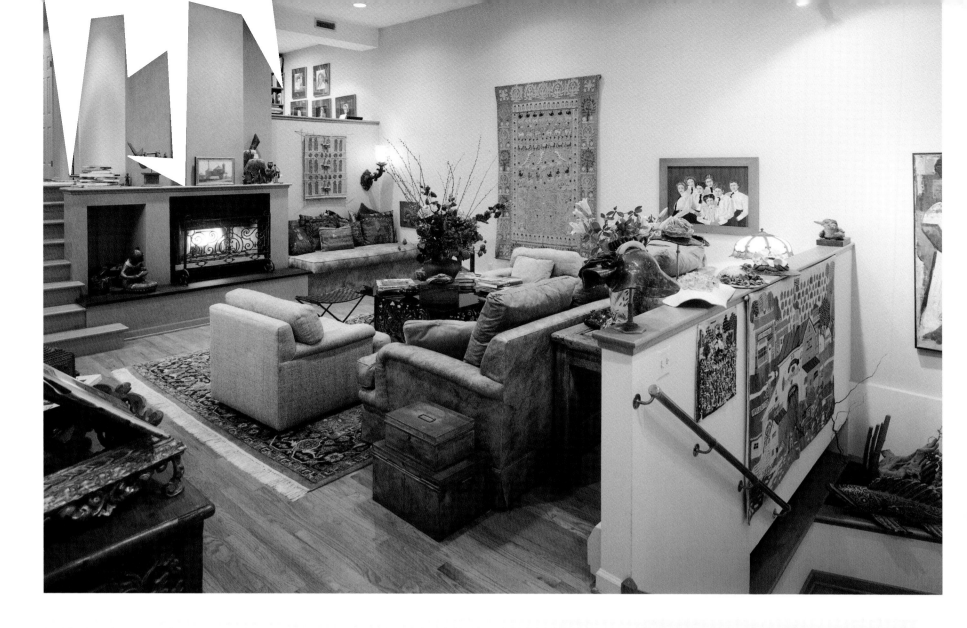

More About Patricia

WHAT IS THE BEST PART OF BEING AN INTERIOR DESIGNER?

The variety of personalities to interpret through design.

WHAT BOOK ARE YOU READING RIGHT NOW?

West of Kabul, East of New York by Tamin Ansary. Everyone should read this book.

WHAT IS THE MOST DIFFICULT DESIGN YOU'VE USED IN ONE OF YOUR PROJECTS?

For the estate in Newtown Square, I had Sherman-Gossweiller create a pair of 9-foot hand-carved solid walnut doors. The family crest was carved in full relief above the doors.

WHAT IS THE MOST UNIQUE, IMPRESSIVE, OR BEAUTIFUL HOME YOU'VE WORKED ON?

I was on television once and a viewer saw the segment, and called me. He was a German aristocrat with a 49-acre estate in Newtown Square. He took me shopping to Germany and England for antique furniture as well as a particular German roof and floor tile.

WHICH DESIGN PHILOSOPHY HAVE YOU STUCK WITH FOR YEARS THAT STILL WORKS FOR YOU TODAY?

Reflect the client and not yourself. I want it to be exclusive for them.

Patricia Crane Associates
Patricia Crane, ASID
107 Forrest Avenue
Narberth, PA 19072
610.668.4770

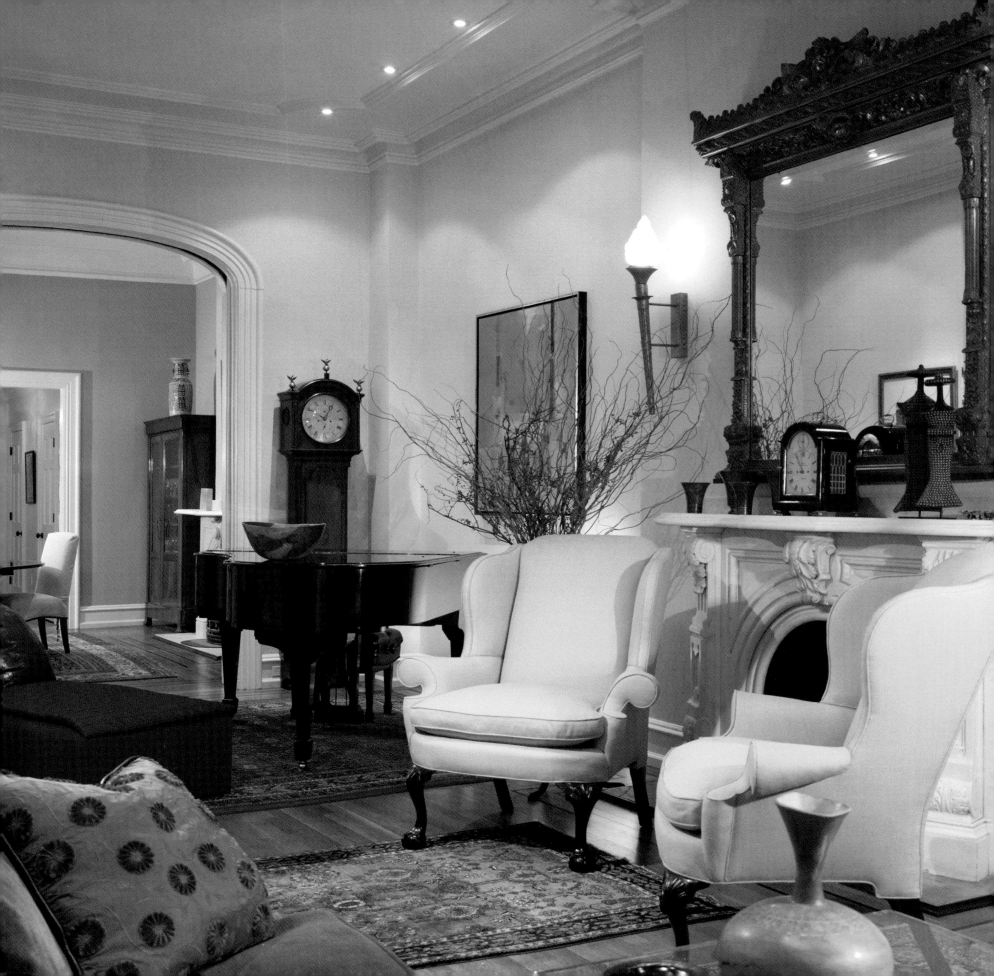

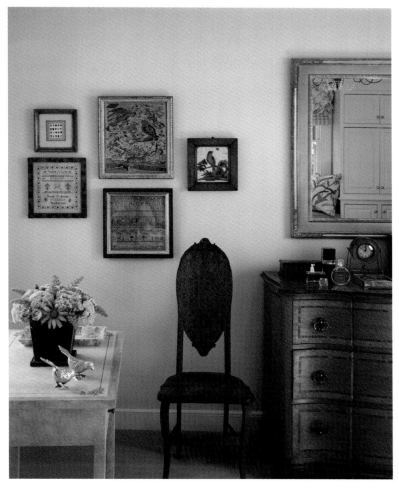

A unique heirloom chair from the owner's family keeps company with antique needlepoint samplers to add special personality and interest to this corner of the master bedroom.

The living room showcases the owner's contemporary artwork collection, as well as their antique rugs.

B arbara Gisel looks like an elegant ballet dancer, rather than a woman who likes healthy banter on a construction site. Managing 60 projects at a time in locales as far flung as California, Canada, Colorado, Cleveland and Center City, this delicate designer is no shrinking violet. After graduating from college, she worked for the mayor of Boston before announcing to a friend that she was going to be an interior designer.

She moved to Manhattan, attended New York School of Interior Design at night, and was spotted for her talent by a professor who recommended her for a job working with restaurant consultant George Lang. She took the post, working side-by-side with Lang's Hungarian staff architect, and calls the experience a unique background in restaurant and hotel design and, for that matter, all design.

Four years later she moved to Philadelphia, and in 1979 opened the firm that bears her name. One by one she has hired designers whose cultures and design perspectives are as diverse as the projects they create. Her team now totals 13, five of whom have been with her for 20 years. They redesigned and expanded their Haverford office, a 200-year-old building with an open, industrial look and a friendly atmosphere.

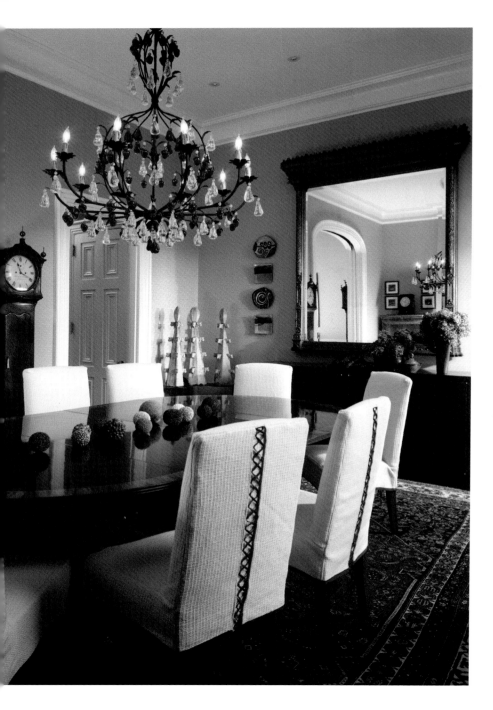

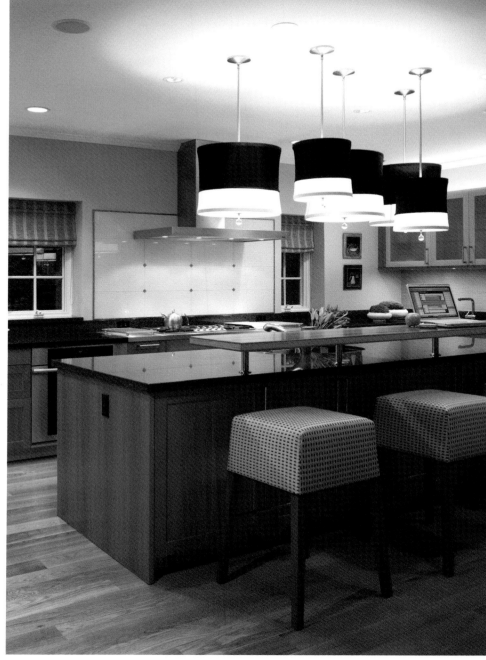

Barbara lauds each designer there for her prowess in different aspects of the discipline. She admits quite confidently to not being the most creative person in the office; her strong suits are space planning, overall concept, and sourcing. This is clearly a place with no egos.

Barbara Gisel Design (BGD) is service oriented. Barbara describes the process: taking clients to school for a time, training their eye, and then giving them something they have participated in. When clients

interview, she advises them to hire the designer they best communicate with. If it is to be BGD, her mission is marrying the client with the right design team who can best relate and discern preferences and desires.

LEFT
The dining room features a verdigris palette accented by amber glass in the chandelier.

RIGHT
Bold black and white shades introduce an unconventional lighting element in this refined contemporary kitchen. Cabinets are Bulthaup natural cherry with Black Absolut Granite counters. Glass tiles with metal accents create a unique backsplash.

Although Barbara lives and has raised her family of three girls in Philadelphia, she grew up in Buffalo. BGD has many projects in Buffalo, including a corporate design for a billion dollar private company, interior design for the new stadium for the AAA baseball team, (this won a spread in *Architectural Record*), and a rustic cottage on the Canadian shore, that makes the most of bringing the seasons indoors. Right now, BGD is completing with an architect and contractor a five-story brownstone in the Rittenhouse Square area for a couple with a love of art and color.

Looking back on 30 years of design, Barbara boasts only about periodically getting the purchase order to redo one room for a Manhattan woman who just likes her master bedroom to be changed every five years.

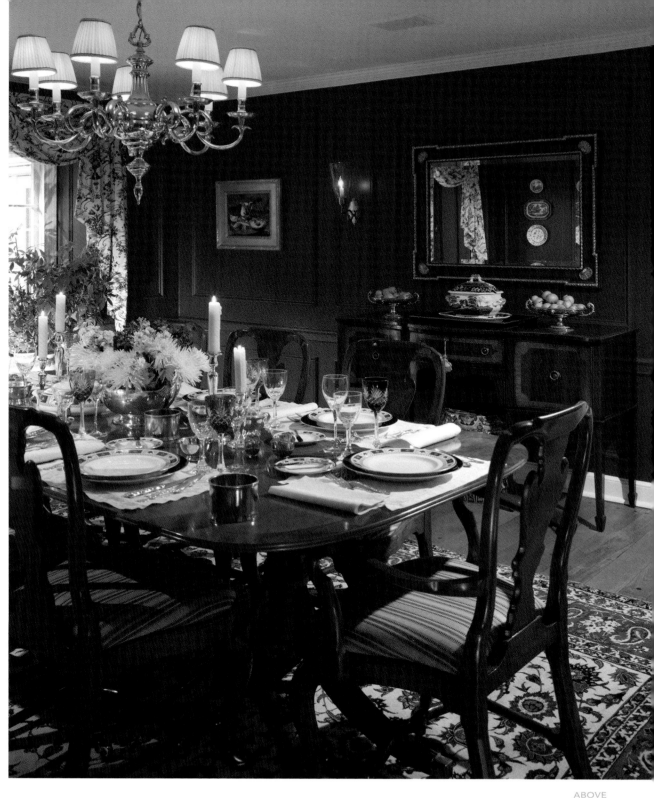

This dining room offers refined traditional elegance with 18th century antiques and a punch of color interest with red walls and blue and white toile curtains.

141

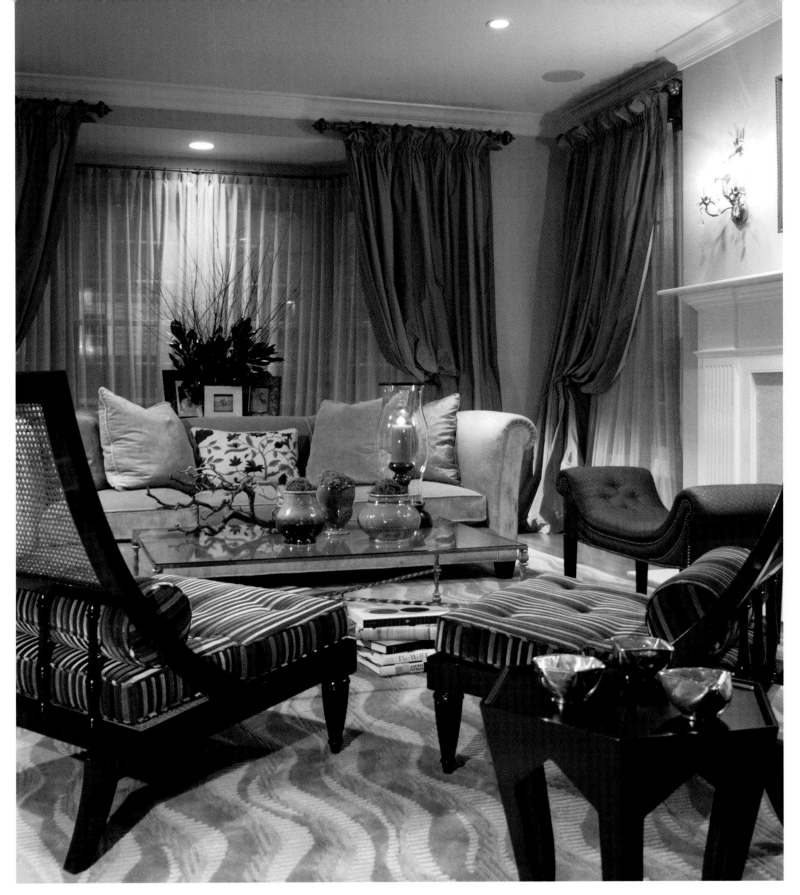

This living room in a new luxury home offers a contemporary twist on the traditional seating area. Warm colors and organic forms lend a sensual air that's anything but ordinary.

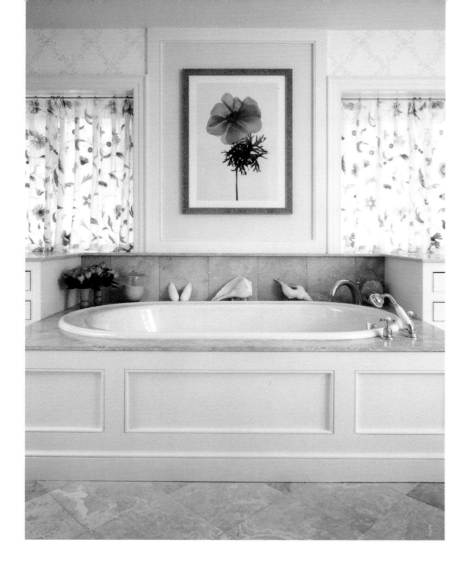

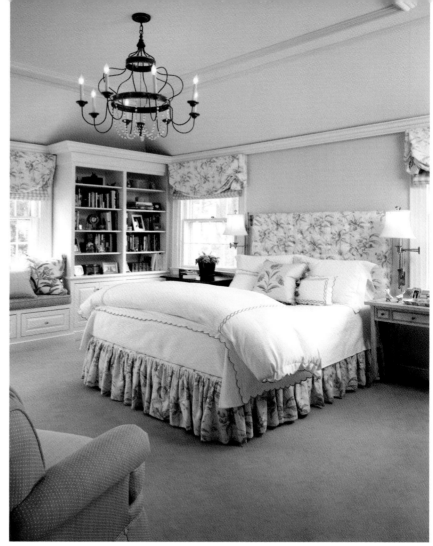

More About Barbara

WHAT IS THE BEST PART OF BEING AN INTERIOR DESIGNER?

Getting to know new people and working with our designers here. The beginning part of the process is fun because you are setting off on a new adventure; and the end is rewarding because our clients have realized their own goals. Sometimes, they even throw parties for us.

WHAT IS THE HIGHEST COMPLIMENT YOU HAVE RECEIVED PROFESSIONALLY?

To be recommended by clients to others, and receiving repeat business.

WHO HAS BEEN THE BIGGEST INFLUENCE ON YOUR CAREER?

We all inspire each other to work hard and be creative.

WHAT ONE ELEMENT OF STYLE OR PHILOSOPHY HAVE YOU STUCK WITH FOR YEARS THAT STILL WORKS FOR YOU TODAY?

We do not design with one style. We are more committed to getting to know our clients and fitting the style of design to their personalities and desires. We listen.

Barbara Gisel Design, Ltd.
Barbara Gisel
365 W. Lancaster Ave.
Haverford, PA 19041
610.649.1975

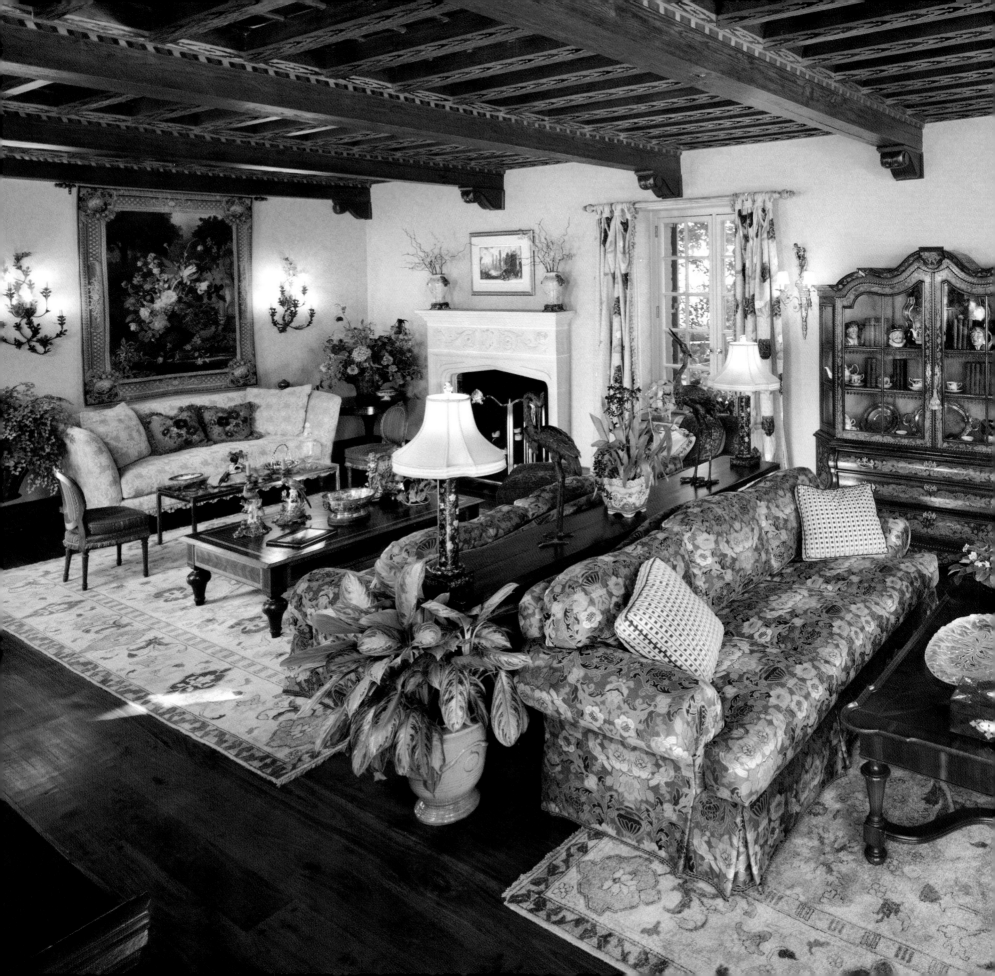

SUE GOLDSTEIN

SUE GOLDSTEIN DESIGN, INC.

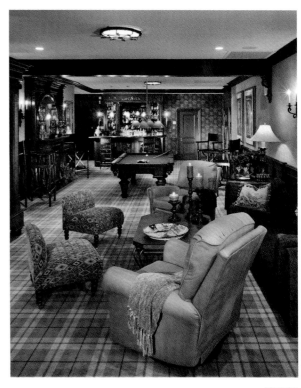

ABOVE
The lower level became the hub of the house when divided into an English pub bar, billiard room, media center, dance floor and game center (not shown).

LEFT
The 18th century Dutch bombay cabinet anchors the long living room. Back to back sofas create intimacy for smaller groups. The pair of 9x12 rugs were the find that inspired the colors and fabric selections.

S ue Goldstein once opened her Bucks County country home, Rabbit Run, for a group tour. This includes a 225-year-old main stone home, two guest houses, a design studio, pool, whimsical gardens and 25 fully-occupied birdhouses. One guest pointedly asked the designer if the house was pure, as in period. Yes, pure folly.

In her country kitchen, a painting of a robust rabbit hides her tiny built-in TV, antique sewing machine bases are the legs of her center island, the front of an armoire, flush with the wall, conceals her china cabinet. The lithe designer, who resembles more of an elegant yoga instructor than the consummate cook and entertainer that she is, spends weekends here with her husband, often entertaining city friends who enjoy her cooking in the tranquil surroundings. She is a cookbook collector, incessantly reading them, but never following a recipe.

She will tell you it is her years being a homemaker and entertaining that have made her a better designer. Who better to understand how a house has to live and that rooms need to be flexible?

145

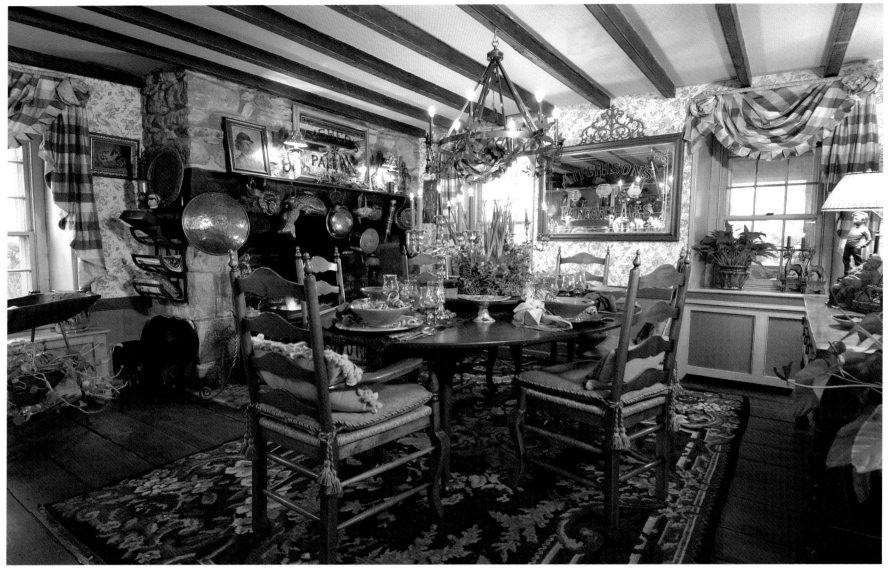

ABOVE
The circa 1780s walk-in fireplace sets the tone for a cozy country dining room. Antique Bessarabian rug inspired the colors. Two antique pub mirrors reflect the varied collections.

RIGHT
A Barvarian antique hunt cupboard anchors this country family room. Natural cedar beams, posts and trusses brought architectural interest that define the space.

Sue knows about preserving history, whether it's a piece left behind by grandma or honoring the architecture of the home. Everyone has a story which should be expressed. Sue doesn't foist her taste on others, though her style leans toward eclectic by mixing periods, colors and textures. Sue is a hopeless bargain hunter, who will go far and wide to find pieces that meet her client's needs and price range because she believes everyone deserves good design and value. With her longtime associate Joanne Bateman, Sue spends long hours studying to get the correct prospective to fulfill the client's dreams.

She believes if clients invest time and money in a home, then it should be timeless. Her philosophy after completing a home is that it should be "tweaked" every few years. When you stop noticing your room, it is time to revisit it and freshen up. Move things around, add or change small things—give it a lift.

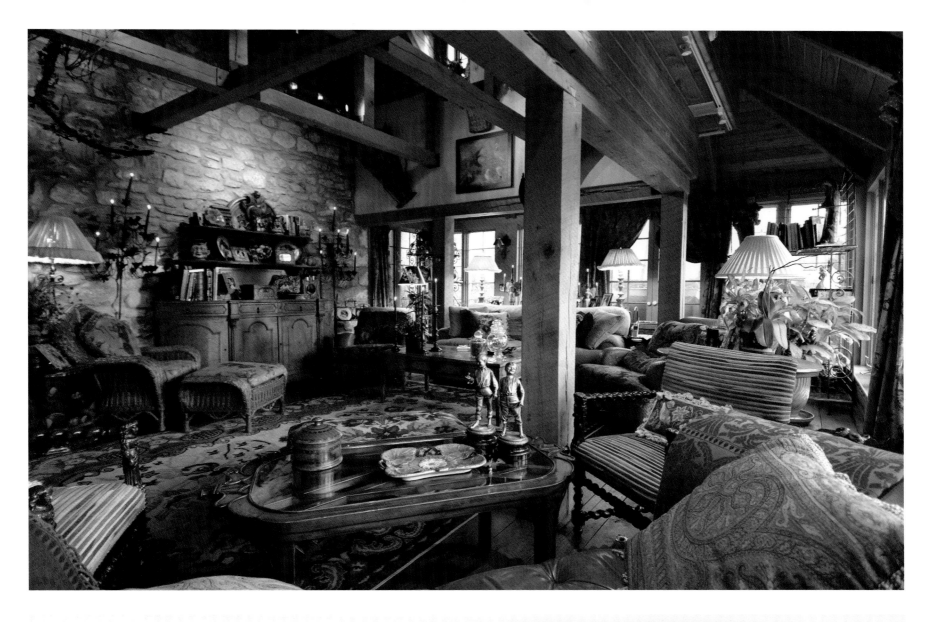

More About Sue

WHAT DO YOU LIKE MOST ABOUT BEING AN INTERIOR DESIGNER?

Making a difference in peoples lives by creating spaces that enrich their lives.

WHAT IS A SINGLE THING YOU WOULD DO TO BRING A DULL HOUSE TO LIFE?

Contrast wall and woodwork colors—de-clutter and bring in natural light.

IF YOU COULD ELIMINATE ONE DESIGN/ARCHITECTURAL/BUILDING TECHNIQUE OR STYLE FROM THE WORLD, WHAT WOULD IT BE?

Snap on mullions on windows and exaggerated ceiling heights.

WHAT ONE ELEMENT OF STYLE OR PHILOSOPHY HAVE YOU STUCK WITH FOR YEARS THAT STILL WORKS FOR YOU TODAY?

I find the single most outstanding architectural element and build around it. In the absence of one, I create it.

WHAT IS THE HIGHEST COMPLIMENT YOU'VE RECEIVED PROFESSIONALLY?

" I smile every time I walk into my house. Thank you."

Sue Goldstein Design, Inc.
Sue Goldstein
Joanne Bateman
2445 River Road
New Hope, PA 18938
215.862.9898

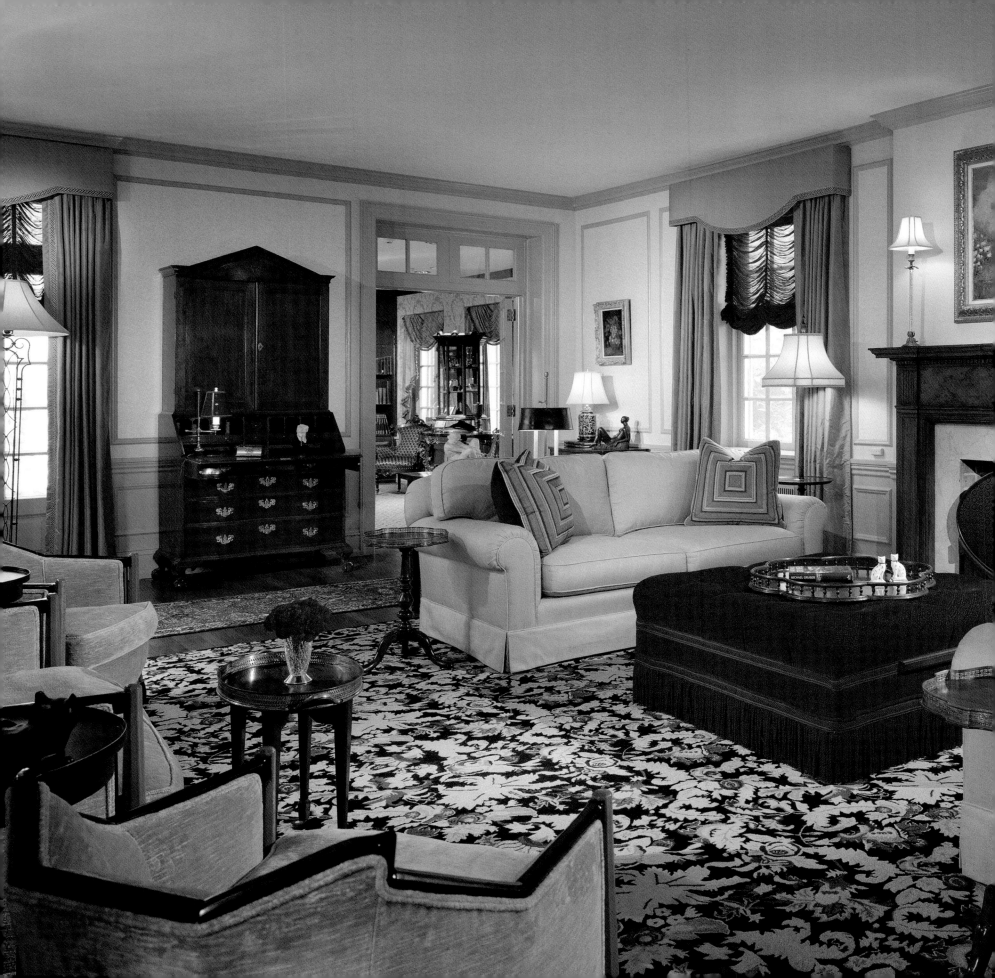

MICHAEL GRUBER

MICHAEL GRUBER DESIGN ASSOCIATES INC

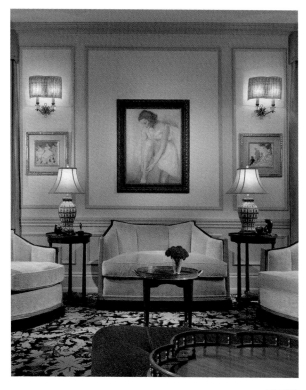

ABOVE
Michael's signature style of seamlessly mixing periods features a French Art Deco salon set within the traditional vernacular of a Bryn Mawr mansion.

LEFT
Another view of the living room showing a rare Chippendale secretary, ca.1790. The large ottoman and occasional tables are Michael's design.

Michael Gruber made a deal with himself long ago. If he wasn't hanging in the Museum of Modern Art by the time he was in his 30s, he'd change careers. Michael practiced fine art photography and was commisioned to make several works in glass, but a spot in MOMA was not to be. Instead, he opened his own gallery, L'Esperance, in the '70s. It was Philadelphia's first gallery to specialize in 20th century decorative arts and a place where he was able to demonstrate that you could buy and live with things you saw in museums. His mantra since then has been "to surround yourself with good design."

Michael went back to Philadelphia College of Art, now UArts, studied interior design, and opened his own firm in 1984. Even though he works with traditional antiques and styles, Michael will always add good quality modern pieces to the mix to keep things fresh. He is most fond of 20th century

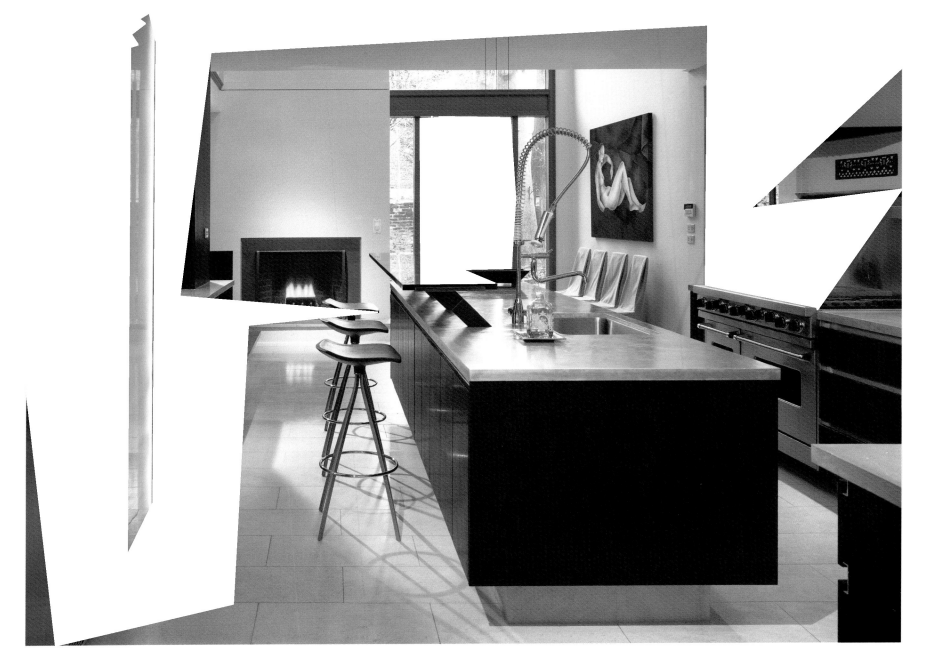

design—from the ornate French Deco pieces of the '20s to the elegant and Moderne ones of the '40s through the mid-century Case Study homes of the 1950s. He uses his fine arts background in designing; each space is approached as a work of art. Case in point: he enjoys the intimacy of drawing, working ideas freehand with and for his clients.

His projects span the Philadelphia area, but some of his most memorable homes reach San Francisco to Chicago to New York, Washington, DC, and Florida. Some have graced the pages of *Art & Antiques, Town & Country, Philadelphia Magazine, Inside Magazine, The Philadelphia Inquirer*, and *Main Line Life*, and have been featured on HG-TV.

His latest project has him truly enamored. It is a renovation of a 1939 Kenneth Day designed Woodward House in Chestnut Hill, a remarkable early modernist home unique to the area. He will furnish it with a mix of contemporary and 20th century modernist furniture and artworks. Michael likes to imbue every space with a sense of style that appears to evolve naturally rather than exhibit the hand of the designer. And there is nothing more modern than that.

LEFT
A modern kitchen integrated into a historic Society Hill townhome. Commercial equipment and a custom designed stainless steel and milkglass pantry make this kitchen not only beautiful but a professional cook's dream.

TOP RIGHT
A Long Beach Island beach house. This raised sitting room with built-in seating celebrates the view of the ocean. A custom designed raw steel audio column is built in, as well.

BOTTOM RIGHT
Simple and spare, the modern living room with its Italian furniture, mid-century classic tables and lamps and a custom rug designed by Michael Gruber bring the glow of the beach into the house.

In Maryland, this contemporary dining room lyrically mixing a French Art Deco ebony buffet, contemporary furniture, transitional architectural details, African and modern art, is typical of Michael's signature style.

Contemporary furniture, modern art and French Art Deco furniture marry this small living room to the dining room. The Gruber designed cabinetry was built by Amish woodworkers.

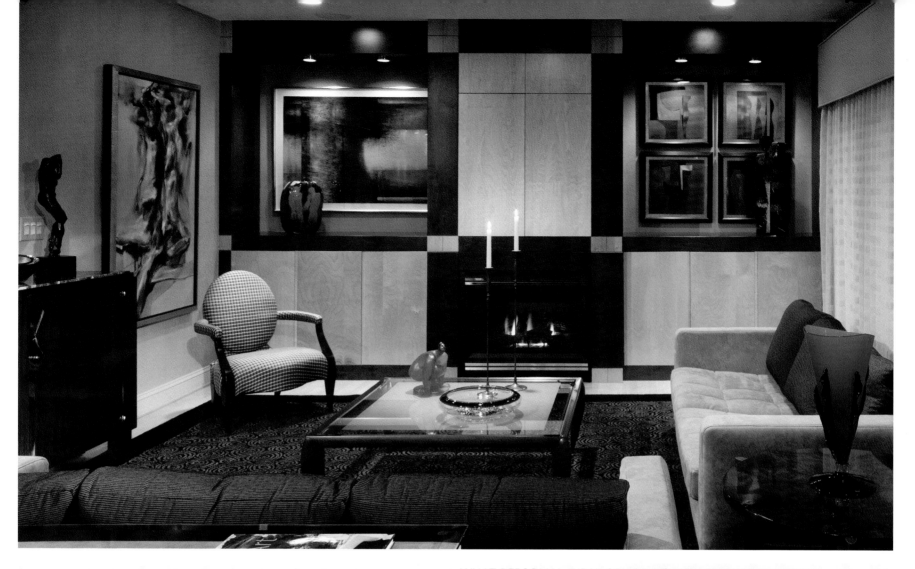

More About Michael

WHAT DO YOU LIKE MOST ABOUT BEING AN INTERIOR DESIGNER?

I love the opportunity of working with art and antiques, selecting, placing and constantly learning.

WHAT ONE ELEMENT OF STYLE OR PHILOSOPHY HAVE YOU STUCK WITH FOR YEARS THAT STILL WORKS FOR YOU TODAY?

Sensitively mixing periods and styles will imbue a home with an enduring quality that appears to evolve naturally.

WHO HAS BEEN THE BIGGEST INFLUENCE ON MY CAREER?

Early on, a university instructor, photographer Ray Metzger, taught me the seriousness of approaching your art as a lifestyle. Currently, my wife Roberta and my associate Tim Powell, both of whom teach at Drexel University, keep me on my toes.

WHAT PERSONAL INDULGENCE DO YOU SPEND THE MOST MONEY ON?

Cars: I have five. Art and antiques; I'll never have enough.

WHAT IS THE HIGHEST COMPLIMENT YOU'VE RECEIVED PROFESSIONALLY?

Being awarded first place by my fellow designers as having designed the best room in a designer showhouse we were participating in.

WHAT BOOK ARE YOU READING RIGHT NOW?

Modernism Rebuilds the American Dream by Eichler and *Until I Find You* by John Irving.

Michael Gruber Design Associates Inc
Michael Gruber, Allied Member ASID
232 David Drive
Havertown, PA 19083
610.853.2111
FAX 610.853.4746
www.gruberdesign.net

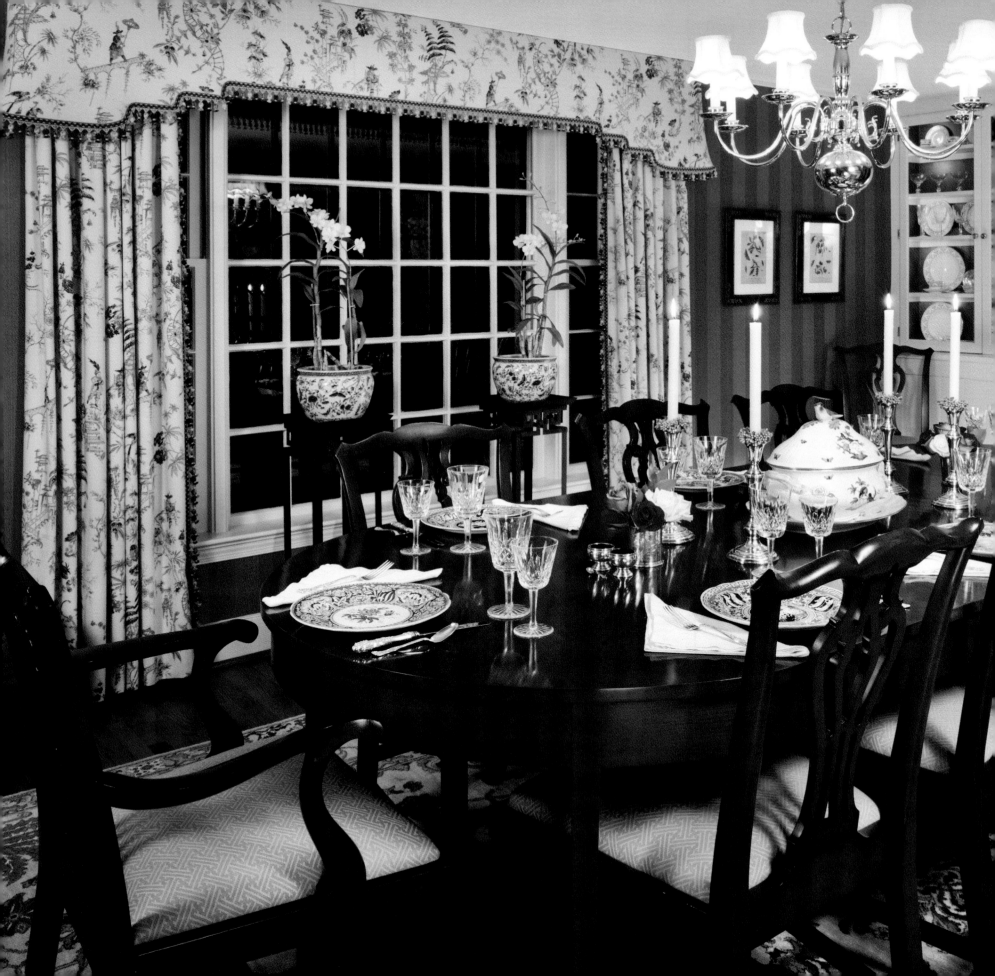

MARY HASTINGS

ABOVE
Mary s great grandfather's umbrella stand, filled with old family canes, sits next to her Hepplewhite chest. The painting above, "Three Pears," is painted by Karin Becker. The watercolor is by Mary herself.

LEFT
The yellow chinoiserie curtains are set off by striped raspberry walls. Chinese fretwork covers the Chippendale chairs.

C reative visions are the gift of a select few. For Mary Hastings, empty rooms summon substance and energy. Plain walls seek the stroke of a brush, and tired furniture awaits revival. Interior spaces are a canvas for her intrinsic sense and desire for composition and color. Mary's purest talent lies in her ability to see potential where others might see confusion.

Her design aptitudes were born early and nurtured through her love for drawing and painting. A trained fine artist with a bachelor of fine arts degree, Mary has always honored her passion for creating while raising her three children over the past 20 years. Her initial zeal for working with interior spaces surfaced in informal and often spontaneous settings; family gatherings frequently evolved into the rearrangement of a room's entire inventory. Vigorous debates over color and materials, comfort and practicality were a normal part of her family's dialogue.

Equipped with the passion and natural sense of color and composition that brought incredible emotional energy to her landscapes and still lifes, Mary seeks the traditional, but with flair. Come to her for elegance, charm and whimsy and you won't be disappointed. Mary deliberately works to make rooms look like they have evolved over time, integrating

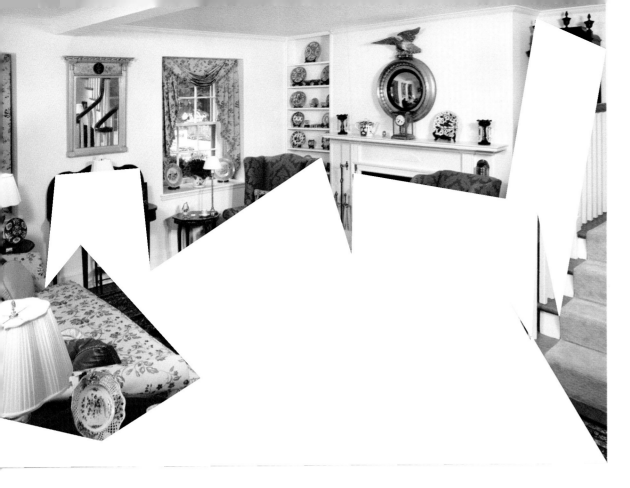

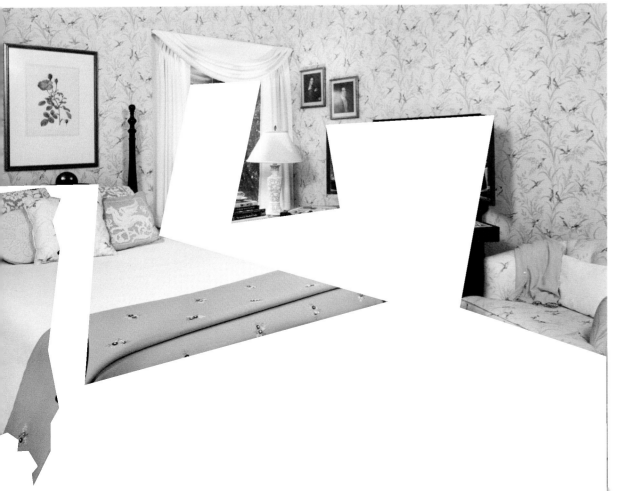

both the old and the new. The opportunity to layer a client's inherited pieces or personal collections with new elements defines and celebrates a family's unique history and style. In an era when houses are often stocked overnight from the pages of a catalog, Mary's ability to blend the old and the new is a gift indeed.

With years of studying the breadth and juxtaposition of colors that emerged on her palette and canvases, it is no wonder that color continues to be Mary's calling card. She is passionate about color and the impact it has on a room's mood. Every color on its own can be evocative, but it can be brought to a new level when it is paired with the right complement. Crisp, clear shades induce immediate delight and comfort. Mary uses color to make the dull brilliant and inviting. She feels it's the most reasonable and easiest way to create a big impact.

For a recent gala at the Marketplace Design Center in Philadelphia, Mary transformed a dining room into a fresh, sophisticated vignette using a striking collection of Staffordshire perched on tomato red brackets against a black wall. To Mary's secret delight, one guest remarked that her work roused images of Sister Parish, a comparison she'll accept any day.

TOP LEFT
A sky blue Brunschwig & Fils lampas covers a Chippendale sofa and is repeated in the windows. Coral Damask wingbacks flank the fireplace. A regency mirror overlooks the room.

BOTTOM LEFT
A Redoute print hangs over the four poster bed with pillows made from antique lace. The dressing table holds a collection of antique sterling perfume bottles.

RIGHT
Chinese red sets off a collection of Staffordshire, antique butterfly prints and a Delft clock.

Mary loves using her drawing and design skills to create what doesn't exist. If she can't find the perfect solution for her client, whether a sideboard, headboard, valence or some other piece of furniture, she'll design it. It gives her immense enjoyment to use her creativity in such a resourceful way.

Today, her clients span from Philadelphia's Main Line to Manhattan, and assignments can be as modest as choosing paint colors to renovating a bathroom or totally designing a home. Mary understands that the design process can only succeed with a strong client relationship that encourages active collaboration driven by a mutual trust and respect. She feels that she is an interpreter—she listens to her client's visions and desires and transforms them into a glorious, practical and durable reality. As a room evolves from thoughts to a living space where a family will spend time together or a child will sleep and dream, Hastings feels a tremendous sense of satisfaction as well as responsibility in her work.

Mary is part visionary and part cheerleader, using her talent for design and love for working with people to make the process successful as well as fun. When it's all said and done, she wants to bring beauty into people's lives.

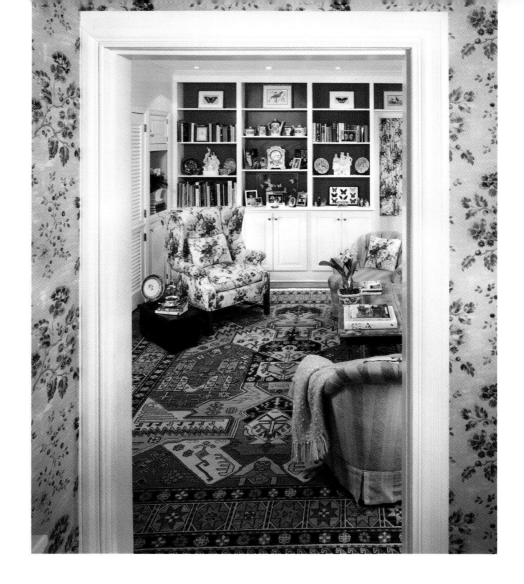

More About Mary

WHAT ONE ELEMENT OF STYLE OR PHILOSOPHY HAVE YOU STUCK WITH FOR YEARS THAT STILL WORKS FOR YOU TODAY?

Interiors should be warm, inviting, and comfortable, and they should speak to the client's interests and intrinsic artistic values.

WHAT IS THE BEST PART OF BEING AN INTERIOR DESIGNER?

Meeting interesting people with different life experiences. I love creating spaces that narrate these stories.

WHAT IS A SINGLE THING YOU WOULD DO TO BRING A DULL HOUSE TO LIFE?

Paint, paint, paint! It's the most simple and effective tool for creating visual harmony and energy.

WHAT IS THE HIGHEST COMPLIMENT YOU'VE RECEIVED PROFESSIONALLY?

The greatest compliment comes when a client calls me back to continue our journey, or when a client refers me to a close friend or family member.

Mary Hastings Interiors
Mary Hastings
236 Leopard Road
Berwyn, PA 19312
610.283.3418

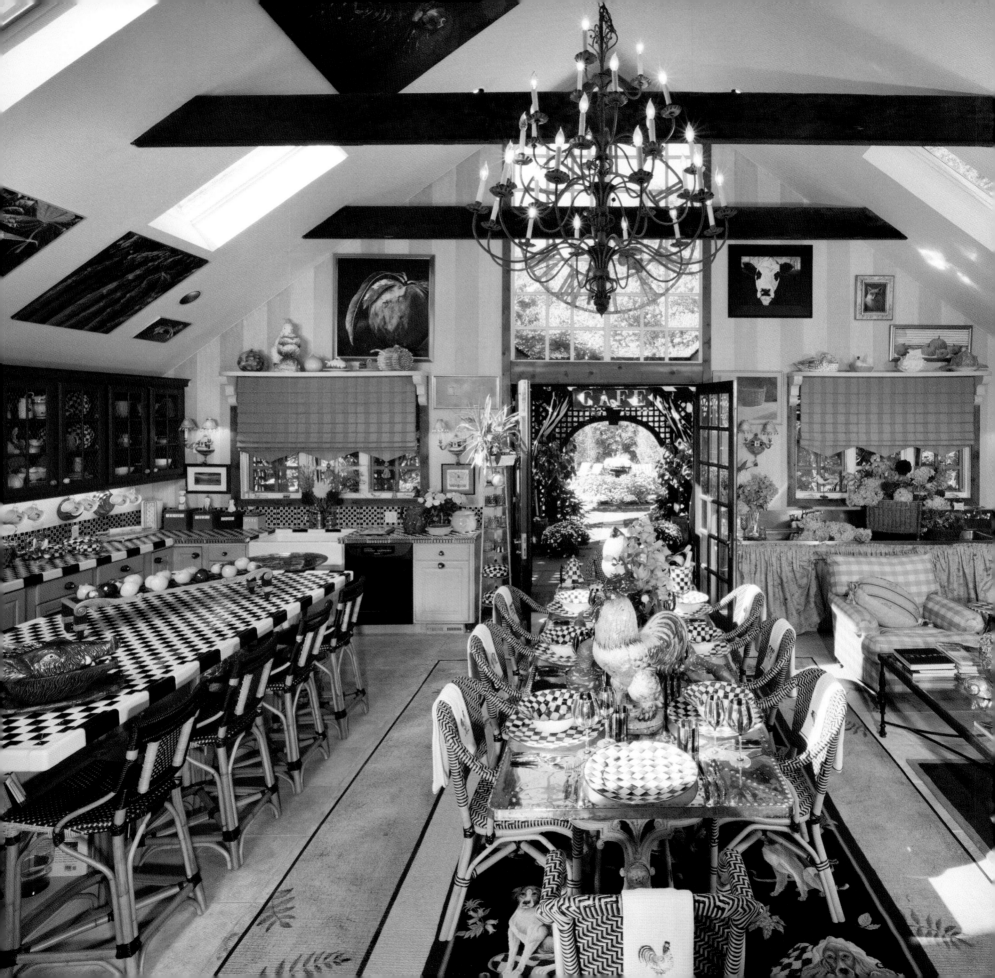

KATHLEEN JAMIESON

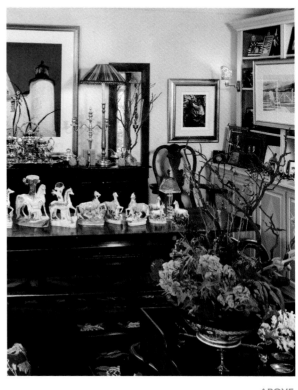

Dining area exhibiting designer's art collection and a Staffordshire collection of porcelain zebras.

Country kitchen leading to pergola gazebo with outdoor fireplace overlooking formal gardens—perfect for family gatherings.

Kathleen Jamieson is a fun, generous, and very talented designer according to her clients. Her finished interiors are full of energy and imagination; an up-to-date Old World look with understated elegance; eclectic with good taste.

In her antique shop, The Mock Fox, in Haverford, Pennsylvania, the eye-popping furniture and merchandise immediately shows her electric approach to designing homes, apartments, shore homes, corporate offices, board rooms, yachts, and museums.

Clad in a velvet duster, silver flats and slim jeans, Kathleen is a tall, statuesque blonde, and always a presence in any room. The original multi-tasker, she has miles of energy, running or flying to client's homes, spending time keeping the store fresh, hosting events at her home in Malvern and serving as president of The National Arts Program©, an organization she helped start and is now in 22 states with 46 annual venues.

One friend effuses about the artfulness of Kathleen's home: "You look somewhere and see something gorgeous, then look some more and see something more spectacular. It has so many ideas and is so unusual, much like her shop."

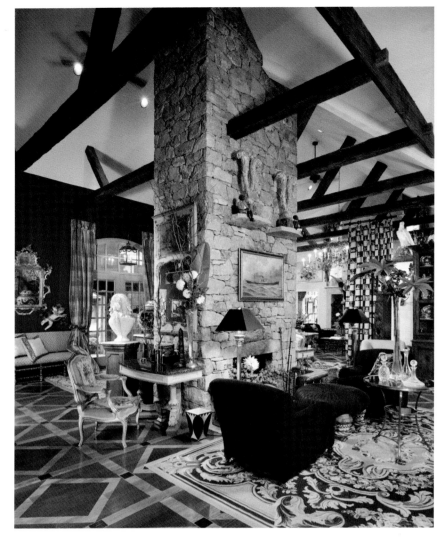

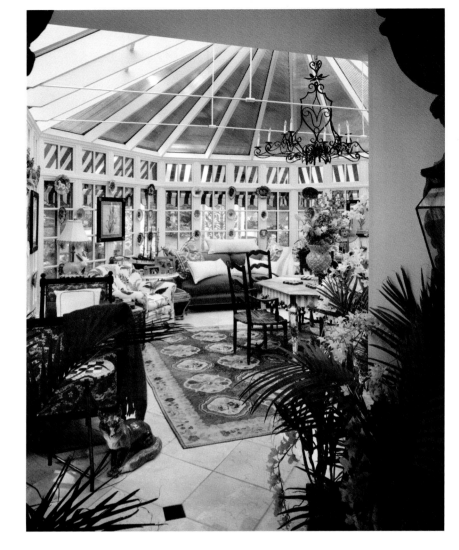

LEFT
Entry hall and living area with 100 year old beams and stone fireplaces.

RIGHT
18th century barn converted into a private art museum for a collector client.

Growing up in Atlantic City, the youngest of 10 children, Kathleen decorated and organized her mother's massive linen closet, replete with sachets she made with tulle and ribbon. All of the ladies in her mother's bridge club paid her to do the same to theirs. Her sister, Pat Baxter, later moved to Chicago and became a famous interior designer and Kathleen followed, working as a gopher when she was an editor of a new magazine, a Martha Stewart Living of its time. The magazine lasted two years but she stuck with designing and decorating.

After college, Kathleen traveled in Europe before marrying and raising five children. Her twin daughters, Jackie and Jill, inspired the name of her business. The Mock Fox name came from a fun hunt they enjoyed at the end of fox hunting season. Another daughter, Judy, worked by her side for years in the business before moving to Princeton and opening Judy King Interiors, also a luxe in-town boutique and design firm.

A home decorated by Kathleen is always unique. She mixes periods and countries, loves the European look or English, anything that says relaxed sophistication. She travels to Europe three times a year to buy and creates her own custom upholstered pieces. She advises her young clients to purchase the best furniture they can afford, and always good art.

In addition to her work in Philadelphia, the designer has recently finished vacation homes in Door County, Wisconsin, Stone Harbor, and Bay Head, New Jersey, and two homes in Chesapeake Bay in Maryland. Her work has been published in many national magazines.

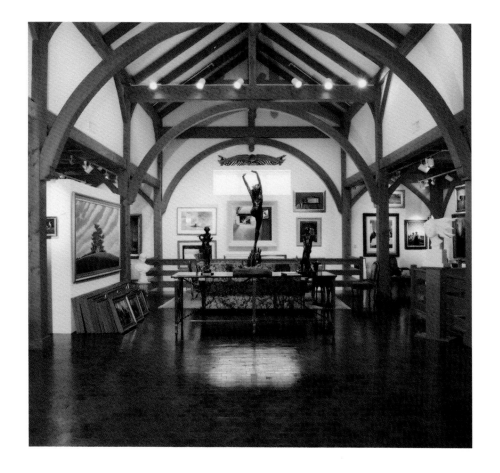

More About
Kathleen

WHAT IS THE BEST PART OF BEING AN INTERIOR DESIGNER?

The people you meet, the fun you have, and to seeing the happiness when the job is finished.

WHAT IS THE HIGHEST COMPLIMENT YOU HAVE BEEN PAID PROFESSIONALLY?

"You have taught me so much and have made my project fun."

WHAT IS ONE ELEMENT OF STYLE OR PHILOSOPHY YOU HAVE YOU STUCK WITH FOR YEARS THAT STILL WORKS FOR YOU TODAY?

Old World with a twist. Good taste with eclectic, and always fresh flowers.

WHO HAS BEEN THE BIGGEST INFLUENCE ON YOUR CAREER?

My sister, who was ahead of her time in design with leather floors and zebra rugs in her mountaintop home.

WHAT IS THE MOST UNIQUE HOME YOU'VE SEEN IN PHILADELPHIA AND WHY?

Too many to pick one.

WHAT IS THE MOST UNUSUAL, EXPENSIVE OR DIFFICULT DESIGN OR TECHNIQUE USED IN ONE OF YOUR PROJECTS?

My client, a serious art collector, asked me to design a private museum to house his collection. I took an 18th century barn on his property and designed the gallery/studio.

The Mock Fox
Kathleen Jamieson
15 Station Rd.
Haverford, PA 19041
610.642.4990

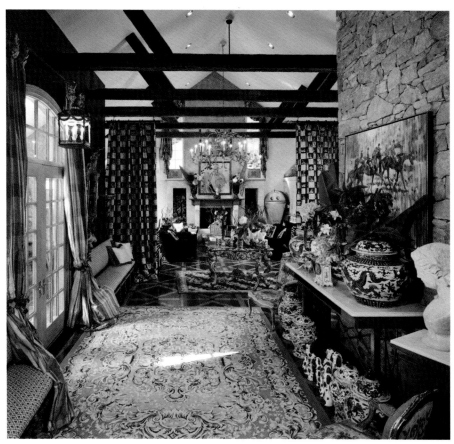

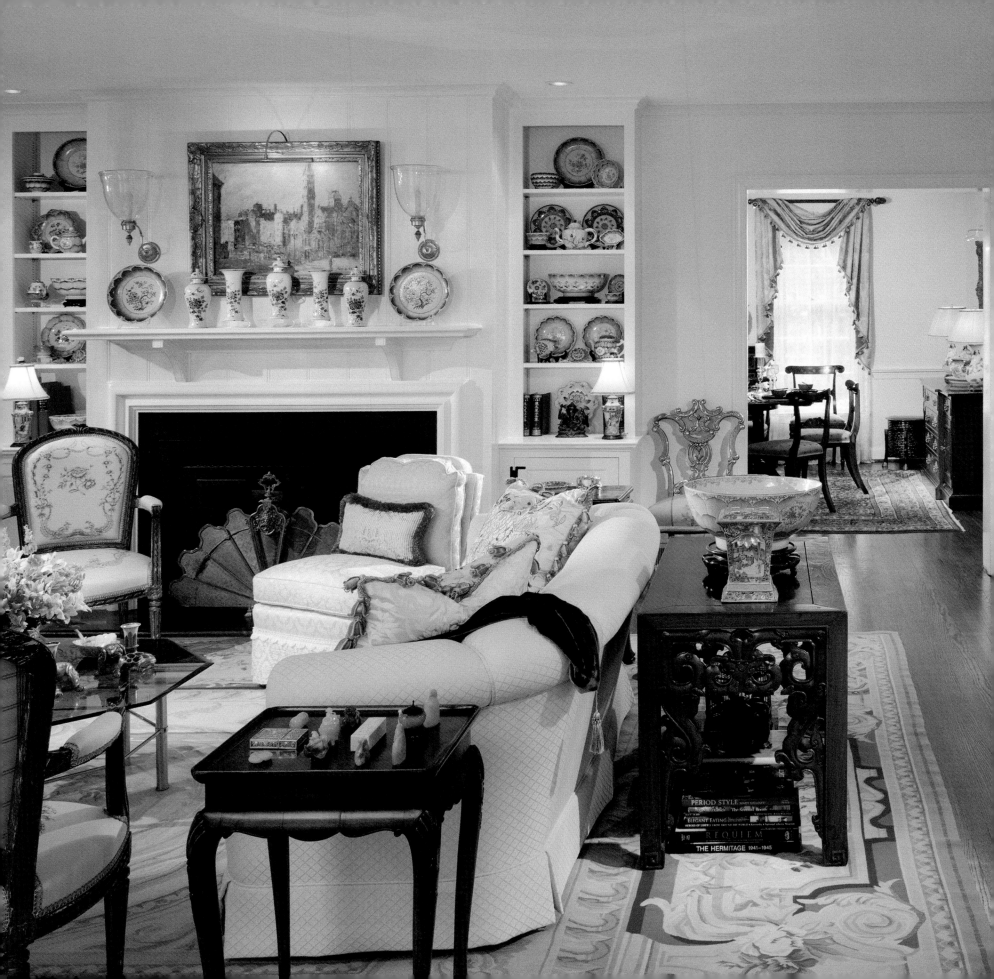

CYNTHIA LEE JOHNSON

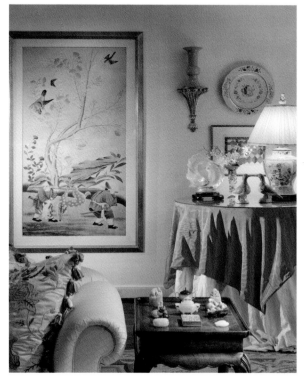

An Aubusson tapestry complements the rose and white tones in Cynthia's living room. Elegant, yet comfortable, the Chinoiserie style reflects her international background.

In a formal corner of her living room, a pair of hand-painted Chinese hunting scenes hang near a Clarence House draped table displaying Chinese exports.

Cynthia Lee Johnson loves to create homes that take your breath away and yet convey warmth and elegance. The same could be said for Cynthia herself—with an impressive dossier, yet the most welcoming of manners.

Everything this designer has done has been a natural extension of a unique childhood. Born to a professional artist father and computer consultant mother, she is a first generation American born of Chinese descent who traveled from her birthplace of Boston to Taipei, Paris, and Milan for her mother's career. Wherever her father's studio was, she had an easel. She studied painting and spent weekends touring museums and visiting his artist friends. Even in French convent school, she unknowingly was preparing for what lay ahead. She learned to speak French and to embroider. The latter skill now comes in handy when she communicates with suppliers.

Cynthia attended the Academia di Bella Arte, the Sorbonne and The New York School of Interior Design. She holds a BA in italian literature and oriental studies from the University of Arizona. After completing her education, Cynthia and her husband traveled the globe for his career, living in several locations in South America and Asia before coming back to the United States, where she founded Cynthia Lee Johnson Designs.

Various lifestyles, richness of landscapes, brilliant colors and textures have influenced her work and how she approaches a project. She calls her look elegant and sophisticated, and says her strong suit is color and mixing period pieces with contemporary furniture.

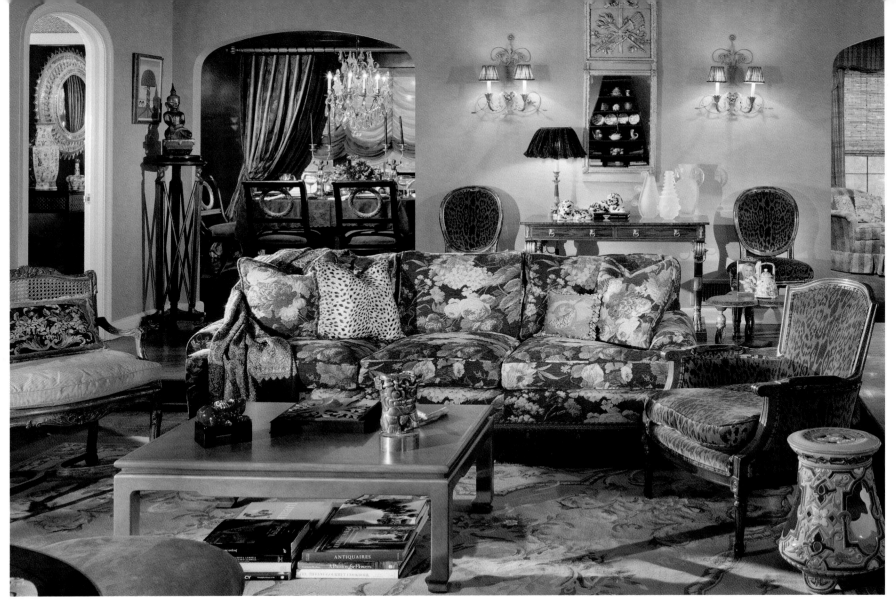

A long-time resident of the Main Line, Cynthia has a clientele that spans the continental United States and also includes Hawaii and Europe. Perhaps one of her greatest coups was the recent renovation of the Ormandy Room at the Philadelphia Academy of Music, a project she was honored to do for her contribution to American history.

She calls each job a beautiful puzzle that she loves solving, and enjoys meeting new people and helping clients realize the beauty of their surroundings. She encourages clients to begin to collect art. It needs to be part of the overall design of a home,

but does not have to follow the period of the room—the collection should make its own statement.

Cynthia believes design should artfully reconcile opposites but have enough of a twist so that it doesn't seem cliché. Projects need diversity and texture, she contends, because design is about many voices speaking different languages. Cynthia speaks five, but says each finished project is the creation of another new brilliant one. How beautifully spoken.

More About
Cynthia

IF YOU COULD ELIMINATE A STYLE OR DESIGN
TECHNIQUE FROM THE WORLD, WHAT WOULD
IT BE?

None, because all design is an expression of personal taste.

WHAT OBJECT HAVE YOU HAD FOR YEARS THAT
REMAINS IN STYLE TODAY?

My 35-year-old coffee table that is a contemporary Italian design.
I collect 18th century Chinese export porcelain Lotus pattern and
Japanese Imari.

WHAT DO YOU LIKE ABOUT LIVING IN
PHILADELPHIA?

I love Philadelphia for its culture, people, countryside, antique
markets and its proximity to New York, London and Paris.

Cynthia Lee Johnson Designs
Cynthia Lee Johnson
901 Parkes Run Lane
Villanova, PA 19085
610.688.9268
www.cljdesigns.com

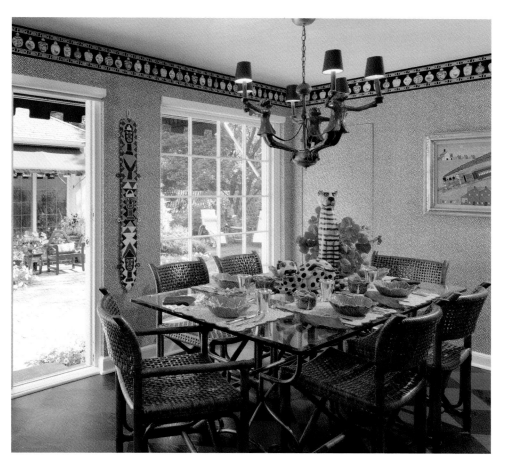

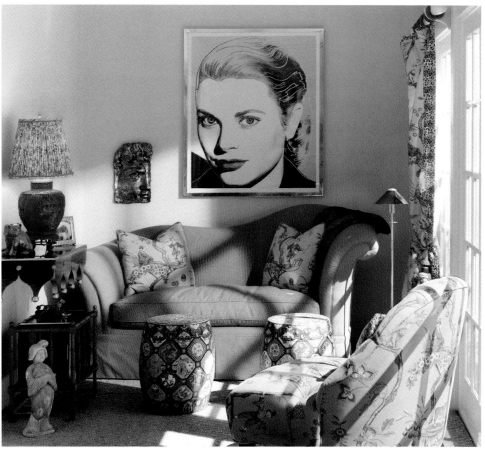

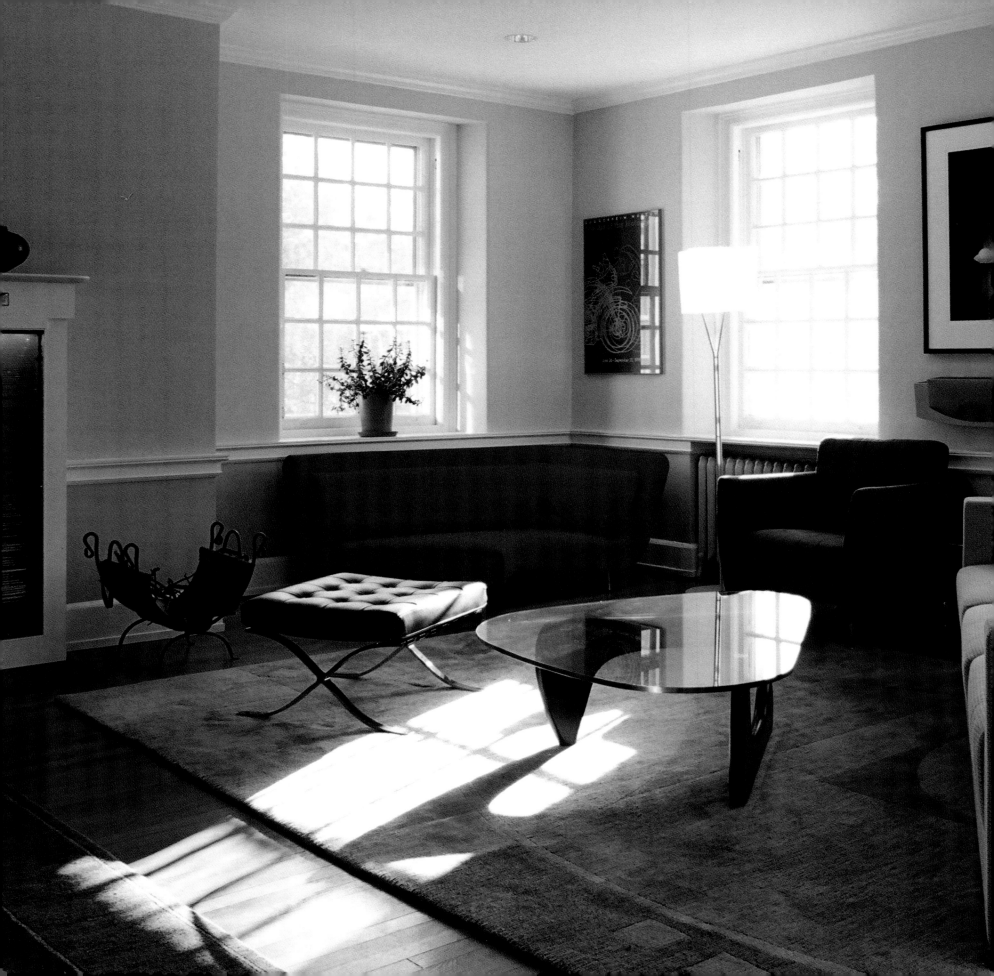

JOEL LEVINSON

ABOVE
Kitchen opens onto breakfast area. Four sculptural openings provide view into planted atrium with stair to second floor. House and interiors by Joel Levinson Associates.

LEFT
One of two living room furniture groupings. Amy Lamb flower photograph. JLA designed mantel, built by James Van Etten, features backlighted panels of stacked glass.

J LA is an architecture and interior design firm founded by Joel Levinson, AIA, in 1969. Its interiors activities began in 1975 when the firm was commissioned to design the Market Place Design Center, the region's merchandise mart, near 30th Street Station in Center City Philadelphia. Immediately thereafter, the firm won a first prize in Philadelphia Magazine's first corporate interior design contest. Commissions then began to come in from corporate and private residential clients.

Joel, who is also an author of fiction and non-fiction and a semi-professional photographer, is delighted the firm now offers both architectural and interior design services, enabling it to create a totally integrated look. Experienced in traditional, contemporary and eclectic styles, the firm takes particular pride in how it's designs reflect each client's particular lifestyle. A feeling of repose, marked by careful lighting, subtle use of colors and inventive detailing, are characteristic qualities in JLA's work.

The firm is respected for its professional approach to rendering service. Cost control and project scheduling are as important as achieving superior design. Creative Accommodation, a unique approach to design developed by Joel, has served the firm well in achieving uncommon results. JLA's projects have been published nationally and internationally.

Joel Levinson Associates
Joel Levinson, AIA
15 W. Highland Ave.
Philadelphia, PA 19118
215.248.5242
www.jladesign.com

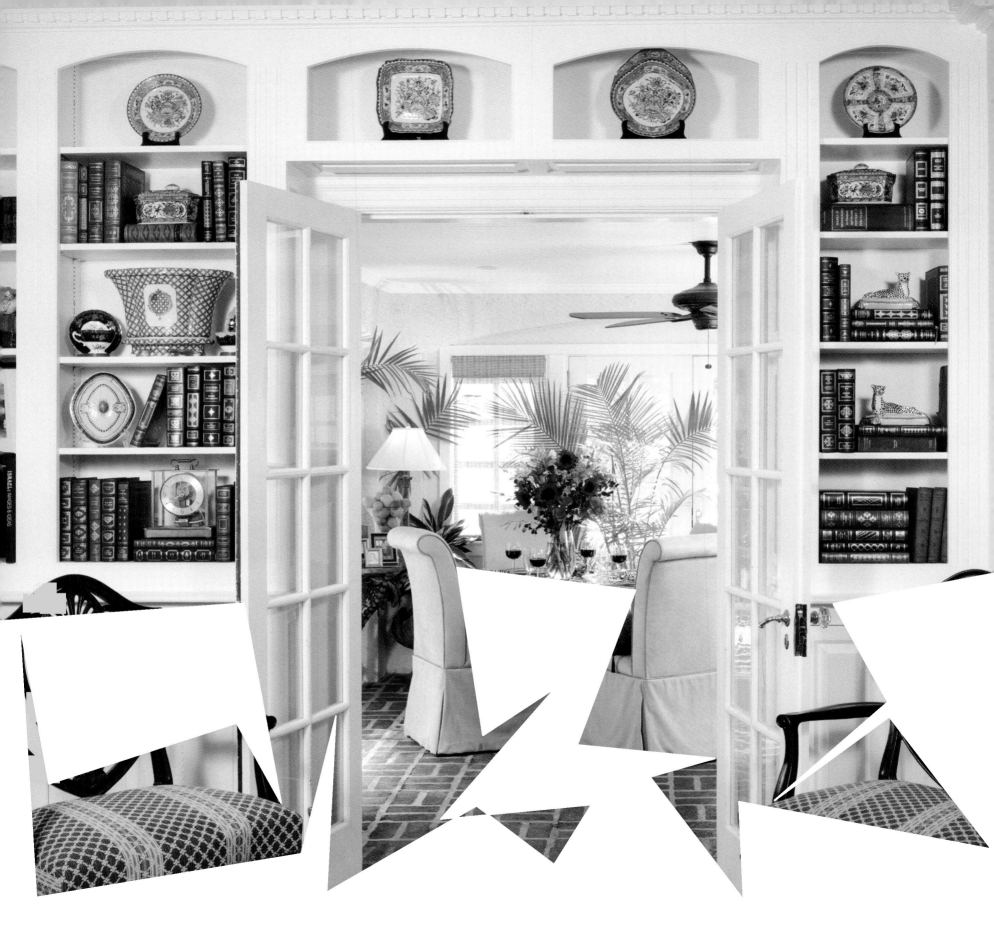

JILL McNeil

MCNEIL DESIGN ASSOCIATES, LLC

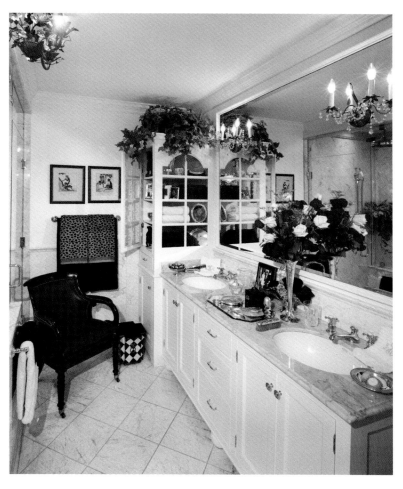

To understand Jill's design philosophy is to know her personality. Her joyful spirit complements her graceful sophistication, and both are rooted in her passion for beauty, balance, and the timelessness that emanates from inspired artistry.

A native of Baltimore, Jill moved to Philadelphia to attend college. She obtained a bachelor of arts in the history of art and architecture, and while in college, received a scholarship to study in Italy. Later, she majored in interior design and architecture at Philadelphia College of Art and Drexel University. Jill's training in European art and architecture broadened over the years, and she developed a passion for American decorative arts as well. She is particularly fond of 18th and 19th century Americana, and she has spent time studying such significant collections as those at Winterthur Museum, Garden & Library in Delaware. Jill's interest in Americana also extends into later periods. From Edith Wharton's Victorian elegance to Dorothy Draper's vibrant early 20th century interiors, Jill gains inspiration from an eclectic array of designers. Her own style reflects this, simultaneously expressing a refined traditionalism and joyful modernity.

Travel fuels Jill's creativity, and her experiences in Europe, Asia, Africa, and the South Pacific have greatly influenced her innovative and artistic use of color, space, and light. Especially when working with clients in such diverse locations as Palm Beach, St. John, Nova Scotia, or Kenya, Jill seeks out local builders, artisans, and furnishings. As a result, each of her designs represents a sense of place that is respectfully unique to each locale.

ABOVE
Bathroom sculpted in Carrera marble; Chelsea House tole wastebasket; bath fixtures by Perrin and Rowe through Ferguson Enterprises; sconces and chandelier rescued from period interior.

LEFT
Antique chairs in Lee Jofa fabric; custom cabinetry surrounds French doors; enclosed porch preserves original outdoor brick floor; armless Leathercraft chairs circle glass table with custom bronze base.

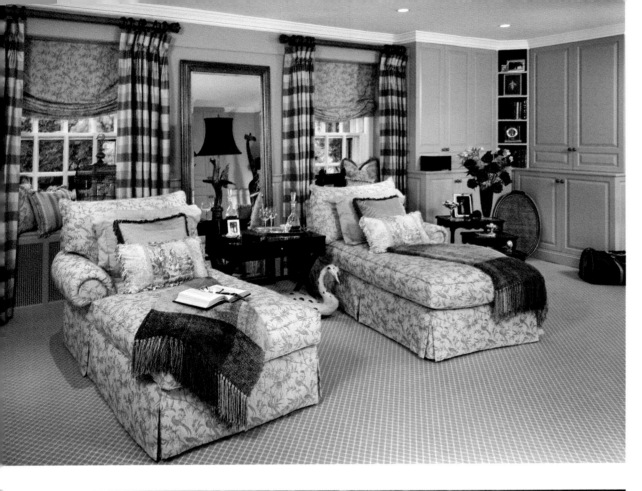

Jill's home in Haverford, Pennsylvania, is a colorful balance of sophistication and playfulness. She enjoys merging traditional and contemporary elements in her work, and her own home reflects this. In her sunroom, for example, she marries neutral-colored, modern furnishings with one-of-a-kind, witty antiques. She designed a hammered copper bar for this space and enlivened it with a large antique mirrored sign. Having once hung in a London apothecary, it boldly reads, "Dispensing Department," unabashedly inviting guests to help themselves to refreshment. Jill's creativity extends outdoors as well, where she converted a vintage Air Stream into a pool house. With single-minded playfulness and wit, she paid tribute to the late 1950s, outfitting it with a pink-and-white-striped awning, pink flamingoes, and a life-size bust of Elvis that doubles as a lamp.

Jill's work has been published in popular magazines, and she has designed rooms for Vassar Show Houses, as well as for the Chestnut Hill Art and Design Show House. She remains an active member of the Interior Design Society, the National Trust for Historic Preservation, and the Preservation Society for Newport County, and frequents a variety of art and furniture collections. When away from work or at home with her son, Austin, and Springer Spaniel, Maggie, Jill combs auctions and yard sales to develop ideas and collect objects for future projects—and for her own enjoyment as well.

TOP LEFT
Down-filled chaises through Beacon Hill; Plumridge silk check drapery fabric; Drapery hardware by Finial Company; Barbara Barry table, Thomas Pheasant floor mirror through Baker Furniture.

BOTTOM LEFT
Wrought iron furniture by Wooward, Scalamandré fabrics complement antique oriental rug; Genie House copper lighting; architecture by Peter Zimmerman Architects.

RIGHT
Antique captain's chest; Hancock & Moore leather chair; Sherrill sofa wears Brunschwig & Fils chenille and bullion; art, antique rug, and accessories collection of owner.

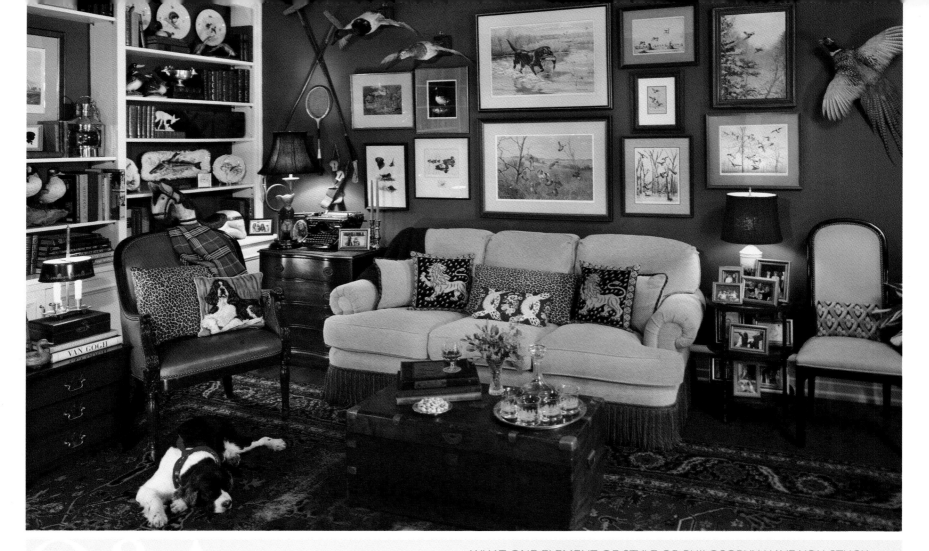

More About Jill

WHAT IS A SINGLE THING YOU WOULD DO TO BRING A DULL HOUSE TO LIFE?

Dull houses need inspiration, and inspiration comes from the use of color, texture, light and the placement of objects. A clean coat of paint does wonders to dissipate dullness and it is one of the easiest ways to brighten and enliven a space. In addition, I like to furnish tired rooms with at least one unique and unusual item that grabs attention. A colorful or interestingly carved center table placed in a sparse foyer, or a bright red Chinese ladder set against tall bookcases in an otherwise traditional living room will do the trick.

WHAT IS THE BEST PART OF BEING A DESIGNER?

I am able to travel to different parts of the world and decorate a variety of wonderful and unique spaces. I am fond of so many different design styles that I can't possibly represent them all in my own home. Working with diverse clients, though, I am able to explore and utilize the eclectic array of styles about which I am so passionate.

WHAT ONE ELEMENT OF STYLE OR PHILOSOPHY HAVE YOU STUCK WITH FOR YEARS THAT STILL WORKS FOR YOU TODAY?

I believe it is most important to carefully and attentively listen to clients and interpret their needs when decorating or designing spaces. I never wish to impose a design style on them, but rather want the color, furnishings, etc. to represent their unique personalities and tastes. I also think it is vital to incorporate personal items that are important to the client.

WHAT IS THE MOST UNIQUE/IMPRESSIVE/BEAUTIFUL HOME YOU'VE BEEN INVOLVED WITH? WHY?

I helped to decorate a large family home made up of individual cottages in Kenya. The home stands on a pristine animal preserve, and I looked to local artisans, furnishings, color schemes, and such to create interiors that reflect the naturally beautiful environment.

McNeil Design Associates, LLC
Jill McNeil
20 Golf House Road
Haverford, PA 19041
610.896.8720

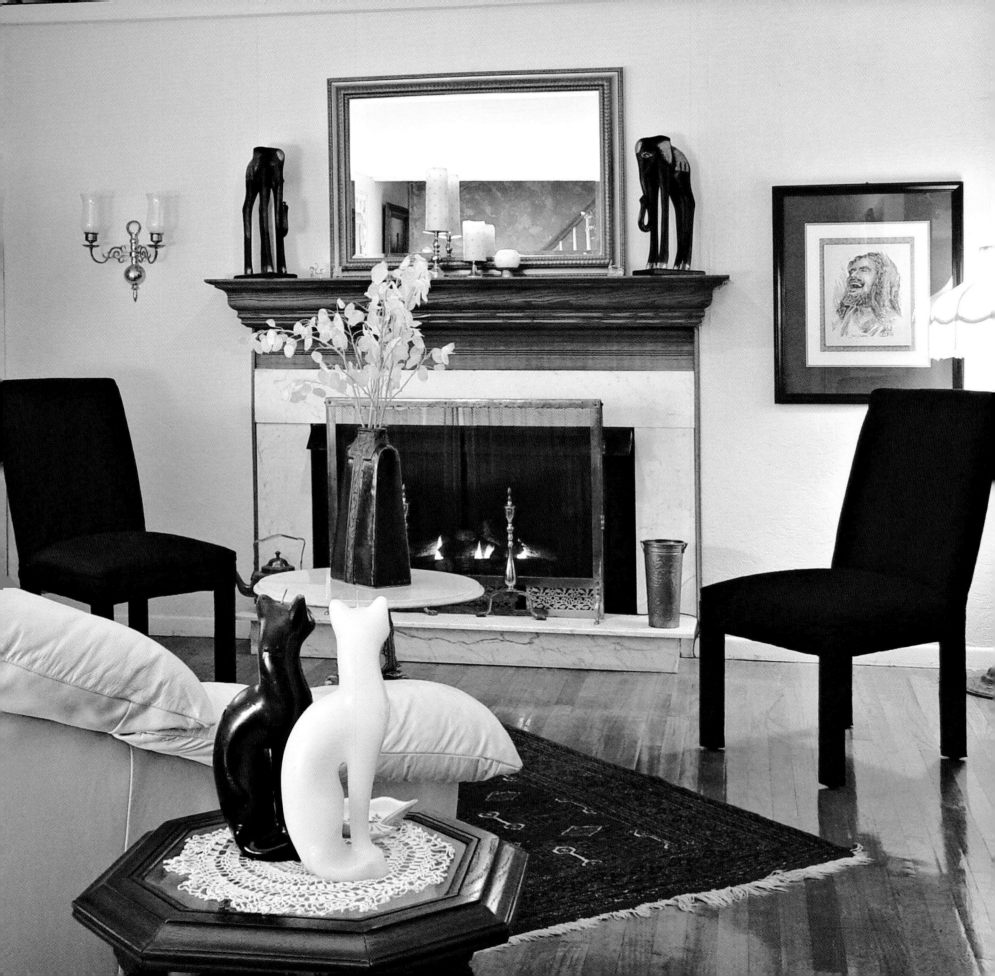

Living Designs Associates, LLC
Deana Murphy, ASID
P. O. Box 462
Bala Cynwyd, PA 19004
570.894.1166
www.livingdesignsassociates.com

Deana Murphy lives a purpose-driven life. With undergraduate and graduate work in economics and business, she left her corporate career and obtained a degree in interior design at Northampton College. She graduated with honors, and encountered her first professional design project before her commencement celebration. She successfully converted sections of a carriage house into the executive offices of a church and charter school.

Through Home and Garden's Television current lifestyle show, "Mission-Organization," Deana meets design challenges by seeing opportunities for erudition. In one recent show, she designed a basement bedroom for two where she demonstrated how to make sense out of confusion and bring order to chaos.

Deana produces tailor-designed solutions according to each client's lifestyle. She gives each client an assignment so there is a reciprocal approach to the design process. Deana believes everyone's design style emanates from within, and she balances applicable colors and textures to bring out the best in each client's style.

Deana's expertise ranges from traditional to modern, using her unique style of mixing the old with the new in perfect scale, proportion and balance. Her goal is that when the design process is complete, every client dwells in a peaceable habitat, safe dwelling and quiet resting place.

ABOVE
Special touches make this bedroom a relaxing retreat. An eclectic mixture of leather, antique silk and Afro-centric artifacts sets Caribbean essence beneath the alabaster glass fan.

LEFT
With its warm, unified mix, this den inspires conversations amid an asymmetrical balance. Black and white fuses a sophisticated simplicity by a cozy focal point.

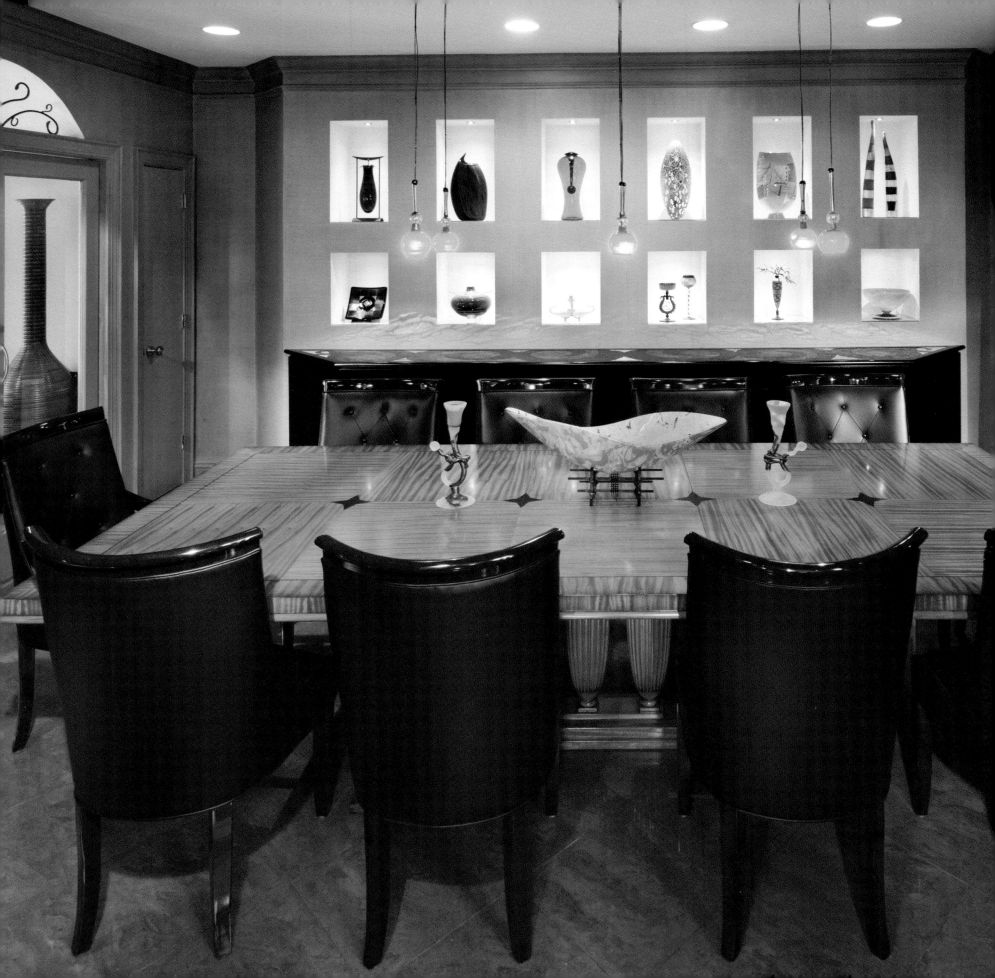

JOANNE BALABAN OLEN

JOANNE BALABAN DESIGNS, LTD.

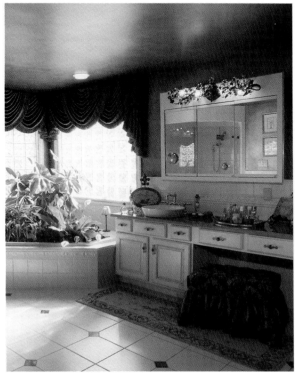

Joanne Olen, a Bucks County designer practicing in the Philadelphia region since 1980, is viewed as a latter-day Alchemist—transforming base materials into a precious object, the "Spectacular" space. With her characteristic flair, she first divines the wants and needs of her clientele, then effectuates that in an aesthetic, creative and functional way. She showcases those distinct sensibilities in an affectingly striking and elegant scheme reflecting the composite occupant persona. Joanne is best known for an eclectic amalgam of natural and high-tech objects and techniques. Think exotic woods cabinetry with fiber optic lighting, lush fabrics offsetting custom decorative metalwork, stained glass mosaics softening 21st century "electronica." She looks to express and amplify the complexity of a space, not defeat it.

Joanne pursued a design path from the outset, albeit at first commercially oriented. Graduating from Drexel University (culminating with stints at Architectural and Lighting firms; the latter, with venerable Raymond Grenald), Joanne worked as project designer at Kenneth Parker Associates doing mega-office space design for Fortune-500 companies. Wanting to branch out, Joanne opened her own business, doing a mix of commercial and residential. She skewed the practice toward the residential side, following the burgeoning growth in the Philadelphia suburbs (where many of her commercial clients had or acquired residences; like Joanne herself, a longtime Yardley resident); grew the firm's staff to four; and with a long-standing interest in the Arts, exhibited her paintings at galleries in New Hope and Gwynned Valley. She is currently preparing for her next show.

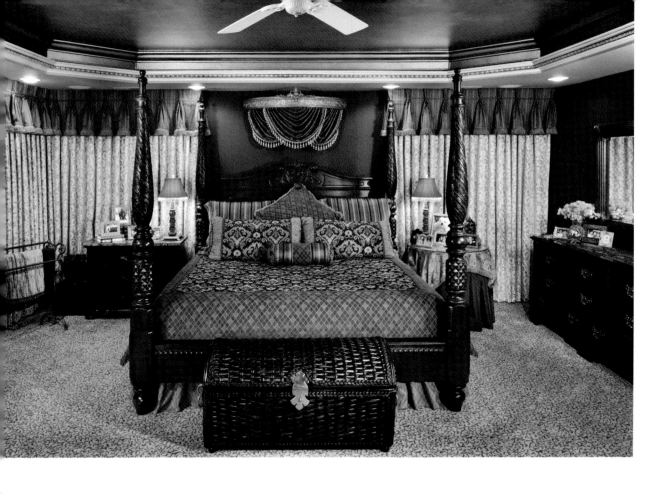

She is effusive when speaking about interior design as her calling. Whisking you through her dramatic home, dynamically lit to emphasize a wide variety of art (including her own Modern oil and acrylic paintings), one enters to black porcelain tile floors spanning the two-story foyer (Medieval style tapestry above) and kitchen. In the adjacent dining room, the floor morphs seamlessly into Black Galaxy granite, surrounding a Maggiolini inlaid olive wood dining table, seating 16 (acquired, like the exotic rug beneath, at auction). Armless scroll back chairs flank the table, which looks like it belongs in a castle; set off above by an Alabaster chandelier, and hand-painted night sky ceiling replete with gold leaf stars and bracket work framing. The kitchen features modern black Birch cabinetry, mellowed with textured glass inserts. An opalescent glass-tile backsplash on the exterior wall plays against the Crème Bordeaux granite counters, island, and full-height backsplash on the adjacent wall; across sits a cozy custom banquette seating (with storage beneath), surrounded by framed floral photos (shot by Joanne, an ardent photographer).

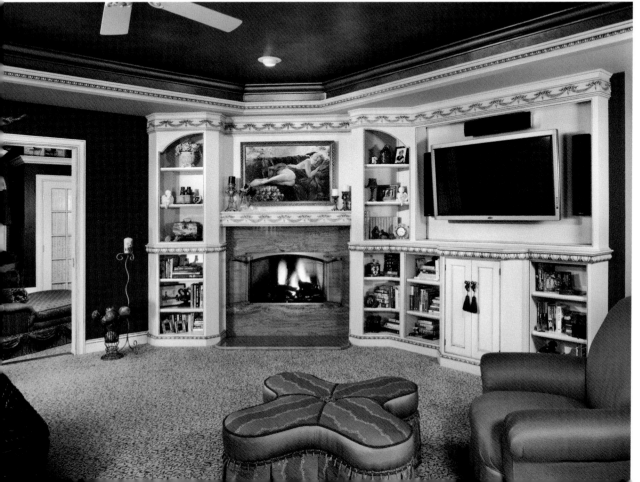

TOP LEFT
Traditional with a twist, bronze hand-painted ceiling with lighting coffer to match entertainment millwork, decorative corona above bed, plays off rich colors and lush fabrics.

BOTTOM LEFT
Granite fireplace surrounded by custom millwork, enhances the media equipment. Articulating mounting allows perfect TV viewing. Dressing room with eight illuminated lace covered French doors beyond.

FACING PAGE TOP
Media and entertaining space features custom designed Paduk and Purple Heart inlaid millwork, stained glass windows, hand-forged end and cocktail tables with pullout ottomans.

FACING PAGE BOTTOM
Millwork surrounds granite topped bar with sink and refrigerator; etched glass topped serving table with custom designed chairs support food service for media room.

The firm's work centers on Bucks and Montgomery counties, but extends through to the Princeton corridor, the New Jersey shore, and (recently) Manhattan, where it worked to relocate husband and wife art collectors from a Moorestown, New Jersey, home (originally designed by Joanne), downsizing to a three-bedroom Upper East side co-op. In the end, Joanne wants clients to feel strongly that her designs express the heart and soul of the home's habitués. After all, if one's home is one's castle, why not have it be for real?

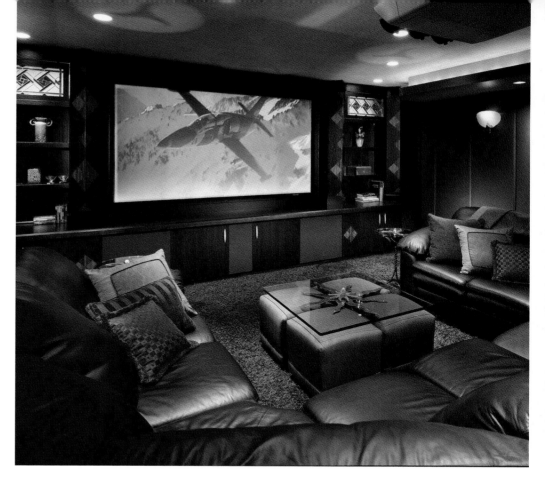

Q&A

More About Joanne

WHAT IS THE BEST PART ABOUT BEING A DESIGNER?

I love the challenge of meeting other people's needs; to make someone's life function better, and in the process make it more beautiful, is a wonderful thing. I also love designing the details; those nuances are what make each space unique.

WHAT ELEMENT OR PHILOSOPHY HAVE YOU STUCK WITH FOR YEARS THAT STILL WORKS FOR YOU TODAY?

Form follows function - and lighting is key. Light is the magic. If you don't illuminate something in a room, you don't see it. I love manipulating lighting to enhance the design.

WHAT IS THE HIGHEST COMPLIMENT YOU HAVE RECEIVED PROFESSIONALLY?

Tears of joy!

WHAT SEPARATES JOANNE BALABAN DESIGNS, LTD. FROM ITS COMPETITION?

Bringing their client's vision into perspective and fruition, without a "canned" or decorated look.

Joanne Balaban Designs, Ltd.
Joanne Balaban Olen
333 Oxford Valley Rd. Suite 302
Fairless Hills, PA 19030
215.943.1810
FAX 215.943.5118
www.joannebalabandesigns.com

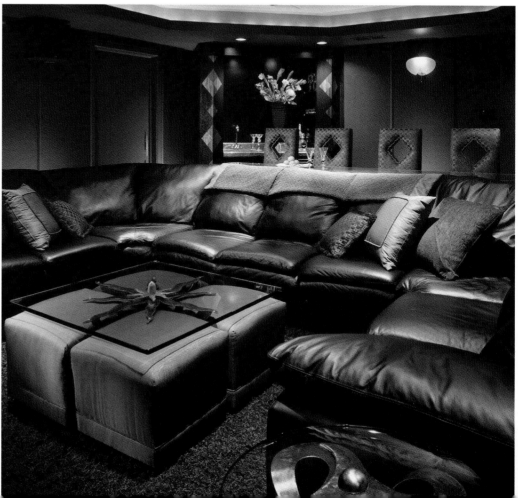

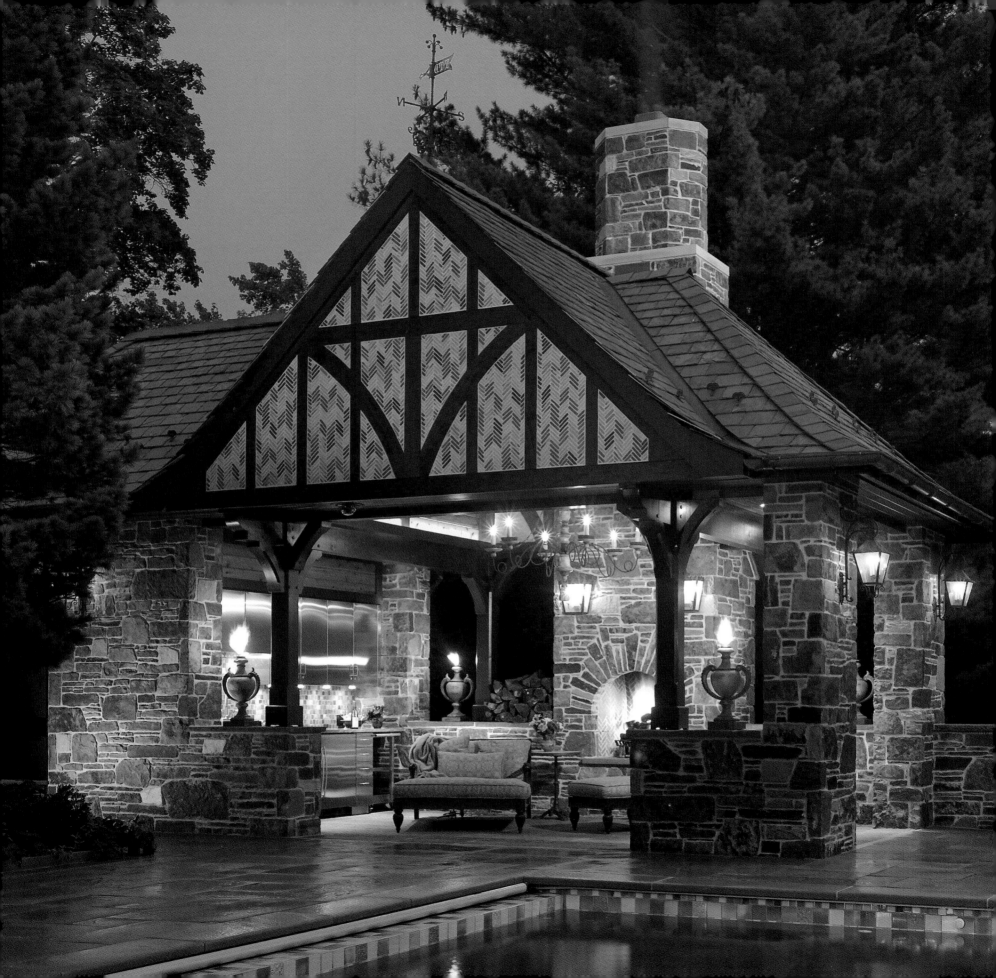

LORI SHINAL

LORI SHINAL INTERIORS, INC.

ABOVE
The designer in the recently completed living room. Lori worked with her decorative painters in creating the custom plaster ceiling and hand-painted silk fabric walls. The mantel is from the 1830s and was a treasure found on a buying trip to Provence.

LEFT
Known as the "gem" of the estate, this pool house was recently built to resemble the original 1929 English Tudor Manor. The elegant outdoor room is used year round.

L ori Shinal grew up as the daughter of a traditional family doctor and quickly learned the value of helping people. Her passion for creating special gifts for friends, hosting and catering fabulous parties and designing spaces of beauty and warmth led her to pursue a career in interior design.

Lori learned hands-on by working within the design field and attending Moore College of Art and Design. From there she launched her "boutique" interior design firm that caters to the high-end residential market, creating magnificent homes along the East Coast.

Her first project was a fabulous estate on the New England coast for an entrepreneur, his wife and three children. Lori helped to transform this modest 1,000-square-foot 1901 cottage into a spacious 12,000-square-foot home, capitalizing on the water views. To celebrate, Lori styled a party for 250 guests toasting the opening of "The Perfect Storm," filmed in the town.

Anyone who meets her instantly feels her warmth and her wonderfully unique approach to interior design. Lori believes that her role is more than creating beautiful environments for clients. She wants one's home to be a reflection of them, be conducive to their lifestyle and the product of their travels, passions and special memories. Lori truly enjoys working with her clients, taking their taste to a new level in the process.

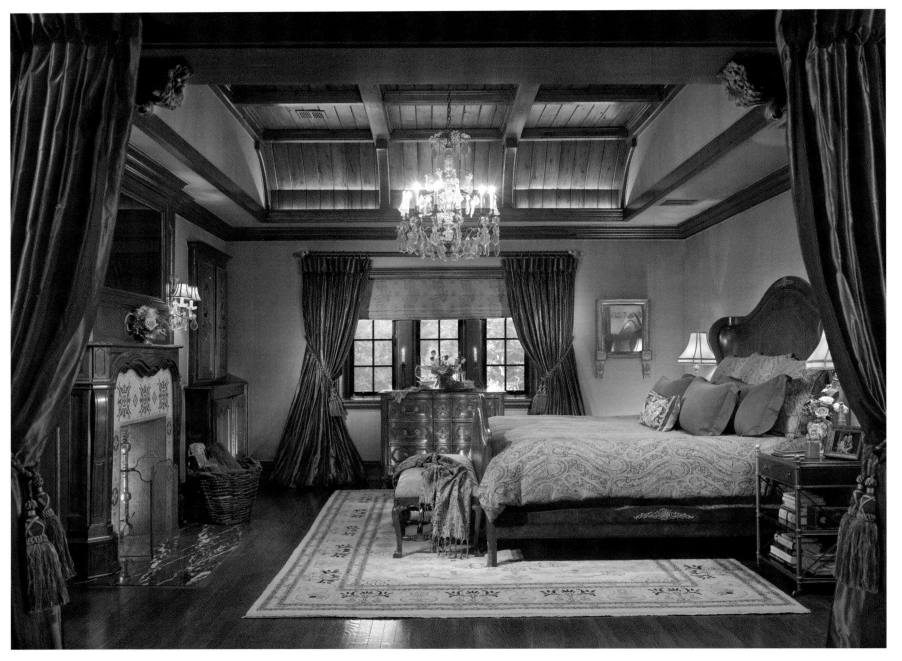

This master suite is filled with warmth and romance. A gorgeous antique chandelier hangs from the reclaimed wooden ceiling. Lori designed the marble mosaic surround to work beautifully into the 18th century French walnut fireplace mantel.

She loves entertaining and is the consummate host. Even when there isn't a fete, each Thursday she adds even more life to her home with beautifully designed European fresh floral arrangements created by Eileen McDade of rue Coco that are as jaw-dropping as this 1929 Tudor estate.

Her love of travel is evident in her design. "Buy things that are pleasing to the eye and remind you of great moments, places and people," Lori advises. Her unique finds are seen throughout her home.

Lori says she likes to think outside of the box and uses every decorative surface available—from the floor to the walls, moldings and her finishing touch is always the ceiling. Her attention to detail is impeccable. Some examples are the fabulous ceilings you will find in almost every room in

her home—hand-painted designs, reclaimed wood, custom moldings, wallpaper and sometimes even tenting a ceiling with red silk.

Lori lauds her tradespeople, putting trust in them and enjoying the process of collaborating with them to create the finest designs. Case in point, her highly regarded decorative painters, John Ferris and Meg Shattuck, are working on the formal living room today, the size of a small ballroom. Meg is painting her own design of red zinnias on a golden, olive silk that is upholstered on the walls, while John is testing shades of color for the dramatic decorative plaster ceiling he designed.

One of her final words of wisdom: "Adding architectural elements to a home will add character and warmth." In her own kitchen, the creative designer had the idea of building a grand hearth. She searched a stone reclamation yard in Provence to find old, charming, oversized bricks that resulted in the kitchen's centerpiece. She also found Swedish pilasters in the Paris flea market that inspired the design process for the dining room. 17th century corbels were found on another buying trip to France and are a focal point of the master bedroom. Each room has these wonderful elements that everyone loves to discover and enjoy.

Her motto has been to find things you love and work around them. While her clients will tell you she brings a level of professionalism to her work, she also brings fun to the table.

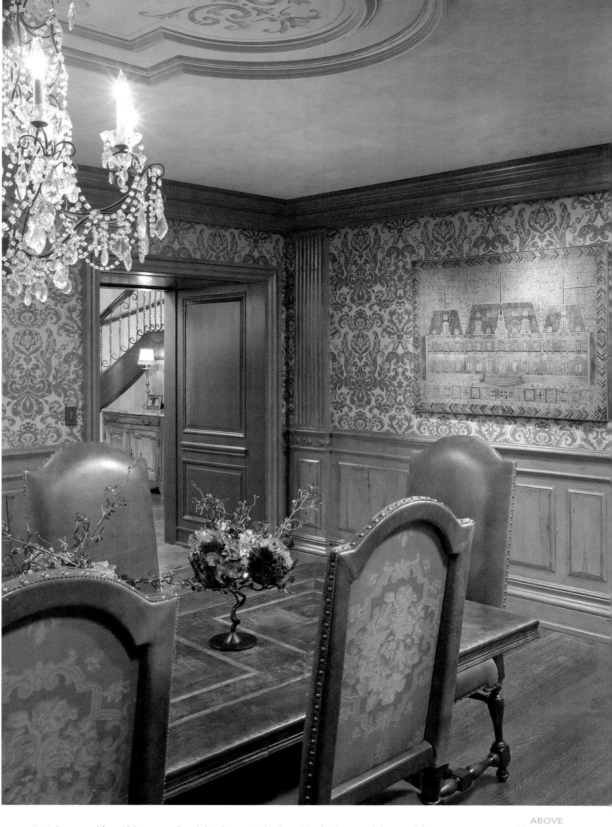

Lori discovered four 18th century Swedish pilasters in the Paris Marche Puce and designed the entire room around them. Her favorite piece of art is the antique mosaic wooden table top that she cut the base off of and hung in the dining room.

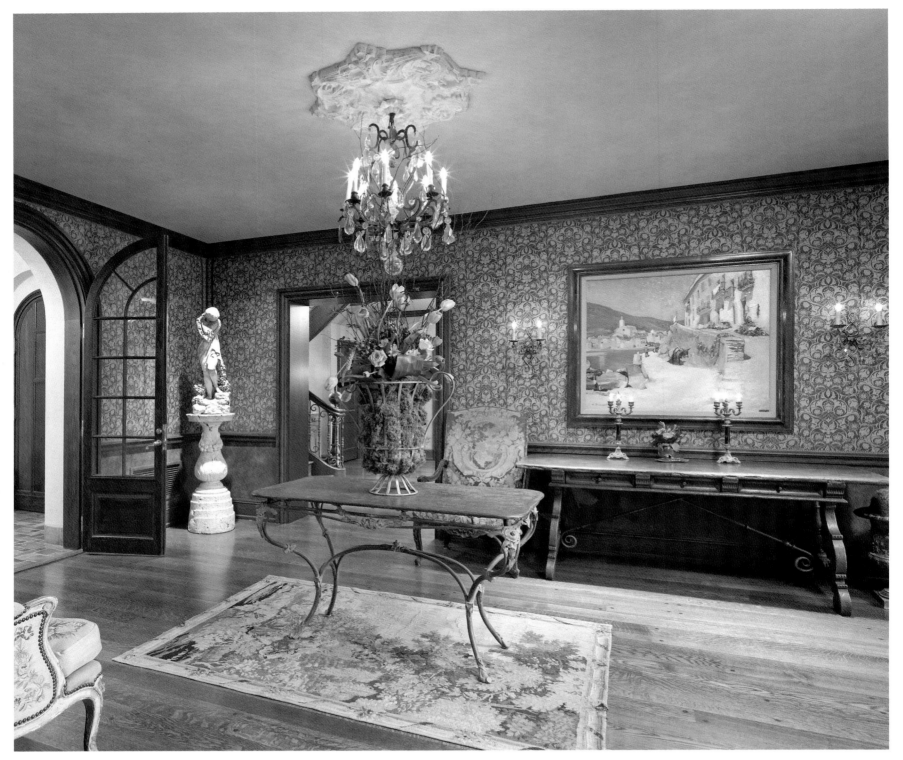

ABOVE
Bringing a bit of the outdoors in, the couple discovered this beautiful Hungarian garden table in their favorite shop in Nantucket.

FACING PAGE LEFT
The ante-room, also known as the dramatic entrance to the formal powder room, was inspired by the work of Jacque Garcia seen by the designer in her favorite Parisian hotel.

FACING PAGE RIGHT
The library is a beautiful mix of elements: houndstooth wallpaper on the ceiling, antique mantel from Provence, handmade encaustic tiles, luxurious fabrics and European oils on the walls.

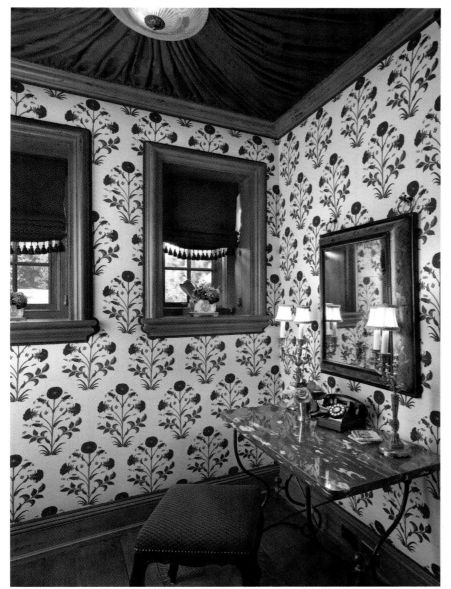

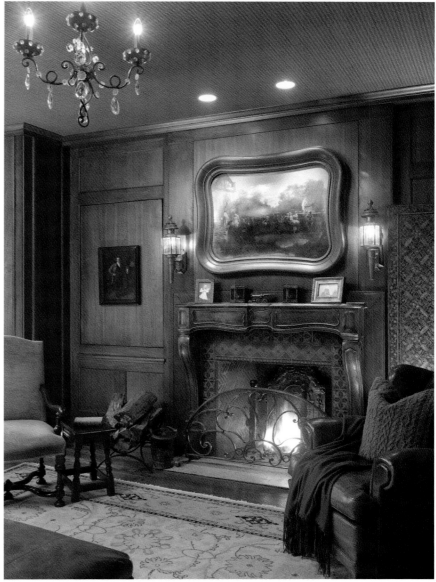

More About Lori

WHAT IS THE BEST PART OF BEING AN INTERIOR DESIGNER?

Making the client happy and the hunt for inspiration.

WHAT ONE ELEMENT OR PHILOSOPHY YOU HAVE STUCK WITH FOR YEARS THAT STILL WORKS FOR YOU TODAY?

Making things elegant but with a twist.

WHAT COLOR BEST DESCRIBES YOU?

Red. A splash of it in every room is my signature.

WHO WAS THE BIGGEST INFLUENCE ON YOUR CAREER?

Interior designer Pam Lindvall from Wilmington, Delware. She is a mentor who took me under her wing. I modeled my business after hers.

WHAT IS THE HIGHEST COMPLIMENT YOU'VE RECEIVED PROFESSIONALLY?

"Every time I walk into my house I smile."

Lori Shinal Interiors, Inc.
Lori Shinal
716 Williamson Rd.
Bryn Mawr, PA 19010
610.520.0810

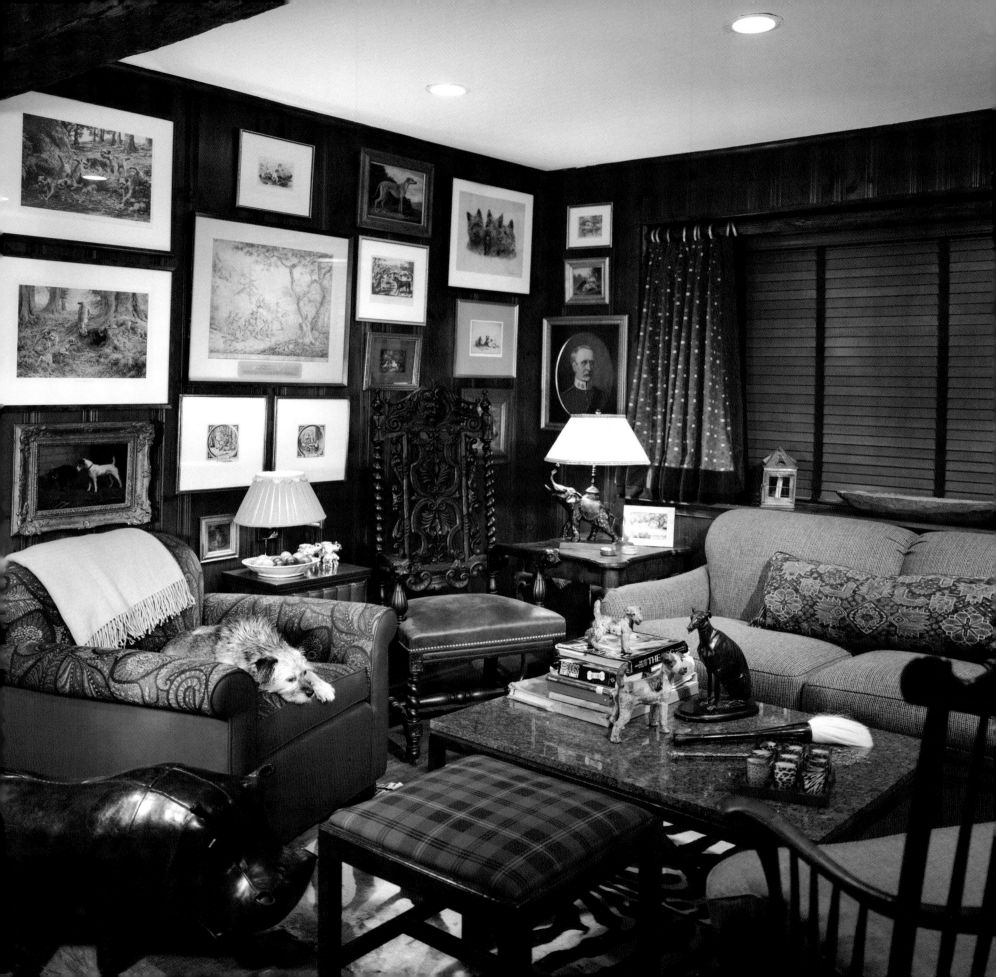

CAROLE SMITH

CAROLE SMITH DESIGN INC

Carole Smith has two borrowed phrases she loves to use when it comes to life and design: "Give me the luxuries of life and the necessities will take care of themselves," and "Houses should be lived in; dogs should be on sofas." Carole loves giving clients livable luxury; she adores dogs (she has five border terriers); Carole enjoys dance, puzzles and is on her way to mastering French as a second language.

This graduate of The University of Pennsylvania went back for her master's in interior design at Drexel University. Her master's thesis consisted of taking a warehouse and creating a cabaret theater, which was a runner up in a national restaurant competition. After finishing graduate school, she worked in contract design for a time, something that has served her well through the years. After all, an interior is more than just choosing blue or green, she confesses.

The affable designer is sharp, warm, and quick witted. She enjoys working with her design assistant Betty and they share a lively banter with the business manager Cindy, in their loft office space. Their projects span the East Coast from Maine to Palm Beach, with numerous projects done throughout the Main Line. The Smith signature is giving clients something

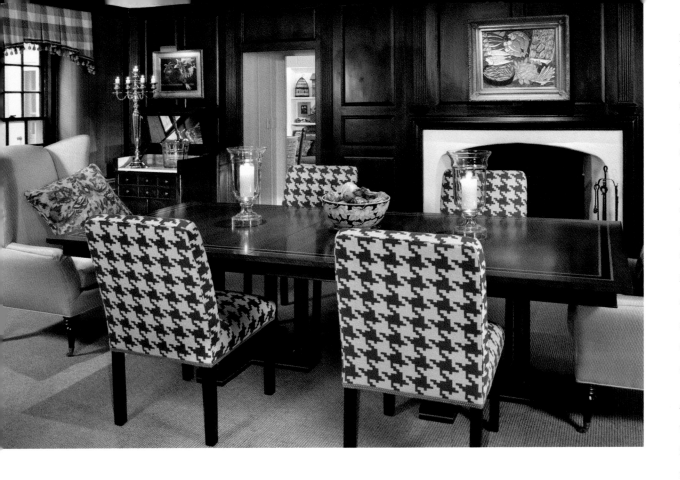

personal, comfortable, and aesthetically pleasing, no matter the style or period. Good design is in balance and proportion. Carole stresses quality and urges clients to get the best the budget allows, because quality is always the best investment.

Admiring such design greats as Billy Baldwin and Mark Hampton, Carole is currently tweaking an Upper East Side Manhattan apartment and her work includes a country farmhouse and residences of varying sizes. She feels much of the business is reassurance that the designer's ideas will translate into a reality which represents the personality and taste of her clients.

Asked what her own taste is, and she will tell you quickly: "I like stuff. If something is interesting and/or attractive, I'll buy it and use it, not hide it away." Carole's own home is full of books, antiques, with all styles of art and contemporary craft. Design is not about one definitive answer and look, or knowing everything there is to know—it is finding the right solution for your clients.

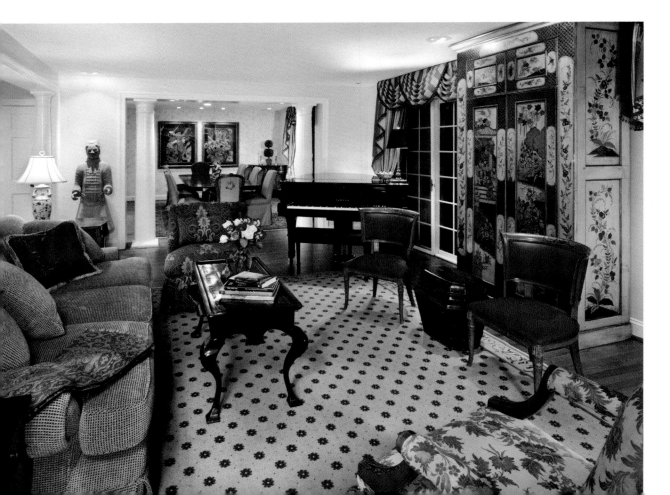

TOP LEFT
Chintz-covered walls and contemporary patterns add interest to this sophisticated dining room.

BOTTOM LEFT
An inviting entertaining area where two spaces combine by using matching draperies and similar colors.

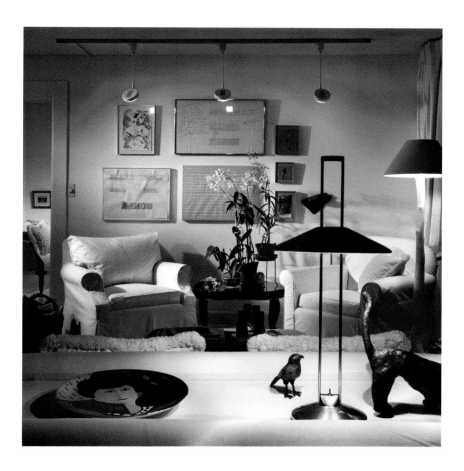

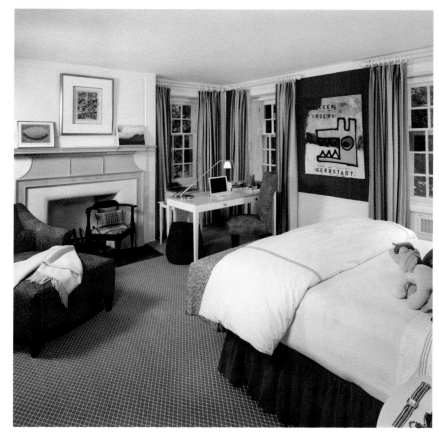

More About Carole

WHAT IS THE BEST PART OF BEING AN INTERIOR DESIGNER?

When it is over, because then you walk in and it looks so good—like being in labor and having your baby!

WHAT PERSONAL INDULGENCE DO YOU SPEND THE MOST MONEY ON?

Earrings and books. I can't go into a store and buy just one book. I read biographies, books on history and beach books.

WHAT ONE ELEMENT OF STYLE OR PHILOSOPHY HAVE YOU STUCK WITH FOR YEARS THAT STILL WORKS FOR YOU TODAY?

Comfort, quality, visual appeal and accessibility. I don't want it ever to be intimidating.

WHAT IS THE HIGHEST COMPLIMENT YOU HAVE BEEN PAID PROFESSIONALLY?

I have a client with many residences, and I designed a large house for the family. She found a bronze of dance shoes to give me, because I used to be a dancer, and she said, "Thank you for making my house a home."

WHAT COLOR BEST DESCRIBES YOU AND WHY?

Red or yellow, and sometimes together. If I am excited, I get effusive.

YOU CAN TELL I LIVE IN PHILADELPHIA BECAUSE I...

"...don't buy hats; I have hats." (A quote about old Philadelphians.)

Carole Smith Design Inc
Carole Smith, ASID
47 Tunbridge Road
Haverford, PA 19041
610.896.6873

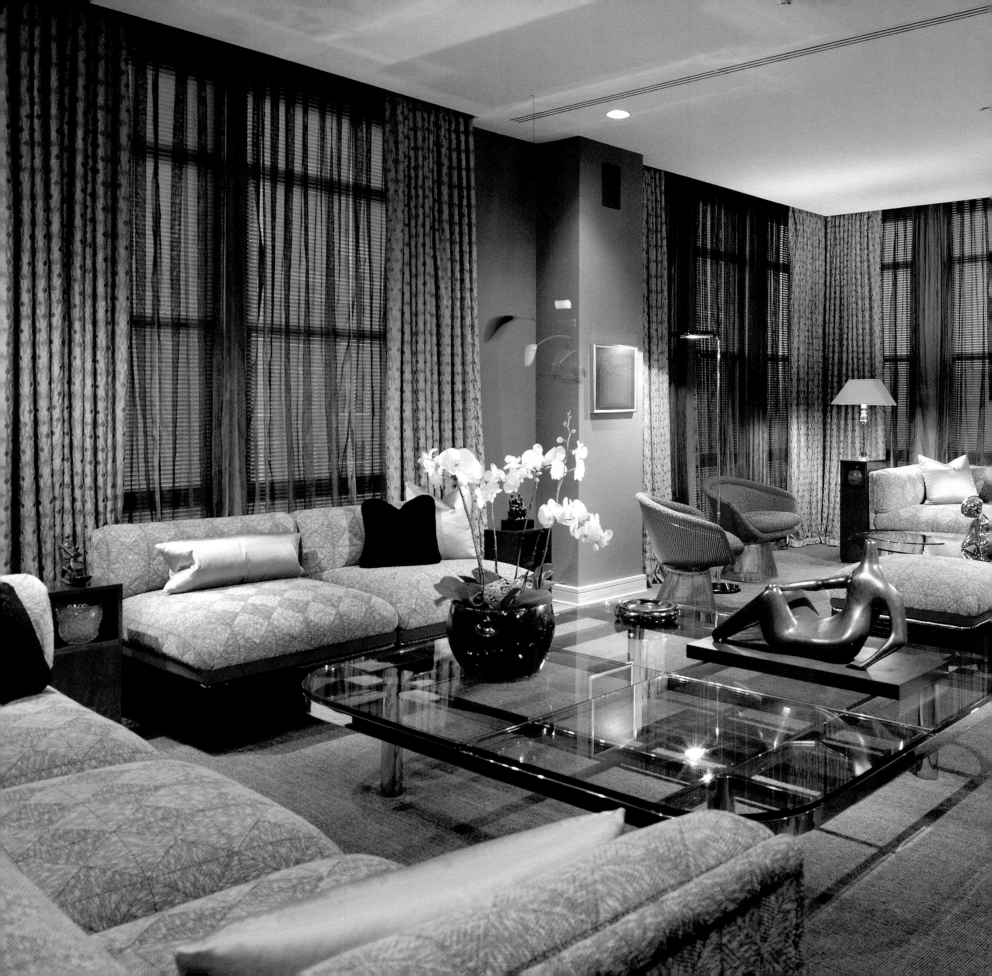

VINCENT SMITH-DURHAM

OBJECTS FOR ROOMS & GARDENS

Vincent Smith-Durham has had many incarnations, all of them very glamorous and none of them he's considered work. Vincent is a refreshing throwback to an era of high style and miles of moxie.

If he is not working with a client, you will find him at his Chester County home, Hav-A-Mil, tending to his most envious garden. He also likes to create gardens for his clients, as it is very important to have total environment inside and out.

When asked how he got his start or training, he declares: "Design is something you have to live; you can't study it in books. You either are or you aren't."

Vincent likes meeting and knowing his clients, then creating the environment. After all, decoration is a stage and we all want to be on it, he professes. His signature has been black-lacquered doors and white woodwork, but he doesn't have a formula for every house.

Although this designer adores what he does, he makes regular trips to his second home in Greece, on the island of Patmos, to recharge his batteries and surround himself with artists, writers, and musicians. He stays there for a month at a time, calling it a mystical place.

LEFT
The penthouse in Philadelphia features Alexander Calder sculpture on coffee table, Henry Moore arch sculpture on far table, chairs by Platner by Albers painting on wall.

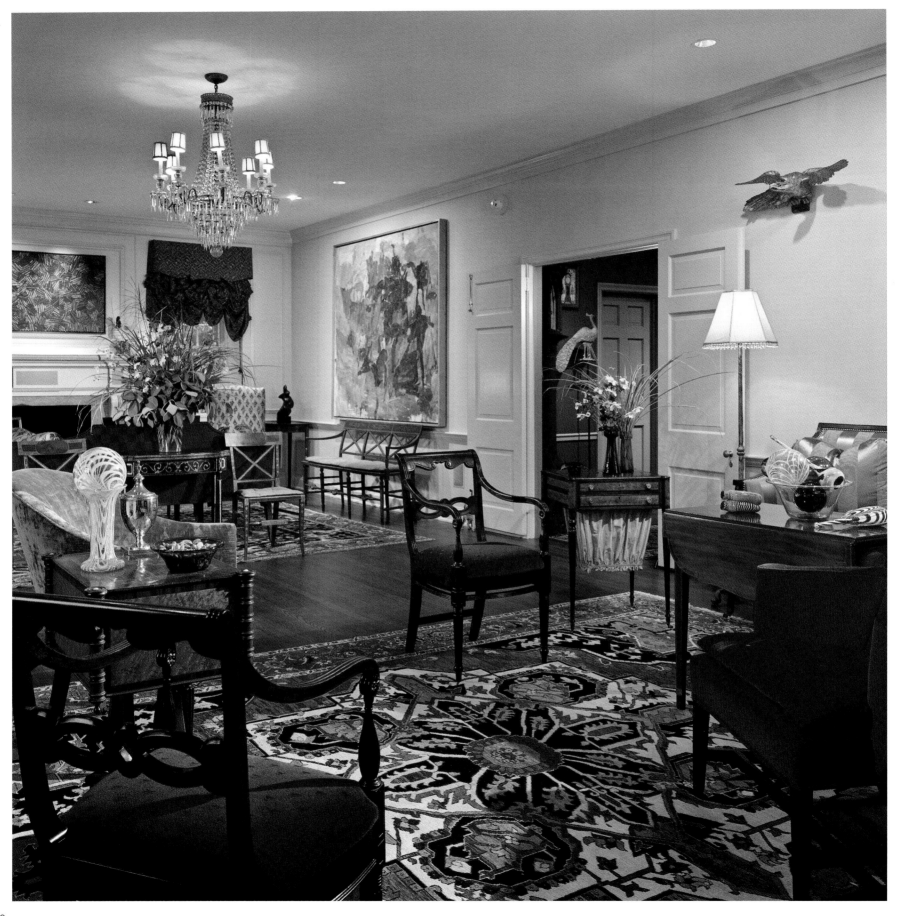

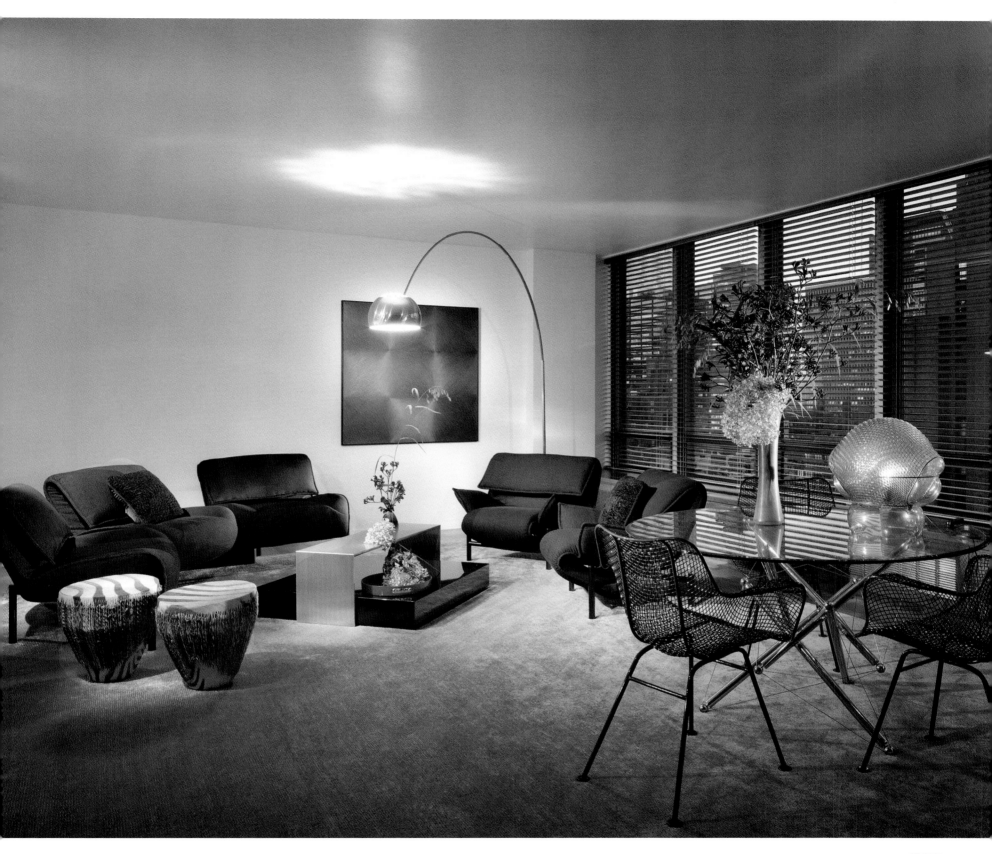

This New York apartment includes Graphite by David Roth, orange silk carpet by Sacco, African drum stools covered in zebra skin, and Arch lamp by Flors, Waddell table by Cassine, Russel Wright chairs.

The drawing room in a Main Line residence utilizes American Federal furniture, paintings by Phillip Guston and Jasper Johns, and a sculpture by Jacques Lipschitz.

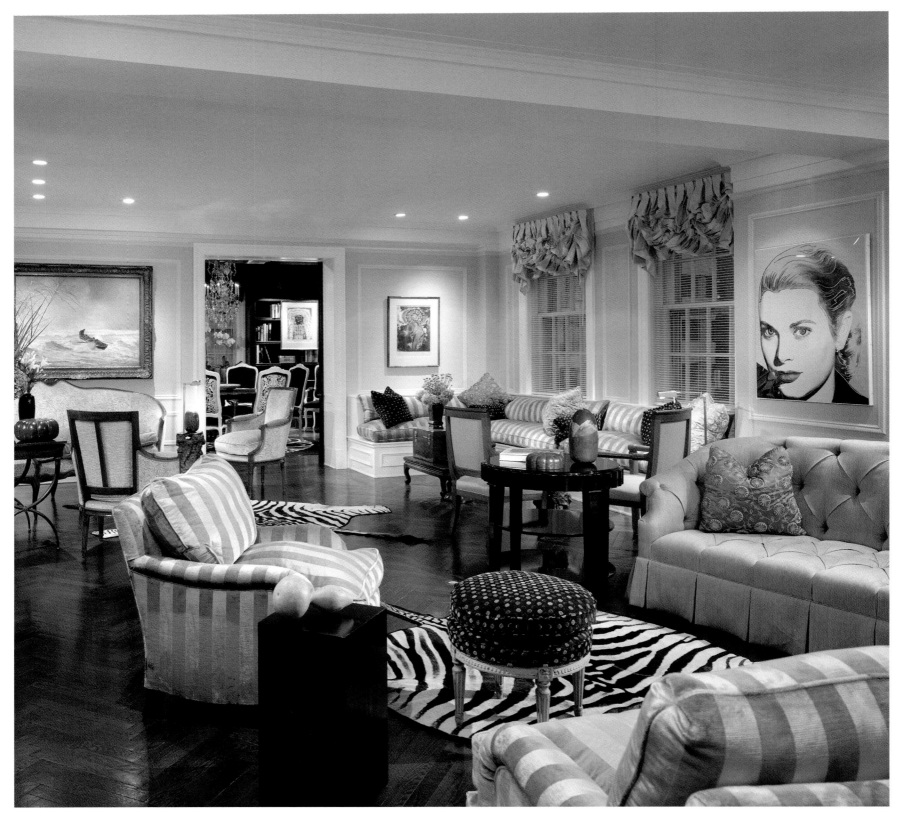

The designer showcased a sculpture by Toshika, and Lithography by Andy Worhol and Salvador Dali in this Philadelphia apartment.
Chairs are 1790 Directorie, stool Louis XV, dining room chandelier is Louis XIV, and the table is Black Lacquer Art Deco.

TOP RIGHT
This mixed assemblage of Continental furniture and art is found in Vincent's own home.

BOTTOM RIGHT
Decorators Escape from Beauty on Patmos, Greece.

More About Vincent

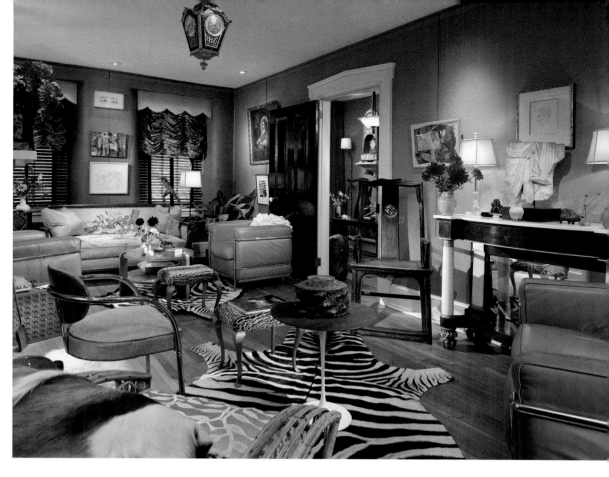

WHAT DO YOU LIKE MOST ABOUT BEING AN INTERIOR DESIGNER?

Always looking forward to something new and fresh.

WHAT IS A SINGLE THING YOU WOULD DO TO BRING A DULL HOUSE TO LIFE?

Give it color or demolish it!

IF YOU COULD ELIMINATE ONE DESIGN/ARCHITECTURAL/BUILDING TECHNIQUE OR STYLE FROM THE WORLD, WHAT WOULD IT BE?

The phony Colonial houses that pop up all over the eastern sea board.

WHAT IS THE HIGHEST COMPLIMENT YOU'VE RECEIVED PROFESSIONALLY?

Being invited into this book.

WHAT PERSONAL INDULGENCE DO YOU SPEND THE MOST MONEY ON?

My gardens.

WHAT COLOR BEST DESCRIBES YOU AND WHY?

Red—Red is around the world.

Objects for Rooms & Gardens
Vincent Smith-Durham
1651 Embreeville Road
Village of Embreeville
Coatesville, PA 19320
610.486.6013

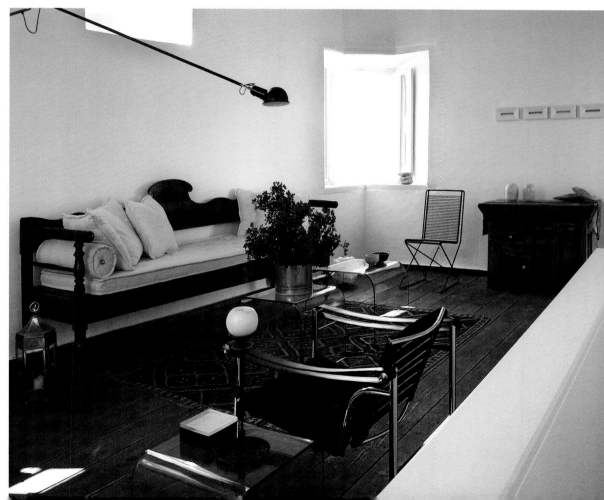

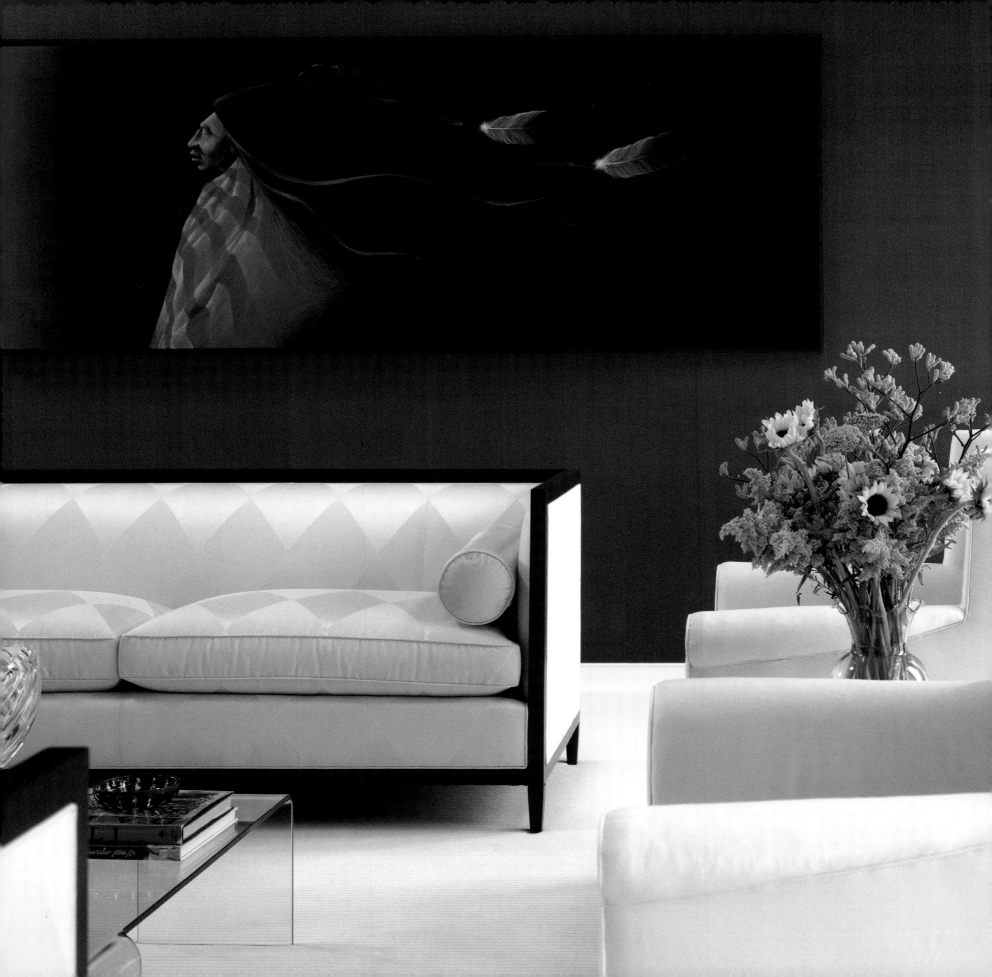

KAREN SPEWAK, BARBARA BOTINELLI & JOY KENDALL

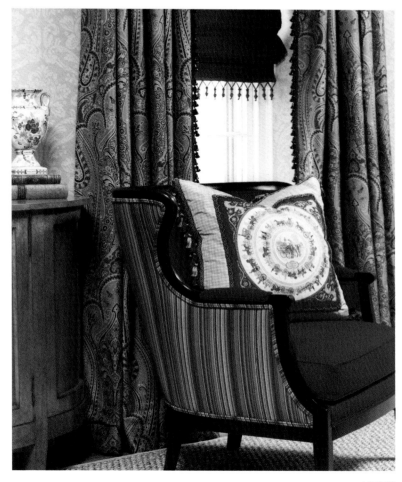

Richness and warmth—the ultimate wing back chair upholstered in red wool, traditional tapestry, custom pillow with Hermes silk scarves, perfect paisley drapery and red roman shades trimmed with wooden beads.

Modern, elegant and classic—Mahogany framed sofa with white silk geometric upholstery, white cashmere wing back chairs, Ralph Lauren's glass cocktail table and red silk Donghia wall covering, portraiture of an American Indian.

The trio called BNK Design is working at breakneck speed to ready the first Mitchell Gold and Bob William store in Philadelphia for its unveiling.

Mitchell Gold and Bob William, the eponymous designers of hip, clean-lined furniture, picked BNK to design the visual merchandising of the store. Clients, like Mitchell Gold and Bob William, turn to BNK because the firm is sensitive to good architecture and known for high style. BNK creations range from sleek and modern in bold red and white, to highlight a client's Native American art, to more traditional fare that incorporates eye candy in textures, colors and seating areas. These ladies have diverse taste. Heated discussions, which somehow always end with a laugh, are part of hashing out design solutions. Each is self-deprecating and complimentary of the other's strengths.

President Karen Spewak graduated from Pratt Institute in New York City, where she worked for 15 years before moving to Philadelphia. Karen was the assistant curator of art acquisition for Chase Manhattan Bank under David Rockefeller, and worked for high-end fashion designers like Issey Miyake. Designer Barbara Bottinelli, a graduate of Parson's School of Design, is a veteran of both residential and commercial design. Her vision is responsible for the bold, striking visual work

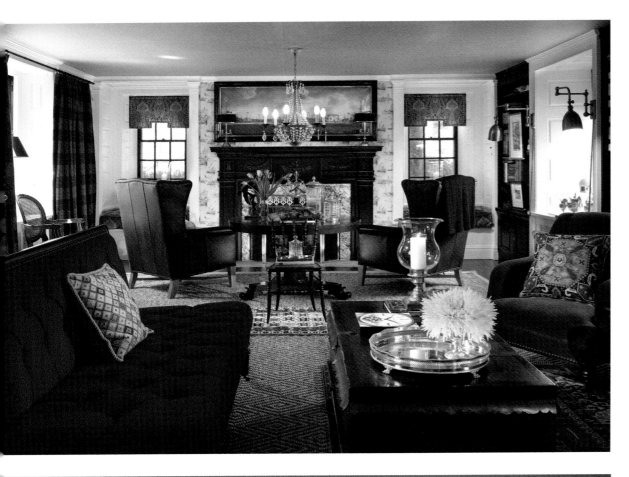

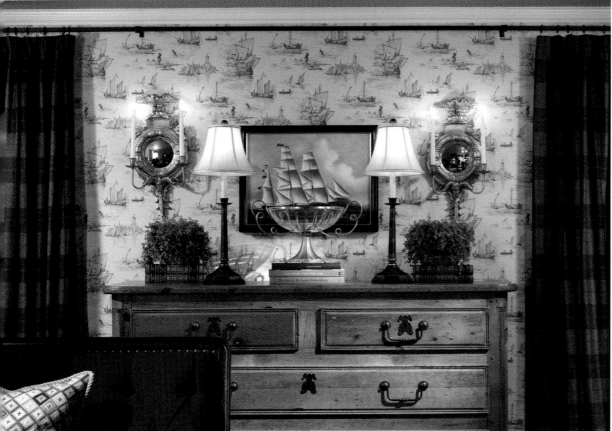

for which BNK is known. Designer Joy Kendall, a graduate of Philadelphia College of Textile, makes sure creative ideas become a reality. Each day, Joy juggles dozens of details on multiple projects to create sumptuous space for each client. The secret to their success is thinking long term. They do not design a room in isolation, as if it were an island, but in the context of the overall vision for the house. In their experience, a commission to design a room will eventually lead to commissions to design the next room and ultimately the whole house.

By quickly grasping and interpreting the client, these ladies help their clients fully understand their taste and preferences, as well as the process of designing new or redesigning existing spaces. In this luxury business, it is their job to express their client's desires more exquisitely and completely than the client would be able to do on their own.

This team manages to marry the style of the house with the design of the home. Many of their clients are in their 40s and are beginning to collect and want to plan a design around their developing collections. Collections and accessories make the house a home. BNK's forte is highlighting them throughout their design.

The firm can design or decorate an entire house or reinterpret an existing space to reflect changing tastes and lifestyles. Their one rule is to always decorate a room by matching it to the style of the home. Their active, dramatically layered, rooms have been featured in *Philadelphia Magazine, Philadelphia Home and Garden, Kitchen and Bath, Walls and Windows, BUCKS, House & Garden,* and *The Philadelphia Inquirer.*

More About Karen, Barbara & Joy

WHAT IS THE BEST PART OF BEING AN INTERIOR DESIGNER?

Barbara: Doing something you love and were born to do.

Karen: The transformation of spaces and the exploration of change. It is nice giving someone a home. It is nice to walk out of a house knowing you have given them a beautiful bedroom or family room they will enjoy for years to come.

WHO HAD THE BIGGEST INFLUENCE ON YOUR CAREER?

Barbara: I had a mentor named John Rosica who took me under his wing while I was still in school and told me to develop.

Joy: My grandmother introduced me to antiques and collecting of fine china at an early age. I fell in love with all of the intricacies of the pieces.

WHY DO YOU LIKE DOING BUSINESS IN PHILADELPHIA?

Philadelphians are not jaded. They appreciate improvements, advancements, and new additions to their city. Not being the biggest, but having the history and the bones, the incredible livability and the possibility of being one of the best makes for a good attitude. The people of this area are well informed and sophisticated, better balanced, and rational. Perhaps, it is part of the their history?

WHAT IS THE HIGHEST COMPLIMENT YOU HAVE RECEIVED PROFESSIONALLY?

Recognition from total strangers that have seen a project and expressed complete adulation. Open and honest, emotional response from a woman that said she began to cry when she saw how beautiful a particular room was.. Simple responses such as, "We love our home. It is beyond our expectations."

BNK Design Consultants
Karen Spewak
Barbara Botinelli
Joy Kendall
200 Barr Harbor Dr., Ste 400
West Conshohocken, PA 19428
610.941.2943
www.bnkdesign.com

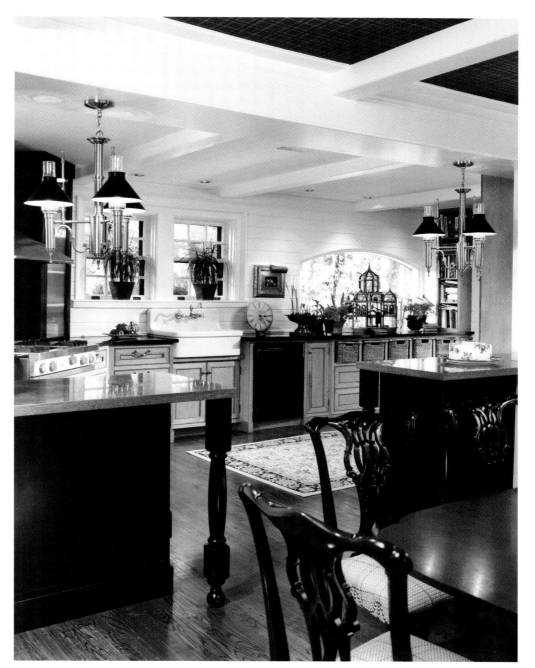

ABOVE
This 1800s Carriage House renovation includes a custom kitchen with bead board ceiling and beams, tartan plaid wall covering installed in ceiling area of dining room, black and natural oak handmade cabinets—nickel plated chandeliers flank the counters

FACING PAGE TOP
Formal farm house living, red wool tufted Ralph Lauren settee, brown velvet club chairs and brown leather wing backs from Mitchell Gold & Bob Williams, plaid wool drapery, velvet paisley window cornices—fabrics from Scalamandre, Sisal from Stark Carpet, Silver and antiques, BNK Design.

FACING PAGE BOTTOM
Ship motif wall covering from Scalamandre, Ralph Lauren Chest, Chelsea House wall sconces create a perfect section in this farm house family living room.

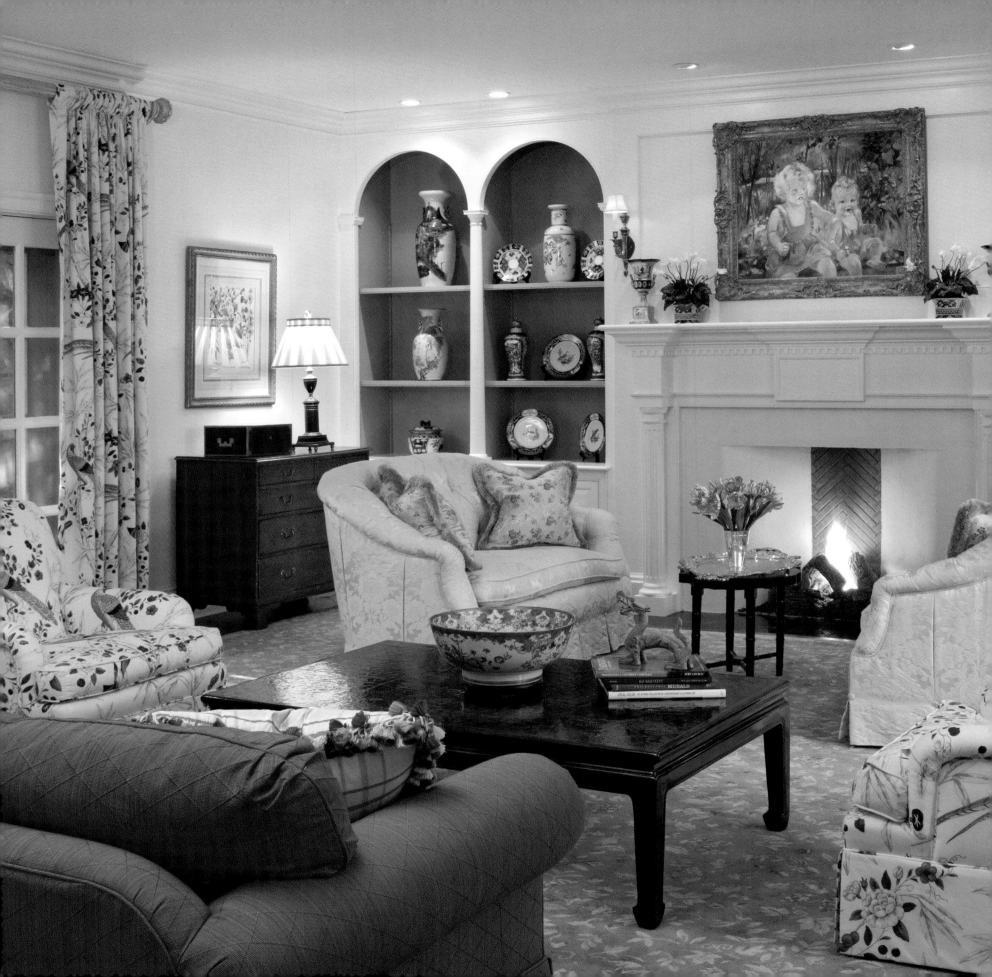

PENNY STEELE

MEADOWBANK DESIGNS, INC.

Penny Steele named the firm she opened in 1984 Meadowbank Design after her circa 1928 estate out on the Main Line. Penny may look like a local gal with her sunny blonde hair and bouclé suit, but her roots are far away from here. A native of Cuba, she spent time in China and studied at the University of Madrid, living near the Prado Museum, a place she visited almost daily. While raising children, a designer friend asked her to help with a project she had because she admired her taste. She stayed on and soon clients were asking to work with Penny, not only for her ideas but for her generous demeanor.

Her great personality has also landed her on many episodes of HG-TV's "Interiors by Design" and in many books—six to date. She is the perfect complement to the work of high-end traditional architects like Peter Zimmerman or firms like Archer and Buchanan, known for their craftsmanship and details.

Her style is traditional, integrating antiques throughout. She believes children should grow up with them, touch them, and have an appreciation for how they are made. For one client she used antiques as functional pieces—a giant armoire in the entrance foyer became a coat closet. The Bryn Mawr home was new but she made it to look 200 years old. The client asked for it to be unintimidating to friends. It featured rough-hewn beams from a barn on the kitchen ceiling, as well as Mediterranean tiles and his and her bathrooms—each one designed for the

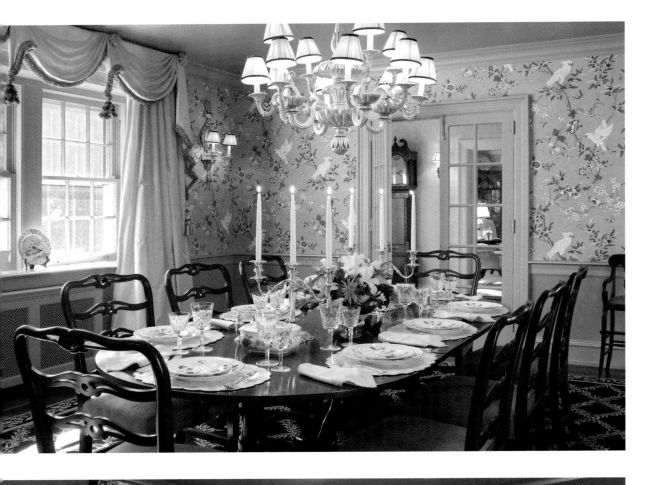

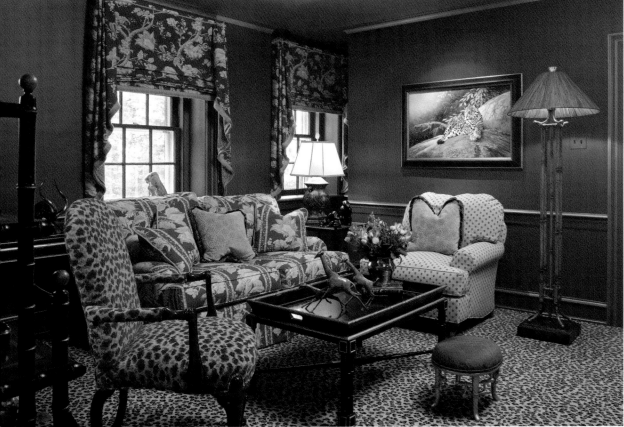

personalities. In one of the rooms, an all-wood ceiling was crafted by a carpenter who did finish work for Ralph Lauren. It resembled a boat hull.

Penny, has two other designers who work with her, Laura Beckwith and Kirsten McCoy. The firm takes on very big interior jobs and handles everything from electrical to millwork to tile work. She is honest, loves the challenge of a new project. Trust is a big part of this business and many Main Liners have hired her to do generations of their family's homes.

While the job is a big responsibility, she loves creating something unique for each client. She likes incorporating family history into a home and once hired a fine painter who painted a mural of what Gladwyne looked like 200 years ago for a client's dining room. Their house was tucked into the corner of the painting. For another Philadelphia estate, she designed rugs which had buttonwood trees like the ones that lined their entrance drive; she also had a special toile fabric made with the family dogs in it for a sofa. Her work has taken her from London to California, the Islands to Aspen where she created a Frank Lloyd Wright inspired home. The locale often influences the look. On her wish list of places to design: the Southwest.

TOP LEFT
Formality is expressed in this dining room with silk window treatments, a Wifton carpet and, of course, exquisite flowers.

BOTTOM LEFT
Cozy and dramatic, this library is the perfect place for quiet reading or entertaining one's closest friends.

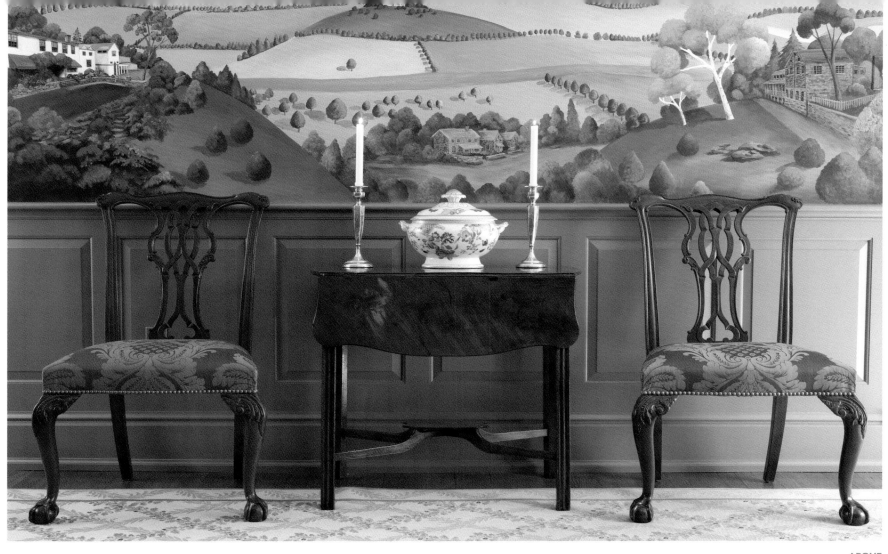

More About Penny

WHAT HAS HAD THE BIGGEST INFLUENCE ON YOUR CAREER?

Travel.

WHAT IS THE BEST PART OF BEING AN INTERIOR DESIGNER?

Creating for someone.

WHAT IS THE SINGLE MOST THING YOU WOULD DO TO BRING A
DULL HOUSE TO LIFE?

Put flowers in it. You want something alive. Use great lighting like the pieces I have found
while traveling in England.

WHAT IS THE HIGHEST COMPLIMENT YOU HAVE RECEIVED
PROFESSIONALLY?

Designing for generations of a family.

WHAT ONE PHILOSOPHY HAVE YOU STUCK WITH FOR YEARS THAT
STILL WORKS FOR YOU TODAY?

Honesty.

WHAT IS THE MOST EXPENSIVE DESIGN TECHNIQUE YOU'VE USED IN
ONE OF YOUR PROJECTS?

Collectible antiques.

Meadowbank Designs, Inc.
Penny Steele
37 West Ave., Suite 101
Wayne, PA 19087
610.688.8090

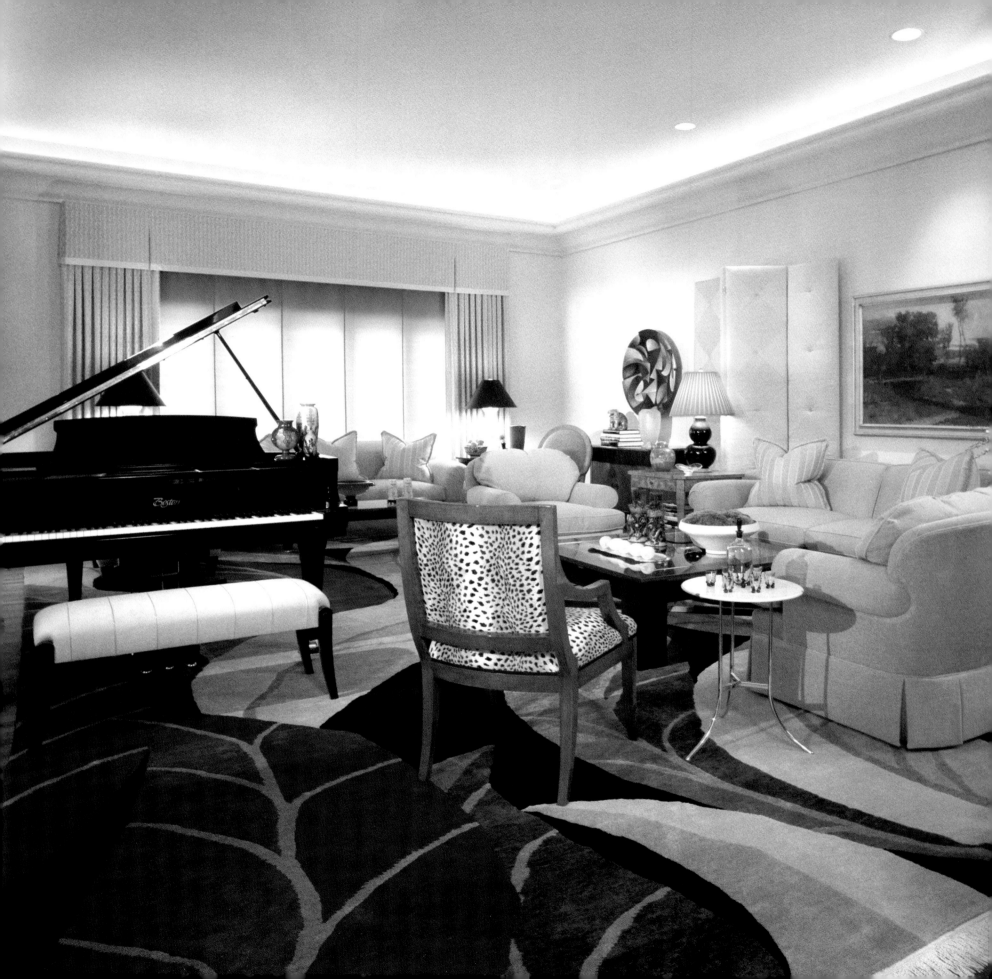

LISA STONE

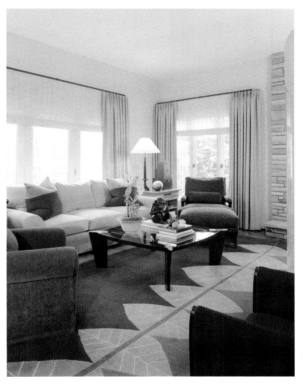

L isa Stone spent a day traveling from Philadelphia to New York and back in pursuit of the perfect orchid cache pot to place in her room for a recent designer show house in Chestnut Hill. For that same room, she commissioned a Pennsylvania Academy of Fine Arts graduate to do an oversized oil to sit overtop an ultra suede banquette she custom designed. The rich silk mattes on the antique botanicals in the room were hand selected from Beacon Hill's extensive library. Conical-shaped acrylic tables were carefully chosen from a designer showroom in Washington, D.C. It is this kind of painstaking care, detail and intense focus she puts into her work everyday. Lisa's love and passion for interior design is apparent in every breath she takes.

While many designers are passionate about their profession, there seems to be no separation between design and ordinary life for Lisa. A trip to the theater, a stroll through an art museum or a walk on the beach, continually inspire a myriad of ideas for her projects. Growing up in Pittsburgh, one of eight children, her mother fostered her deep love for painting, sculpting and

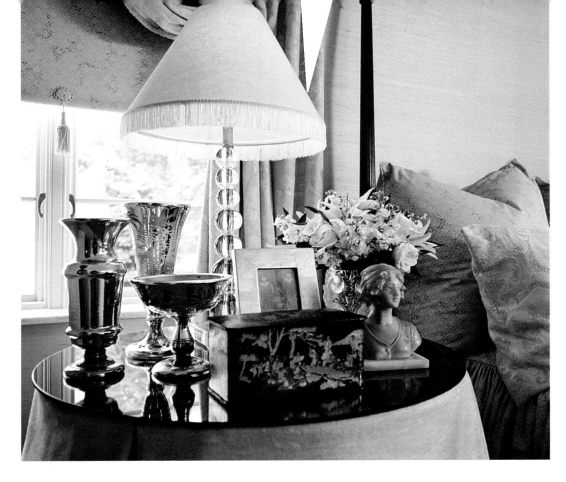

metalsmithing from a very young age. When she was having her kitchen renovated, Lisa, at 13, told her mother's designer that the hardware she was suggesting was improper for the cabinets. She helped her mother with the kitchen and the rest of the house instead.

A graduate of Drexel University's Interior Design program, she now enjoys the unique challenge of every design project whether it is a 16,000-square-foot grand estate or a 1,000-square-foot waterfront condominium.

Lisa's keen ability to envision her client's needs enable her to work closely with them to create original interiors that always reflect their taste, lifestyle and interests. Her award-winning, published work illustrates her honed skill at crafting one-of-a-kind rooms in all design styles. Whether a room is traditional, modern or eclectic, Lisa always strives to design spaces that are inviting, sophisticated, livable and timeless.

Lisa's demanding schedule takes her from Philadelphia to New York, Washington D.C., Palm Beach and Jackson Hole. Her personal forte is juxtaposing various pieces—whether contemporary and antique or traditional and ethnic. Lisa layers jewelry, her favorite indulgence, much the same way. She'll wear vintage Miriam Haskell with modern Marlene Stowe, something inherited from her grandmother and an inexpensive piece from an island vacation all on the same day. The disparate pieces all work together just like the elements in her harmonious, beautifully designed spaces.

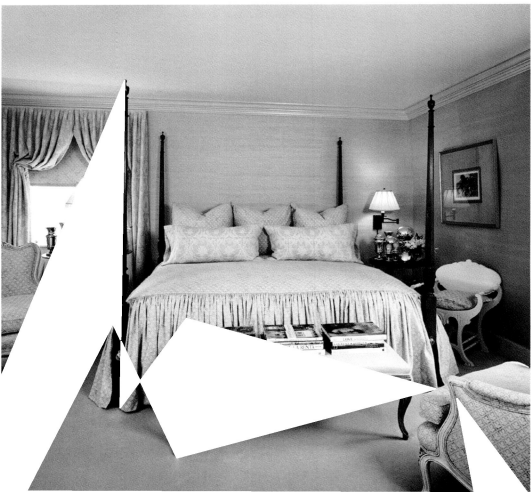

TOP LEFT
A Scalamandre linen velvet skirted table displays part of the client's extensive antique mercury glass collection, which gives the room a lovely and timeless sparkle.

BOTTOM LEFT
This sumptuous master bedroom is wrapped in luxury with its silk upholstered walls and warm taupe palette that is further enhanced by antique French chairs and a gold leaf Nancy Corzine bench.

RIGHT
Rich Chinese red lacquered walls envelope this cozy reading room with its scrumptious chocolate brown Stark carpet, acrylic drum tables and custom ultra suede banquette.

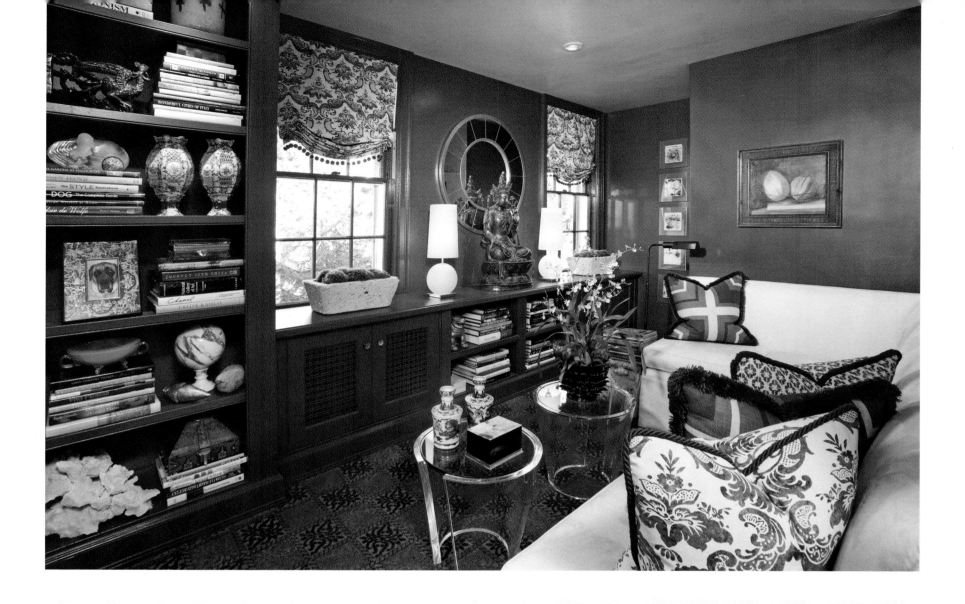

More About Lisa

WHAT COLOR BEST DESCRIBES YOU AND WHY?

Red, because it can be warm and inviting, passionate and intense and energetic, exciting and fun.

WHAT IS THE BEST PART OF BEING AN INTERIOR DESIGNER?

The incredibly positive impact that I can make on the way my clients live and feel. Their entire outlook on life can be greatly changed and enhanced by the creation of a new space.

WHAT PHILOSOPHY HAVE YOU STUCK WITH FOR YEARS THAT STILL WORKS FOR YOU TODAY?

To always carefully listen to what my clients have to say.

WHAT IS THE HIGHEST COMPLIMENT YOU HAVE RECEIVED PROFESSIONALLY?

Anytime I receive a referral from a client, I feel I have received the ultimate compliment. It means they value my work enough to share it with someone they care about.

WHO WAS THE BIGGEST INFLUENCE ON YOUR CAREER?

My husband, who encouraged me to strike out on my own and, to this day, is a constant source of support, guidance and love.

Lisa Stone Design
Lisa Stone
116-0 Montrose Square
Rosemont, PA 19010
610.525.3091
www.lisastonedesign.com

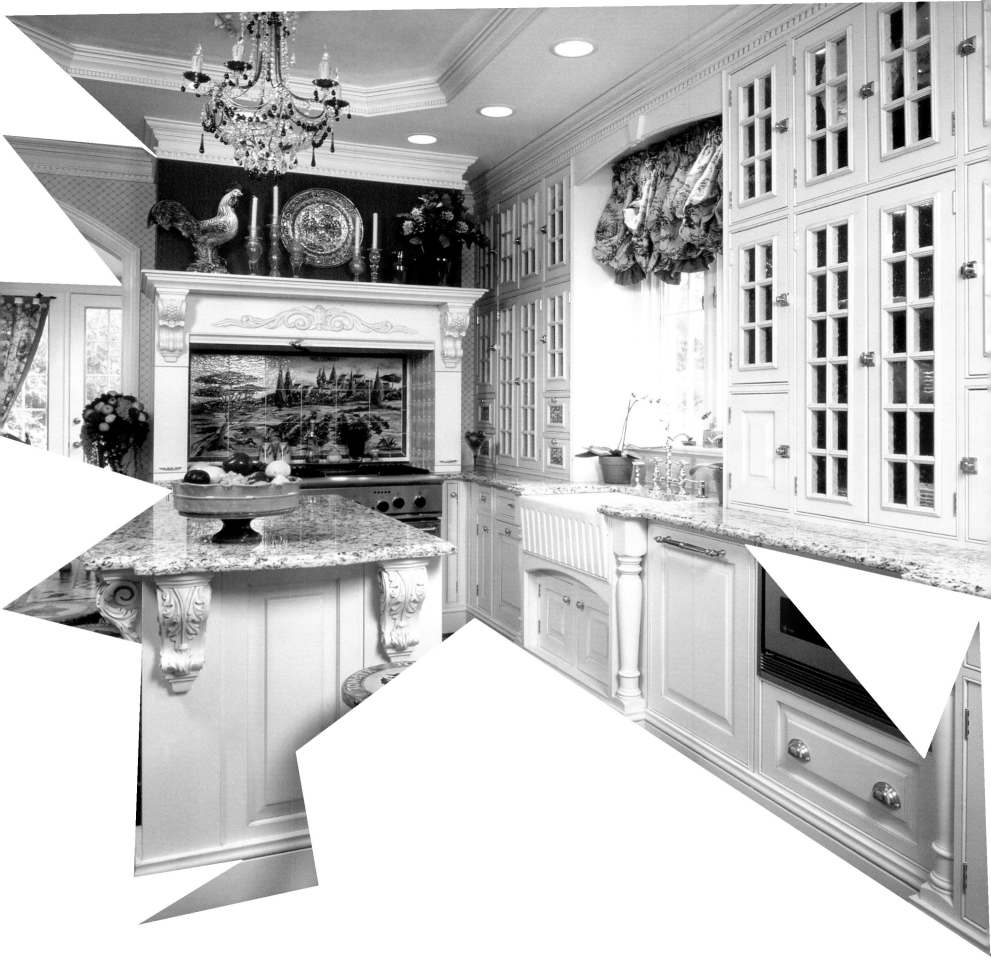

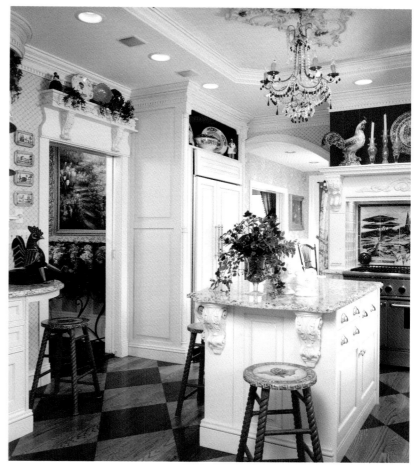

A touch of eloquence is evident in this French inspired kitchen. From the hearth hood to decorative corbels and full length mulling glass doors.

Custom details such as the coved ceiling, checkerboard hardwood stained floor, red painted hood and interior accents embellish this kitchen design.

Julie Stoner, CKD, ASID, opened The Rutt Studio On The Main Line in Wayne six years ago, with the mission to design unique kitchens that will reflect her clients' personal taste and style preferences. Her award-winning designs feature fine hardwood cabinets finished in custom created colors. Cabinetry pieces crafted to resemble free-standing furniture, islands both stunning and practical, hearth hoods evocative of those found in Tuscany, all find their way into Julie's kitchens.

Recently she won first place in the annual NKBA contest recognizing design excellence. Julie was further honored for this design by her peers when they chose her design to represent the United States in a world competition held in London.

Drawing on the colors and architectural elements seen during her travels is Julie's method for finding inspiration. She used the sun-drenched colors seen in Italy as the basis for her signature palette of rich paint and glaze combinations. The attention to detail she brings to her designs makes a Rutt Studio kitchen highly sought after.

Julie is an interior design graduate of the University of Illinois whose work has been published in *Kitchens by Professional Designers*, *Woman's Day Kitchen and Bath*, *This Old House*, and *Chesapeake Home*.

The Rutt Studio on The Main Line
Julie Stoner, CKD, ASID
503 W. Lancaster Avenue
Wayne, PA 19087
610.293.1320
www.ruttstudioonthemainline.com

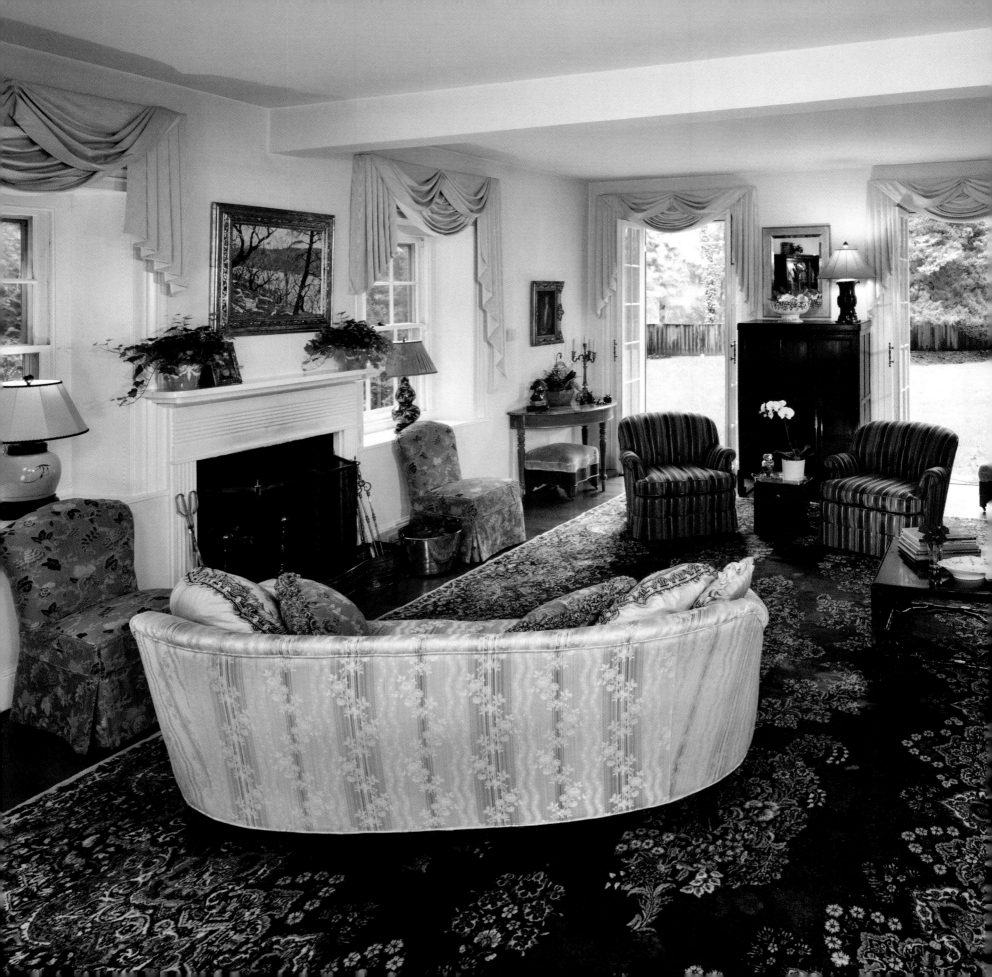

JANE M. YEUROUKIS

JANE M. YEUROUKIS, INC.

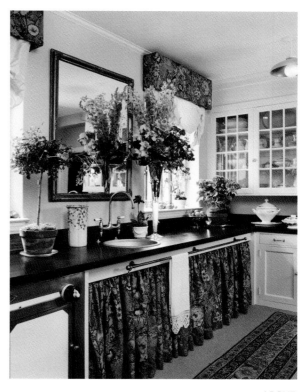

Jane Yeuroukis is somewhat of a late bloomer. Even though she knew she wanted to be an interior designer as a child, she did not attend New York School of Interior Design until she was in her 30s. Now, more than a decade later, she and her partner, master carpenter Tom Carbone, are linked in business and in love. With a nod to the past, they enrich and enhance their clients' homes in Princeton and Bucks County.

The spirited and elegant designer is perched on a slipcovered antique chair in the living room of Marge Manor, a grand stucco circa 1762 house, on the Delaware River, a former 350-acre tobacco farm. She is flanked by her matching butterscotch mates, her devout Golden Retriever, Dewey Dog, and Mr. Hunter Meow. Hunter is pouncing from chair to chair—linen and cut velvet slipper chairs Jane created for a designer showhouse and simply could not part with. Her Yardley home and Whimsy, her oceanfront house in Rhode Island, are a testament to her love for renovating and preserving history. The kitchen, which dates to the Civil War, is now fun and serviceable, allowing Jane to cook creatively. Her homes and her business have her living design seven days a week.

Jane is totally involved—from the redesign of the renovation of Whimsy, to rolling up her sleeves, scraping paint and loading the dumpster. It is her dichotomy that makes her so refreshing. One

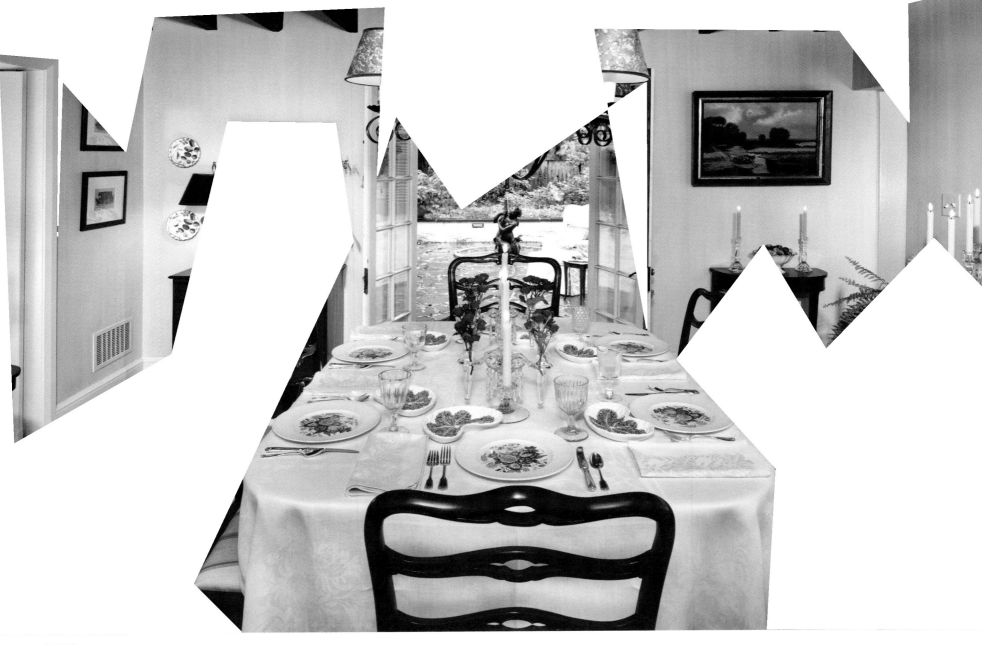

appointment she shows up in the Mercedes and another in a Jeep; she has a penchant for vintage furs, even wearing one to shovel snow.

When in Rhode Island, she is always on the prowl for clients, scouring shops for old furniture she can give a Cinderella second life to and pieces she can turn into quirky accessories. A giant silver tray she bought sits on a painted wooden base and holds makeup and cosmetics. An old pine cupboard in her bedroom is filled with her sweaters, many in pink, a color she loves for its range—from very vibrant shades to very soft and quiet hues.

She often builds rooms around one element—a rug, a treasured family chair—and encourages her clients to use sparkling color to bring their houses to life. Her living room is a silvery grey, the perfect backdrop for her elegant camel back sofa and local landscapes by area artists. Her palette is serene and sophisticated—from flax to blueberry to shades of pink. To test colors with clients, she paints color boards and suggests that they live with them before committing to the color. Engaging the client to participate and enjoy the process, she knows, will be positive for the end product, and most importantly, be a reflection of them. Her credo: If it is beautiful and functions, is warm and comfortable, then she has done her job.

Her design influences are her joy of everyday living, the emotion of color and her life experiences.

In addition to the pleasure of infusing their old beach house with new life, Jane and Tom also enjoy participating in area designer showhouses. One of their favorites was the Regents Meade Designer House in Princeton, New Jersey, where they revived the butler's pantry, recreating the mahogany countertop and filling the glass-fronted with beautiful antique porcelains, many from Jane's personal collection.

More recently, they collaborated on the Bucks County Designer House. Jane, a native of the Pittsburgh area, has lived in Bucks County for 20 years, a place she now calls home. It is the magical mix of historical ambiance, the richness of resources available, and an appreciative clientele that impart such a special feeling to Bucks County.

ABOVE
The receiving room at Valley Farm, The Bucks Country Designer House, 2005.

More About Jane

WHAT PERSONAL INDULGENCE DO YOU SPEND THE MOST MONEY ON?
Whimsey, my oceanfront home in Rhode Island. We enjoy this house year round, whenever we can get away for a few days.

WHAT BOOK ARE YOU READING RIGHT NOW?
The Art of Rockefeller Center by Christine Roussel as well as a books by Danielle Steele!

WHAT DO YOU LIKE MOST ABOUT BEING AN INTERIOR DESIGNER?
I delight in the complete project! I enjoy the design challenge, the client interactions, and the designer relationships.

WHAT ONE ELEMENT OF STYLE OR PHILOSOPHY HAVE YOU STUCK WITH FOR YEARS THAT STILL WORKS FOR YOU TODAY?
I believe in the style elements of good design—regardless of style, traditional, contemporary or eclectic. It is critical to respect the function of any given space—the proportions of the furnishings and the relationship of color to function and proportion.

WHO HAS HAD THE BIGGEST INFLUENCE ON YOUR CAREER?
No single person has influenced me. I regularly attend lectures/talks given by well known interior designers, fabric and rug designers, and other knowledgeable and respected design related individuals. These professionals, combined with my own experiences, have influenced my design process.

Jane M. Yeuroukis, Inc.
Jane M. Yeuroukis
Marge Manor
651 River Road
Yardley, PA 19067
215.295.3338

THE PUBLISHING TEAM

Panache Partners LLC is in the business of creating spectacular publications for discerning readers. The company's hard cover division specializes in the development and production of upscale coffee-table books showcasing world-class travel, interior design, custom home building and architecture, as well as a variety of other topics of interest. Supported by a strong senior management team, professional associate publishers, and a top-notch creative team of photographers, writers, and graphic designers, the company produces only the very best quality of these keepsake publications. Look for our complete portfolio of books at www.panache.com.

We are proud to introduce to you the Panache Partners team below that made this publication possible.

Brian G. Carabet

Brian is co-founder and owner of Panache Partners. With more than 20 years of experience in the publishing industry, he has designed and produced more than 100 magazines and books. He is passionate about high quality design and applies his skill in leading the creative assets of the company. "A spectacular home is one built for entertaining friends and family because without either it's just a house...a boat in the backyard helps too!"

John A. Shand

John is co-founder and owner of Panache Partners and applies his 25 years of sales and marketing experience in guiding the business development activities for the company. His passion toward the publishing business stems from the satisfaction derived from bringing ideas to reality. "My idea of a spectacular home includes an abundance of light, vibrant colors, state-of-the-art technology and beautiful views."

Kathryn (Kitty) Newell

Kitty is a Senior Associate Publisher for Panache. This book series has been a labor of love as she gets to show off the beautiful homes of her native Philadelphia. After spending 20 years in the stock market, she has been enjoying the world of publishing. To Kathryn, what makes a spectacular home is comfort, color, light and the ability to sync the internal design with the natural setting.

Steven M. Darocy

Steve is the Executive Publisher of the Northeast Region for Panache Partners. He has over a decade of experience in sales and publishing. A native of western Pennsylvania, he lived in Pittsburgh for 25 years before relocating to his current residence in Dallas, Texas. Steve believes, "Family is what makes a home spectacular."

Carol Bates

Carol is an architectural photographer specializing in residential, and commercial photography. Bates Photography, Inc. has been in business for eight years, with most work in the competitive high-end New York market. Some projects have taken her around the world. "A spectacular home must have lots of natural light, bringing the outside in. Where inviting, comfortable furniture and art match the ambience the owners have created."

Barry Halkin

Barry is a contributing photographer for Spectacular Homes of Philadelphia. I feel fortunate to have had this hands-on experience and the insight it gives me into the thought processes and goals of my clients—as well as the aesthetic sensitivity it helped nurture. "A spectacular home is not necessarily grand but visually interesting and comfortable to be in."

Kathleen Nicholson Webber

Kathleen author, wrote about fashion design for the pages of W magazine and Women's Wear Daily during a decade spent in Manhattan. She shares her Bucks County home with children Sullivan, Rory, and Nell and husband Greg. "A spectacular home is welcoming and a treat to the eye—filled with interesting art and lots of family photos."

Additional Acknowledgements

Design—Emily Kattan
Project Management—Carol Kendall
Production Coordinators—Elizabeth Gionta

PHOTOGRAPHY CREDITS

BREAST HEALTH INSTITUTE

CATALYST TO A CURE

The Breast Health Institute (BHI) is a Philadelphia-based, world-renowned, non-profit foundation, think-tank and catalyst to advance breast cancer research and treatment. In addition to sponsoring a series of International Consensus Conferences, BHI is dedicated to developing the talents of a new generation of physicians by initiating Breast Cancer Fellowships, and to advancing the scope of scientific research through seed grants to pioneering doctors. The Breast Health Institute's mission is to work with the best minds in breast cancer throughout the world to find the cure and to eradicate breast cancer. In short, BHI funds research, helps to develop young doctors and sets guidelines for treatment, raising funds through a variety of local and international programs and events.

Founded in 1990 by Shelley and Gordon Schwartz in Philadelphia, Pennsylvania, the Breast Health Institute is a world-renowned breast cancer foundation and "Think Tank" acting as a catalyst to advance breast cancer research and treatment. Our proudest accomplishment has been to bring together groups of the world's outstanding scientists in different disciplines. Since 1997, these groups have formulated groundbreaking guidelines for research and treatment of breast cancer. In its early years, BHI targeted the greatest needs in the local community-funding for widespread availability of mammograms, particularly for the underserved. By launching the Mammocare ™ program, BHI helped thousands of women with limited health care options to obtain mammograms. Numerous organizations have followed suit, carrying out the significant work that BHI started.

In 2005, BHI conducted a major fund-raising event, "An Evening of Elegance," in the Baker, Knapp & Tubbs, Beacon Hill, Century Design, Grange, Roche-Bobois and Interior Works showrooms in the Marketplace Design Center in Philadelphia. The evening showcased themed table and room settings created by interior designers and florists, along with culinary treats provided by area caterers and pastry chefs. Sixty Interior Decorators, 30 Floral Decorators and 30 Caterers participated in the event, donating their time and talents to join BHI in its ongoing fight against breast cancer.

"An Evening of Elegance" was an outstanding success, not only among those who attended, but for those who participated. It was also a significant fund-raiser for Breast Health Institute.

BREAST HEALTH INSTITUTE

Breast Health Insitute
1616 Walnut St.
Philadelphia, PA 19103
215.732.2300
FAX 215.732.7575
www.breasthealthinstitute.org
info@BreastHealthInstitute.org

INDEX OF DESIGNERS